THE DAILY BOOK OF

art

THIS BOOK BELONGS TO:

Walter Foster Publishing, Inc.
3 Wrigley, Suite A
Irvine, CA 92618
USA
www.walterfoster.com

ISBN-13: 978-1-60058-131-1
ISBN-10: 1-60058-131-5

Authors: Colin Gilbert, Dylan Gilbert, Elizabeth T. Gilbert, Gabriel Guzman, Rebecca J. Razo, Sharon Robinson, Amy Runyen, and David J. Schmidt
Copyeditors: Meghan O'Dell and Sandy Phan
Designer: Shelley Baugh
Production Artist: Debbie Aiken
Production Manager: Nicole Szawlowski

Printed in China.

10 9 8 7 6 5 4 3 2 1

THE DAILY BOOK OF
art

Colin Gilbert

Dylan Gilbert

Elizabeth T. Gilbert

Gabriel Guzman

Rebecca J. Razo

Sharon Robinson

Amy Runyen

David J. Schmidt

Introductions

How can you capture everything about the world of art in a single book? The answer is simple: You can't. Art is an incredibly broad and ever-changing field, and it would be silly for us to think we could fit it all into one little book. The definition of art itself is so elusive that people have been arguing about it for thousands of years with no consensus in sight. (See page 19 for more on "what is art?" It's okay—you can skip around a bit if you like.)

With respect for the art world's enormous scope, we've slimmed down our subject matter to touch mainly on the visual arts, highlighting ideas, events, and personalities that we feel are important to understanding the big picture of art and its fluid boundaries. Whether your goal is to build on a previously under-nurtured interest in art, freshen up your existing knowledge, or gain inspiration to create your own artwork, you're sure to find value in the pages that follow.

We've organized the content of this book into ten categories that span the range of art: Art 101, Philosophy of Art, Art Through the Ages, Profiles in Art, A Picture's Worth ~~1000~~ 200 Words, Art from the Inside Out, Art Around the World, Unexpected Art Forms, Artistic Oddities, and Step-by-Step Exercises. In that order, the ten categories will rotate throughout the year, bringing you a variety of unique voices to guide you on your journey. If all goes well, you'll receive a full year's worth of education and entertainment! But, before you jump ahead to Day 1, read the following pages to get a sense of the year to come as the author of each category states his or her intentions.

ART 101 WITH ELIZABETH T. GILBERT

For some people, art is a luxury to be enjoyed as decoration or pursued as a hobby. For others, art is essential, quenching a thirst for expression in a way no other outlet can. Regardless of the function art serves for us, we could all use a little more of it in our lives than we usually allow.

Art 101 isn't just for readers whose intention is to become an artist. Many of the terms and theories in this category are also significant for art lovers desiring a framework from which they can view and discuss art. Interpreting, savoring, and sharing thoughts about art are all made easiest when equipped with the fundamental knowledge and pertinent vocabulary that follows.

But to satisfy those who *do* want to try their hand at art, I also cover the basics of drawing and painting, introducing you to a handful of media and techniques. My goal is not to load you with intimidating details or instructions, but rather to provide a springboard for artistic experimentation. You never know—with the help of these readings, some of you might just make the leap from art lover to artist. —ETG

PHILOSOPHY OF ART WITH COLIN GILBERT

The universe of art is nebulous in nature, occupying an unruly land-scape where passionate revolution is always blurring the boundaries of what is tasteful and acceptable. Ever since humankind first became aware of its predicament and naturally overwhelmed by it, people have needed an outlet for their thoughts and emotions. Thus, art exists as a vehicle for expression. The branches of its evolution have continued to blossom in unexpected ways, dividing exponentially over time and reaching across every continent.

Analyzing art as an abstract concept is one of the most intriguing of all philosophical pursuits, but also one of the most maddening. You know the people who can't decide whether falling trees make sounds? Well, imagine the same people trying to agree on the value of art or the essence of beauty. It's not going to be a pretty picture…Or maybe it will be pretty to some but not others. Perhaps the perception of beauty is different for each individual…Are you starting to get a sense of what you're in for?

Our focus in these pages will be on breadth rather than depth, touching on many different topics and thereby giving you a chance to see what naturally engages your curiosity. Ideally, you will discover new areas of interest and explore them independently in the future. Since these philosophers' ideas have a timeless relevance to our world, worthy of modern interpretation, we'll speak of them in the present tense. —CKG

ART THROUGH THE AGES WITH AMY RUNYEN

Why read about art history? What do we gain from knowing when and how a movement, "-ism," or era came about, and why it is important? Well, beyond its entertainment value, art history informs us about human history—not just about what fashions people used to sport, but how people used to *think*. Art history can be the compass that guides us on artistic journeys. Understanding what came before helps prevent us from walking in circles (although that could technically be considered performance art). Art is more than a record of events and lives past; it is an existential cry and a testament to the creative human spirit. Each time new art is created, another spoke is added in the ever-turning wheel of art history.

From Paleolithic cave painting to contemporary electronic media, these selected writings are an overview of some of the most influential eras in art history primarily from the Western world, along with a few often overlooked but relevant movements. It is my sincere hope that you will enjoy them and build a deeper appreciation for this wondrous and living entity we call "art." —ARR

PROFILES IN ART WITH REBECCA J. RAZO

The closest I've ever come to being an artist was in the first grade when my painting won third place in a school contest. My "masterpiece" depicted a young girl and a brown dog standing next to a red-apple tree in the front yard of a two-story house. Although the scene wasn't an exact representation of my life—my family lived in a one-story, the *green* apple tree was in the backyard, and we had a black dog—my circumstances obviously provided some artistic inspiration.

To what extent does an artist's background influence his or her art? Van Gogh's later works reflected his deeply distressed state of mind. Picasso's many women surfaced in his work repeatedly. Michelangelo depicted a papal chamberlain, whom he disliked, in hell in *The Last Judgment.* Clearly, in these cases, art imitated life.

While it's impossible to know all of the driving forces behind an artist's inspiration, possessing even rudimentary knowledge about his or her life provides just one of many enriching lenses through which to view a work. It widens perspective and deepens understanding; it enables us to connect with an artist's vulnerability and resolve; it invites us to sway to the energy of the art like we would an evocative melody. An artist's story is as much a gift as the artwork itself. —RJR

A PICTURE'S WORTH ~~1000~~ 200 WORDS WITH DYLAN GILBERT

A picture's worth 1000 words...we've heard the cliché a million times. This expression is a convenient way to say that pages of information can be communicated by a simple picture. But have you ever noticed that most people have very little to say when asked to talk about a painting? In just about every case, we can count on the average response telling us that a picture's worth more like 10 words (maybe 20 if we're lucky).

So what are we missing? Often it's one fancy little word: context. Behind every great work of art, there is a great story. The art in this book didn't just randomly spring into existence; each piece was painted by an artist who occupies a unique place in the world. The majority of people reading this book can recognize at least a few of the works featured in the following pages. However, many people may not know anything about the stories these paintings tell or the impact these paintings had—and continue to have—on the art world.

In touching on the significance of each painting, I hope to give you a new appreciation and perspective on both the artist and his or her creation—an insight or

kernal of knowledge that might inspire you to learn more. Although (as our cliché suggests) there is much to say about each painting, my editor has informed me that I have only about 200 words to work with. So as long as we're reading this book, let's just have the saying go like this: *A picture's worth 200 words.* —DDG

ART FROM THE INSIDE OUT WITH SHARON ROBINSON

 For the major players in the "art world"—from artists and critics to collectors and museum directors—the definition of art is in constant flux, often shifting from one exhibition or trend to the next. Art from the Inside Out will take you on a journey to explore the origins of museums in 18th century Europe to the frenetic pace of New York City during Armory Week. You will find yourself front and center at an art auction, breathing in the salty air of Miami Beach during Miami Art Basel, and then traveling to Paris to marvel at the vast collections of art at the Louvre Museum. By the end of your expedition through these pages, you may find multiple answers to the age-old question, "what is art?"—some that may completely contradict each other! —SBR

ART AROUND THE WORLD WITH SHARON ROBINSON

 Are you the kind of person who looks past the crowds gathered in front of Leonardo da Vinci's *Mona Lisa* at the Louvre Museum, searching for the often overlooked work of art? Do you find beauty in unexpected places and objects? Like an *amuse-bouche* for the traveling soul, the many objects, sites, and histories presented in Art Around the World offer a little taste of adventure to inspire future flights of fancy. Many of the works, such as the Greenlandic tupilak sculptures or Japanese sumi-e paintings, are collectible and relatively accessible in galleries, museums, gift shops, and even on the Internet, while many others can only be experienced on location. For armchair travelers and true road warriors alike, these pages provide voyages to the farthest reaches of the globe—Africa, China, New York City, Madrid, even the volcanic shores of Easter Island. The thousand-year-old Buddhist statues in Luoyang, China, and the carved sacred city of Lalibela in Ethopia do not hang quietly on the walls or sit stoically on a granite pedestal; these sites are, in and of themselves, works of art. Many of the objects, such as Russian pysanka, hand-decorated Easter eggs, or the popular Dalecarlian horses from Sweden, can be found in the homes of those who make and admire them. Whether your travels take you around the world or across the street to your local bookstore, only one question remains: Where do you want to go today? —SBR

UNEXPECTED ART FORMS WITH DAVID J. SCHMIDT

"...Loud laughter is the mirth of the mob, who are only pleased with silly things..."
—*Phillip Dormer Stanhope, 4th Earl of Chesterfield*

In the widely published letters directed to his son, Lord Chesterfield severely hedges the definition of propriety regarding practically every social interaction. The English nobleman would likely have disapproved of art drawn on a person's footwear or fashioned from household fruits and vegetables, not to mention the more belligerently informal media of graffiti and caricature.

Unexpected art forms, however, are not always the visual equivalent of "loud laughter"—they are sometimes deeply inspiring. When talent is honed more sharply as a result of disability, or breaks through astounding physical adversity, creativity proves itself impossible to suppress.

Sometimes, art shatters the boundaries of convention so resoundingly as to be shocking. The 1998 film *The Big Lebowski* presents a telling parody of unorthodox artistic technique. When the title character becomes startled by Maude's practice of haphazardly painting while suspended from the ceiling, he becomes the Everyman of the medieval morality play. Every one of us runs the risk of fleeing from, and thus dismissing the significance of, art that appears outside of its expected borders. All are in danger of joining Lord Chesterfield in what Jeffrey Lebowski would describe as "the square community."

It can be tempting to reject the unexpected, spontaneous, and unpolished forms of art for the warm, assuring embrace of narrowly circumscribed definitions. I invite the reader, nonetheless, to continue forward into the uncharted depths ahead.

Come, let us cross through the looking-glass together. —DJS

ARTISTIC ODDITIES WITH GABRIEL GUZMAN

odd·ity (äd' ə tē): *noun*
 1. the state or quality of being odd; queerness; peculiarity; strangeness
 2. *pl.* oddities —·ties an odd person or thing*

While the topics in this category may not squeeze into that definition perfectly, I feel they are all members of the same class of information. Artistic Oddities covers stories about art that might not be in the "mainstream" but that exist on the fringes—the bleeding edge,

in some cases—the fuzzy boundaries of the art world. Talented pioneers of art, tales of art-meets-technology, the largest, and the smallest have all made their way into this category. While much of this book takes itself more seriously, I was given license not to. And so I've done my best to collect tidbits of information about the "oddities," if you will, of art.

On the days of the year that fall in this category, I hope you will smile or raise an eyebrow at something you might not have known. From the annals of history to the modern day, from the just plain odd to the incredibly interesting, Artistic Oddities strives to redefine what it is we think when we hear the word "odd." —GRG

STEP-BY-STEP EXERCISES

1 2 3 Every ten days, you'll get a chance to *really* get your artistic juices flowing. This interactive category asks you to grab some paper and a pencil (or colored pencils) and see what you can do. Artists Ed Tadem and Eileen Sorg offer a wide range of easy, cute, retro, funky, and fun subjects to re-create step by step. And the materials needed are easy to find, dry, and portable, so you can do them practically anywhere.

You can complete Ed's graphite drawings with any pencils you have in the house, but you may have to purchase a set of colored pencils to complete Eileen's exercises. Take a look at the list below of recommended colors for the projects in this book.

blush pink • bright pink • bright purple • bright yellow • brown • brownish orange • dark blue • dark blue-violet • dark brown • dark gray • dark green • dark pink • dark purple • dark warm gray • dark yellow • green • light blue • light blue-violet • light brown • light cool gray • light gray • light green • light orange • light purple • medium cool gray • medium warm gray • olive green • orange • orange-pink • orange-red • red • red-orange • reddish brown • teal • violet • yellow ochre • yellow-green • yellow-orange

(Note: Each of Eileen's exercises builds on a line drawing, which is always shown at the start of the project. If you don't feel that you can replicate the line drawing, consider making an enlarged photocopy of it and transferring it to your paper.)

The Elements of Art

BEGINNING WITH THE BASICS

To understand the significance of these elements, think of them as the building blocks of art. If this metaphor is too broad, you might choose to imagine them as components of a visual language; when skillfully arranged, they come together to create a cohesive message.

Although not every piece of art incorporates each element, we rely heavily on this collection of terms when describing and dissecting art. Knowing the elements will help you understand why an artist has made certain decisions, as well as how you can build your own art from the ground up. Below you'll find each element listed and briefly described, but note that we will address all of the elements in greater depth throughout the year.

- *Line:* A line is a pathway, either visible or implied, that moves the eye through a piece of work.

- *Shape:* Shape is the two-dimensional area taken up by an object.

- *Form:* This element refers to the illusion of a three-dimensional object on a two-dimensional surface.

- *Value:* Value is the lightness or darkness of a color or of black.

- *Texture:* Texture in drawing or painting refers to the way we discern the qualities of an object's surface.

- *Color:* We all know what a "color" is, but not everyone realizes how an artist's choice of color impacts the viewer. A complex element, color will receive plenty of attention as we move forward in Art 101.

- *Space:* Space is the area within the borders of your work; it is what fills the length, width, and perceived depth of a work of art. —ETG

What is Aesthetics?

MAKING JUDGMENTS ABOUT JUDGMENTS

"A Picture is worth a thousand words." —Napoleon Bonaparte

Strictly speaking, aesthetics is not the same thing as the philosophy of art. Aesthetics is a broader term, not just referring to created artwork but to matters of taste in general. Translated from the original Greek, the word encompasses any sort of sensory perception. It wasn't until the 18th century that the German philosopher Alexander Gottlieb Baumgarten gave aesthetics its modern meaning. In short, the study of aesthetics, as we understand it today, is concerned with how our judgments of taste relate to our language, our minds, and our surroundings.

Of course, this book is about art first, so our primary focus will be on the branch of aesthetics interested in art—the philosophy of art. Some of the unique questions found in the philosophy of art involve the value and purpose of art, the role art plays in different societies, and the aesthetic trends in the artistic world.

Think about the *Mona Lisa* (page 12). It's probably the most famous painting in the world. Is it your favorite painting? Why is it so famous? Why is it worth so much? If you saw it for the first time today and had never heard of it, would you find it beautiful? Instead of blindly accepting the standards and traditions of our culture, a little philosophizing will challenge us to justify our beliefs about beauty and the arts. —CKG

QUESTIONS TO PONDER

• *We constantly perceive the world through our five senses. Why do we like some sensations more than others?*

• *How might the study of aesthetics affect our experience of art?*

Paleolithic Painting

THE ORIGINS OF ART

Although humans had been using tools and most likely making art for millennia, the first known evidence of art was produced 34,000 years ago by Cro-Magnons. The Cro-Magnons were the first Early Modern Humans to inhabit Europe in the Upper Paleolithic era. Their most impressive legacy was the images they left on cave walls.

The most notable cave and rock painting sites in Western Europe are the Chauvet (32,000–30,000 BCE) and Lascaux (15,000 BCE) caves in France and the Altamira (18,500–14,000 BCE) cave in Spain. These caves featured vaulted ceilings and walls that served as canvases for this early, sophisticated art in which paints made with natural pigments from the earth were applied with fingers, sticks, fur, moss, and hair.

The cave paintings feature images of extinct animals, such as the wooly rhinoceros, auroch, and wooly mammoth. Some scientists hypothesize that artists tried to magically "make" animals by painting them in a sacred place. Others suggest that these paintings were made to ensure a successful hunt. A third theory is that these were early exercises in animism. Different animals may have represented male and female humans, and were depicted to promote fertility. Whichever theory is correct, we can be sure that the paintings were created for a ritualistic purpose, not mere decoration. One can only imagine what life was like during a time when art was used as more than a cultural compass, but was believed to be a necessary part of survival. —ARR

Leonardo da Vinci (1452–1519)

MASTER OF ALL TRADES

Artist, scientist, inventor—these distinctions merely scratch the surface of the prodigious artist and thinker Leonardo da Vinci, whom many still consider one of the smartest people in history.

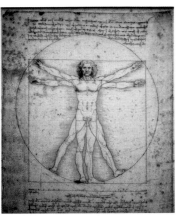

Leonardo da Vinci's legendary pen and ink drawing, Vitruvian Man, *c. 1487.*

Born illegitimately to a notary and a peasant girl near Florence, Italy, da Vinci showed artistic promise at an early age. Under the apprenticeship of famed artist Andrea del Verrocchio, 15-year-old da Vinci soon demonstrated that his talent was far greater than that of his mentor. Unlike his contemporaries, da Vinci endeavored to paint the human form in a manner faithful to its real-life counterpart—an approach reflected in his two most famous paintings, *Mona Lisa* and *The Last Supper*. He often looked to science and nature for artistic inspiration.

Although da Vinci is probably best known for his art, he held various positions over the years that expanded outside this realm, including occupations as a military engineer and an architect. As an inventor, he was well ahead of his time and drafted designs for various flying machines. Another of his passions was the study of human anatomy; he often worked late into the night to examine human cadavers before they succumbed to decomposition. Fortunately, da Vinci documented his ideas, inventions, and studies in several notebooks that historians hold in high esteem to this day. —RJR

Notable works: *The Last Supper*, 1495-97 (page 42); *Mona Lisa*, 1503-06 (page 12); *St. John the Baptist*, 1513-16.

FUN FACT

Da Vinci was a vegetarian and an ardent lover of animals and nature; he was a gentle man and would buy birds in cages just so he could set them free.

Mona Lisa

LEONARDO DA VINCI, C. 1503-1506

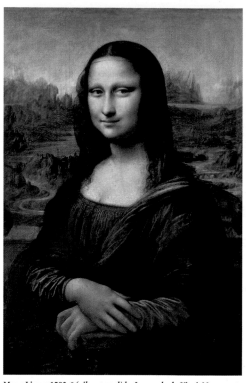

Mona Lisa, c.1503-6 (oil on panel) by Leonardo da Vinci. Movement: Italian Renaissance.

What better place to begin than with *Mona Lisa* by Leonardo da Vinci—possibly the most famous painting in the world? This Italian Renaissance piece is thought to be a portrait of Lisa Gherardini, commissioned by her wealthy husband, Francesco del Giocondo. The painting is also known as *La Gioconda,* referencing her married name.

Have you ever wondered why this painting has achieved such notoriety? I can offer a few technical reasons: First, the portrait showcases da Vinci's mastery of a technique called *sfumato*—a layering of translucent colors to produce subtle blends that merge shadows seamlessly over a form. Note the soft curvature of her brow, cheeks, and mouth. Second, da Vinci was innovative in his approach. He painted Lisa at half length from a three-quarter view at a time when full-length profiles were the norm, forever altering the direction of portraiture.

An enormous and almost uncanny amount of attention has been showered on *Mona Lisa,* especially within the last century. A host of theories and questions have cropped up over the years: Is the painting a self-portrait of da Vinci in disguise? Did she once have eyebrows and eyelashes? And what is up with that mysterious landscape behind her? Although we have more answers now than ever before, Lisa's mysterious smile suggests that we may never know the full story. —DDG

Cabinet of Curiosity
THE ORIGIN OF THE MODERN MUSEUM

Everyone has been to a museum of some sort: natural history, science, fine art, tourist traps, or halls of fame. The museum, which gets its name from the Greek word *mouseion,* meaning "seat of the Muses," originated as a place to discuss philosophy, mathematics, science, and politics. European museums of the 17th century developed into

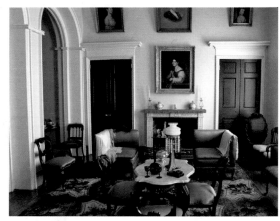

Many world-famous contemporary art collections began as private works hung in 18th-century homes.

fancy houses devoted to collecting and categorizing noblemen's scientific curiosities, from fossilized teeth and bones to cultural oddities collected during the explorations of the Age of Enlightenment.

Twenty-first century museums stem from these earlier methods of collecting, preserving, interpreting, and displaying objects; some cover an encyclopedic range (the British Museum in London and the Metropolitan Museum of Art in New York City) while others became highly specialized (Museum of Neon Art in Los Angeles or Baseball Hall of Fame in Cooperstown, New York). Since only a fraction of objects in the tens of thousands of museum collections worldwide are on display at any given moment, many institutions devote time and energy to creating a collections and exhibitions database, accessible via the Internet; you can take a "virtual tour" of the museum without leaving your home.

Today, many museums are free and provide an educational and entertaining day trip for families. And museums are not just vast depositories for objects—they provide educational programs, guided tours, interactive exhibits, cafés, and at least one museum gift store where you can purchase books or last-minute gifts and souvenirs. There's always something for everyone! —SBR

Tupilak
TRADITIONAL ART OF GREENLAND

If you visit the island of Kalaalit Nunaat (also known as Greenland), you will be delighted by the astonishing variety of Inuit artistry, which includes *tupilaks,* small grotesque figures carved in narwhal or walrus tooth, whale ivory, or reindeer antler. A tupilak can function as a highly charged man-made object, a spectral being, or a restless soul of the deceased. Tupilaks became popular trade items after contact was made between indigenous peoples and European explorers in the late 19th century.

Ranging from two- to twenty-inches tall, tupilaks feature stylized renderings of mythic animal and humanoid beings, and serve as important talismans. Traditionally, tupilaks were created to attack and harm an enemy. Creating a tupilak was not without its hazards; if the targeted victim of the spell had greater spiritual powers, the enchantment could reverse upon its creator and his community. Today tupilaks are popular souvenirs and can be found in gift shops or on the Internet. A dent in your wallet is the biggest danger you may face when purchasing a tupilak—most reputable dealers charge upwards of $1,000 for a six-inch totemic sculpture. —SBR

WHAT IN THE WORLD?

Based on a 1926 short story by H.P. Lovecraft, the 2005 black-and-white short film The Call of Cthulhu *featured a carved tupilak made of polyeurethane resin to resemble aged walrus tusk.*

•

The 2001 French short film Tupilak *involves two polar explorers who tragically abandon their Inuit guide, eventually encountering his vengeful spirit two years later in a museum.*

Covered in Clay, Plastic, and Concrete

ALBERTO BURRI'S CRACKED ART

Throughout the course of human history, the merciless forces of war, disease, and natural disaster have wiped many communities from the map.

Such is true of the Sicilian town of Gibellina, which was abandoned in the 1960s after a massive earthquake. The inhabitants of the hamlet fled for a different community, leaving behind a ghost town. In an existential work of apocalyptic proportions, Alberto Burri covered the entire hamlet with cracked white concrete.[1]

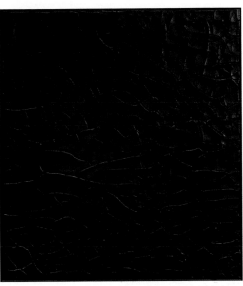

Nero Cretto G 5 *by Alberto Burri. Photograph by Giuseppe Schiavinotto, Studio Fotografico.*

Other works, while much smaller in scale than the vast expanse of Gibellina, nevertheless evoke the same arid, desolate look of cracked mud. The artist elicited this effect from various materials, including mud, concrete, and a plastic substance known as *acrovinilico*.

There is a corporal feel to Burri's creations. His work was often charred and otherwise punished, creating a crisscross of zigzagging scars that exposed the layers beneath the wounded surface. Having experienced the horrors of war as a doctor during World War II, the artist explored themes related to human suffering. The intimately personal inspiration behind Burri's cracked sculptures endows them with a timeless, universal relevance. —DJS

Painting Pachyderms
THE ELEPHANT ARTISTS OF THAILAND

"Is that a Sri-siam, or perhaps a Wanalee? The style is reminiscent of the early elephant masters...." While you most likely won't hear this any time soon, it's conceivable. Elephant artists have been creating original art since 1998, unbeknownst to many people. Although requiring some human guidance at first, the elephants with aptitude soon start painting of their own accord—and some go on to produce works that sell at auction for more than $2,000.

My Egyptian Moment *by Wanalee. Acrylic on cotton and cellulose paper. Courtesy of The Elephant Art Gallery and the owner of the painting, Ms. Alice S. Marx.*

The National Elephant Institute in Thailand has a cadre of 16 painting elephants, each with his or her own distinctive style that continues to mature over time. Grasping paintbrushes with their agile trunks, these elephants create paintings that are often colorful, energetic, and (surprisingly) compositionally balanced. Just like their human counterparts, elephant artists have good days as well as bad days when they literally walk away from the canvas, refusing to paint.

There is even a market for "fake" elephant art, which—with the help of humans—resembles everyday objects. Aum-Mon Weesatchanam, a former Director of The Elephant Art Gallery, believes that "elephant art is an original painting that is created by an elephant, unaided by human hand," and feels that works created with human help are no substitute for the real thing.

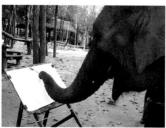

An elephant artist at work. Courtesy of The Elephant Art Gallery.

Look through the hundreds of images out there, and you'll find it hard to disagree. What elephants do on their own is far more interesting than what they do with human intervention.

Although these pachyderms have their share of critics, you can't help but wonder if a human artist will one day be crediting an elephant as an influence. —GRG

Exercise 1

WINE STILL LIFE WITH ED TADEM

Use basic shapes to
sketch the wine bottle,
glass, and cork.

Develop the shapes,
erasing unneeded lines
as you go. Suggest
the liquid in both
glasses and block in
the wine label.

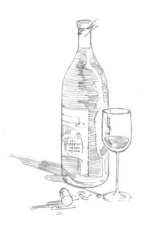

Start shading,
leaving white areas
in places to suggest
reflective surfaces.
Add cast shadows,
a tear in the foil
at the top of the
bottle, and a piece
of foil attached to
the cork. Texture
the cork with small
dots.

Darken all the elements,
taking care to leave the
highlights white.

Line, Shape & Form

BREATHING LIFE INTO YOUR MARKS

You may have been told that there are no true lines in nature—only divisions in value. Art teachers often use this expression to protect students from the bad habit of "over-outlining." However, it's not a basis for avoiding lines altogether. They can be used as effective tools for communication; varying a line's thickness can suggest weight, emphasize contours, and simply add character. As an element, line can also refer to "implied lines," or visual pathways (created by the arrangement of objects in the scene) that generate interest by guiding the eye through a work of art.

When an area is enclosed by a line (or by divisions in value), it's considered a shape. Curvaceous, angular, thin, or pointy, a shape can create a sense of unity when repeated subtly within a work of art.

Form builds on shape to bring us from a two-dimensional to a three-dimensional world. An easy way to envision the relationship between shape and form is to think of a circle becoming a sphere. Unlike a flat, weightless circle, a sphere appears to have weight and presence. Creating this illusion of volume is a crucial step toward realistic drawing and painting. —ETG

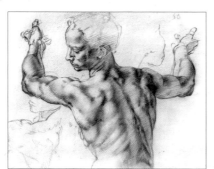 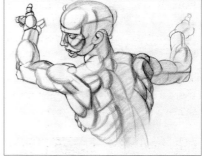

Above is an exercise by artist Lance Richlin. At left is Lance's rendition of Michaelangelo's study for the Libyan Sibyl. (The final painting of this figure graces the ceiling of the Sistine Chapel.) At right, Lance has reduced the figure to its most basic forms, exaggerating the shadows and minimizing the surface shading to emphasize the volumes. These volumes represent bumps and bulges that might lie within the body, indicating the underlying structure. As Lance has done, try creating a volume study of your own subject to better understand its forms.

What is Art?

A LEXICOGRAPHER'S NIGHTMARE

"Art is either plagiarism or revolution." —Paul Gauguin

The most fundamental question in the philosophy of art is that of the nature or definition of art in general. Of course, many philosophers have debated the question but never has there been universal satisfaction with any one theory.

It's worth asking whether it is even possible to properly address the question, "what is art?" or whether there is any practical purpose in doing so. The arguments may be fascinating to some, but supposing a proper definition is even possible, what would its creation accomplish? Part of art's appeal is in its freedom from rules and boundaries, and time has shown that art is a fluid concept defying rigid classification. Whenever new art forms emerge from revolutionary minds, humanity gradually adapts to the change and the concept of art is modified.

So, it is important that radical views on art receive open-minded consideration. However, if the idea of art is going to retain meaningful specificity, it is going to need some boundaries. If everything could be considered art, then the word "art" would be void of meaning. We must use some discretion in identifying art in order to prevent such a fall into semantic oblivion.

When it comes to matters of taste and technique in the world of art, subjectivity is all well and good, but it may become troublesome if we become too relativistic with our categories. —CKG

QUESTIONS TO PONDER

• *How would you define "art"?*

• *Do you believe it is possible to define art in a way that satisfies everyone?*

Ancient Egyptian Art

ART FOR ALL ETERNITY

Though paint can fade and papyrus disintegrates, stone and gold can last for millennia. The Ancient Egyptians sought to achieve that goal for the glory of their Pharaohs, creating monuments, sculptures, and burial masks that would stand the test of time and last for all eternity. How else could a Pharaoh live forever and keep on impressing us?

> **WHEN & WHERE**
> *c. 3,000 BCE–332 BCE*
> *Egypt*

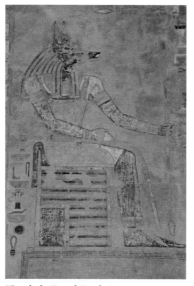

Hieroglyphs, Karnak Temple, near Luxor, Egypt. Photo courtesy of Nathan Rohlander.

Like the materials they used, the Ancient Egyptians' artistic style weathered the storms of time and barely evolved over centuries. Since it is difficult to find major stylistic differences between artwork from several dynastic eras, it seems that ancient Egyptian culture was strict with what it would tolerate from art. Ancient Egyptians were either stiffly double-jointed, or their artists had specific intentions when drawing figures. In wall paintings and relief the Pharaonic image was flatly idealized, whether it sat or stood in rigid dignity or vanquished enemies in military escapades. Many poses may appear odd or unnatural to the contemporary viewer, as artists of the time only depicted the most complementary positions of individual body parts. In addition to the gods, royalty, servants, and ordinary citizens were similarly stylized, shown going about their daily tasks in a peaceful and abundant realm that only a great Pharaoh could sustain.

The afterlife was paramount to Ancient Egyptians, and it appears that they did achieve a form of life after death. Though the Pharaonic era came to an end, their art has endured, and they still speak to us through stone, paint, and gold. —ARR

Jan Vermeer (1632–1675)

A MASTER OF LIGHT

Johannes (Jan) Vermeer was born in 1632 in Delft, Holland, where he also spent most of his life. He married Catharina Bolnes in 1653, with whom he had 15 children. He is believed to have enjoyed a happy home life, despite an antagonistic relationship with his live-in mother-in-law.

Vermeer's compositions, rendered with geometrical precision, exemplify *repoussoir* (French for "to push back"), a technique used to give the illusion of depth by situating large objects or figures in the foreground. Vermeer's art hails from the Delft School, which is characterized by scenes of calm, peaceful domesticity—much like the village itself. His exquisite use of color and light, and his attention to textures and fabrics, further augment his thoughtful representations of daily life, which often captured subjects seemingly engaged in moments of quiet reflection. Facial expressions are frequently contemplative, ambiguous, or suggestive, and viewers of a particular work may feel as though they have stumbled on a deeply private moment. Some scholars believe that Catharina was the subject of *Woman in Blue Reading a Letter,* although there is no solid evidence to support this.

While Vermeer enjoyed prosperity for a time, he ultimately fell victim to the perilous economy surrounding the French Invasion of 1672 and died penniless. Today he remains a revered master; his 36 surviving paintings are exhibited in museums around the world. —RJR

Notable works: *The Milkmaid,* 1658-60 (page 182); *Girl with a Pearl Earring,* 1665; *The Art of Painting,* 1666-1673.

FUN FACT

Vermeer's deft renderings of textures and fabrics in his paintings may have come from observing his father, whose trade was in textiles.

Sunflowers

VINCENT VAN GOGH, 1888

Think about it. There is somebody you know who either owns a refrigerator magnet featuring Vincent van Gogh's *Sunflowers* or has a print of the painting hanging somewhere in his or her house. Am I right?

The story behind these famous flowers begins November of 1887 in Paris, France. Van Gogh wasn't even a decade into his career as a painter, but he had already crossed paths with many of the most famous painters of the time, not the least of which was Paul Gauguin. Van Gogh and Gauguin began a professional and personal relationship that was, let's just say, mercurial in nature.

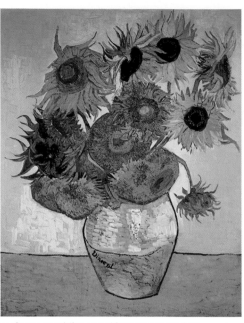

Sunflowers, 1888 (oil on canvas) by Vincent van Gogh. Movement: Post-Impressionism.

By 1888, van Gogh had grown weary of life in Paris and relocated to the town of Arles. There he dreamed of founding an art colony with many of the artists he had met in Paris and soon convinced Gauguin to come and live with him in the same house. This piece is the most famous of a series of paintings that van Gogh created—each with bright colors and thick, lively brushstrokes—for the house in anticipation of Gauguin's arrival. Perhaps it's this welcoming spirit that has given *Sunflowers* an enduring presence in the homes of people around the world for over a century. —DDG

The Permanent Collection
THE "HEART" OF THE MUSEUM

Building a museum's collection brings with it a great deal of work, respon- sibility, and inevitable controversy. It is no easy task to collect, document, preserve, and showcase the hundreds, and possibly thousands, of objects that make up a museum's permanent collection. What you see on display at any one time in a museum is only a mere fraction of its total holdings; most works sit in storage or reside offsite in a traveling exhibition. Most museums simply don't have the room or finances to build exhibition spaces for all of the works they own, so most permanent collections are constantly rotated.

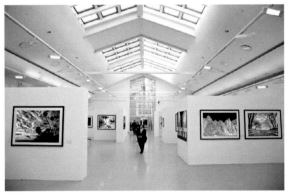

The work you see on view in the museum's galleries often represents only a small fraction of the permanent collection.

The "heart" of every museum—the collec- tion—is a dynamic, living thing; museums constantly reevalu- ate their collection's objects to more ac- curately reflect their institutional mission. The processes of ac- cessioning and de- accessioning (buying and selling) artworks are not tasks to be taken lightly, for with every work sold, the proceeds are traditionally reinvested into the collection. Many museums build around an existing collection, yet the resources to make acquisitions have to be supplemented by gifts of art and funding from public and private institutions. Controversy has haunted many a director and mu- seum board; misappropriation of funds, withdrawal of a promised gift, and repatriation of stolen artworks are problems that plague a surprising number of institutions. —SBR

Those Lovely Bones

CELEBRATING THE DEAD IN MEXICO

Imagine planning all year for a holiday devoted to communicating with and celebrating the deceased! With a rich history dating back more than 500 years, the art forms of the Mexican holiday the Day of the Dead, or *El Día de los Muertos,* are at once respectful of the dead and laced with humor. The Mexican celebration occurs on November 1 (All Saints' Day) and November 2 (All Souls' Day) and evolved from a 12th-century Aztec festival dedicated to the deity Mictecacihuatl, or Lady of the Underworld, who guarded the bones of the deceased. After encounters with 15th-century Spanish explorers, the pre-Columbian traditions merged with Catholic rituals and the modern-day festival developed.

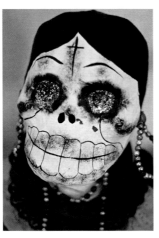

Doll created in celebration of Mexico's Day of the Dead.

The most recognizable symbol of the holiday is the skull, or *calavera.* Sugar skulls, decorated with colored icings and inscribed with the recipient's name and *pan de muerto*—sweet egg bread twisted to resemble bones—are left at gravesites, on the family altar, or given as gifts to loved ones. Masks, or *calacas,* and costumes made for the holiday are decorated to resemble bones. Drawings, etchings, and papier maché sculptures of Catrina, the skeletal figure of a high-society woman popularized by early 20th-century printmaker José Guadalupe Posada, comically remind us that death comes to everyone. With the celebratory tone that permeates the food, art, and culture of the festival, the boundaries between the living and the dead seem to temporarily blur. —SBR

WHAT IN THE WORLD?

You can celebrate Dia de los Muertos *in a multitude of ways around the world: Take a day off in Brazil; fly a handmade kite in a Guatemalan graveyard; or float paper lanterns down a river to guide ancestors home during the Bon Festival in Japan.*

Happenings
FROM THE ROUTINE TO THE SURREAL

To witness Wolf Vostell's exhibit, spectators are led through an expanse of forest, following a meandering path in and out of the trees. They emerge into a clearing to find a swimming pool and tennis courts. Performers are hurling smoke bombs back and forth; some wear gas masks. Further down the path, the observers see an assemblage of television sets lying in beds.

This is a "happening."

During the Fluxus movement of the 1950s, artists such as Vostell began to create participatory scenes for observers to experience. In the above-mentioned 1964 happening, entitled simply "You," the German artist created an unnerving sequence of surreal scenes in Long Island, New York.[2]

Allan Kaprow produced equally bizarre happenings, many of which were mapped out ahead of time in handwritten blueprints, or "scores." Women licked jam from the hood of a car; a group of people walked through city streets, each of them dragging a single shoe by a string. The 1962 happening entitled "A Service for the Dead II" involved three men buried up to their necks in sand, their heads covered with plastic bags.[3]

Not all of Kaprow's happenings incorporated such peculiar elements, however; the American artist was especially partial to events involving quotidian, prosaically routine activities. Women repetitively squeezed oranges; men laboriously built a wall from large stones. "Labor Day" consisted of nothing but the tedious actions of changing car tires and shoveling sand; the happening has been recreated on college campuses well into the 21st century. —DJS

The Museum of Bad Art

PRESERVING OUR "MASTERPIECES"

Where does bad art go to die? The trash, a landfill, or eBay®? Not if the Museum of Bad Art has anything to say about it. Since 1994, MOBA has been building a collection of really bad art. From *Mana Lisa,* a testosterone-laden take on one of the world's most famous paintings (at right), to *Bone Juggling Dog in a Hula Skirt,* which needs no explanation, the museum staff diligently selects only the worst of the worst for their permanent collection.

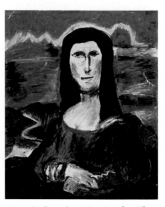

Mana Lisa by Andrea Schmidt. 16" x 12", oil on canvas. Donated by the artist. MOBA catalog #370. Courtesy of The Museum of Bad Art.

MOBA has grown from a handful of pieces kept in the basement of one of the founders to more than 500 pieces housed in a warehouse and two separate galleries in the Boston area.

You might think that anyone can produce bad art; MOBA disagrees. They set a very high standard for the works that are accepted into their permanent collection. According to MOBA's curator-in-chief, Michael Frank, a work "must have been created by someone who was seriously attempting to make an artistic statement—one that has gone horribly awry in either its concept or execution."

As their mission statement declares, they're the "only museum dedicated to the collection, preservation, exhibition, and celebration of bad art in all its forms." —GRG

Exercise 2

BUTTERFLY WITH EILEEN SORG

Fill in areas of the wings with bright
yellow. Stroke over this with a layer of
yellow-orange, and then touch this into
the right pupil and antenna.

Add red-orange over the yellow-
orange. Darken areas of the
wings, upper body, right eye, and
antennae with reddish brown.

Add the purple and blue areas of
the wings with bright purple and
bright blue. Add true blue to the
left eye and antennae.

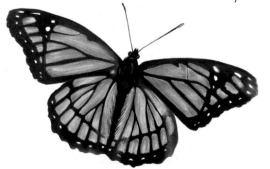

Add black to
any empty areas,
overlapping some
colors. Fill in almost
all of both eyes with
black, and add some
black to the right
antenna.

Value

LIGHT, DARK, AND EVERYTHING IN BETWEEN

Value (as an element of art) refers to the relative lightness or darkness of a color or of black. Value is what gives a shape the appearance of three-dimensional form; using a range of values to render an object will help you suggest highlights, shadows, curves, corners, and textures.

When working with colorless media (such as pencil) or variations of one color, you rely entirely on value to represent your subject. That being said, it is extremely important to record values accurately. To do this, try squinting at your subject, which will help you break it down into simple shapes of value while minimizing distracting detail. It's also a good idea to familiarize yourself with the range of value you can produce with your medium. Do this by creating a value scale (as simulated below)—simply work from lightest to darkest on a length of paper.

Value scale in graphite 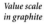 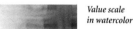 *Value scale in watercolor*

Value also plays an invaluable role in works of art that incorporate color. Below is a series of illustrations by artist Joseph Stoddard that show how value helps a viewer "read" a painting. In example A, the watercolor sketch displays accurate colors and accurate values. Example B has correct colors but incorrect values, and example C has incorrect colors but correct values. Of examples B and C, which is more dynamic? Although we know most trees aren't red, hillsides aren't royal purple, and skies aren't yellow, the eye is still drawn to and pleased by the clarity and value variety in example C. —ETG

A 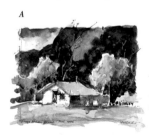 *B* 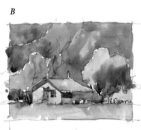 *C*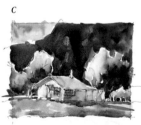

What is an Artist?

DO YOU MAKE THE CUT?

"The artist is not a different kind of person, but every person is a different kind of artist." —Eric Gill

The above quote is charming in its political correctness, making us feel all warm and fuzzy inside as we bask in our newfound status as artists, but not everyone would agree with it. Other basic definitions of an artist would include "someone who actually does art," "someone who actually does art *well*," and "someone who does art for a living." Well, which is it?

Obviously, the question is closely related to our previous topic, *what is art?* If art includes everything from composing symphonies to making coffee, then we certainly are all accomplished artists. However, if we only think of the "fine arts" as true art, then the number of artists in the world quickly diminishes. Even then, the word can be used in different ways. It's one thing if someone sees you doodling on a notepad and says, "You're a pretty good artist!" and quite another if someone asks you what you do and you say, "I'm an artist."

Sometimes it's a close call. We call someone who paints portraits an artist, but we might not say the same about a person who paints houses. What about someone who paints furniture? What about the person who carved the furniture? They are all skilled at their craft, and they all contribute to the beauty of our surroundings. It's funny how arbitrary we can be when separating our concepts. We should be careful though; people's identities are at stake! —CKG

QUESTIONS TO PONDER

• *What does it take for a person to be a true artist?*

• *Would you consider yourself an artist? Why or why not?*

Classical Greek & Roman Art

A CELEBRATION OF FORM

Understanding naturalistic form through direct observation of the human body and the natural world was an exercise in rational thought and a celebration of beauty for the Greeks and Romans of the Classical period.

WHEN & WHERE

c. 450 BCE–476 CE

Greece and Ancient Rome

Standing on the shoulders of hundreds of years of art and architecture, the Classical period was one of the most fruitful and influential eras in all of art history. Greek temples, painted amphorae, bass reliefs, and marble and bronze statues reflect a culture that prized balance, harmony, and natural beauty in the visual arts. A perfectly toned male body was admired and held equal value to a well-developed mind; subsequently, Classical Greek art featured many nude lads.

Having absorbed many cultures through conquest, the Roman Empire's art was an eclectic blend of traditions, mainly Greek, making a Roman "style" hard to define. However, we do know that art was a staple of everyday life for Romans. They were prolific creators, spreading Roman values of dignity, power, and history through sculptures, coins, portraits, and murals—not to mention their architectural triumphs. Keen observation and representation of non-idealized figures became a trademark of Roman portraiture, wrinkles and all. —ARR

Zeus or Poseidon of Artemisium, bronze, 460 BCE—replica.

Vincent van Gogh (1853–1890)
ARTISTIC GENIUS, TORTURED SOUL

More than 100 years after his death, Vincent van Gogh remains one of the most recognized and revered artists in the world. His signature style—a fusion of brilliant color applied with heavy, concentrated brush strokes—speaks not only to his artistic sensibilities but also reflects the intensity of his disposition and temperament.

Sunflowers were a key source of inspiration for van Gogh, who rendered them with vibrant intensity.

Born in 1853 in Holland, van Gogh's story is mired in tragedy and despair. He struggled with mental illness throughout his life and failed at several careers early on, including occupations as an art dealer and clergyman. Ultimately, he turned to art as a means to express his views about the world around him, although his genius was not recognized until after his death.

Van Gogh's early work was generally conformist, but his travels and associations with various artists, particularly Paul Gauguin, contributed to the evolution of his craft. He had dreams of creating an artists' colony with Gauguin; however, an argument between the two resulted in van Gogh's infamous severing of his own ear—an incident that also marked the onset of his complete mental demise. Although the troubled artist continued to paint over the next two years, his battle with mental illness proved unbearable, and he committed suicide in 1890; he was 37 years old. One can't help but ponder what additional masterpieces van Gogh might have produced had he lived to realize his full potential. —RJR

Notable works: *Café Terrace at Night,* 1888; *The Bedroom,* 1889; *The Starry Night,* 1889 (page 132).

FUN FACT
Vincent van Gogh shared a close relationship with his brother Theo, a successful art dealer. It was through Theo's ongoing and generous financial support that Vincent was able to spend most of his adult life pursuing art.

The Birth of Venus

SANDRO BOTTICELLI, 1485

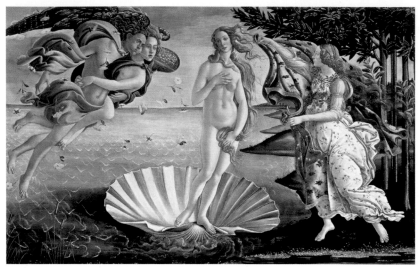

The Birth of Venus, *c.1485 (tempera on canvas) by Sandro Botticelli. Movement: Italian Renaissance.*

This well-known tempera painting by Italian Renaissance artist Sandro Botticelli depicts the watery birth of the Roman goddess of love and beauty. Within the painting, imagery from nature—often adorned with gold—mark the occasion as an extraordinary celebration of beauty. Amidst a sprinkling of pink flowers, her guilded scallop shell blows toward the shore with the help of two Zephers (the figures at left). No labor pains or cold, sterile hospital rooms here! Clearly this is not your typical birth, but let's face it—Venus is no typical woman.

Back in 15th-century Italy, there were a number of wealthy and powerful families who commissioned artists from around the country to create works of art. The most famous of these families was the Medici family from the region of Florence. Lorenzo de' Medici (dubbed "the Magnificent") is considered to be the most significant patron of the arts from this family. Around the year 1482, Lorenzo commissioned this tempera painting. Botticelli obliged, and a classic was "born." —DDG

Behind the Scenes

SO YOU WANT TO WORK AT A MUSEUM?

Walking along the hushed gallery spaces of any museum, you might never suspect the hive of activity occurring just steps from the artwork. A museum runs well only because of the hard work of its staff, from the lowest-level museum guard to the wealthiest donor on the Board of Trustees. The museum's director works closely with the curatorial staff to conceptualize and coordinate traveling and permanent collection exhibitions. Curators direct the acquisition and exhibition of objects in the collections. Larger museums have a separate research division or institute as well as an education department that provides interpretive materials and programs to the general public, but in smaller institutions, these individual units may be merged and overseen by the curatorial department. The registrar is responsible for the conservation, archiving, evaluating, categorizing, and often the installation and de-installation of any object in the collection, from the moment it enters

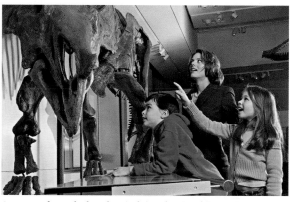

A museum educator leads students in their exploration of dinosaur bones at a natural history museum.

the museum to the day it leaves the climate-controlled vault. The registrar and collections manager maintain the museum's history, which may consist of photographs, films, video and sound recordings, and electronic and paper files dating back to the museum's foundations.

In addition, museum guards, café and bookstore clerks, preparators, and interns work within the museum as quiet forces dedicated to keeping things running as usual. Only through the hard work and collaboration between all levels of museum staff can a museum function as the educational and inspiration center of learning people have come to know and love. —SBR

Retablos and Ex-votos Paintings

IMAGES OF DEVOTION

Retablos and ex-votos represent two unique hybrid genres of art, where the religious themes and iconography of Catholicism fuse with the traditional folk art styles of Mexico, and Latin and Central America. *Retablos,* from "retablo," which is literally translated "behind the altar," are small, multi-paneled oil paintings on wood depicting Christ, the Virgin Mary, or any one of the multitude of Catholic saints. *Ex-votos,* from the Latin "from a vow," are paintings on tin or canvas offered as thanks to particular saints who have helped an individual in a specific way. Found at pilgrimage sites or domestic shrines, these small paintings traditionally include a short illustrated testimonial featuring the saint and the exact date and time the miracle occurred.

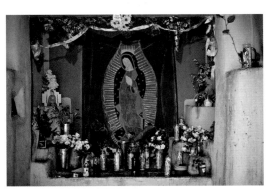

The Virgin de Guadalupe is a popular icon in retablos and ex-votos paintings.

Both art forms shared similar themes and iconography, but developed from different traditions and purposes. The Church used retablos after the 16th century as storytelling aids in an attempt to convert the mostly illiterate indigenous populations to Christianity. Conversely, ex-votos developed out of a strong pre-Columbian votive tradition; the themes and narratives of Aztec deities overlapped with images of the Catholic saints, of which the Church strongly disapproved. The unique artistry of ex-votos involved bold, deeply saturated colors and the use of mixed media, setting it apart from the more conventional retablos paintings.

Both retablos and ex-voto folk art spread north to what is now the American Southwest during the 18th and 19th centuries. The largest public collection of retablos in the US is in the art collection of New Mexico State University, which houses more than 1,700 objects. —SBR

The Vintage Collages of Anne Taintor

"...ONE COCKTAIL AWAY FROM PROVING HIS MOTHER RIGHT"

About 70 years ago, advertisements began to do much more than provide information about a product—they turned to selling an idealized way of life.

Anne Taintor's clever, subversive art offers a would-be backstage pass into the internal monologues of those who participated in these utopian displays.

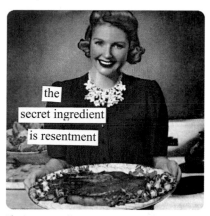

The Secret Ingredient Is Resentment. *Image courtesy of Anne Taintor.*

From a combination of original advertisements, landscapes, interiors, and colored paper, Taintor creates a unique style of collage that mimics the look of 1930s-, '40s-, and '50s-era publications. The apparent "domestic tranquility" presented in these idyllic scenes contrasts with the witty quips attributed to the men and women involved.

In recent years, Taintor has had the pleasure of contacting many of the original models from the vintage advertisements, affectionately referring to them as her "Taintorettes."

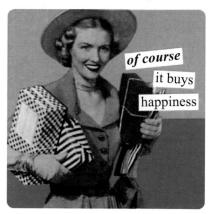

Of Course It Buys Happiness. *Image courtesy of Anne Taintor.*

The artist emphasizes that, despite the constrained gender roles they were selling, these women were pioneers of sorts, progressively building their own careers. "At a time when it was far from the norm, many of these women were wage-earners on whom their families depended," she affirms, "even as they posed as ladies who could conceive nothing more thrilling than a new brand of dish soap." —DJS

Camera Obscura

WHO NEEDS MEGAPIXELS?

Have you ever wanted to step inside a photograph? While this may not be entirely possible, with the help of a large camera obscura, you can get pretty close.

Built in 1766, the Clifton Observatory in Bristol, England, shares its large camera obscura with tourists from all over the world.

A relatively simple device, a camera obscura is a darkened room (or chamber) with a small pinhole in the wall for light to enter and a smooth surface (such as a wall or a canvas) opposite the hole. Whatever is going on outside of the room will display itself upside-down on the smooth surface of the room. More complex camera obscuras involve lenses and mirrors that change the size, clarity, and orientation of the projected image. This device was a precursor to the modern camera, which still works in very much the same way.

Camera obscuras have been around for about 1,000 years, ranging in size from a small box that fits on a table to a large, walk-in room. They have been used over the centuries by scientists to study astronomy and by artists as a way of projecting a scene onto canvas or paper. In fact, most historians agree that Vermeer used a camera obscura to achieve his remarkable realism, and speculation exists that a handful of other masters used similar optical devices. —GRG

Exercise 3

SNAIL WITH ED TADEM

Draw a misshapen circle for
the shell; then add the neck,
head, and tentacles.

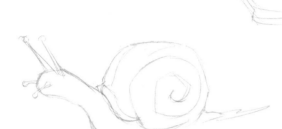

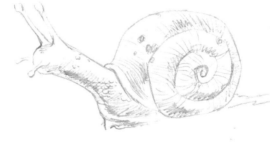

Refine the basic
shapes, defining the
tentacles and adding
the spiral pattern to
the shell. Indicate a
"slime" trail.

Continue refining
shapes and begin
shading, adding
radial lines and
spots to the shell.

Build up the darks,
deepening the shading
and creating the
ridged texture of
the shell. And he's
off! (Sort of.)

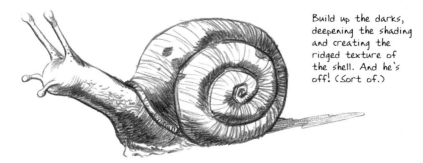

Texture

FEELING WITH YOUR EYES

Unlike other elements of art, texture engages our sense of touch. Soft, silky, rough, bumpy, slick, grainy—all of these tactile qualities (and more) can be represented with drawing or painting media, triggering our brain to imagine what the surface may feel like.

The appearance of texture (or *perceived texture*) emerges when light falls across a surface. Light defines even the subtlest of peaks and dips, helping us "read" the feel of a surface. Communicating this dynamic between light and shadow is essential for realistic drawing and painting. Don't underestimate the benefits of incorporating a variety of textures into your work; a scene without texture can run the risk of appearing flat.

Distinct from perceived texture is *actual texture*. Just as you might guess, this refers to the physical texture of a surface—one that you can touch and feel. Artists sometimes enhance their paintings with actual texture by applying thick impasto strokes. In this case, the thick paint has dimension and casts subtle shadows onto the canvas. —ETG

SEE FOR YOURSELF!

• *For an example of perceived texture, turn to Boucher's* Lovers in a Park *on page 372. Note the satin-soft billows of fabric that make up each woman's dress.*

• *In van Gogh's* Sunflowers *on page 22, the actual texture of the blue background enlivens what could have been a flat, solid space.*

The Purpose of Art
WHAT'S THE POINT?

"All art is quite useless."
—*Oscar Wilde,* A Picture of Dorian Gray, *Preface*

Why do people create art? They may want to imitate an experience, express a personal passion, or just make a few bucks. But why *should* people make art? Are some motives more virtuous than others?

One popular contemporary view, concisely summarized in Wilde's quote, is that art should not attempt to achieve anything at all. In other words, the noblest art, perhaps the only true art, is "art for art's sake." Under this view, the only valid reason for making art is *to make art*. Any other motive, such as the communication of meaning or the paying of bills, devalues the art or disqualifies it altogether.

Opponents of the "art for art's sake" mindset are not satisfied with unemployed art; they want results! Some philosophers go so far as to demand that art perform a specific function, such as reflect truth, work to unify society, or at least decorate a room.

Many of us probably reside somewhere in between the two extremes, recognizing virtue in the mere creation of art but having greater respect for that which seeks to better humanity or improve the lives of individuals. So then, if altruistic intent is more admirable than selfish or indifferent motives, should all art aim to produce an overall good in the world? Or is the simple desire to make art as good a reason as any? —CKG

QUESTIONS TO PONDER
• *Should all art strive to fulfill a certain purpose? If so, what should be its goal?*

• *Is the creation of art, per se, a noble ambition?*

Early Christian & Byzantine Art
A CHRISTIAN CORNUCOPIA

Deep beneath the busy streets of Rome, dark catacombs reveal the earliest known images of Jesus, depicted in a blend of Christian and pagan symbolism that influenced the iconography of Byzantine

> ### WHEN & WHERE
> *c. 100-1453 CE*
> *The Ancient Holy Roman Empire*

art and beyond. These wall paintings, frescos, and mosaics contain images of Christ as the good shepherd or as a charioteer with a sun-like nimbus—both of which are borrowed from early Christianity's oppressor, the Roman pagans. Though often naïve in execution, they reflect an attempt to capture naturalistic forms, as in pagan art.

The earliest works by Christian artists were scarce and impermanent due to worshiping their god in secrecy for fear of Roman persecution. However, after Constantine's Edict of Milan, Christians were allowed to worship openly, and their art flourished, continuing uninterrupted in the west.

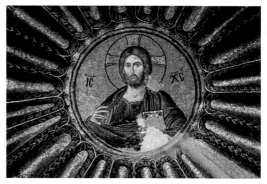

Mosaic of Jesus Christ in the Hora church, Istanbul, Turkey.

In the east, early Christian art morphed into Byzantine art. In 324, Constantine moved the Roman capital to the Greek colony of Byzantium, renamed the city Constantinople, and gave it a facelift. Although Byzantine art maintained the use of pagan symbolism, it discarded naturalism for a more stylized aesthetic that favored elongated human proportions, slightly distorted, compressed, and flattened spaces, as well as bejeweled surfaces. Byzantine mosaics, icons, and statues were meant to exhibit the wealth and power of the Empire, with images of Jesus and the Madonna looking more like solemn, ancient rock stars than a humble carpenter and his mom.

The Byzantine Empire fell in 1453 to the Ottomans, yet its artwork created themes for Christian art that became dominant in the Western world for hundreds of years. —ARR

Andy Warhol (1928–1987)

FIFTEEN MINUTES OF FAME, AND COUNTING

Andy Warhol, born Andrew Warhola in Pittsburgh, Pennsylvania, was more than an artist; he was a self-created persona. Following his studies at the School of Fine Arts at Carnegie Institute (now Carnegie Mellon University), Warhol began his career in advertising, which undoubtedly helped cultivate his aesthetic.

Armed with an irreverent attitude and a burning desire to be famous, Warhol created pieces that deliberately blurred the lines between fine art and popular culture, thereby destabilizing commonly held notions toward art at the time. His signature style consisted not only of rendering mass-produced objects on canvas, including Campbell's soup cans and Coca-Cola bottles, but also involved mass producing the very art itself, rather like a consumer-products manufacturer. His artistic sensibilities were even reflected in his studio's name: The Factory. Conceptually, Warhol's art embodied the basic tenets of the then-emerging postmodern era and ultimately ushered in a new—and immensely popular—genre: Pop Art.

Warhol's obsession with celebrity manifested itself in his art as well, as evidenced in his silkscreen portraits of such notable personalities as Liz Taylor and Marilyn Monroe. As his own celebrity status grew, so did his public profile. He formed a diverse social circle that ran the gamut from eclectic bohemians to politicians; he hosted notoriously wild parties; and he began producing Avant-Garde films. In 1968, Valerie Solanas, a marginal figure around the The Factory, shot and critically injured Warhol. Although Warhol lived, he never fully recovered physically or emotionally, and therefore maintained a much lower profile until his death. —RJR

Notable works: *Brillo Boxes,* 1964; *Marilyn Monroe,* 1964; *Mao,* 1973.

FUN FACT

Andy Warhol coined the phrase "fifteen minutes of fame" to refer to people who enjoy momentary celebrity via the media, until the novelty wears off and the public's attention is diverted elsewhere.

The Last Supper

LEONARDO DA VINCI, 1495–1497

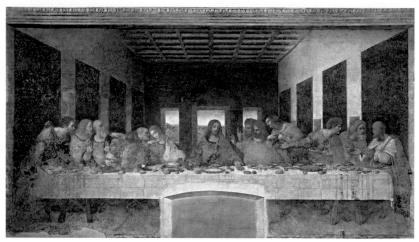

The Last Supper, *1495-97 (fresco) (post restoration) by Leonardo da Vinci. Movement: Italian Renaissance.*

Leonardo da Vinci began *The Last Supper* in 1495 at the request of his patron, Ludovico Sforza, the Duke of Milan. It took da Vinci 3 years to finish the expansive mural, which is almost 30 feet wide. One of the world's most beloved paintings, it is an ambitious work of art in terms of both composition and execution.

Traditionally, murals of this size were rendered with raw pigment and water on a base of wet plaster—a technique known as "fresco." Ever the innovator, da Vinci decided to try painting on a dry wall instead. His non-traditional masterpiece was magnificent, but unfortunately it did not preserve well. *The Last Supper* began deteriorating not long after it was completed, and it has required ongoing (and occasionally controversial) preservation efforts.

The Last Supper is often praised as a textbook example of one-point perspective (page 98). Notice that lines of the receding walls point toward the face of Jesus Christ. Arms outstretched, central to the iconic scene, Jesus appears calm. The twelve disciples around him, however, are distressed—and rightfully so; he has just predicted that before daybreak, one of them will betray him. Look carefully at the reactions of the men. Who do you think is the guilty one? —DDG

Metropolitan Museum of Art

NEW YORK CITY

Founded in 1870 with 174 Dutch and Flemish paintings, the Metropolitan Museum of Art sits on the eastern edge of Central Park in New York City, a massive Gothic-Revival structure housing more than 2 million works of art. Cared for and maintained by 19 curatorial departments, hundreds of museum staff, and one very busy director, "the Met" has been greatly expanded since the late 1800s; currently its 2 million square feet of gallery space offers a bit of everything imaginable, spanning 5,000 years of creativity from even the most far-flung corners of the world. Its encyclopedic collection contains masterworks from European Post-Impressionism and ancient Greco-Roman artifacts, as well as the Egyptian Temple of Dendur (from 15 BCE) and stone *lamassu,* towering mythic beasts that guarded the gates to the ancient Assyrian city of Kalhu.

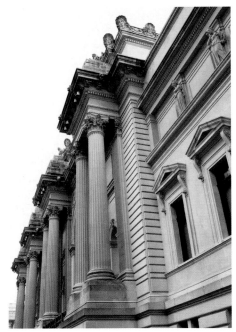

Façade of the Metropolitan Museum of Art.

The medieval portion of the Met's collection is housed in the Cloisters, a building and garden complex built from and modeled after medieval sanctuaries and other monastic sites in southern France. Located in Fort Tryon Park in northern Manhattan, the Cloisters' collection encompasses 5,000 works of art, ranging from 9th-century tapestries to 15th-century stained glass windows and other works of art. Between the two locations, you could spend a lifetime enjoying the variety and history of the works on display and still not see everything in the Met's collection!
—SBR

Propaganda Art

REVOLUTION IN CUBA

Who hasn't seen a T-shirt, poster, coffee mug, or sticker with the bold black and red visage of Che Guevara in a gift shop or museum store? What the image does not tell you is the history of the man behind the symbol. Ernesto "Che" Guevara—doctor, Castro confidant, and guerrilla martyr—has come to symbolize revolution for millions. Much like the socialist revolutions in China and Russia in the early 20th century, the leaders of the Cuban Revolution (1952–1958) drew upon the arts to glamorize revolutionary figures and disseminate information to the population. They sponsored artists who created poster art—a relatively quick and inexpensive medium for getting information out quickly to a mass of people.

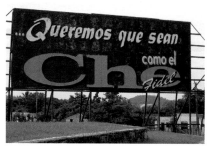

"We All Want To Be Like Che," Havana, Cuba.

Artists silk-screened posters with wildly colorful Pop-inspired imagery and socio-political slogans, inspiring people to take up the charge of revolt against the powers that be. The imagery and slogans used on the posters created during the Cuban Revolution celebrated nationalistic pride; promoted literacy; opposed the U.S. involvement in Vietnam; supported Cuban popular culture such as music, film, and sport; and were emblazoned with images of leaders Fidel Castro and Che. Today, the legacy of the revolutionary poster resides in billboards dotting the highways and roads of Cuba. The employment of the poster in the 20th century offers a fascinating window into the history and politics of Cuba, as well as an innovative chapter in graphic design. —SBR

Painted Tennis Shoes of Mesoamerica

ANUAR ROSALDO AND THE UNITY OF ALL

The vectors of ancient Aztec legend, psychic introspection, and Chicano identity meet on top of a white sneaker.

Anuar Rosaldo paints each shoe as a personal gift for a friend, drawing from the artistic and spiritual traditions of pre-Columbian Mexico with which he personally identifies.

Anuar has represented the four cardinal directions using the traditional colors of Aztec cosmology—red, blue, white, and black—as a nod to the "embedded synesthesia" that existed in many Mesoamerican cultures, in which each color was associated with a particular deity, cardinal direction, animal, tree, and day of the year.[4] (For more on synesthesia, see pages 86 and 245.)

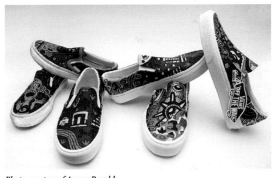

The heavenly and the terrene are as intertwined in Anuar's paintings as they are in the indigenous cosmology. The sun, *Tonatiuh,* and the earth, *Tonantzin Tlalli,* are revered as the givers of life and sustenance. The recurrent symbol of the flower, *Xóchitl,* represents beauty and creativity.

Photo courtesy of Anuar Rosaldo.

"In my paintings," the artist states, "I have tried my best to represent how the 'Grandfathers' saw the world."

Anuar integrates the ancient with the modern and the mundane with the sacred in an artistic expression of the Aztec concept of integral completeness, known in the Náhuatl language simply as *cé*… "one". —DJS

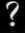
Nazca Lines

ANCIENT GEOGLYPHS OF PERU

About 200 miles south of Lima, Peru, in the desert plains, there are nearly 1,000 depictions of geometric shapes and animals. When seen from the ground, they are nothing more than lines in the sand, but when viewed from above, they are impressive works of art. Some of the earliest examples of what are commonly called "Nazca Lines" date to about 200 BCE. Shapes of lizards, monkeys, hummingbirds, spirals, triangles, and perfectly straight lines that stretch for miles on end litter the valley floor. These shapes are so large that to fully appreciate them, you need to be in an airplane or hot air balloon. Why were they made, then, at a time when neither technology existed?

Although people speculate that some of the lines may have been used as landing strips for alien ships, or even as giant astronomical references, the jury is still out on what exactly inspired the creation of these amazing, larger-than-life glyphs. The most compelling research at the moment suggests that the lines may have been related to sources of water in the desert or used as part of the native culture's religion. In either case, they continue to inspire a sense of mystery and awe. —GRG

Aerial shot of spider-shaped Nazca lines in the desert plains of Peru.

Exercise 4

PARROT WITH EILEEN SORG

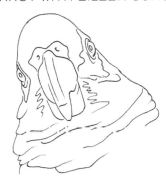

Apply yellow around the eyes and beak. Fill in the pupils and other areas of the eyes with a dark, warm gray, leaving highlights in each eye. Apply this color over the beak, varying the pressure and leaving some areas white to suggest shape. Also stroke in the darks around the beak and within the feathers.

Fill in the irises with red-orange. Then apply bright green to most of the feathers and deepen the beak with black.

Fill in the rest of the feathers with teal, overlapping the bright green in places. Fill in the pupils (leaving highlights) and the holes above the beak with black.

What is Color?

AN ELEMENT OF MANY FACES

Color is a phenomenon of perception and reaches our eyes in a way you might not expect. Colors are actually wavelengths of light; when an object is red, it is reflecting red wavelengths and absorbing all other colors. In other words, you could say that an apple technically isn't red—the apple is *reflecting* red.

Color is the element of art that seems to invite the most discussion. Because of this, the art world boasts an extensive vocabulary that helps us describe, categorize, and label colors. Traditionally, colors are distinguished by three qualities: hue, saturation, and value. Hue refers to the actual color in its brightest, purest form; saturation (also called "chroma") is the color's intensity; and value, as we've touched on, is the lightness or darkness of the color.

Because our eye is trained to notice color more than value, you may not have picked up on the variations of value between colors. For example, a black-and-white photograph would reveal that—in their purest forms—yellow is lighter in value and violet is darker in value than other colors.

A single color or hue (A) can vary in saturation and value in the form of tints, tones, and shades. A tint is a color plus white (B), a tone is a color plus gray (C), and a shade is a color plus black (D). Take a look at the variations of green below. —ETG

A B C D

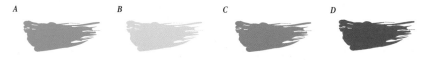

FUN FACT

In the visible spectrum of light, red wavelengths are longer than all other colors, and violet wavelengths are shorter than all other colors. But visible light represent only a small fraction of the full electromagenetic spectrum. Wavelengths shorter than violet include ultraviolet, X-rays and gamma rays, and wavelengths longer than red include infrared, microwaves, and radio waves.

The Value of Art

IS IT WORTH IT?

"Things are only worth what you make them worth." —Molière

When we talk about determining art's value, we can be referring to many different things. Judgments can be made about art in general, categories of art, or individual pieces of artwork. Likewise, art can be of value to the world as a whole, to specific groups, or to individuals. Finally, the concept of value can refer to monetary worth or to various, intangible kinds of significance. With so many scenarios of value assessment possible, it is extremely difficult to develop any meaningful system of deciding art's value.

Consider this example: In 2006, a Klimt portrait (page 332) sold for $135 million. Was it worth it? You might not think so, but the owner obviously did (and hopefully still does!). What made it so valuable to him? Its composition? Its history? The fact that it would look perfect above his yellow couch? Who knows?! The point is that its value cannot be resolutely determined. Value is a slippery, incalculable notion, dependent on innumerable factors.

Any attempt to quantify value arrives at the same dilemma. A person or society will find value in that which it deems important. Art, as an inherently subjective entity, is especially elusive. A religious person might tremendously value art that provides spiritual inspiration, while a dog lover might place more value in anything relating to dogs. It's a matter of taste and priorities. —CKG

QUESTIONS TO PONDER

• *What piece of art is most valuable to you?*
Do you think everyone should see the same value in it?
• *Can you make a confident, universal claim about art's overall value in our world?*

The Art of the Middle Ages

A CROSS-CULTURAL POTLUCK

The period of time known as Medieval, Middle Ages, or formerly the Dark Ages, were anything but "middle" or "dark." Despite the tumultuous socio-geopolitical climate that occurred in the aftermath of

> **WHEN & WHERE**
> *c. 100-1453 CE*
> *The Ancient Holy Roman Empire*

the fall of the Western Roman Empire in 476, this was a cross-culturally creative time of lofty cathedrals and beautiful stained glass windows.

Stained glass rose window at Notre Dame de Paris, France, 1250.

As power shifted to the newly Christianized north, Arabic tribes brought Islam's ornamental art to Spain and North Africa. Islamic, Celtic, Germanic and Roman art amalgamated, creating the style that dominated Western art for approximately 1,000 years. Artisans working in guilds or monasteries labored over intricate illuminated manuscripts, mosaics, tapestries, paintings, and sculptures. All of these mediums underwent drastic stylistic changes due to the influx of multicultural styles.

Under the umbrella of the Middle Ages, art periods are divided into two main subgroups: Romanesque and Gothic. Two-dimensional art was ornamental with a compressed sense of space and proportionally inaccurate, distorted figures. Giant humans jostled around crooked miniaturized cities. Tempera paint and gold leaf allowed brilliant color. In architecture, it was all about cathedrals. Tall buildings with spires that reached toward the heavens were encumbered by masses of carved figures with stylized features. The Gothic arch, an icon of the time, was a later device.

Chronologically sandwiched between the brilliance of Roman art and the Renaissance, the Middle Ages was once overlooked. Now, historians agree that this time was integral in the development of Western art and has a beauty all its own. —ARR

Selected artists: Cimabue, Duccio, Giotto, Lorenzetti

Sandro Botticelli (1444/5–1510)

REDISCOVERING BEAUTY

Although Italian painter Sandro Botticelli is hailed as one of the finest artists of the early Renaissance, his work had fallen into virtual obscurity with the emergence of the High Renaissance and preeminent artists such as da Vinci, Michelangelo, and Raphael. Thus, Botticelli's legacy remained dormant until the 19th century when the artistic pendulum swung back in favor of early Renaissance aesthetics.

Details about Botticelli's early life are sketchy. Born in the prosperous city of Florence, he apprenticed with artist Fra Filippo Lippi for a few years before opening his own studio in 1470. Among Botticelli's principal patrons was the distinguished and influential Medici family, whose benefaction helped establish his reputation as a foremost painter of the period. Botticelli's quintessential works *Primavera* and *Birth of Venus* are thought to have been direct commissions for Florentine ruler Lorenzo de' Medici, and they incorporate the mythological and Neoplatonic themes that proliferated in the intellectual Medici circle. The figures in the works appear to manifest both a delicate sensuality and a powerful presence. Their ethereal bodies seemingly float across the canvas; however, heavy outlines firmly anchor them into the frame and ultimately render space and dimension immaterial. The result is a tranquil beauty of the finest degree.

In 1481, Pope Sixtus IV invited Botticelli and several other artists to paint frescos on the wall of the Sistine Chapel; however, within two short decades, Botticelli's body of work had fallen out of fashion, and he died in relative anonymity. —RJR

Notable works: *Adoration of the Magi,* 1475; *Primavera,* 1478; *Birth of Venus,* 1485 (page 32).

Fun Fact

Sandro Botticelli was christened Alessandro di Mariano Filipepi. His nickname is thought to derive from the Italian word **botticello,** *which means "little barrel."*

The Gleaners

JEAN-FRANÇOIS MILLET, 1857

Today, the word "gleaners" is only vaguely familiar to our ears. Perhaps we first heard it in the ancient love story of Ruth and Boaz. Since Biblical times, centuries before farmers had machinery to harvest their crops, workers reaped the fields with hand-held tools such as the scythe. As they hurried to gather the crops before rain or

The Gleaners, *1857 (oil on canvas) by Jean-François Millet. Movement: Realism.*

wind destroyed them, a scattering of wheat or barley was left behind. Traditionally, the local poor were invited to enter the fields after the harvest, gathering up or "gleaning" the remaining grain free of charge. Jean-François Millet's painting captures a trio of peasant women in the midst of this yearly ritual.

Millet's intention in painting this graceful scene has been closely considered. Some critics suggest that the work is a visual ode to the lower classes. At the time, France was less than a decade removed from a major social revolution, and many of the educated elite felt threatened by working classes who increasingly embraced the socialist messages of Karl Marx and Friedrich Engels.

Was Millet making a socio-political statement? Or, with sunlit fields as a golden backdrop, was the artist—the son of peasant farmers himself—simply celebrating the dance-like beauty of the gleaning women? —DDG

Museum of Modern Art (MoMA)

NEW YORK CITY

Any visit to New York City would be incomplete without a visit to MoMA! Dedicated to helping people understand and enjoy the visual arts of our time, the Museum of Modern Art in New York City, founded in 1929 by avid art collector Alfred H. Barr, Jr., has become a primary lo-

The city of New York is home to hundreds of museums and cultural institutions, including the Museum of Modern Art (MoMA).

cation to view mid-century modern American, European, and Latin American Art. The museum, renovated no fewer than half a dozen times, grew from a gift of eight prints and one drawing to a collection encompassing more than 150,000 paintings, sculptures, drawings, photographs, and design objects. MoMA has so many objects in its collection that it stores much of its holdings in a massive warehouse across the East River in Queens (which also served as exhibition space during the most recent renovation). MoMA owns a number of films (some 20,000), and globe-trotting scholars of modern art take advantage of more than 4 million film stills in its extensive library and research archives.

In 2000, MoMA partnered with the independent exhibition space P.S.1 Contemporary Art Center (which began life as a public school in Long Island City, New York), combining MoMA's collection resources with P.S.1's contemporary programming. Today, the museum and P.S.1 welcome thousands of visitors every year who enjoy a wide variety of artwork, including seminal paintings by Paul Cézanne, Vincent van Gogh, and Pablo Picasso, as well as more contemporary works by Matthew Barney and Rachel Whiteread. —SBR

Arpilleras

TEXTILES OF PEACE AND PROTEST

What imagery comes to mind when you think about political protest? Brightly colored posters with provocative slogans plastered against a wall? People marching in unison against an oppressive regime? How about embroidery?

From 1973 to 1989, the population of Chile lived under extreme censorship and endured numerous human rights violations after the overthrow of democratically elected President Allende by the military coup led by Augusto Pinochet. Thousands of people were kidnapped, tortured, and imprisoned if they dared to voice their opinion against his regime. The wives, mothers, and daughters of the "disappeared" hid their heartache and grief over these injustices in their textile art called *arpilleras.*

In response to the oppressive sadness surrounding them and as a way to commemorate their loved ones, women wove the portraits and names of the missing surrounded by grieving families into their *arpilleras* as a subversive form of political protest. *Arpilleras* traditionally depict happy scenes of celebration and festivity with brightly colored embroidery and appliqué on burlap or cloth sacks. By incorporating photographs and old scraps of clothes, these textiles become a kind of "living" art form: Each *arpillera* tells a story of sorrow, frustration, and hope unique to that individual. When combined, these embroidered works of art weave together the social and political history of Chile—through the fingers of the survivors. —SBR

WHAT IN THE WORLD?

You can find arpilleras *made by individual folk artists as well as community co-ops in Chile, Peru, and Bolivia. If your travels only take you so far as the Internet, many fair trade organizations offer them for sale online.*

Talent Emerges in the Classroom
ART THAT WILL EARN YOU A WEEK OF DETENTION

When high school students grow bored with traditional classroom methods and rote memorization, their innate artistic abilities often bleed through in effortless, semiconscious expressions of creativity. As a part time substitute teacher, I have frequently run across such unexpected displays of talent.

Some students, disinterested with traditional script, go so far as to write entire essays and book reports using graffiti-style "tagging" letters. (For a detailed discussion of graffiti as a legitimate though oft-criminalized art form,

Caricature of David Schmidt (author) by David Roy.

refer to Bob Bryan's documentary *Graffiti Verite*.) While writing a mandatory list of "twenty facts I learned from watching *Harry Potter and the Sorcerer's Stone,*" these multi-taskers are simultaneously sophisticating the aesthetics of their lettering style.

One day, I found a pencil that had been shaved and subsequently defaced with multiple repetitions of a single profanity. Yet this was no mere act of rebellion. The script was so stylized, the size of the vulgarities so varied—mommy and daddy profanities swam together with their little baby profanities in a sea of offensive syllables.

High school student David Roy produced a much less abrasive creation while I was substitute teaching his music class and created a skillful caricature of yours truly. Quite fittingly, David is a student at a San Diego magnet school that focuses on the creative and performing arts.

I suspect the depicted caricature won't be his last published drawing. —DJS

The Watts Towers

30 YEARS OF HARD WORK AND INSPIRATION

In the middle of South Los Angeles, California, stands a testament to human will, dedication, and perseverance. Simon Rodia, an Italian immigrant, dedicated 30 years of his life to dreaming up and building "Nuestro Pueblo," more commonly known as the "Watts Towers."

Simon's original name is perhaps more accurate, considering that the full work consists of 18 buildings, 3 of which reach 55 feet, 97 feet, and 99 feet, respectively. Each building is decorated with pieces of broken glass, ceramics, bottles, and hand-drawn symbols, etched into the mortar that covers the structures.

The Watts Towers in Los Angeles, California.

Built using hand tools, secondhand materials, and determination, the sculptures have become a cultural and community icon. They are one of only a handful of pieces of folk art to be listed on the National Register of Historic Places, and they attract thousands of visitors each year.

After completion, Rodia handed the deed for his property to a neighbor and walked away, never to return.

In the ensuing years, the work has survived an attempted razing by the city of Los Angeles, earthquakes, and a stress test designed to prove its structural soundness. A group of citizens took over the property for a time and then deeded it to the city, which then deeded it to the state, where it officially became a National Historic Landmark.

When asked in later years what motivated him to create the towers, Rodia answered: "I had in mind to do something big and I did it." —GRG

Exercise 5

HORSE WITH ED TADEM

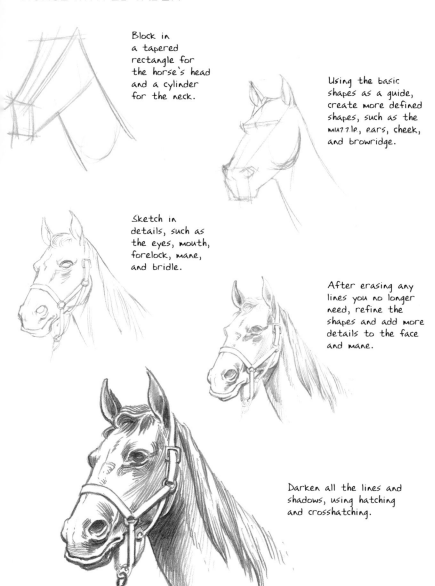

Block in a tapered rectangle for the horse's head and a cylinder for the neck.

Using the basic shapes as a guide, create more defined shapes, such as the muzzle, ears, cheek, and browridge.

Sketch in details, such as the eyes, mouth, forelock, mane, and bridle.

After erasing any lines you no longer need, refine the shapes and add more details to the face and mane.

Darken all the lines and shadows, using hatching and crosshatching.

The Color Wheel

UNDERSTANDING COLOR RELATIONSHIPS

Within the first hour of an introductory course on art, chances are you'd see this recognizable image (at right) flash up on the projector screen. But really, there's no better way to lay the foundation for understanding color. The color wheel shown at right is a visual tool that illustrates the relationships of pigment colors. As you begin your study, it's important to first acquaint yourself with a few proper terms.

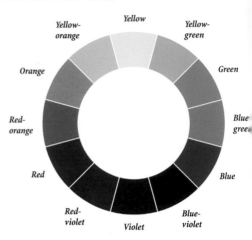

Primary colors are red, blue, and yellow. With these you can mix almost any other color; however, none of the primaries can be mixed from other colors.

Secondary colors include green, orange, and violet. These colors can be mixed using two of the primaries. (Blue and yellow make green, red and yellow make orange, and blue and red make violet.)

A *tertiary* color is a primary mixed with a near secondary, such as red with violet to create red-violet.

Neutral colors are browns and grays, both of which contain all three primary colors in varying proportions.

Complementary colors are those situated opposite each other on the wheel, such as purple and yellow. —ETG

FUN FACT

In the world of light, the color wheel is very different from the pigment wheel shown above. For example, red, green, and blue are considered the primary colors of light (often referred to as "RGB"); red and green light combine to make yellow; and all light colors combine to make white instead of black. Counterintuitive once you're familiar with pigment relationships, but important to know!

What Makes Something Beautiful?

BESIDES PHOTOSHOP®...

"Everything has its beauty, but not everyone sees it." —*Confucius*

If we can agree that beauty is that which provides pleasure or joy to the senses or the mind, then we can proceed to the more challenging task of deciding which qualities produce beauty. It is often said that "beauty is in the eye of the beholder," implying that the concept of beauty is not static but contingent upon each individual's unique preferences, feelings, and circumstances. However, there are some human experiences that almost everyone describes as beautiful.

Most would agree that works of art like van Gogh's *Starry Night* (page 132) or Beethoven's *Für Elise* are beautiful, or that diamonds or sunsets are beautiful. On the other hand, "beautiful" is not usually one of the first words chosen to describe the sound of fingernails on a chalkboard or the contents of a porta-potty. These trends suggest that there are certain properties and proportions that are generally more pleasing than others.

There is no shortage of theories about the roots of beauty. Everything from general rules (curves are more beautiful than straight lines) to rigid mathematical formulas (the Fibonacci Sequence, page 209) have been offered as indisputable explanations for the true source of beauty, but there is always a counterexample to refute such narrow claims. Perhaps we should be content with the delight that beauty brings us, but then we wouldn't be very good philosophers! —CKG

QUESTIONS TO PONDER

• *How much of beauty is relative to individual experience and how much is the same for everyone?*

• *How is beauty different from goodness? Can thoughts and actions be beautiful?*

The Italian Renaissance

THE REBIRTH OF CLASSICAL VALUES

The word Renaissance doesn't mean "rebirth" for nothing! After the Middle Ages, renewed interest in the Classical values of ancient Greece and Rome reinvigorated art and academics in Italy. A return to naturalism from direct observation of form broke the mold of flatness from the art of the Middle Ages.

> **WHEN & WHERE**
> *c. 1400–1600*
> *Italy*

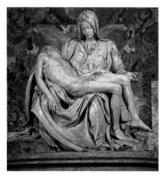

Pietà, *Michelangelo, marble, 1499.*

Prior to the Renaissance, artists were considered craftspeople, most working namelessly in guilds. With new attention and privilege being paid to artists as individuals, they became celebrities. Titans like Leonardo da Vinci, Michelangelo, and Raphael emerged. The "Renaissance man" concept came from this time when artists were recognized not only as painters or sculptors, but also as architects, scientists, inventors, and beyond. Knowledge was power and it was every artist's obligation to live up to his god-given potential.[5]

Chiaroscuro and linear perspective were developed, opening up a world of possibility to create the illusion of volumetric, realistic space. Beauty and nobility were embodied in lifelike human figures existing in a space with accurate linear and atmospheric perspective. Oil paint usurped tempera, allowing for more depth and jewel-like color. Frescos decorated churches like full-body tattoos. Sculpture was reborn as artists imbued the craft with lifelike structure from studying anatomy and human emotion.

The Renaissance left an indelible mark on history with its heroic artistic, architectural, and inventive achievements and left a cherished imprint in the hearts of art lovers. —ARR

Selected artists: Botticelli, Brunelleschi, Donatello, Michelangelo, Raphael, Titian, da Vinci

Rembrandt Harmenszoon van Rijn (1606–1669)

IN THE BUSINESS OF ART

Rembrandt van Rijn was a commercially successful artist. Born in Leiden, the Netherlands, he attended Latin school where he studied classical literature, rhetoric, mythology, and religion. As a teen, he attended the University of Leiden, but dropped out after only a few months to pursue art full time.

For three years, Rembrandt apprenticed with local artist Jacob van Swanenburch, followed by a brief apprenticeship with historical artist Pieter Lastman. A short time later, he opened a studio with established artist Jan Lievens and began taking on pupils of his own. At 22 years old, Rembrandt was already surpassing his mentors and peers.

A statue of the artist in Amsterdam's Rembrandt Square.

In 1631, Rembrandt moved to Amsterdam, married, and began to enjoy great success as a portrait artist. As business grew, so did his need for help; thus, he employed a number of assistants. In fact, art historians believe that under Rembrandt's tutelage, these assistants may actually have rendered some of the works for which the famous artist is credited. Today, there are scholars devoted to properly identifying and attributing these works.

Nevertheless, Rembrandt created hundreds of paintings, etchings, and drawings over the course of his lifetime, including roughly 50 to 60 self-portraits depicting him at various stages of his life and always with an air of humility. He was known as a compassionate man and an intuitive artist, whose work adeptly captured and conveyed human emotion with near flawlessness. Although Rembrandt suffered financial ruin in his later years, he continued working until his death. —RJR

Notable works: *The Anatomy Lesson of Dr. Tulp,* 1632; *The Night Watch,* 1642; *Self-portrait,* 1660–63 (page 112); *Self-portrait,* 1669.

FUN FACT

During his career, Rembrandt experimented with different signatures. His earliest signatures were simple monograms: "R" and "RHL." In 1632, the signature evolved into "RHL-van Rijn," followed by "Rembrant." In 1633, he added a "d," and the signature became the well-recognized "Rembrandt."

Arrangement in Grey and Black No. 1: Whistler's Mother

JAMES ABBOTT MCNEILL WHISTLER, 1871

James Whistler's best-known painting demonstrates that a work of art can take on meaning and significance quite different from what its creator intended. In 1872, the Royal Academy of Art in London, England refused to exhibit Whistler's somber creation unless he changed its title to *Portrait of the Artist's Mother.* Whistler had called the work *Arrangement in Grey and Black,* which spoke of his original vision. For

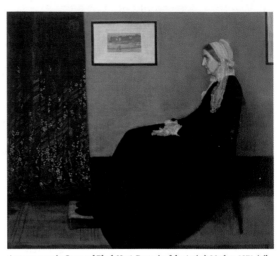

Arrangement in Grey and Black No. 1, Portrait of the Artist's Mother, 1871 *(oil on canvas) by James Abbott McNeill Whistler. Movement: Art for Art's Sake.*

him, it wasn't meant to be a portrait at all—it was instead a thoughtful study in composition and color.

Does it look like a typical portrait to you? Notice that most of the lines in this painting are horizontally or vertically oriented—the wall's edge, the leg of the chair, the starkly rectangular painting. The exception is the artist's mother. She defies not only the linear nature of the composition with her curved and fluid shape, but, by facing away from her viewers, also challenges the traditional notion of a portrait. We learn more about this woman from her posture and attire than from her face.

Despite Whistler's intentions, *Whistler's Mother* has become one of the most famous "portraits" in the world. In the years that followed the painting's release, audiences have generally ignored Whistler's scholarly intentions and have instead embraced his painting as a tribute to motherhood. —DDG

Los Angeles County Museum of Art

FINDING ART ON THE MIRACLE MILE

Who would have thought a museum located next to a prehistoric tar-filled swamp would become a premier destination for the arts? Centered halfway between the Pacific Ocean and downtown Los Angeles, the Los Angeles County Museum of Art contains more than 150,000 works spanning the history of art from ancient civilizations to contemporary societies. Founded in 1910 as the Los Angeles Museum of History, Science and Art, the institution that began with no permanent collection quickly made up for lost time by snapping up works of art, and in 1965, with the help of a devoted community and board of trustees, the new museum opened with a new name: "LACMA." The museum boasts one of the largest encyclopedic collections on the West Coast and holds an array of objects: Korean ceramics, Japanese silk-screen prints, European paintings, early American furniture, German Expressionists prints, and contemporary art. Highlights include pre-Columbian masterpieces, along with works by leading modern and contemporary artists, including Diego Rivera, David Hockney, and Barbara Kruger.

At the time of this printing, the museum is under a 10-year renovation and expansion program entitled *Transformation;* the initial phase includes 60,000 additional feet of gallery space and newly acquired public sculptures. And while you meander through the 20-acre museum complex, make sure to visit the La Brea tar pits, which contain the remains of saber-toothed cats and mastodons buried in thick tar, still actively bubbling away just steps from LACMA's world-class collections! —SBR

Walking up the museum steps leading to the William Pereira-designed main entrance at the Los Angeles County Museum of Art.

Six Decades of Sensuality

THE ARCHITECTURE OF OSCAR NIEMEYER

Sexy, daring, and irreverent—these words are often used to describe the work of Brazilian architect Oscar Niemeyer, who has been busy creating innovative designs in steel, exposed concrete, and glass for the past 60 years. A dash of modernist ideals combined with a healthy dose of sensuous curves inspired by the female denizens of his native country, Niemeyer's designs simultaneously spark controversy and delight. The exhibit, *Brazil Builds,* at the Museum of Modern Art in New York City in 1943, which featured his unorthodox architectural plans for overhauling Brazil's capital city, Brasilia, brought Niemeyer international acclaim. Many of his projects, including the French Communist Party Headquarters in Paris and the 39-story United Nations Secretariat in New York City, have become iconic monuments to his style. Yet the Catholic Church refused to consecrate the Pampulha Church of São Francisco de Assis (1942), in the northern suburbs of Brasilia, until nearly a decade after it was built because of its unconventional design.

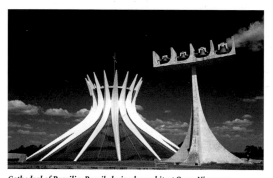

Cathedral of Brasilia, Brazil, design by architect Oscar Niemeyer.

In Brasilia, Niemeyer's domed and saucer-shaped structures, snaking walkways and ramps, and seemingly weightless monumental buildings seem to come from the future, but his philosophy is firmly rooted in the present, in the awareness of creating architectural spaces that attempt "to make this unjust world a better place in which to live."[6] At 101, age hadn't even slowed this inventive architect: Niemeyer continues to draft projects for cultural centers, museums, and public spaces throughout the world, always with his distinctive artistic vision, one that embraces function, beauty, and a certain shock value. —SBR

Bleed

RUSSIAN GRAFFITI

"Russia cannot be understood by means of logic; she is not to be measured with the same stick used for others…"

—*Fyodor Tyutchev, 1866*

Nowhere is the reality of the "Загадочная русская душа" (enigmatic Russian soul) more clear than in this most raw, ribald expression of Russia's soul—her 21st-century graffiti. While lewd, simplistic "tags" are as common here as in any country, much of Russia's graffiti takes on a more metaphysical tone.

Take, for example, the poetic ingenuity of this three-word epithet: "лох это судьба." Where a simple profanity would have sufficed in other cultures as a blanket condemnation of passersby, this street poet waxed philosophical in his defacement. The best approximation to a translation for the oddly recondite insult would be: "You are a schmuck, and forever shall you be a schmuck, for this is your destiny."

English words emerge in the most enigmatic contexts. I once saw a wooden construction barrier that had been spray-painted with a single English phrase—"party time."

My favorite, however, was the succinct statement that some anonymous kindred spirit painted on a dull concrete wall near a bus stop I used to frequent. In bright red paint, at the bottom of the lifeless cement barrier, a single word stood out: "BLEED."

—DJS

Style. *Photography by Andrei Sergeyevich Abramov.*

The Smallest of the Small

TINY ART, BIG TALENT

How small is small? If a painting is too small to see with the human eye, can it still be appreciated? If no one could see it on the wall or anywhere in the house, would someone still buy it? Apparently, the answer to these last two questions is "yes."

Micropainter Stefano Busonero creates paintings that are less than a square inch in area. He is also known for paintings done on the end of a syringe and inside sewing needles. All of his smallest works require a magnifying glass in order to appreciate them properly.[7]

Sculptor Willard Wigan is well known for his rendering of the Statue of Liberty inside the eye of a needle, as well as his rendition of Lloyd's of London on the head of a pin. These pieces are also best viewed with the aid of magnification.[8]

Stepping down even further into the world of the small, artist J'Sha has pioneered a technique he calls "nanoentonography," which allows him to create works smaller than a speck of dust, viewable only through a microscope.[9]

We can imagine, in the not too distant future, a time when it might not be the artwork itself that sets you back the big bucks but the equipment you will need to properly show it off. —GRG

Exercise 6

APPLE WITH ED TADEM

Indicate the plane of the top of the apple and the pit that slopes into the stem, as well as the cast shadow.

Begin shading, leaving a white highlight. Then darken the stem.

Deepen the shading, emphasizing the shadowed left side of the apple and the cast shadow.

Color Temperature

VISUAL SENSATIONS

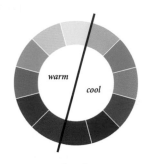

W e've all heard the phrases "red hot" and "icy blue" before, so the idea of color temperature shouldn't be entirely foreign to you. *Color temperature* refers not to the physical warmth or coolness of the actual pigments but to the feeling one gets when viewing a color or a set of colors.

The color wheel at right has been divided into warm and cool colors. Generally, blues, greens, and purples are considered cool, whereas yellows, oranges, and reds are considered warm. When used within a work of art, warm colors seem to advance toward the viewer, whereas cool colors appear to recede into the distance. This dynamic is important to remember when suggesting depth.

Now it gets a little trickier: There are warm and cool versions of each color. Take violet, for example (A). This color lies in the cool half of the color wheel, but it can lean either to the blue side (B) or the red side (C). Below you can see that the blue-leaning violet appears much cooler than the red-leaning violet. —ETG

A B C

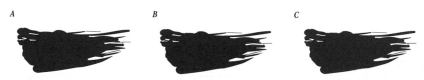

REMEMBER THIS!

When buying your first set of paints, include a warm and a cool version of each primary color (plus white, black, and perhaps a brown), which will allow you to mix just about any color. But always keep in mind that mixing two colors of an opposite temperature bias will yield a muddy result.

Creativity

THE NATURE OF INVENTIVE INTELLIGENCE

"The world is but a canvas to the imagination."

—Henry David Thoreau

Creativity is a bizarre, often misunderstood concept. It is typically classified as a sort of mystical enemy to the relatively boring world of logic in the epic battle between the left and right hemispheres of the brain. In reality, though, creativity is more of a friend to logic. In fact, you could say the two have a rather codependent relationship. Creativity allows us to come up with new ideas and make connections between preexisting ones. Logic guides the process and directs it toward fruitful ends.

Although it's commonly associated with art, creativity is involved in every type of thought, whenever we think in an innovative way. In art, though, there is another, more enigmatic aspect of creativity that can yield some truly wondrous results—imagination. Our minds have the marvelous ability to experience ethereal, fabricated sensations of things that aren't really there.

Essential to both the creation and experience of art, imagination takes us temporarily out of our immediate surroundings and into a shadowy realm of alternate realities. While visiting these other worlds, we gain new experiences that become assimilated into our conceptual network. In this way, our creative connections grow exponentially, weaving between worlds of reality and illusion. In art, creativity and imagination are free to run wild and reach their full potential. —CKG

QUESTIONS TO PONDER

• *Where do the invaluable mental powers of creativity and imagination come from? The mind? The brain? Evolution? God?*

• *How is imagination involved in experiences of art?*

The Northern Renaissance

BEAUTY IS IN THE DETAILS

Richly detailed and symbolically dense, the Northern Renaissance engages the imagination. Born from the Gothic period, the Northern Renaissance maintained a certain naïveté of underlying form yet dedication to surface detail

WHEN & WHERE
c. 1400–1600
Northwestern Europe

and ornamentation from its parent era. Situated in present-day France, Germany, the Netherlands, and Belgium, the "North" became its own entity.

As opposed to the Italian interest in classical values, naturalistic form, and perspective, the Northern Renaissance artists were invested in religious reform, surface realism, and symbolism. Figures and perspective were sometimes askew; however, flowing garments, reflections, patterns, and the like were rendered with exquisite care and particularity, down to individual leaves on trees and hairs on heads. Color was king! Every detailed object had symbolic value, telling several little stories embedded in the larger picture. Many of these paintings are small; one may admire a painting from this era as they would admire a jewel, beautiful in all its minute facets. These paintings demand close observation.

After the Reformation began, another divide between the Northern and Italian Renaissance was the Northern penchant for secular content. True, you will still see many a Biblical scene, but another subdued version of piety emerged in scenes of humble peasant life or in the glory of dramatic landscapes.

Northern Renaissance eventually succumbed to Mannerism. But the realism achieved in the work shows us a living world; it is a beautiful window into the past. —ARR

Selected artists: Hieronymous Bosch, Pieter Bruegel the Elder, Robert Campin, Albrecht Dürer, Jan van Eyck, Matthais Grunewald, Hans Holbein

Henri Matisse (1869-1954)

THE COURAGE OF ART

"For a painter, nothing is more difficult than to paint a rose, because in order to do so he must first forget every rose that has ever been painted." —Henri Matisse

"Creativity takes courage," said French artist Henri Matisse, one of modern art's original founding fathers. Indeed, Matisse would have been intensely aware of just how deeply the two were intertwined. For one, he wasn't supposed to be an artist. Matisse studied law and only took up drawing to pass the time during his recovery from a long illness. Thus, his first act of creative courage was leaving the legal profession to pursue art—much to the dismay of his father.

Reproduction of Henri Matisse's famous paper cutout, Blue Nude.

While Matisse's earliest paintings were skillfully rendered, it was his interest in the Impressionists that ultimately inspired him to create paintings using bold, undiluted color applied with dense strokes; moreover, the subjects depicted on canvas were often secondary to Matisse's unpredictable, though complementary, color combinations. Matisse unveiled his new approach in 1905, alongside the works of several artists of the same aesthetic; the reception was less than favorable. One prominent critic compared the artists' works to *fauves,* French for "wild beasts," a term that, ironically, gave this unfamiliar genre its new name: Fauvism—one of the century's first modern art movements.

While Fauvism was somewhat influential, the movement was relatively short-lived and was just one of many art forms in which Matisse participated. Matisse also designed sets, sculpted, painted murals, and, when illness confined him to a wheelchair, cut out silhouettes from colored paper and created collages. In 1947, Matisse published his paper collages and some of his thoughts in a book entitled *Jazz.* He died in 1954 in Nice, where he is also buried. —RJR

Notable works: *Open Window, Collioure,* 1905; *The Dance II,* 1910; *The Knife Thrower,* 1947.

The Creation of Adam

MICHELANGELO BUONARROTI, 1508-1512

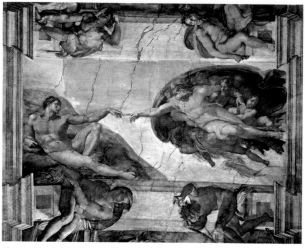

The Creation of Adam from the Sistine Chapel, *1508-12 (fresco) by Michelangelo Buonarroti. Movement: Italian Renaissance.*

Michelangelo's magnificent fresco on the ceiling of the Vatican's Sistine Chapel is one of the artistic Wonders of the World. The vast painting was done 500 years ago and Michelangelo accomplished it without the help of modern technology. In fact, the artist spent four years lying flat on his back on a scaffold, suspended almost 70 feet into the air.

The Creation of Adam is one of nine paintings within the Chapel's scope illustrating the Biblical story of God's creation of the world, capturing the moment when God "breathed" life into the first man. We see God moving powerfully toward Adam, accompanied by a heavenly host; God is about to transform him into a living soul. Adam, in the split-second before God's eternal energy reaches him, is clearly alive, but his languid posture exudes weakness. He seems urgently in need of God's empowerment.

In the years of discomfort and weariness the artist spent painting the Chapel's ceiling, spurred on against his will by Pope Julius II, Michelangelo must also have felt the need of an enlivening divine touch to help him complete his task. Perhaps he spoke of himself when he said, "Every beauty which is seen here by persons of perception resembles more than anything else that celestial source from which we all are come." —DDG

The School and Art Institute of Chicago

ART IN THE WINDY CITY

The world-renowned Art Institute of Chicago is not only an art school of-fering undergraduate and graduate degrees to nearly 3,000 students, but is also a world-class museum containing more than 300,000 works of art. Its original building complex, constructed in 1879 from the charred rubble of the Great Chicago Fire of 1871, moved to its present location on the "Magnificent Mile," the famous strip of hotels and boutiques along Michigan Avenue. Its collection contains masterpieces ranging from American and European paintings to 15th century textiles, but what many come to see is the remarkable collection of Impressionist and Post-Impressionist paintings, including *A Sunday on La Grande Jatte* (1884–86; page 302) by George Seurat, immortalized in the 1986 American film *Ferris Bueller's Day Off*.

Founded by a group of studio artists, the School of the Art Institute of Chicago enjoys a stellar reputation as a first-rate art school and is located directly across the street from the museum. Imagine the delight students find after learning about Impressionism in an art history class only to walk across the street and come face to face with a painting by Claude Monet! After you visit the Art Institute of Chicago, you will understand how this museum helped to define this richly diverse city known for its architectural wonders and innovative public art. —SBR

One of two giant bronze lion sculptures guards the famous western entrance (off Michigan Avenue) to the Art Institute.

Antoni Gaudí (1852-1926)

SPAIN'S NATIONAL TREASURE

Unlike his contemporary Vincent van Gogh, Spanish architect Antoni Gaudí enjoyed popular success before his untimely death in 1926. The city of Barcelona is filled with Gaudí's unique designs, which definitely follow their own set of rules. Inspired as a child by his artistic parents (both from families of metalsmiths), Gaudí incorporated shapes found in the natural world into his work. His playful style jumps between categories, simultaneously embracing the undulating lines and shapes of Art Nouveau and Surrealism and the soaring verticality of Gothic art. Doors, windows, and columns resemble human and animal bones. When looking at his giant stone animals embedded around his parks' serpentine walkways, you might believe they are alive because their sparkly surfaces, entirely covered in irregular, colorful mosaics, shimmer in the sun.

Gaudí's **Sagrada Familia** *in Barcelona, Spain.*

Begun in 1882, the still unfinished mammoth church complex *Sagrada Familia* is perhaps Gaudí's most well-known work. Resembling a desert rock formation carved by otherworldly hands, its 18 spiraling towers dedicated to the apostles and the Holy Family involved a large number of architects, sculptors, and craftsmen. Gaudí's devotion to Catholicism caused him to eventually abandon all projects except his work on Sagrada Familia. The project completely engulfed him to the point where he moved his entire studio into the church, and he would have probably continued working on it had he not died from injuries sustained in a tragic trolley accident. Buried within his beloved Sagrada, Gaudí's spirit continues to inspire work on the church, now estimated to be complete in 2033. —SBR

Shattered Glass

THE ART OF BARRY LE VA

Barry Le Va creates sculptures such as "One Edge, Two Corners; On Center Shattered" by dropping heavy weights onto arranged panes of glass. One would assume that the resulting aesthetics would be largely the product of happenstance.

Despite their chaotic appearance, however, such arrangements are meticulously orchestrated. Many of Le Va's works are, in fact, planned in drawings ahead of time (perhaps a carryover from the artist's initial education as an architect)[10]. While the particular snowflake of fissures and cracks produced in the glass is unique to every work, Le Va has left as little as possible up to chance.

One Edge, Two Corners; On Center Shattered *by Barry Le Va. (Variation 13, Within the Series of Layered Pattern Acts) 10" by 84" by 96" (25.5 cm by 214 cm by 244 cm) glass (28 sheets, 8 layers of 4 varying sizes) 1968/2007 COURTESY: MARY BOONE GALLERY, NEW YORK. (MBG#9707)*

Still, it would be unwise to accuse the artist of being overly fastidious. The performance piece *Impact Run—Energy Drain*, for instance, involved the artist running back and forth across a gallery, hurtling himself against opposing walls as he did. Reportedly, Le Va had resolved to simply continue running until he was physically unable; the footsteps become increasingly belabored throughout the hour-and-a-half-long auditory recording.

The piece depicted herein, while not as physically taxing, nevertheless involves a similar principle. The creation observed is the end result of chance meeting premeditation at the point of collision. —DJS

The Largest of the Large

PUSHING THE BOUNDARIES OF SIZE

What's the biggest work of art you've ever seen? Whatever it was, it probably doesn't compare to any of the works that follow.

The world's largest print photograph was created inside an airplane hanger that had been converted to a gigantic camera obscura (page 36). The final print measured roughly 32 × 111 feet.

Stepping things up a notch, a group of 25 Iranian artists created the world's largest piece of sand art by designing a Persian carpet made up of 70 different types of sand, measuring almost 40,000 square feet.[11]

Then, at just over twice that size, Swedish artist David Aberg used more than 100 tons of paint to create his 86,000 square-foot *Mother Earth,* which is one of the largest single-artist paintings in the world.[12]

Finally, perhaps the largest piece of art in the world is Australian artist Ando's *Mundi Man,* a face etched into the Mundi Mundi plains in New South Wales (page 285).

One thing is for sure: Until someone figures out how to use the whole earth as a canvas, people will continually be pushing the boundaries of what we consider "large" art.

—GRG

Exercise 7

PINK FLAMINGO WITH EILEEN SORG

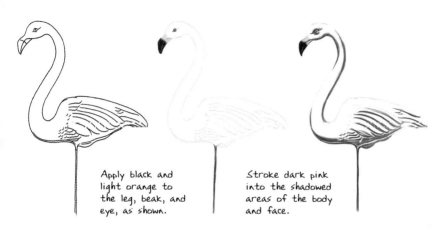

Apply black and light orange to the leg, beak, and eye, as shown.

Stroke dark pink into the shadowed areas of the body and face.

Add more color to the flamingo, building up layers of reddish pink and leaving some of areas of the head and body free of color for now. Further define the shadows with accents of dark purple.

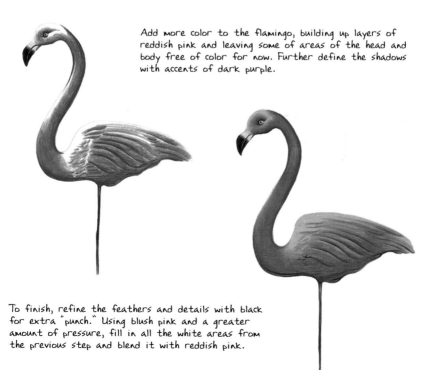

To finish, refine the feathers and details with black for extra "punch." Using blush pink and a greater amount of pressure, fill in all the white areas from the previous step and blend it with reddish pink.

Color Psychology
A KALEIDOSCOPE OF ASSOCIATIONS

What do you think of when I mention the color blue? How about yellow? Chances are that more will come to mind than just an image of the color. Humans associate colors with everything from specific moods to seasons and times of day—and some people even associate them with letters of the alphabet, tastes, or sounds (page 86). Some of our responses are products of cultural conditioning, but others are linked to physical reactions within our brains.

When creating a work of art, it's important to consider the effect of your color choices on the viewer. Although each person has his or her own filter for receiving and interpreting colors, below are the most common associations. —ETG

Warm colors, such as orange and yellow, are associated with autumn (top), whereas cool colors, such as blue and purple, are associated with winter (bottom).

Yellow
joy, sun, summer, cowardice, vitality; bright, friendly

Blue
winter, water, ice, sky, stillness, loyalty, melancholy; soothing, peaceful

Red
danger, blood, anger, passion; spicy, seductive, exotic

Green
nature, spring, health, fertility, envy, nausea; fresh, organic

Purple
royalty, wealth, creativity; feminine, dreamy

Orange
fire, autumn, citrus; invigorating, refreshing, energetic

Gray
indifference, antiquity, maturity; practical, gloomy

White
purity, innocence, peace, surrender; clean, unblemished, empty, classy

Black
sophistication, night, mystery; mournful, morbid

FUN FACTS

• *The majority of people choose blue as their favorite color.*

• *On a diet? Consider wearing red or yellow! Studies show that viewing these colors can speed up your metabolism.*

Plato (427–347 BCE)

ART AS IMITATION OF IMITATION

"But what if man had eyes to see the true beauty—the divine beauty, I mean, pure and clear and unalloyed, not clogged with the pollutions of mortality and all the colors and vanities of human life…?"

—*Plato*, Symposium, *212*

You may vaguely recall from Philosophy 101 that a guy named Play-Dough wrote about some cave and was really into these things called "forms." Well, besides the spelling, you wouldn't be too far off. Plato was definitely obsessed with the unattainable ideals that he (and his mentor Socrates before him) called Forms. In Plato's view, these perfect ideas exist only in the mysterious Realm of Forms, outside the world of sensory experience. So, our earthly perceptions of virtues like Truth or Beauty are only inferior approximations of their corresponding Forms.

This means that when an artist creates an original work that imitates human experience, the result is nothing more than an imitation of an imitation of the Forms. Artists with a keen sense of measurement and proportion can come closer than others in reflecting the essence of Beauty. But, because of the senses' inherent fallibility, human creations will never capture the perfection of the Forms.

Since art is always twice removed from the Forms, Plato is not a huge fan of it. However, he respects art's ability to shape people's thoughts and feelings, and therefore believes it should be strictly censored by the wisest members of a society. —CKG

QUESTIONS TO PONDER

• *Is any work of art ever perfectly beautiful, or is it always flawed in some way?*

• *Are the five senses capable of receiving universal truths about our world?*

Baroque Art

ALL THE WORLD'S A STAGE

Lights, camera (obscura), Baroque! With a heavy sense of theatrics, Baroque art pierces the heart with a heightened sense of emotion and a rich, stagelike aesthetic. At this time many countries were exploiting riches

> **WHEN & WHERE**
> *c. 1600–1750*
> *Western Europe*

from their newfound colonies overseas. Not only was the Catholic church still a great patron of the arts, but wealthy private citizens wanted to impress their friends with fancy paintings and sculptures. Religious subject matter was always in vogue, but new themes emerged in triumphant landscapes that dwarfed their human occupants, still lifes were big, and portraiture of ordinary people was all the rage.

The Catholic church was waging the Counter Reformation war, and this emotive style was just the catalyst they needed to communicate their message. Value contrast in painting became more acute, figures were portrayed in action, and human expressions were dramatic yet genuine. Painting, sculpture and architecture were bursting with energy. For the first time, sculptors considered 360° views of a piece; subsequently, figures spiraled around in space and activated all angles. While religious motifs were concentrated in the country of Baroque origin, Italy and the Northern countries went for more earthly subject matter. Portraits, genre scenes, and rich still lifes decorated the homes of many a Dutch patron.

Ironically, Baroque art partially emerged as a reaction to the decorative Mannerist era, and once Baroque art had its run, it was replaced by the ultraornate Rococo period. —ARR

Selected artists: Gian Lorenzo Bernini, Caravaggio, Rembrandt, Jan Vermeer, Peter Paul Rubens, Artemisia Gentileschi, Diego Velázquez, Frans Hals, Judith Leyster, Nicolas Poussin

Michelangelo (1475–1564)

A STUDY OF THE SUBLIME

By all accounts, artist, sculptor, architect, and poet Michelangelo Buonarroti was a cantankerous man prone to angry outbursts. He maintained an openly public rivalry with notable contemporary Leonardo da Vinci, and had few friends during his lifetime. Yet Michelangelo's unpleasant disposition did not corrupt his artistic sensibilities; perhaps it even enhanced them. Many historians and philosophers have described Michelangelo's art as virtually flawless, taking note in particular of its *terribilita,* a somewhat fluid term that refers to the artistic expression of discernable intensity that both inspires and induces fear.

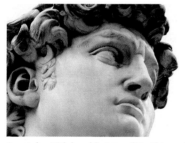

Even today, Michelangelo's statue of David is considered one of the finest representations of the human form in art.

Although Michelangelo preferred sculpting to painting and openly ridiculed the latter as an artistic medium, he rendered two frescos for the Sistine Chapel: one on the ceiling depicting pivotal Biblical scenes and figures; the other on the vast wall behind the altar, appropriately named *The Last Judgment.* Both are considered among the finest paintings of Italy's High Renaissance period.

Michelangelo's myriad sculptures—many of which he completed before the age of 30—are beyond reproach, as well. His most celebrated, *David,* was a tribute to the strength and resolve of his native Florence, whose security was under constant threat by neighboring states. It has been revered for its sublime aesthetic representation of the human form and reproduced at length. —RJR

Notable works: *The Pietà* (in St. Peter's Basilica), 1499 (page 60); *David,* 1501-04; *The Holy Family,* 1504.

FUN FACT

An Italian variant of Michelangelo's name is "Michelangolo," which is how it appeared on the first edition of the artist's poetry, published in 1623 —60 years after his death.

End of an Arabesque

EDGAR DEGAS, 1877

What is an *arabesque*? The word can describe several things in reference to art, but in this case it describes a particularly challenging ballet position that involves balancing on one foot, with the other leg high in the air and arms outstretched. Edgar Degas's painting captures this move, and although the details of the performance are left to the viewer's imagination, we know the audience deemed it worthy of a bouquet of flowers.

The dynamic composition of this piece is evidence of Degas's interest in photography. The ballerina is a bit cut off on the right side, and the viewer sees her from an unconventional vantage point—both of which contribute to a "snapshot" quality. It is as though we're lurking at sidestage and sneaking a quick glance at the harshly lit stage performer.

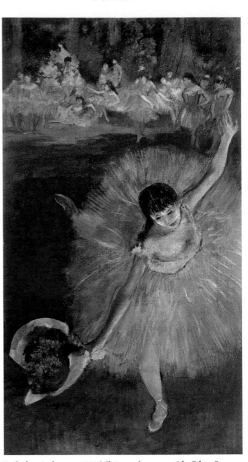

End of an Arabesque, *1877 (oil & pastel on canvas) by Edgar Degas. Movement: Impressionism.*

When in his mid-thirties, Degas became interested in painting a variety of scenes from everyday life. This was not, in fact, a wise decision for a painter of his time; audiences and critics expected to see art that was inspired by loftier sources such as literature and history. Nonetheless, Degas cast caution and his reputation to the wind, painting workers, racehorses, and Parisian café life. But he is perhaps best remembered for his lovely ballerinas, through whom he captured the grace and beauty of both the dance and the dancer. —DDG

Palacio Nacional

MEXICO CITY, MEXICO

Located in Mexico City and home to the offices of the Federal Treasury, the State Archives, and a major library, the Palacio Nacional boasts a storied past: The building originally functioned as the early 16th-century palaces of the Aztec *tlatoani*, or supreme ruler. Later the palace became the personal

Façade of the Palacio Nacional.

home of Spanish explorer Hernán Cortés and his Spanish viceroys, and more recently, the office of the president. While not a traditional museum, the building may be best known as a site rich with art and history; dramatic mural paintings by Diego Rivera, depicting the history of Mexico from its settlement by Moctezuma II in the early 16th century to post-revolutionary times in the 20th century, occupy the main stairwell and many walls on the second floor. The murals, painted between 1929 and 1935, contain famous and infamous characters and stories, and even a portrait of the artist's wife, artist Frida Kahlo (page 231). The murals and the building reflect the country's intertwined Spanish and Aztec heritage; archeologists have unearthed artifacts dating back to the original Aztec occupants, including the majority of the building's structure. Taking a trip to the Palacio Nacional is like going back in time to see the beginnings of a nation and the formation of its identity. —SBR

Glasgow School of Art

THE LEGACY OF CHARLES RENNIE MACKINTOSH

For more than 100 years, the vitality and creativity flowing through the Glasgow School of Art has attracted artists and tourists alike. In the late 1890s, the building received a facelift by the renowned 20th century Scottish artist (and GSA graduate) Charles Rennie Mackintosh. His unique designs, incorporating stylized flora and fauna motifs, branded the building a rare but excellent example of Scottish Art Nouveau with an Arts and Crafts twist. From the tiniest light fixture to the grandest carved mahogany doorway, his designs infiltrate the Mackintosh building's interior and exterior spaces—how could you not be inspired when completely surrounded by creativity?

Exterior of Glasgow School of Art.

Centrally situated in the traditionally working-class town of Glasgow, the School is both muse and locale for a vibrant contemporary music scene, including Scottish bands Travis, Belle and Sebastian, and Simple Minds. Artists such as Iain McCaig and Simon Starling cut their creative teeth at the school before going on to win the Turner Prize and working on Hollywood films. In addition to the hundreds of active students rushing to and from class, thousands of tourists a year take guided tours through the historic halls of "The Mac," as the students call it, catching glimpses of aging 19th century photographs juxtaposed with colorful flyers advertising the latest downtown art exhibition. One hundred years strong, the School embraces its myriad roles as educational center, heritage building, and tourist destination—Mackintosh would undoubtedly be pleased. —SBR

Murals of the Border Wall

LA CIUDAD ESPEJO

Each time I descend the spiraling pedestrian walkway leading from San Diego, California, into Tijuana, Mexico, I find it slightly disorienting, vaguely reminiscent of the meditative labyrinths built into the medieval cathedrals of Europe. The US-Mexico border region, to be sure, is a metaphysically unique space, akin to the "states of nonordinary reality" explored by Carlos Castaneda and William James alike.

The border wall itself—more precisely, a corrugated metal section located near the Tijuana International Airport—has become the medium of expression for painters native to the region. An expanse of murals depicts the myriad cultural, social, and political idiosyncrasies of border life.

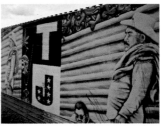

Many images are repeatedly duplicated on adjacent panels, making them readily visible to passing motorists. Depictions of the Virgin of Guadalupe, *norteño* guitarists, *cholo* and *pachuco* fashion, and international flags illustrate the unique cultural landscape.

US-Mexico border wall, Tijuana, Baja California, Mexico. Photographs courtesy of Leticia Talavera.

In recent years, revolutionary groups from deeper Mexico have added their voices to the mix, spray painting the metallic barrier with one-word manifestos: *"anarquismo,"* "EZLN," and "APPO."

Then there are the crosses—simple, white-washed wooden crosses attached to the western stretch of the wall, commemorating the anonymous souls who died while attempting to cross the deserts to the east. Their muted voices, too, join this collective artistic statement. —DJS

Synesthesia and Art

SEE THE MUSIC AND HEAR THE PAINTING

What if every number had a specific color, or if months of the year were three-dimensional? What if certain sounds caused you to feel a certain temperature? You might suspect that this sort of experience would require a mind-altering substance or deep meditation. However, a small percentage of people actually have a

The Part You Throw Away, *a synesthesia-inspired painting by and courtesy of artist John Bramblitt (page 245).*

neurological condition called "synesthesia" in which one sense (sight, sound, taste, touch, or smell) triggers a response in another unrelated sense.

Often associated with people of a creative mindset, synesthesia has influenced artists throughout the centuries. Many have consciously used this condition to dictate their work, from musical composers (notably Franz Liszt and Leonard Bernstein) to painters and writers. Being able to "see" music or "hear" a painting has allowed people to delve deeper into what it means to really experience something. There are even non-synesthetes who, imagining what this must be like, attempt to evoke a synesthetic response in viewers. There has been some debate over whether the abstract painter Wassily Kandinsky had this neurological condition, but we do know that he attempted correlation between music, color, and brushstrokes in his work, resulting in lively and memorable masterpieces. —GRG

Exercise 8

PENGUIN WITH ED TADEM

Start this little guy by blocking in the body using basic shapes.

Add the wings and beak, and start fleshing out the feet and chest. Indicate the ground.

Designate areas of light and shadow on the wing and head, and shade the body and feet with hatchmarks. Then add the beady eye.

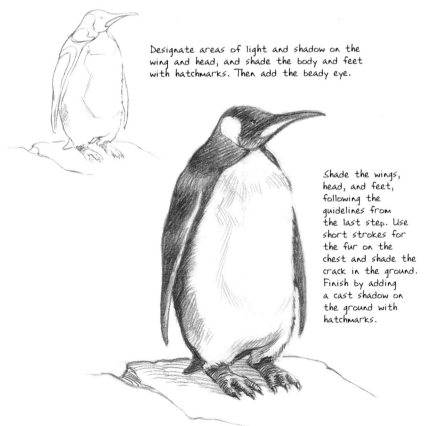

Shade the wings, head, and feet, following the guidelines from the last step. Use short strokes for the fur on the chest and shade the crack in the ground. Finish by adding a cast shadow on the ground with hatchmarks.

Color Schemes

NARROWING DOWN YOUR PALETTE

Just as you coordinate the colors of your clothes before getting dressed in the morning, you'll want to coordinate the colors of your painting *before* you put the brush on the canvas. If you ignore this step, you might end up seriously clashing.

Color schemes are sets of colors that work well with one another. Each scheme has a different effect on the human eye; some schemes encourage a sense of unity and harmony, while others create exciting contrasts. Before you settle on a set of colors, it's important to think about how possible schemes could aid in communicating your intended message. —ETG

Achromatic
This colorless scheme uses only black, white, and shades of gray. As in a black-and-white photograph, you can create an unexpected amount of drama with this scheme.

Monochromatic
In this scheme, the artist chooses one color along with its tints, tones, and shades. These schemes can be moody and soothing.

Complementary
This scheme is dominated by two complementary colors (such as purple and yellow). When placed side by side, complementary colors appear brighter and can create a great amount of energy in a painting.

Analogous
Analogous schemes include colors situated next to one another on the wheel (such as red, orange, and orange-yellow). Because these groups of colors are similar in hue, they produce a sense of unity in a work of art.

Split-Complementary
A split-complementary scheme features a color plus the two colors on either side of its complement (such as yellow, blue-violet, and red-violet). This scheme touches on the excitement of the complementary scheme but offers a wider range of colors.

Triadic
A triadic scheme includes three colors that are equidistant on the color wheel (such as yellow-green, red-orange, and blue-violet). It's easy to overwhelm the eye with this scheme, so artists generally choose to make one color dominant and use the other two as accents.

Complementary Scheme in Action
Dominated by complements orange and blue, this night scene vibrates with energy.

Monochromatic Scheme in Action
Monochromatic scenes, such as the one at left, are generally calming and easy on the eyes.

Aristotle (384–322 BCE)

ART AS INSPIRATION

"…generally art partly completes what nature cannot bring to a finish, and partly imitates her." —Aristotle, Ethics; *Book II, pt. 8*

In some ways, the Greek philosopher Aristotle agrees with his teacher Plato. He grants that most art is imitative in nature and that beauty is dependent on a proper balance and ordering of measurements. He also recognizes art's capacity to incite enthusiasm in an individual. However, unlike Plato, who sees art's powers of persuasion as a threat to society, Aristotle admires its ability to affect people's thoughts and emotions.

He is fascinated by the way humans respond to and interact with art, especially poetry and epic tragedy, pointing out that while fictional stories may not correspond to factual events, they can still contain universal truths. In such a way, Aristotle believes art can actually improve on that which it imitates.

In *Poetics*, he explains that people gravitate toward art because they see it as a reflection of their own lives or of human existence in general. In many cases, art may offer empathy and consolation to its recipient. At other times, it can inspire people or even, as in the case of tragic drama, illuminate the perils of foolish behavior.

The experience of painting, poetry, or music can provide us with a better understanding of our purpose and predicament. Aristotle believes that when created nobly and performed with masterful technique, art can foster moral growth and an overall improvement of society. —CKG

QUESTIONS TO PONDER

• *Has an experience of art ever inspired you to change your character or behavior?*

• *Should all art strive to reflect universal truths about human life?*

The Rococo

THE AGE OF LUXURY

Gold, gold, and more gold! The Rococo period is characterized by an ornate style that originated in the decorative arts. After the death of Louis XIV, the French aristocracy

moved away from the formality of Versailles to the salons of Paris. They furnished their new townhouses with an eye for intimate details and pastel colors rather than the darker grandiosity of the Baroque royal palace. Inspired by natural patterns, Rococo artisans designed luxurious rooms where paintings fought for attention amongst lavish drapery and elaborate wall ornamentation.

Rococo paintings were rendered in a soft palette and echoed the curvilinear forms of 18th century decorative arts. Many paintings were escapist and erotic, featuring pastoral landscapes, theatrical myths of love, and porcelain-toned aristocrats on leisurely outings. Portraiture of the upper classes was also in vogue. Highlighting feminine beauty in this age of romance was paramount, and no decent lady would be seen in a portrait without her jewels, furs, flowers, and big, big hair!

The Rococo style spread from France throughout Europe, but as bourgeois tastes moved toward the Neoclassical, this sumptuous style was dismissed as a frivolous fashion. However, it is now considered a major period in art history and an excellent record of the spirit of the time. —ARR

Selected artists: Francois Boucher, Etienne-Maurice Falconet, Jean-Honoré Fragonard, Thomas Gainsborough, Giovanni Battista Tiepolo, Marie-Louise-Elisabeth Vigee-Lebrun, Jean-Antoine Watteau

FUN FACT

The name Rococo is a combination of the French word Rocaille *(rock and shell garden decoration) and the Italian word* Barocco *(Baroque).*

Francisco Goya (1746-1828)

DOCUMENTING POLITICAL UPHEAVAL

Francisco Goya's career spanned more than six decades and was greatly influenced by the politics of his time. Indeed, his work is akin to a timeline documenting the state of governmental affairs in his native Spain. It's also been noted that his early art reflects a peace and optimism that fades into literal and figurative darkness in his later works with the passage of time.

Born in Fuendetodos, Goya apprenticed with artist Jose Luzán as a teen. He later joined the studio of brothers Francisco and Ramón Bayeu y Subías and married their sister, Josefa. In 1774, Goya began painting commissions for the aristocracy. He was appointed royal painter under Charles III, which continued into the reign of Charles IV; however, the French occupation of Spain in the early 1800s brought with it total chaos. The Spanish monarch was overthrown, and Joseph Bonaparte, Napoleon's brother, assumed the throne. Goya was appalled, but pledged his loyalty to the new crown nonetheless and continued in his appointment. When Spanish rule was reinstated a few years later to Ferdinand VII, Goya's art began detailing the horrors of war and the suffering of the Spanish people under French rule; however, Ferdinand questioned the artist's loyalty, and the royal commissions dried up.

Angry and bitter, Goya retired to the country where he painted works that became increasingly dark and ominous—his so-called "Black Paintings." To escape political scrutiny, Goya eventually moved to Bordeaux where he lived for the rest of his life. —RJR

Notable works: *The Family of Charles IV,* 1801; *The Naked Maja,* 1805; *The Third of May, 1808,* 1814 (page 162).

FUN FACT

The tumultuous political climate wasn't the only reason for Goya's increasingly bad-tempered disposition. An illness and high fever in the 1790s left him completely deaf, which caused him great anguish.

Ophelia

JOHN WILLIAM WATERHOUSE, 1894

The British artist John William Waterhouse, loosely associated with the Pre-Raphaelite Brotherhood, was fond of portraying scenes from mythology and poetry. The painting below shows Ophelia, the heroine of Shakespeare's tragedy *Hamlet,* shortly before she drowns in a brook. In the play, Ophelia loses her mind after Hamlet accidentally kills her father, Polonius.

Waterhouse depicts Ophelia sitting on a log, surrounded by lilies. In her paradoxical expression we see both lightheartedness and despair. The ambiguity in her body language hints at the insanity that plagues her mind. Flowers in her lap and hair foreshadow the heartbreaking moment when she will disappear into the nature surrounding her.

Waterhouse painted three different scenes of Ophelia's last moments. His celebration of her intense emotional struggle and beautiful natural surroundings touch on the ideals of the Pre-Raphaelite tradition. —DDG

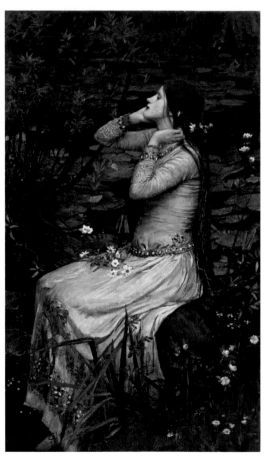

Ophelia, *1894 (oil on canvas) by John William Waterhouse. Movement: Neoclassical/Pre-Raphaelite Style.*

Museo Nacional del Prado

MADRID, SPAIN

If you round a corner and come face to face with the painting *Third of May,* Francisco Goya's brutal depiction of the execution of Spanish patriots by Napoleon's firing squad (page 162), do not be surprised if you get a few goose-bumps. Many spine-tingling moments are scattered throughout the Museo Nacional del Prado, or the Prado, in downtown Madrid, Spain. Etchings, paintings, and sculptures by the old masters such as Albrecht Dürer and Peter Paul Rubens hang alongside masterpieces by Hieronymus Bosch and Diego Velázquez. For those visitors with only a few hours to spend in the galleries, the Prado features "Highlights of the Collection" tour recommendations that provide a more concentrated visit of the museum's "greatest hits."

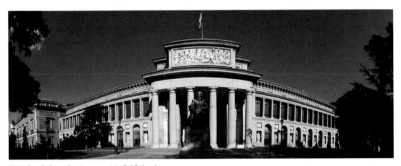

Façade of El Prado Museum, Madrid, Spain.

Originally designed as the Natural History Cabinet in 1785, the building en-dured a number of changes until 1819, when the museum opened to the public as a showcase for the royal collection devoted to promoting Spanish art. Dur-ing the Spanish Civil War in the 1930s, Republican government-sponsored agencies, functioning as "Red Cross units for art," relocated the Prado's col-lection for safekeeping in churches, basements, and other fortified structures across Spain; this was the one and only time Diego Velázquez's masterpiece, *Las Meninas,* has ever left the Prado. Currently, the museum's collection has grown to include 20,000 paintings, sculptures, prints, drawings, and historical documents, but is only able to exhibit a small fraction of them. —SBR

If Walls Could Talk

THE POLITICAL MURALS OF NORTHERN IRELAND

Since the 1960s, artists from Northern Ireland have painted nearly 2,000 murals that depict a running social commentary and narrative of the people and events during "the Troubles," the name given to the 30 years of violence and conflict between Northern Ireland's nationalist, primarily Roman Catholic community and its unionist, principally Protestant community. Painting a wall with political slogans or images of local heroes could get you shot or thrown in prison during the Troubles, but in Ireland today, the murals have become a rather popular tourist attraction.

Mural from 1973 in Belfast, Northern Ireland.

The murals function not only as works of art but as political commentary, historical markers, and communal memorials. For these communities, blank walls have always been the appropriate place to commemorate and memorialize the dead and imprisoned, even football heroes, with banners, flowery wreaths, brass plaques, and murals. Previously seen as harbingers of urban blight situated in dangerous locations, the socio-political murals in Northern Ireland are now highlighted attractions on bus tours and are regularly featured in tourist guidebooks. It seems the rest of the world is finally catching up with these "painted" sentiments. —SBR

WHAT IN THE WORLD?

Since 1993, muralists and brothers Tom and Will Kelly and their friend Kevin Hasson have worked together as The Bogside Artists. In 2007, the US government invited them and other Irish muralists from East Belfast to recreate various murals on a gable wall in Washington, D.C. for the Smithsonian Folk Life Festival.

Latte Art

A GLOBAL PHENOMENON

The average American drinks a total of 200 gallons of coffee each year*. And, in his lifetime, will accidentally eat seven spiders while sleeping. And will quote fourteen made-up statistics every month. Or something like that.

Whatever the actual figure is, there's no denying that Americans drink a lot of coffee. Beyond the borders of this country as well, the ubiquitous latte or cappuccino has become a constant factor in a world increasingly connected by a shared, globalized culture.

The practice of drawing in the foam atop a latte has spread to practically every continent on the planet. A mushrooming number of cafés, from Moscow to Tokyo, now provide this drinkable art to their patrons, producing baristas who go on to win international competitions.

Flowers, rosettes, leafy configurations, and wild animals emerge from the frothy canvas, formed by pouring the steaming milk into the cup and using various styli to manipulate the espresso. Syrup is sometimes added for additional detail.

As cultural forms become globalized, one worldwide trend appears to have emerged in conjunction with them—the tendency to transcend practicality, producing non-pragmatic beauty in something as mundane as a morning cup of coffee. —DJS

* Statistical source: the dark recesses of David Schmidt's imagination.

Art-o-mat®

NOT YOUR AVERAGE VENDING MACHINE

Where do you buy your art? If Artists in Cellophane have their way, it could very well be from a repurposed cigarette vending machine. Since 1997, this art organization (AIC for short) led by Clark Whittington has been rescuing and restoring old cigarette vending machines. The AIC turns these machines into pieces of art themselves—not only are they sleek and beautiful, they are functional pieces of equipment that dispense art instead of cigarettes.

This featured Art-o-mat is a resident of the Studios of Key West. Artists in Cellophane are always searching for new artist contributors. Visit www.artomat.org for more information.

Just buy a token for the Art-o-mat (about $5 US in 2009), select the art you would like, give a nice yank to that satisfying lever, and out comes your appropriately sized, original piece of art. What kind of art? Small photos, hand-sized sculptures, little paintings—whatever the artists can dream up and fit into a container of about cigarette box proportions (2-1/8" × 3-1/4" × 7/8").

This all started with just one machine in a coffee shop that sold Clark's own photographic prints, but now many venues—including museums, art centers, and boutiques—are hosting Art-o-mats. At the time of this printing, AIC has about 85 machines spread across the US, Canada, and Austria. With more than 400 contributing artists, Clark is well on his way to making art an accessible part of people's daily lives.

As its website states, "AIC believes that art should be progressive, yet personal and approachable. What better way to do this, than with a heavy cold steel machine?" —GRG

Exercise 9

GUITAR WITH ED TADEM

Sketch the number "8" (or a snowman, whichever you prefer). Then add straight lines for the fretboard (or neck).

Add form to the base of the guitar and block in the basic parts (the soundhole is the circle, and the bridge is the rectangle). Erase the lines in the neck.

Erase any guidelines you don't need. Add more details, such as the strings, frets (the horizontal lines on the fretboard), machine heads (the bolts on the uppermost part), and the strap.

As you start shading, concentrate on the fretboard strap, shadowed edges of the guitar, and the soundhole. Don't draw every string going up the fretboard; the viewer's eye will fill them in.

Linear Perspective

THE ILLUSION OF SPACE, PART 1

One of the most exciting aspects of drawing and painting is that you can transport the viewer to any place you wish, whether it involves re-creating a landscape from life or fashioning a scene from your own imagination. To help you convincingly represent these locations to the viewer, it's important to know the basics of *linear perspective*—a geometric framework for representing a scene or three-dimensional object on a flat surface (such as your paper). The system is based on the fact that objects appear to shrink and parallel lines converge as they move into the distance. Let's summarize the two most common types: *one-* and *two-point perspective.*

The most basic type is one-point perspective, in which all parallel lines leading away from the viewer converge to one *vanishing point* (VP) in the distance. This point lies about eye-level on the what we call the *horizon line* (HL). Train tracks, streets, and piers (below) offer perfect examples of this.

Learn to see one-point perspective in photos before tackling it in a drawing or painting. The diagram at near right marks the VP (red), HL (purple), and converging parallel lines (green). When drawing or painting, start by establishing the HL; then mark the VP. Lead all parallel lines to this point.

A more complicated vantage point might display *two-point perspective,* which involves exactly what you might suspect: two vanishing points. As a short exercise, take a look at the photo at right and determine the horizon line and vanishing points.
—ETG

REMEMBER THIS!

Don't be afraid to use a ruler to determine the angle of your parallel lines.

Some artists advise against this in favor of a more oragnic style—

but for beginners, accuracy is more important.

St. Augustine (354–430 CE)

BRINGING GOD INTO THE PICTURE

"…to us is promised a vision of beauty—the beauty of whose imitation all other things are beautiful, and by comparison with which all other things are unsightly."

—*Augustine,* De Ordine, *19.51*

Like Plato, St. Augustine (pronounced *uh-GUH-stinn*) rejects physical, bodily things in favor of metaphysical, spiritual ideals. However, Augustine is also a Christian who relies on scripture to guide his beliefs and behavior. It's a unique theological challenge for him to reconcile the Christianity in his heart with the Platonism in his head, especially when analyzing art.

In many ways, art is a physical pursuit. Every art form requires tangible materials, and the reception of art involves sensory perception. For people like Augustine, then, who frown on physical objects and distrust sensory experience, art must be a defective enterprise.

But the implications change when the topic of art is viewed through a Christian lens. God made the physical universe, created humans in his own image, and became flesh in the person of Jesus. So creation in general can't be completely worthless to Augustine, right?

He recalls the Garden of Eden story to help sort things out. God gave humans free will so they could have moral responsibility, but that also gave them the freedom to screw up His perfect creation, which they wasted little time in doing. Whenever humans create, their inherent sinfulness taints the results. According to Augustine, we can only experience true beauty when we experience God. —CKG

QUESTIONS TO PONDER

- *How might a theist view art differently from an atheist or agnostic?*
- *What might be some potential conflicts between Christian belief and Platonic Dualism in the analysis of art?*

Neoclassicism

VERY REASONABLE!

How enlightening! With rational reserve and a sense of nationalistic duty, the Neoclassicists ushered in a new era in art.

WHEN & WHERE

c. 1750–1850

France, England, USA

The Age of Enlightenment brought forth new ideas that espoused the old: reason, liberty, and sacrifice. Looking back on Classical Greece and Rome, Neoclassical artists and philosophers prized reason and simplicity over the extravagance of the Baroque and Rococo eras. Austerity over ostentation. This was a time of three revolutions: the French, American, and Industrial. A middle class was being born and now art was for everyone, not just the Church and aristocrats. National museums were established and art spoke directly to the masses. We had now entered the modern world.

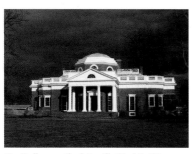

Monticello, near Charlottesville, Virginia, US, Thomas Jefferson, 1772.

Fueled by the rediscovery and excavation of the volcanically preserved Roman town of Pompeii in 1748, the Neoclassicists emerged creating paintings, sculptures, architecture, and interior design that paid homage to the ideology of the ancients. Their didactic imagery preached virtue over vice through courageous images of revolutionary heroes depicted as martyrs. Greek and Roman history scenes and mythological stories were popular. Portraits of philosophers like Voltaire, and leaders like George Washington and Napoleon astride his noble steed are emblematic of the time.

Neoclassicist painters demonstrated their calm and restraint in their manner of paint handling. Clean edges separated forms from one another crisply. Value and color transitions were smooth and controlled. Sculpture included classical elements such as togas and columns.

The rigidity of Neoclassicism eventually fatigued, and artists began to look to their own time and place for inspiration and beauty. —ARR

Selected artists: Jacques-Louis David, Jean-Antoine Houdon, Jean Auguste Dominique Ingres

Mary Cassatt (1844–1926)

MADE IN AMERICA

"There's only one thing in life for a woman; it's to be a mother… A woman artist must be…capable of making primary sacrifices."
—*Mary Cassatt*

Although Mary Cassatt never married or had children, she was exceptionally gifted when it came to capturing quiet, tender moments between mother and child on canvas. Born into wealth in Allegheny City (Pittsburgh), Pennsylvania, Cassatt was well educated and raised in the shadow of the 19th-century proviso that she'd eventually fulfill her role as a proper Victorian wife and mother. Instead, she chose to be an artist.

She attended the Pennsylvania Academy of the Fine Arts in Philadelphia for a time, followed by a move to Paris in 1865 to study the old masters. The outbreak of war in 1870 forced her to return to America. Her father, adamantly opposed to her chosen career, refused to provide for anything more than her basic needs, and, for a time, it appeared as though Cassatt might abandon art altogether; however, a small commission yielded income sufficient enough for her to return to Europe. She studied art in Spain, Italy, and Belgium before settling down in Paris.

Cassatt achieved some success in the early 1870s. In 1877, after repeated rejections by the Salon, Edgar Degas invited her to exhibit with an independent group called the Impressionists; she instantly felt at home. Degas continued to mentor Cassatt, and the two remained close friends. A strong advocate of her fellow Impressionists, Cassatt used her influence in affluent social circles to secure purchases of their art, which subsequently helped introduce the genre to America. Today she is hailed as one of America's premier Impressionist artists. —RJR

Notable works: *In the Loge,* 1878; *The Child's Bath,* 1893; *Breakfast in Bed,* 1897 (page 322).

The Houses of Parliament, London, with the Sun Breaking Through the Fog

CLAUDE MONET, 1904

French Impressionist painter Claude Monet, like many artists throughout history, traveled abroad to paint the exotic scenes of foreign lands. London was one of Monet's preferred destinations. He traveled there twice over the course of his career, studying the techniques of British artists (such as John Constable and Joseph Mallord William Turner) and painting the local scenery.

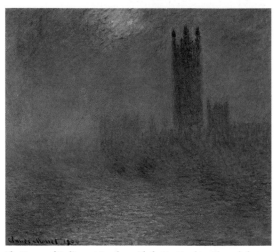

The Houses of Parliament, London, with the Sun Breaking Through the Fog, *1904 (oil on canvas) by Claude Monet. Movement: Impressionism.*

This painting is one in a series of works created by Monet in an effort to capture the British Parliament building in various combinations of light and weather conditions. In 1905, he set up his easel next to a window at St. Thomas's Hospital overlooking the Thames river and painted this scene. Here we have one of the most colorful paintings in the series. As you can tell, Monet was much more interested in conveying a mood and atmosphere with his art than creating a detailed and lifelike replica of his subject. How would you describe the mood of this painting? —DDG

Musée du Louvre

PARIS, FRANCE

No other museum in the world can conjure up the quintessential definition of "museum" quite like the famous Louvre located in central Paris. Following a royal edict to provide illuminating examples of fine art to inspire future artists, the massive stone, steel, and glass building complex opened in 1793 and houses an encyclopedic collection admired the world over. Nearly 6 million visitors—including aspiring and established artists alike—flock to the Louvre every year, many attracted to the "Big Three:" *The Venus de Milo,* the *Victory of Samothrace,* and Leonardo da Vinci's *Mona Lisa.* Since the museum's vastness can intimidate even the experienced art aficionado, the visitor center provides a map (in several languages) and a key to the most popular rooms and art works.

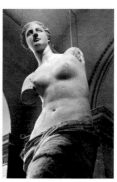

Statue of Aphrodite of Melos (Venus de Milo) in the Louvre Museum, Paris.

Even the museum's website provides an exhaustive treasure trove of information: It offers a number of thematic trails, based on a certain period or artistic movement, designed to give an overview of the scope and richness of the museum's collections. Each trail is based on a selection of works that typify a period, an artistic movement, or a theme. The trails are organized thematically; titles include "Calligraphy in Islamic Art," "Masterpieces of the Louvre," and even a tour devoted to exploring the facts and fiction of *The Da Vinci Code,* the popular novel that draws its myriad themes and settings from the museum and its collection. Outside the gallery walls, more delights await; walking through the open-air Jardins des Tuileries provides a brief respite from the eventual "art fatigue" even the most diehard museum visitor cannot avoid! —SBR

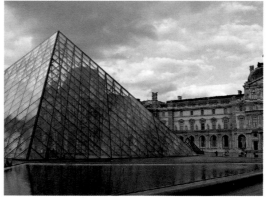

The I.M. Pei–designed glass Pyramid in front of the traditional Louvre Museum buildings.

Il Palio or Palio di Siena

HORSERACING, ITALIAN STYLE

Like many contemporary rituals, the Italian traditional horse race *Il Palio* is steeped in ancient rites, religious mysticism, and good old-fashioned pageantry. If you get a chance to witness this spectacle, be prepared to be swept up in the colorful display of a centuries-old tradition, dating back to medieval times.

Siena's Piazza Del Campo, the site of the Il Palio.

Held in the Tuscan city of Siena every year during the dog days of summer, the 17 *contrades* (or city wards) compete for 10 coveted racing spots; those riders not included in last year's race automatically get a spot with the rest left to compete in a lottery. The month-long festival includes spectacular parades filled with colorfully costumed musicians, soldiers, and flag bearers winding their way through the city filled with residents and tourists alike.

The culminating moment of *Il Palio,* the actual horse race, is quite brief: barely a minute and a half. Riding bareback, the riders push their horses three times around the narrow track. The event is dangerous for all involved; although a thick layer of dirt carpets the grounds of the Piazza de Campo and a row of mattresses cushions the tightest corners, many a rider, horse, and spectator have suffered injury, even death.

The winning horse and rider, awarded a hand-painted silk banner, or *palio,* are ushered into the main cathedral, surrounded by the deafening cheers of their supporters. If you find yourself sympathizing with your fellow *contradaioli* over the rivalries between the *contradas,* discussing the qualities of each horse and rider, and praying to the patron saint of your "adopted" *contrada,* chances are you have fallen under the intoxicating spell of Siena's *Il Palio!* —SBR

!

Massive Expanses of Fabric

THE CREATIONS OF CHRISTO AND JEANNE-CLAUDE

In the popular consciousness, Christo and Jeanne-Claude are oft associated with their wrappings, including the 2.4 kilometers of the Australian coast in Little Bay that were wrapped with synthetic fabric in 1969.

If there is one factor connecting much of their work, however, it is not the act of "wrapping," but rather the grandeur and vast mag nitude of these fabric, cloth, and textile displays.

Consider, for instance, the 11 islands in Biscayne Bay, Florida, which were completely surrounded with floating, pink polypropylene fabric. Or the 40 kilometer-long piece known as "Running Fence": an extension of nylon fab-

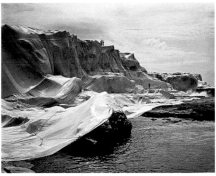

Christo and Jeanne-Claude. Wrapped Coast, One Million Square Feet. *Little Bay, Australia, 1968–69. Photo: Harry Shunk.* © *Christo 1969.*

ric that stretched across Northern California, rolling up and down hillsides until reaching the coast and extending into the ocean.

Christo and Jeanne-Claude. Running Fence. *Sonoma and Marin Counties, California, 1972–76. Photo: Jean-Claude.* © *Christo 1976.*

Christo and Jeanne-Claude finance every one of their works themselves, accepting no donations or sponsors.

While on display, these creations often incorporate the natural elements. As the California sunlight reflects off of "Running Fence" or the wind blows across the wrapped Australian coast, they become visibly manifested in ways previously unseen. Although the artists remove all physical traces of their work after its exhibition, witnesses have stated that the landscape undergoes a metaphysical change that remains imprinted on the terrain long after the artwork has been dismantled. —DJS

Museum Mixup

WHAT HAPPENS WHEN AUTHORITIES DECIDE WHAT ART IS

How would you feel if you sent a piece to a museum for display, and the curators decided that they wanted to show only the stand on which you sent your work? Unlikely, you say? Well, it actually happened to British sculptor David Hensel.

David was invited to submit a piece for inclusion in the Royal Academy's "Summer Exhibition." He submitted a piece called *One Day Closer to Paradise*, which is essentially a macabre-looking head with a huge smile. It was delivered to the Academy along with a plinth (or stand) for display.

To the artist's surprise, the museum decided that the plinth itself was what they were going to exhibit—not the actual sculpture. So, the curators put the sculpture in storage and the stand on display.

The whole situation raises questions about the nature of art and those who critique it. Who decides what art is? In this case, says David Hensel, "It became art because it was chosen by eminent artists."[13]

Luckily, David was able to see the humor in the situation and, after its run at the museum, he actually auctioned off the plinth. —GRG

One Day Closer to Paradise. *Photo courtesy of David Hensel (http://www.hensel.co.uk).*

Exercise 10

FISH IN BOWL WITH EILEEN SORG

Use a light, cool gray to outline the shape of the fishbowl and shade areas of the goldfish. Then add darker outlines to the bowl using a medium, warm gray. Bring in some light cerulean blue for the water. Next add blue-gray to the bottom of the bowl and along the surface of the water.

Lighten the outlines of the fish with an eraser; then fill them in with bright yellow. Apply dark pink over the gray areas on the fish.

Create the mouths with black. Then accent the fish with red and erase any remaining pencil lines.

Atmospheric Perspective

THE ILLUSION OF SPACE, PART 2

Have you ever wondered why a distant mountain appears blue when it's actually covered in green trees or brown dirt? Or why things seem to "fade" into the distance? Believe it or not, the atmosphere isn't completely translucent; air is full of particles such as dust and moisture that affect the way we see objects. The particles scatter short wavelengths of light (blue and violet), veiling objects in the distance with a cool, bluish hue. This optical effect, called "atmospheric" or "aerial perspective," also subdues shadows and highlights, reducing the contrast of distant objects and rendering them less distinct. A subtle overall lightening of distant objects also occurs. And, of course, the more distant the object, the more obscured it becomes to our eyes. Factors like fog, haze, and pollution exaggerate this effect.

To suggest distance in a drawing or painting, it's important to translate this form of perspective to your paper or canvas, particularly when working with landscapes. Render the most distant objects with low contrast, very little detail, and cool hues. For extra impact, contrast them with warmer, more saturated colors and sharp detail in the foreground. —ETG

In this landscape painting by Frank Serrano, the most obvious application of atmospheric perspective is in the cool hues of the mountains. But compare the dark, sharp shadows of the trees with those of the mountains, and note the warm, crisp orange flowers in the pasture foreground. Frank has successfully employed several aspects of this optical phenomenon.

Immanuel Kant (1724–1804)

IN A VERY SMALL NUTSHELL

"Beautiful art must look like nature, although we are conscious of it as art." —Kant (Critique of Judgment, 45)

German scholar Immanuel Kant (pronounced *KAHNT*, not *CAN'T*) was the first major philosopher who attempted to bridge the gap between Rationalism (the belief that reason alone is a reliable source of knowledge) and Empiricism (the idea that knowledge can only be attained through the senses). In his three famous *Critiques*, he attempted to prove that reason had to work together with the senses in order for truth to be obtained.

In the last of his three famous works, the *Critique of Judgment*, Kant focuses on "judgments of taste" and essentially sets the stage for all of modern aesthetics. The first part of the work is dedicated to analyzing judgments of the beautiful and sublime. Although the two words can be used almost synonymously today, they have very different meanings as rigid philosophical categories. An experience of beauty immediately induces feelings of lighthearted joy, while the sublime is mysterious and overwhelming. Each can provide pleasure in its own way.

Kant believes it takes the talent of genius to produce art that simultaneously pleases judgments of taste and satisfies the criteria of a particular art form. Art is only beautiful if it resembles nature, yet it must also reflect the imagination of the artist in a way that transcends conceptual understanding. —CKG

QUESTIONS TO PONDER

- *It what ways are reason and sensory perception both necessary in the appreciation of art?*
- *Can you think of a piece of art that is beautiful in a way you can't put into words?*

Romanticism

VISUAL POETRY

Breathtaking landscapes and gruesome human atrocities; Romanticism was a complex, emotional movement that prized the intuitive and poetic side of the individual life. As an oppositional reaction to the moral

WHEN & WHERE
c. 1790–1850
France, England, USA

authority and staunch rationalism of Neoclassicism, Romanticists embraced the expressive power of art and nature, the sublime. Both movements were incited by the Enlightenment, but had very different responses indeed.

Romanticist artists were inspired by the stories of the Middle Ages and Classical myth. Tales of bravery, love, freedom, and truth lit the way. The lure of exotic cultures was represented in richly painted Islamic scenes. The grandeur of dramatic, raw landscapes were painted to envelope the viewer in awe. They wanted to represent life and the soul as untethered by reason and science. Political issues like the fight for liberty and the tragic woes of the proletariat from the ravages of war were fodder for often monumentally sized paintings. From images of contorted corpses to beautiful trees at sunset, they covered it all!

Though styles and content varied among artists, they had a similar rebellion against the norm in the way they executed their work. The polished look of Neoclassical paintings was not for them. Romanticists breathed life into their brushes and let the paint itself be expressive. Strokes could be seen and edges were blurred.

Romanticism opened the door for the potential of art to be an individual's personal expression, representations of our inner selves and imaginations. —ARR

Selected artists: Eugène Delacroix, Caspar David Friedrich, Théodore Géricault, Francisco Goya, William Turner

Giotto di Bondone (1267–1337)

SETTING A PRECEDENT

Florentine painter, architect, and sculptor Giotto is best known for his masterful frescos that grace every wall in the Scrovegni Chapel in Padua, Italy. The murals, commissioned by 14th-century Italian nobleman Enrico degli Scrovegni to adorn the chapel adjacent to his family's palace, tell the Biblical stories of Joachim and Anna, the Virgin Mary, and the life and death of Christ. In addition to creating dramatic compositions and capturing emotional depth, Giotto was especially adept at depicting his subjects with a realism and precision unseen in the work of any other artist of the time. His technique departed from the conventional methods of the medieval tradition and marked a turning point in Western art.

Giotto's luminous frescos adorn the walls of the Scrovegni Chapel in Padua, Italy.

Much of Giotto's recorded biographical information comes from 16th-century art historian Giorgio Vasari in his seminal c. 1550 text, *Lives of the the Most Excellent Painters, Sculptors, and Architects*—although it should be noted that some of the facts contained therein are debatable. It is generally accepted, however, that Giotto trained with the famous artist Cimabue, whose aesthetic partially influenced that of his protégé. According to Vasari, Cimabue invited Giotto to apprentice in his workshop when, while out on a walk, he observed the boy drawing images on rocks of the sheep that he was charged with watching.

In time, Giotto became known for his superior frescos and received commissions from the papacy and a number of wealthy patrons; moreover, his skill and originality appealed to a number of subsequent artists, including the great Michelangelo, whose work reveals some of Giotto's influence. —RJR

Notable works: *Raising of Lazarus*, 1305; *The Lamentation*, 1306; *Madonna Ognissanti*, 1310.

FUN FACT

Seeing Giotto's magnificent art doesn't require a trip to Italy. Take a virtual tour of the Scrovegni Chapel at www.giottoagliscrovegni.it.

Self-Portrait

REMBRANDT VAN RIJN, 1660–1663

Rembrandt is unique among every Western painter in that he created dozens of self-portraits over the course of his career. The question of why he did this remains a topic of lively scholarly debate, but the abundance of self-portraits allows us to track the evolution of his style.

In his earlier portraits, Rembrandt is shown dressed up in 16th-century fashion—berets, gold chains, and all—looking poised and polished. But as he aged and his style evolved, his looser and more direct painting style (as evi-

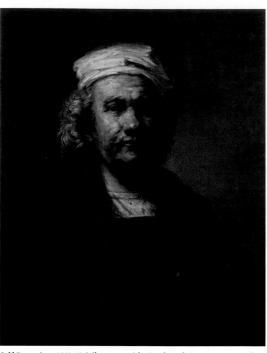

Self-Portrait, c.1660-63 (oil on canvas) by Rembrandt Harmensz. van Rijn. Movement: Dutch Golden Age.

denced in the portrait at right) contributed to a falling out with his patrons. This sense of rejection appears to come through in this painting, which is frank, candid, and oozing with self-scrutiny. —DDG

The National Gallery

LONDON, ENGLAND

Centrally located in London's Trafalgar Square, the National Gallery is a must-see for anyone interested in exploring one of the world's preeminent collections of Western European painting. Founded in 1824 by the House of Commons, the 38 pictures that formed the heart of the collection cost a little more than $80,000. Originally displayed in the house of banker John Angerstein (whose works accounted for the origins of

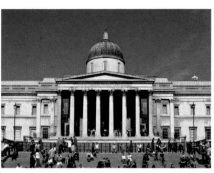

Designed in the Greek Revival style, the façade of London's National Gallery remains essentially unchanged since its construction in 1832.

the collection), the museum's rapidly expanding collection forced a move to its current location in 1831, making it equally accessible to all classes of people. From its beginning, art students have been welcomed to the museum, to study and sketch the paintings and sculptures on display. Even today you may find students, young and old, with sketchpads, pencils, and pastels, ensconced in front of Vincent van Gogh's *Sunflowers* (page 22) or Leonardo da Vinci's *Madonna of the Rocks,* attempting to replicate the old masters' styles and techniques. Wandering through the vast galleries, you can expect to see other famous works by legendary artists JMW Turner, Raphael, Titian, Peter Paul Rubens, and Hans Holbein.

During World War II, the collection of the National Gallery went literally underground. The British government, anticipating attacks on several key buildings in London, including the National Gallery, evacuated the collection to various secure locations including a Welsh slate mine where 200 feet of solid rock protected these valuable works for future generations to enjoy. —SBR

Presepe
NATIVITY SCENES FROM ITALY

These days Christmas decorations seem to go up as early as Halloween, but in Italy, the season does not officially begin until December 8th with the Feast of the Immaculate Conception, a day honoring the Virgin Mary, when the intricately carved and painted nativity crèches, or *presepe,* are revealed. Plainly visible in churches, storefronts, public squares, and private homes, these nativity scenes are the heart of the holiday tradition in this predominantly Roman Catholic country. Each crèche contains figurines of the Holy Family, but can also include hundreds of other figurines, religious and secular.

Hand-crafted nativity crèches are an integral part of the Italian Christmas season.

Italy is the alleged birthplace of the *presepe;* its roots trace back to the 13th century and the small town of Greccio, outside Rome, where St. Francis of Assisi celebrated Mass near a hay-filled, torchlit manger, echoing the scene from Christ's birth in Bethlehem two centuries before. —SBR

WHERE IN THE WORLD?

Where are the best places to see presepe? *Naples is known for some of the most intricate and well-made nativity scenes; Il Museo Nazionale di San Martino in Naples has a crèche collection dating from the 18th century. Vatican City erects a huge presepe in St. Peter's Square for Christmas. Also in Rome some of the biggest, most elaborate presepi are found in Piazza del Popolo, Piazza Euclide, Santa Maria in Trastevere, and Santa Maria d'Aracoeli. In addition to the Christmas marketplace, a life-size crèche is set up in the popular square, Piazza Navona.*

Date Palms and Pine Needles

MODERN INTERPRETATIONS, ANCIENT MATERIAL

Given that the native peoples of California have been weaving the natural fibers that grow there for countless millennia, this is hardly an "unexpected" art form in and of itself. Modern San Diego artists, however, have taken these ancient materials in new directions, exploring societal and introspective themes.

Transitions by Peggy Wiedemann. Photo courtesy of Peggy Wiedemann.

Polly Jacobs Giacchina constantly searches for untried configurations to incorporate into her woven creations. She sometimes interlaces the natural fibers, such as the date palm seed frond, with painted strips of canvas, blending and contrasting natural, earthy hues with artificial tones.

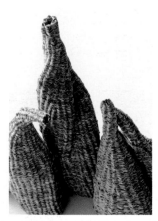

Where Are We by Polly Jacob Giacchina. Five units woven separately, attached together, and hung approximately 6 feet up on the wall, looking down on viewer. Twined date palm seed frond. Photo credit: Rodney Nakamoto.

While her technique is always evolving, her inspiration continues to draw from forms that occur in nature. Works such as "Where We Are" present very fluid, organic contours, even as the conical structures protruding from the wall appear almost otherworldly.

Peggy Wiedemann often gathers her own materials from the wild, selecting fibers for their particular texture and pliability. Her imaginative designs are deeply philosophical. *Transitions* resembles a common, utilitarian, woven basket that has unraveled and developed a mind of its own. The rolling loops seem to contemplate all that is transient and unpredictable. —DJS

Mechanical Mirrors

MIRROR MIRROR, ON THE WALL...

Mechanical mirrors? Yes, that's right—mirrors that aren't your average looking-glass but that reflect, in a manner of speaking, what is in front of them. One is made of wood, one is made of trash, one is made of 600 wooden dowels, and one is made of 768 small mirrors. Whatever the material, all these mirrors share a similar design. They are computer controlled and mechanical, and when you stand in front of them, you can see a reflection of yourself.

Wait, did I just say that you can see a reflection of yourself while looking at a bunch of wood? Or some trash? Yes, that's exactly right. Each of these mirrors has a hidden video camera attached, and when you stand in front of it, the computer (also hidden) figures out how to create your image, using whatever material the mirror is made of. Before your very eyes, accompanied by a pleasant whirring noise as the motors rotate the individual pieces, you find yourself reflected in a new and interesting way.

One of the mirrors, *Mirror Mirror,* is unique in that only the person looking at the mirror can see the image that is reflected back.

These mechanical mirrors are the work of Daniel Rozin, an "artist, educator, and developer" who teaches at New York University's Tisch School of the Arts. —GRG

Wooden mirror at work. Photo courtesy of Daniel Rozin (www.smoothware.com/ danny).

Exercise 11

PANDA WITH ED TADEM

Start by drawing the rough shapes of the panda, emphasizing the rounded belly.

Construct the features, adding the ears, nose, muzzle, and leg. Suggest a few blades of grass.

Continue refining the features, adding the eyes, mouth, and paw. Then create more fur and grass and add a bamboo stick in his mouth.

Tighten up your lines and erase those you no longer need. Add leaves to the bamboo and details to the panda's face. Begin filling in his dark markings with hatching.

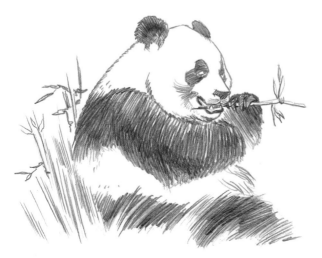

To finish, darken all the shading and add bamboo leaves behind the panda. Fill in the black claws and pupil, leaving a highlight in the eye.

Contrast

VISUAL JUXTAPOSITION

Contrast in art is easy to spot but challenging to define. Essentially, contrast in a work of art is a dynamic of dissimilarity within elements. It is a tool of many tricks; it can add depth, increase drama, emphasize, and clarify. Whether it's rooted in a difference in value, color, shape, line, or texture, an area of high contrast stands apart visually and attracts the eye. Below we'll touch on a few ways contrast can occur. Keep these examples in mind as you plan a work of art; consider using contrast within your work's area of focus.

Take a look at the three images below. Which one stands out more than the others? Chances are that you've zeroed in on the black-and-white pattern, which displays greater contrast in value.

The set of images below features circles, squares, and triangles. The one at far right, which includes all shapes, should draw your eye more than the others. The juxtaposition of the smooth curves and angles creates an exciting contrast of shape.

As you know by now, complementary colors placed side by side produce a great amount of contrast. Compare the three examples below, and you'll find your eyes gravitating toward the image of blue and orange. —ETG

Georg Wilhelm Friedrich Hegel (1770–1831)

THE END OF ART?

"Art is and remains for us, on the side of its highest possibilities, a thing of the past." —Hegel, Philosophy of Fine Art

The German philosopher Hegel is very concerned with the purely spiritual nature of consciousness, reality, and truth, which, for our purposes, he collectively calls the Idea. The Idea can be expressed and received through the senses (with varying degrees of success). Beauty is the external appearance of the Idea, and art is beautiful insofar as it accurately reflects the artist's understanding of the Idea.

Art is categorized by Hegel as Symbolic, Classic, or Romantic. Symbolic art, best exemplified by architecture, is never completely successful because it attempts to represent extremely abstract ideas through concrete external forms. Classic art refers specifically to Greek sculpture, which Hegel sees as the ideal art form, capable of expressing the Idea fairly well through the immediacy of the human form. Romantic art usually refers to an attempt to reflect the perfection of the Christian God through painting, music, or poetry. Since a finite human mind can never adequately fathom or characterize the infinite nature of God, this kind of art is also doomed to fall short of its goal.

Hegel notices that art continually fails to reveal purely spiritual qualities. He believes that as people become more spiritually aware, they won't need physical forms anymore to help them understand the Idea. Once Spirit achieves its goal of self-realization, art will be rendered unnecessary. —CKG

QUESTIONS TO PONDER

- *Can art ever perfectly reflect what is in the mind of the artist?*
- *Could art ever be "dead" if it no longer served a meaningful purpose in society?*

Realism

BRUTALLY HONEST

WHEN & WHERE

c. 1840s–1890s

France, England, USA

What does an image of a child toiling in the fields evoke? Pathos? Anger? A desire for change? In France, Realist artists created work in the wake of the French Revolution of 1848 and the new socialist philosophies championed by Karl Marx. Under the rule of extravagant monarchs, food was scarce and the divide between the haves and have-nots grew. Through their art, the Realists sent a clear social and moral message by glorifying the proletariat.

The Realists distinguished themselves from Neoclassicism and Romanticism by rejecting traditional and exotic themes in favor of socially conscious and gritty images. They subverted class hierarchies by elevating the common laborer to a heroic status through honest, yet beautifully painted, portrayals. The directness of their aesthetic was in part influenced by the advent of photography and its ability to reflect unembellished reality.

Realism was born in France, but quickly spread to England and the United States. Often shunned by the Salons, the movement was seen as crude and vulgar by some critics of the day. However, the Realist dedication to depicting nature and contemporary society, ugliness and all, became an important inspiration for the Impressionists, The Ash Can School, and American Scene Painting to strive for beauty and timelessness in the commonplace. —ARR

Selected artists: Rosa Bonheur, Ford Madox Brown, Gustave Courbet, Honoré Daumier, Thomas Eakins, Winslow Homer, Jean-François Millet, Henry O. Tanner

FUN FACT

Courbet and Daumier spent a small amount of time in a French prison for their radical, anti-establishment views and art.

Jackson Pollock (1912–1956)

LEAVING ART TO CHANCE

"On the floor I am more at ease, I feel nearer, more a part of the painting, since this way I can walk around in it, work from the four sides and be literally 'in' the painting." —Jackson Pollock, 1947.

As unpredictable as the ocean's waves, the art of Jackson Pollock ebbs and flows to the rhythm of its own creation. Although the American-born artist found inspiration in Surrealism, Mexican muralist painters, and Native American art, among other things, his distinctly progressive philosophies challenged the 20th-century American art establishment.

While Pollock experimented with various techniques, he is best known for his revolutionary "drip" paintings. Instead of using brushes to apply paint to a canvas mounted on an easel, Pollock used the force of his body to drip, fling, splatter, and pour paint onto a large canvas affixed to either the floor or a wall—a process later called Action Painting. Pollock also used a number of implements, including sticks, palette knives, rags, and his hands, to further cultivate his art. And sometimes he would alter the paint's texture by adding sand, glass, or anything else that he felt suited his purpose.

In these works, Pollock was less concerned with the aesthetics of a finished painting than he was with the process of creation. Yet inasmuch as Pollock might have left the final outcome to chance, he was not inattentive to his methods. Rather, he let his intuition guide him. Thus, each piece reflects a cathartic emotional energy that wholly distinguishes his art from that of his contemporaries.

In 1945, Pollock married fellow artist Lee Krasner. Shortly thereafter, they purchased a farmhouse on Long Island where they lived and painted. Sadly, Pollock died in a car accident at the age of 44; however, his art remains firmly fixed in the minds of today's emerging and established artists. —RJR

Notable works: *The Key,* 1946; *Number One,* 1950; *Greyed Rainbow,* 1953.

Mont Sainte-Victoire

PAUL CÉZANNE, 1900

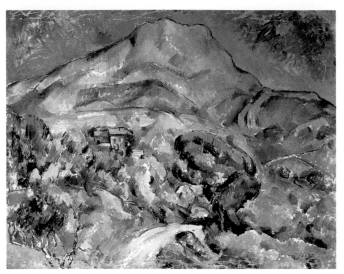

Mont Sainte-Victoire, *1900 (oil on canvas) by Paul Cézanne.*

Most artists delight in change and variety, but many great painters have also returned to the same scene or subject time and again. Such was the case with Post-Impressionist painter Paul Cézanne. However, instead of coming back to themes such as sunflowers, ballerinas, or self-portraits, he repeatedly painted a rugged mountain named Mont Sainte-Victoire located near his home in Aix-en-Provence, France.

Cézanne's intentions for his mountain series were similar to those of Claude Monet and his paintings of London's Parliament. Similarly, Cézanne wanted to depict the characteristics of his neighboring mountain in variations of light and shadow, sun and storm. But he also wanted to portray it from different angles.

Cézanne was using his familiar subject to experiment with new ideas and painting techniques. By the time he had begun his paintings of Sainte-Victoire, he was well into his forties and was tiring of Impressionism. He was captivated by his revolutionary developments that would later influence future masters such as Pablo Picasso. Notice the pronounced geometric shapes and the limited color palette that distinguish Cézanne's Sainte-Victoire. It's not difficult to see how his emerging style influenced Picasso and Georges Braque in their development of Cubism less than a decade later.　—DDG

Vatican Museums

VATICAN CITY, ROME, ITALY

If the word "Vatican" only con-jures up images of the Pope, you will be pleasantly surprised to learn that it also houses an enormous museum complex, filled with art and objects from the past 2,000 years. Originally the Vatican museums were used by Pope Julius II in the early 16th century as a depository for his personal collection of sculptures. By the 18th century, Popes Clement XIV and Pius VI opened up their papal collections to the public, which now attract up to 4 million visitors a year. From classic Greco-Roman sculptures to Hebrew lapidary and Etruscan funerary objects, the 54 galleries, or *salas,* exhibit hundreds of thousands of objects gathered over a 500-year period of church-sponsored explorations and excavations throughout the world. On any given day, you can see a painting by High Renaissance master Caravaggio, an Egyptian sarcophagus, or a 15th-century map of the New World. You can also strain your neck marveling at the Sistine Chapel's ceiling vividly painted by Michelangelo or wonder at the woven intricacies of a medieval tapestry. Or you can save these treasures for another day as you relax with an espresso and biscotti, taking in the sights at any one of Rome's outdoor cafés! —SBR

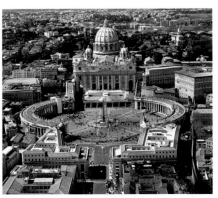

Vatican City is home to a vast complex of museums and private galleries filled with art.

The Bone Church of Sedlec

HUMAN BY DESIGN

If you are looking for the ultimate in recycled construction design, you may have to leave IKEA® behind and travel to the Sedlec Ossuary in the former Czech Republic. Located beneath the small Roman Catholic All Saints Church in Sedlac near Prague, the ossuary dates back to the 13th century and is decorated inside and out with the remains of over 40,000 people. Every bone in the human body—from femur to fibula—decorates the architecture and furnishings of the chapel.

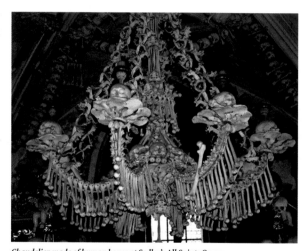

Chandelier made of human bones at Sedlec's All Saints Ossuary.

The large number of bones is a result of a resourceful monk and a handful of dirt from Jerusalem. Sent on a diplomatic mission to the Holy Land in 1278, the Abbot of Sedlec brought back earth from Golgotha (the supposed site of the Crucifixion) and sprinkled it over the cemetery of the monastery. Consequently, the place became a popular burial spot for rich and poor alike throughout Central Europe. The plague that swept through the region in the 14th century only contributed to the necropolis' burgeoning population by 30,000.

The current design of the Bone Church dates from 1870 when František Rint, a Czech wood carver, was commissioned to compile all the bones and use them in an artistically pleasing way; he even signed his name, in bones, over the last bench in the chapel. The standout structure is, if not most macabre, the massive chandelier hanging in the center of the chapel, surrounded by garlands of skulls draping the vaulted ceilings. Death truly becomes this place of final repose. —SBR

The Art of Adaptation

DON BANIA, JR.

Although Don Bania has been drawing since early childhood, his style has drastically changed since 1970—he no longer uses his hands.

Chat Line *by and courtesy of Don Bania.*

Shortly after graduating from high school, a devastating motorcycle crash left Don paralyzed from the shoulders down. After a dark period of drug and alcohol abuse, Don experienced a spiritual transformation at the age of 26 that awakened his zeal for life—and for drawing. He notes, "My brokenness made me aware of my desperate need for God."

Light of the World *by and courtesy of Don Bania.*

An easel was constructed to fit Don's wheelchair, and he spent countless hours teaching himself to draw using only his mouth, re-learning the skills that had lain dormant for seven years since the accident. Over the course of more than a year, the artist progressed from simple shapes and letters to complex designs.

Early on in his artistic career, Don opted for drawing with pencils and colored pastels, a method that allows him to mix his own colors. The relative convenience of this medium notwithstanding, Don typically invests upwards of 100 hours of painstaking labor in one drawing.

The hope and perseverance conveyed in Don's drawings express the artist's hard-tested conviction that "life is a precious gift…within every tragedy lies an opportunity". —DJS

New York City Garbage

EVERYONE'S GARBAGE IS ONE MAN'S TREASURE

What's New York City to do with all its trash? Recycle it? Send it to landfill? Maybe give it to artists, who can then sell it to those of us not cool enough to have a piece of NYC garbage?

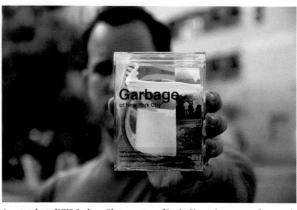

A custom box of NYC Garbage. Photo courtesy of Justin Gignac (www.nycgarbage.com).

Don't laugh—New York artist Justin Gignac has been doing just that for several years. He collects trash from the streets of NYC, packages it in cute little plastic cubes (yes they are sealed, and no they don't stink), signs and numbers each one, and then sells them.

And what's the going rate for a piece of New York? When he first started, he would sell the cubes for $10 each. Due to their incredible success and the demand for NYC's trash, prices are now up to $50 for regular garbage and $100 for limited editions.

Fifty dollars isn't really so much for a piece of the city, though. Especially if you consider that, had you bought some when it first came out, your investment would have easily paid for itself. In fact, forget stocks—I'm thinking the next bubble will be in the garbage market.

The only problem is finding someone creative enough to make it work. Luckily for Justin, he seems to have that issue neatly squared away:

One-of-a-kind, cute boxes. Of garbage. —GRG

Exercise 12

RECORD PLAYER WITH ED TADEM

Start by sketching an open box
for this portable record player.

Divide the inside of the lid with guidelines.
Drawing an "X" helps find the midpoint.
Use these lines to place the inside label,
handle, and latch. I also draw an oval for
the record.

Add the top latch, a
speaker, the corner
bumpers, and the needle
and knobs. Then erase
guildelines, round off
the box, and detail the
corner bumpers.

Shade the bumpers black and crosshatch the
speaker for texture. Use parallel hatching
over the box, keeping the lines somewhat
irregular to suggest a worn, antique
texture.

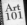
Principles of Composition
THE BASICS OF DESIGN

Although the term "composition" can mean a number of things, let's discuss it as it refers to the arrangement of elements within a work of art. Whether you like a composition is largely intuitive; although there is a bit of subjectivity involved, good composition generally appeals to our most basic senses of balance and harmony. But even knowing this, you may find it difficult to put into words why you like a particular arrangement. The principles of composition below will help you organize your thoughts. Knowing these principles is important for both appreciating the work of others and learning how to create your own engaging artwork (page 128). Below you'll also find questions to guide you through the composition of any piece of art. Always think about how your answers might relate to the artist's intended mood or message.

- *Balance:* Does the piece feel heavier on one side than the other? Is it top-heavy or bottom-heavy? Is there too much or too little of a particular color or texture?

- *Focus:* What is the area of emphasis in the piece, and how does the artist bring attention to it?

- *Movement:* Does the general flow of lines within the piece encourage your eye to move around?

- *Contrast:* Is there dramatic or subtle interplay of visual dissimilarities within the piece?

- *Pattern:* Is there repetition of shape or texture throughout the piece, giving it a visual rhythm?

- *Proportion:* Do the sizes of the objects comfortably and realistically relate to one another?

- *Unity:* Do all of these principles work together to create a harmonious feel? —ETG

SIDE NOTE

As we learn about "rules" of art, keep in mind that it's not always best to slavishly follow each one. Sometimes the key to creating successful art is knowing how to bend a rule or two in favor of strengthening your message.

Arthur Schopenhauer (1788–1860)

A SHORTCUT TO REALITY

"Music is as direct an objectification and copy of the whole will as the world itself, nay, even as the Ideas, whose multiplied manifestation constitutes the world of individual things."

—*Schopenhauer,* The World as Will and Idea

Okay, so it's not the most inviting quote in the world. But it does sum up Schopenhauer's philosophy of art fairly well, so let's take a minute to dissect it. First off, what does he mean by the will? You can think of the will, as Schopenhauer understands it, as the source of all reality, of all truth, action, and being. It is the inner nature of everything we perceive in the world. The perceptions themselves are one way the will is manifested to us.

Schopenhauer adopts a significant portion of Plato's belief that the things we see around us are but blurred reflections of an ultimate reality that our senses cannot access. However, unlike Plato, Schopenhauer doesn't even think that the light of reason (the Ideas) can immediately reveal to us the innermost nature of the will. All our concepts and sensations are representations of the will, but only in art do we experience it directly.

Notice the focus on music in the quote. Schopenhauer believes that all art is extraordinary in its ability to bridge our minds with the will, but he especially admires music for its independence from objects and concepts. Somehow, music reveals to us the true nature of ultimate reality in a way that is universal and transcends description. As a philosophical pessimist, Schopenhauer doesn't believe our needs or desires will ever be satisfied, but he finds consolation in the beauty of art. —CKG

QUESTIONS TO PONDER

• *Do you agree that art can capture and communicate reality in ways that thoughts and sensations cannot?*

• *What sets music apart from other art forms?*

The Pre-Raphaelite Brotherhood

REVIVING THE PURITY OF THE PAST

In an effort to renew the purity and drama of painting before the time of Raphael, a group calling themselves the Pre-Raphaelite Brotherhood formed in mid-19th-century England with an eye for romance, beauty,

> **WHEN & WHERE**
> *c. 1848–1854*
> *England*

and detail. Two of the young founding members were colleagues at the Royal Academy in London. They despised the strict conventions enforced by the Academy and reacted to what they saw as the downfall of art from the time of Mannerism on.

Pre-Raphaelites depicted heroic tales from the Bible, ancient mythology, fairytales, and Shakespearian stories. Their repertoire also included images of family life and contemporary social issues. During a time of cultural upheaval in industrial Victorian England, their decorative and poetic images can be seen as escapist. Their aim, however, was to create work with a moral message. Believing in justice, piety, and nature, they relished medieval themes and many an innocent yet sultry damsel graced their canvases.

Finding truth in observing and painstakingly rendering nature was central to the Pre-Raphaelite aesthetic. Their work was highly influential on the Arts and Crafts movement, Symbolism, Surrealism, and the Classicists. It remains a popular movement that engages the imagination to this day; apparently dreamy-eyed beauties don't go out of style. —ARR

Selected artists: Ford Madox Brown, Edward Burne-Jones, William Holman Hunt, John Everett Millais, Dante Gabriel Rossetti

> **FUN FACT**
> *Despite the morality they championed in their art, the Pre-Raphaelites*
> *were enchanted with beautiful women and had many tumultuous affairs*
> *with each other's wives and models.*

Raphael (1483-1520)

ARTISTIC TRANSCENDENCE

"While we may term other works paintings, those of Raphael are living things…" —*Giorgio Vasari in* Lives of the Most Excellent Painters, Sculptors, and Architects, *c. 1550.*

Although the Italian Renaissance saw no shortage of magnificent art, one cannot fully appreciate the period without reflecting on the impeccable work of Raphael. Raffaello Santi was born in Urbino, Italy, on Good Friday. His father, an artist of average talent, taught his son the rudiments of art. Later Raphael apprenticed with Pietro Perugino, under whose guidance his talent flourished.

In 1504, Raphael moved to Florence to study the masters. Although it has been well documented that da Vinci and Michelangelo greatly influenced his art, Raphael's consummately classical approach—reflected in his celebrated Madonna paintings, in particular—embodies an emotional depth, transcendent beauty, and soupçon of ambiguity that markedly distinguishes his work from that of his predecessors and peers. But if it's true that imitation is the sincerest form of flattery, Michelangelo, unfortunately, was not moved by Raphael's admiration. Instead the elder artist was bitterly jealous of Raphael's success and made no attempt to mask his condescension.

In 1508, Pope Julius II invited Raphael to Rome to paint frescos on the walls of his papal suites in the Vatican. The most famous of these, *The School of Athens,* depicts Plato and Aristotle surrounded by a large group of Greek philosophers. The scene also includes Michelangelo—allegedly portrayed as the cynical philosopher Heraclitus, which perhaps references the artist's gloomy temperament.

Raphael also incorporated himself into the composition. Gazing out at the viewer from the far-right edge of the canvas, his expression is both discerning and mischievous, reinforcing the vague, mystical tenor behind much of his art.
—RJR

Notable works: *The School of Athens,* 1511; *Triumph of Galatea,* 1512; *Sistine Madonna,* 1514.

The Starry Night

VINCENT VAN GOGH, 1889

The great emotional and spiritual sensitivity that emanate from Vincent van Gogh's paintings caused serious disruptions in his personal life. For example, after losing the friendship of fellow painter Paul Gauguin, van Gogh's mental health declined so dramatically that he committed himself to a mental health asylum in the town of Saint-Remy.

During his time there, he painted *The Starry Night,* which was the scene from his window. Without artificial light, van Gogh had to paint the scene from memory. But what a scene he remembered! It is hardly the way the landscape would have looked from his lonely room. Some even speculate that medication, syphilis, or absinthe influenced his perception of this scene.

To create his stunning composition he added a cypress tree, mountains on the horizon, and a church. But why? Many have speculated about the painting's possible symbolism. The tree in the foreground towers over a similarly shaped steeple on a distant church—a church from which no light is shining. Did this reflect van Gogh's belief that the God is more present in nature than in the church? And beyond their evocative beauty, the painting's eleven swirling stars may also hold a meaning of their own. They are curiously reminiscent of an image from the Bible in which the beleaguered Patriarch Joseph saw eleven stars, representing his cruel brothers, bowing before him. —DDG

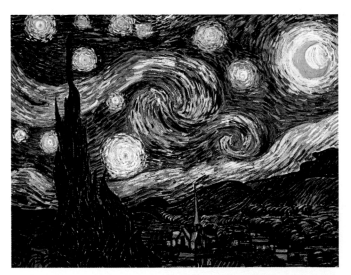

The Starry Night, *June 1889 (oil on canvas) by Vincent van Gogh. Movement: Post-Impressionism.*

Acropolis Museum

ATHENS, GREECE

The city of Athens is home to not one but two Acropolis museums, both in the process of transition. The "old" museum, located east of the Parthenon, was founded in the late 1800s but is now closed and slated to be remade into a café and refurbished gallery space. While temporary exhibitions have opened to the public, the "new" Acropolis Museum's grand opening ceremony has been postponed. Why? Though the Acropolis Museum's collection includes many important ancient and sacred Greek art forms, the most controversial Elgin marbles have yet to be returned from their current home in London's British Museum. Named after the 7th Earl of Elgin, the 19th-century British ambassador who either liberated or stole them from the Greeks (depending on your point of view), the 5th-century marbles represent more than half of the surviving sculpture from the Parthenon. The legitimate ownership of these priceless artifacts has been in doubt for nearly 200 years.

Designed by Swiss-French architect Bernard Tschumi and located at the foot of the "old" Acropolis, the new museum will have room to display the 4,000 objects and artifacts gathered from the Acropolis, including a large gallery devoted to displaying the reunited Parthe-

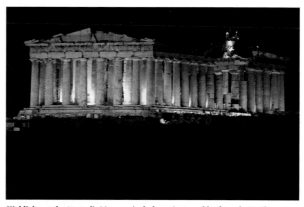

Highlights at the Acropolis Museum include ancient marbles from the Parthenon (pictured above).

non sculptures in a way reminiscent of ancient Greek times. Transferring the objects to the new building was not an easy task; three construction cranes hauled more than 300 ancient sculptures and architectural elements from the Parthenon, some weighing more than two tons. —SBR

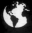

Pysanky
THE ART OF UKRAINIAN EASTER EGG PAINTING

Hand-painted Ukrainian pysanky are symbols of fertility and friendship.

If you visited the Ukraine around Easter and someone gave you a pysanka, or painted Easter egg, you would be receiving not only a unique work of art but a token of friendship, an ancient protective talisman, and a symbol of rebirth and creation. That's pretty heavy stuff for one small, painted egg! How did the egg became an important element in pagan and Christian belief systems? The traditions of creating pysansky with beeswax and homemade dyes date back to 1,300 BCE and possibly to the Trypilljan culture in Ukraine from 3,000 BCE. In Ukrainian folklore, pysanky placed in the home brought good fortune and health, along with protection from natural catastrophes. Although many of the ancient designs have blended with Christian symbology, the most popular Easter egg designs remain geometric abstractions of circles, crosses, stars, dots, wheat, fir trees, horses, deer, bears, and other animals. If the design is relatively simple, the process of applying the design using a wax stylus and dipping the egg in a variety of dyes may take only two to three hours.

In pagan rituals, the egg represented the rebirth of nature after winter (spring) and the promise of a fruitful harvest. With the acceptance of Christianity in 988 CE, the pysanka has been part of the Christian Easter traditions in Ukraine by symbolizing the Resurrection (or rebirth) of Jesus Christ, and continues to be a popular gift at Easter. —SBR

WHERE IN THE WORLD?

Vegreville, a small farming community in Canada, holds the title of largest Canadian Ukrainian settlement and World's Largest Pysanky. Created in 1976, the polychromed metal egg turns in the wind much like a weathervane. It would take 10 adults holding hands to circle once around the egg!

Dust in the Windshield

SCOTT WADE AND THE ART OF DIRTY CARS

If television commercials are to be trusted on existential matters, the type of vehicle one drives expresses the innermost essence of one's personality.

Einstein. *Dirty Car Art by Scott Wade.*

Scott Wade turned this axiom on its head years ago. Rather than purchasing a car as a means of self-expression, he chose to treat the accumulated dust on his vehicle as an ever-renewable canvas for soulful creativity.

Fate situated Wade's childhood home at the end of a long dirt road in central Texas, where the budding artist began doodling on the windows of the family car. By the turn of the 21st century, Wade's finger sketches had given way to sophisticated replications of classical artistic masterpieces and complex original works.

The lifespan of Wade's work is extremely limited. Almost immediately following its inception, a drawing suffers the effects of wind, morning dew, light rain, and the foot traffic of the artist's pet cats. He describes this temporary nature as integral to his work: "It reminds me that we won't be here all that long, and to really enjoy wonder and beauty while we're here."

Since 2003, Wade has drawn commercially, creating filthy artistic treasures for advertising campaigns and wedding receptions alike.

All makes and models accepted. —DJS

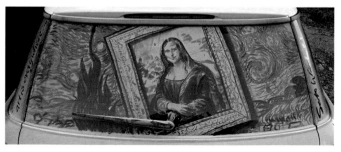

Mona Lisa/Starry Night. *Dirty Car Art by Scott Wade.*

Processing

THE COMPUTER PROGRAMMING LANGUAGE FOR ARTISTS

What do you get when you cross a computer programmer with an artist? A Computist? An Artogrammer? There may not be a term for it yet, but a medium suited for this person already exists.

Processing (at www.processing.org) is a programming language tailored to communities centered around electronic art and design. Created originally to be a digital sketchbook, Processing quickly morphed into a tool capable of producing professional-level output and has been used to create animations and visualizations for famous bands, scientific journals, professional design firms, and research institutions. There are even universities that teach the Processing language as part of their arts, mathematics, or science curricula.

Processing was originally created by Ben Fry and Casey Reas while students at the Massachusetts Institute of Technology (MIT).[14] The project was released under an Open Source License and now has a thriving community of contributors and content creators. The site features easy-to-follow, step-by-step tutorials and an exhibition gallery so digital artists can share their masterpieces. Processing is great for getting people interested in programming because they can get instant visual feedback from their programs—plus it is free to download and use.

Feel more comfortable with a keyboard and mouse than a paintbrush? Then Processing might be for you! —GRG

Exercise 13

GUMBALL MACHINE WITH EILEEN SORG

Fill in the gumballs using a variety of colored pencils, leaving a small highlight in most of the circles to show the reflective surface. Use lighter pressure where the gumballs are seen through the rounded corners of the glass. Add shadowed areas of the machine's base with reddish brown.

Create the lighter sides of the machine's base with red. Leave an area of white on the corner to suggest the shiny metal surface.

Using light and medium shades of cool gray, create the chrome on the machine, adding accents with touches of true blue. Leave some areas of the paper white to show the shiny surface. To finish, add black to several areas of the machine, including the top part of the glass.

Steps to Effective Composition

A CHECKLIST FOR DESIGN

Once you get to know the principles of composition, it's easy to sit back and critique the design work of others. But how about creating your own composition? Below you'll find important steps to creating a thoughtful and pleasing arrangement for yourself.

- Decide what you want to communicate. Know the goal you're setting out to accomplish regarding the subject and mood.

- Experiment with canvas or paper shapes. Instead of a horizontally oriented rectangle, try vertical formats, circles, panoramas, or even triptychs.

- Consider a dynamic viewpoint. Beginners are prone to recording scenes as they see them from eye level, but looking up or down on your subject can add drama and impact.

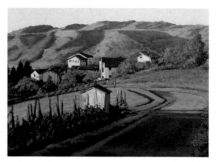

In this acrylic piece by artist Tom Swimm, a winding path leads the eye to the focal point: a cluster of red rooftops that vibrate against a soft landscape of muted colors. Note Tom's use of light and shadow to break up the picture plane.

- Establish your focus (or *focal point*). Avoid placing your focus in the center; instead, divide your canvas into thirds vertically and horizontally, and place your focal point on one of the four areas of intersection (called the "rule of thirds").

- Break up the monotony of the "picture plane" (the area within the borders of your work) by visually dividing it into sections that vary in value and hue.

- Lead the eye into and around the work with curves and diagonals that extend beyond the edges of the paper or canvas.

- Create a sense of depth by including overlapping objects and employing linear and atmospheric perspective.

- Emphasize the focal point using devices such as line, color, and contrast.

- Avoid symmetry (which creates a static composition) and visual clutter (which can overwhelm the eye).

- Finally, revisit page 128. Run through the list of composition principles as they might apply to your piece. —ETG

Leo Tolstoy (1828–1910)

GETTING ART'S PRIORITIES STRAIGHT

"Art…is a means of union among men, joining them together in the same feelings, and indispensable for the life and progress toward well-being of individuals and of humanity."

—*Leo Tolstoy,* What is Art? *Chapter V*

When the famous Russian writer and philosopher Leo Tolstoy was given the opportunity to visit an opera rehearsal, he was repulsed by what he witnessed. An excess of time, effort, and money was being poured into what he considered to be a purely absurd, meaningless charade. To make matters worse, he saw performers suffering all kinds of verbal abuse from miserable directors. Worst of all though was the fact that the participants were neglecting the most important aspects of life in order to participate in the foolishness.

Tolstoy acknowledges that "art" is nearly impossible to precisely define. However, in light of how many people devote their lives to art's creation, he insists that it should be virtuous in nature, possessing the power to "infect" others with feelings of brotherly love, and important enough to justify any sacrifices necessary for its creation. For Tolstoy, art can be something as simple as a warm greeting.

He asserts that people are usually too concerned with the pleasure art can give, while they should focus more on the purpose it can serve in people's lives. Furthermore, Tolstoy believes that an adherence to Christian beliefs provides the best guide for discerning what is good and bad in art. —CKG

QUESTIONS TO PONDER

• *Do you believe people sometimes spend too much time and energy focusing on art, to the neglect of more important matters?*

• *Is it enough to receive pleasure from art, or should it also foster a loving spirit?*

Symbolism

OPENING THE MIND'S EYE

Deliberately embracing ambiguity, the Symbolists rejected the reality of nature celebrated in the past movements of Impressionism and Realism. As the Industrial Age drastically changed the economic and cultural landscape of Europe, the Symbolists turned to fantasy and used dream logic to guide their art. Their dreamscape images were inspired by the darker sides of Romanticism and the Pre-Raphaelites. Severed heads, the femme fatal, spirits, and monsters were some of the subjects they used to convey a morbid fascination with the unknowable subconscious. They excavated classic mythology, the work of symbolist writers, and the Bible for content as well.

> **WHEN & WHERE**
> *c. 1850–1910*
> *Europe*

Transcendental, erotic, and macabre, Symbolism is a difficult movement to sum up in a neat historical package with a defined aesthetic. Symbolism was more of a general outlook on the arts. Symbolists prized the artist's personal, inner vision over the re-creation of reality, and evoking an emotion was the key to their approach. Their aesthetic ranged from mimetically rendered figurative paintings to highly abstracted fields of color.

Symbolism spread throughout Europe and its reach extended beyond the visual arts into theater, literature, and music.

Eventually, dethroned by Modernism and World War I, the Symbolist state of mind was relegated to history as an aberration. However, many of the great Modernist movements—from Expressionism to Surrealism—owe much of their inspiration, imagery, and style to Symbolism. —ARR

Selected artists: Aubrey Beardsley, Arnold Böcklin, James Ensor, Paul Gauguin, Gustav Klimt, Gustave Moreau, Edvard Munch, Pierre Puvis de Chavannes, Odilon Redon

Diego Velázquez (1599–1660)

TALENT FIT FOR A KING

Spanish artist Diego Velázquez was perhaps one of the most accomplished painters of his time. Although he painted landscapes, religious and myth-ological themes, and still lifes, he was best known for his masterful portraits rendered with near perfect skill. He was appointed as the official painter to King Philip IV and the Spanish court in Madrid while still in his early 20s.

Velázquez was born in Seville, Spain, to Juan Rodriguez de Silva and Jeronima Velázquez, whose family had minor aristocratic ties. He was the eldest of five brothers and one sister, though little is known about his siblings. Although he received a well-rounded education as a child, Velázquez was clearly destined for art. As a teenager, he studied with Francisco Pacheco, an artist of some note who painted mostly religious-themed works. When Velázquez was 19, he married Pacheco's daughter, Juana, with whom he had two daughters.

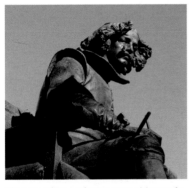

This statue of Diego Velázquez greets visitors at the Museo del Prado in Madrid, Spain.

As the painter to "his Majesty," Velázquez enjoyed a robust salary and many privi-leges. He held a number of positions, one of which included planning royal events. At the urging of his friend Peter Paul Rubens, Velázquez journeyed to Italy in 1629 to study the masters. He traveled to Italy only one other time 20 years later on business for the king, at which time he painted the awe-inspiring portrait of Pope Innocent X. Outside of those trips, Velázquez remained in Madrid in the king's service for the rest of his life.
—RJR

Notable works: *Los Borrachos,* 1629; *Pope Innocent X,* 1650 (page 232); *Las Meninas (The Maids of Honor),* 1656.

FUN FACT

Diego Velázquez's oeuvre has had a substantial influence on a number of artists through the ages, including Corot, Courbet, Manet, Dalí, and Picasso.

The Tempest

GIORGIONE, C. 1508

This oil painting is one of the few surviving works by an Italian Renaissance painter known as Giorgione (also known as Giorgio da Castelfranco). Most likely commissioned by a Venetian nobleman, the piece is considered by some to be one of the first landscape paintings in Western art. Also, it is often described as "poetic" and is widely praised for its success at evoking a mood— a novel achievement that influenced other Renaissance painters.

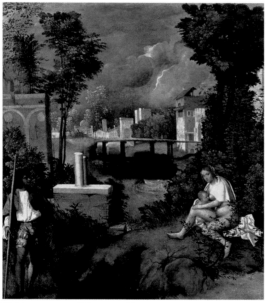

The Tempest, c. 1508 (oil on canvas) by Giorgione (Giorgio da Castelfranco). Movement: Italian Renaissance–Venetian School.

In general, Giorgione's work is shrouded in mystery, but this piece in particular is a prime example of how art historians can't always put together all pieces of the puzzle. A man stares in the vicinity of—but not directly at—a breastfeeding woman and her child. An ominous storm (or *tempest,* hence the title of the painting) looms overhead, creating a fantastic tension within an otherwise peaceful setting. The muted colors and the triangular, visually comfortable composition contribute to the feel of "the calm before the storm."

So what does all of this mean? Some have speculated on various symbols throughout the piece, and some have attempted to relate it to mythology or Bibical stories. But when all is said and done, art historians are still unsure of Giorgione's exact intentions with this painting. —DDG

The Hermitage

ST. PETERSBURG, RUSSIA

Though its name conjures up images of monks in seclusion, the State Hermitage Museum in the heart of St. Petersburg, Russia, provides sanctuary for those seeking rare art and artifacts from around the world. Contained within six massive buildings, including the former Winter Palace for Russian royalty, the museum began as a refuge for entertaining guests who came to view the private collection of Empress Catherine the Great in 1764; its original concept of a palace and art complex was modeled after the gardens and architecture of Versailles, France's official royal residence.

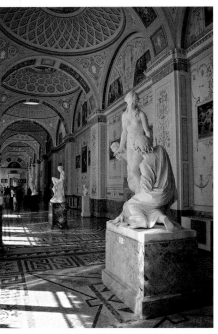

One of many art-filled grand hallways at the Hermitage.

Officially opened in 1852 and named a state museum in 1917, the Hermitage has grown to include more than 3 million artworks and artifacts. The collection represents cultures from Paleolithic to contemporary times, including the armory of Czar Nicholas I, Siberian art collected by Peter the Great, and more than 120 rooms devoted to displaying 1,000 years of Western European art. During World War II, museum caretakers closed the Hermitage, a prime target for Nazi air-raids, and evacuated the collection to the Ural Mountains. Even with the losses incurred during wartime, the Hermitage received gifts of artworks from artists, like French Fauvist painter and sculptor Henri Matisse (page 71), and contains one of the largest painting collections in the world. —SBR

Dalecarlian Horses

UNOFFICIAL SYMBOL OF SWEDEN

How did a painted wooden horse become one of the most recognizable and beloved symbols of Sweden? The earliest Dalecarlian wooden horse (or *Dalahäst* in Swedish) dates back to 1623 in the Swedish province of Dalarna. Traditionally, the Dalecarlian horse was a child's toy, whittled from scrap wood by firelight during long winter evenings. Left undecorated or painted in a single color (red, blue, or gray), they were often traded by peddlers, along with baskets, wooden casks, and other household utensils. Horse carving became a family affair; the skill was passed down to the next generation. In the late 1800s, one of the most famous Dale painters, Stikå Erik Hansson, introduced the *kurbits* (flowering vine) technique of painting with two colors on the same brush, still used today.

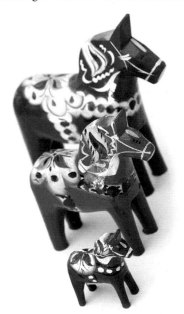

A trio of red Dale wooden horses.

The 1939 World's Fair in New York City brought the horses international attention (and manufacturing orders) when the Swedish exhibition designers placed a larger-than-life Dalecarlian horse at the entrance to their pavilion. The contemporary Dalecarlian horse remains a handcrafted article, made of pine and painted in the traditional brightly colored, floral style inspired by 19th-century furniture decoration. Today most Dalecarlian horses are made in Nusnäs, a little village located around Lake Siljan in central Sweden. For four generations, Grannas A. Olsson's Hemslöjd AB, a workshop founded in 1922 in Nusnäs, still produces hand-carved and hand-painted dala horses— so you can take a little piece of Sweden back home. —SBR

One Unbroken Line

THE ETCH A SKETCH® DRAWINGS OF GEORGE VLOSICH III

If you've ever attempted to draw a happy face on an Etch A Sketch only to have it come out square-shaped, you can appreciate the talent of George Vlosich.

Before investing countless hours in creating an image, Vlosich must test an Etch A Sketch for clarity of screen and consistency in the lines produced. He then sketches out an image on paper before undertaking the miraculous task of precisely reproducing it using only the horizontal and vertical knobs of the Etch A Sketch board. Meticulous patience is required, as one inerasable slip of the hand will ruin an entire piece.

An avid sports fan, Vlosich's drawings have afforded him the opportunity to meet many of the professional athletes depicted therein. His work has been featured in several art shows; most recently, Vlosich created an image of President Barack Obama, which was displayed in a Washington, D.C. gallery prior to Obama's inauguration.

As *maître suprême* of the medium, Vlosich has even developed a technique for safeguarding a completed drawing: the aluminum powder and the stylus that apply it are both carefully removed from the board, leaving the image perfectly preserved. —DJS

Andy Griffith Etch A Sketch *by George Vlosich. Photo courtesy of George Vlosich.*

You've Been Dumped
ART FROM INFORMATION

If you were a teenager in 2005 and posted online about your breakup, then there's a small chance you made it into *The Dumpster*.

The Dumpster is an artistic glimpse at a cross section of teen culture. It is a website that offers an interactive experience, allowing you to browse through 20,000 collected posts related to breaking up. *He broke up with me, I broke up with him, I was cheating, he didn't think the right bands were cool...* the gamut of teen angst has been captured in an incredibly easy-to-use piece of visual art.

Created by Golan Levin, Kamal Nigam, and Jonathan Feinberg, and using the artistic programming language Processing (page 136), the site succeeds in creating odd-but-engaging art from information.

Quivering, migrating dots cluster on the screen; simply roll over them with your mouse, click on one, and enjoy the break-up blurb that follows. Not only is the application visually appealing, it is addicting as it lets you quickly and easily browse through thousands of breakups, related breakups, and more breakups, creating a unique matrix of emotions before your eyes. You can easily spend an hour clicking and reading, getting lost among the Sarahs, Charlies, Steves, and Lisas.

If you find yourself struggling to recall your teenage years, spend some time in The Dumpster. It will all come back—guaranteed. —GRG

The Dumpster: *Golan Levin with Kamal Nigam and Jonathan Feinberg (http://artport.whitney.org/commissions/thedumpster/index.html).*

Exercise 14

SEAHORSE WITH ED TADEM

Draw a modified "S" for the foundation of the body and build on the curves to suggest the body's form. Sketch the fin.

Add the spines on the head, the plates on the body, and the eye.

Refine the lines, erasing when needed, and further define the body plates.

Darken the lines and shade with parallel hatchmarks. Pull out highlights with a kneaded eraser where necessary and add a few bubbles escaping from the mouth for good measure.

Positive and Negative Space

THE YIN AND YANG OF GOOD COMPOSITION

The interplay of positive and negative space in a work of art is an impor-
tant dynamic often brushed aside by beginners. Paying close attention
to how they work together to influence the shape, balance, and energy of the
work can help you improve and refine your compositions.

Positive space is the area in your work occupied by the subject, whereas negative
space refers to the area between and around the subject. Think of negative space
as a support system for your positive space; it should not take attention away
from the positive space but instead should complement it. For example, nega-
tive space can echo the shapes of the subject to create rhythm within the work.

Sometimes a beginner's tendency is to fill a picture plane with as much subject
matter as possible, cramming the scene with forms and utilizing every inch of
empty space. However, the eye relies on areas of inactivity to rest and digest
the scene as a whole. Many artists suggest aiming for a balance of positive and
negative space, as too much of one can create a sense of excessive "fullness"
or "emptiness." Others argue that using equal parts of positive and negative
space creates confusion; the eye doesn't know where to focus. So, what to do?
My advice is to let either the positive or negative space subtly dominate the
composition. Play with ratios until you feel the dynamic best communicates
your message. —ETG

SEE FOR YOURSELF!

In Jeremiah Mourning Over the Destruction of Jerusalem *(page 342),*
Rembrandt uses plenty of negative space—the area around the figure—
to emphasize Jeremiah's isolation.

Friedrich Wilhelm Nietzsche (1844–1900)

THE GODS ARE ALIVE

"With eyes strengthened and refreshed by the sight of the Greeks, let us look upon the highest spheres of the world around us."
— *Nietzsche,* The Birth of Tragedy, *15*

Nietzsche is very influenced by the work of Schopenhauer. Nietzsche agrees with his predecessor that intellectual and artistic endeavors create a kind of illusion that helps us understand our existence. He's also a pessimist like Schopenhauer, viewing life as essentially tragic. Naturally, then, he has a soft spot in his heart for ancient Greek drama.

He is fond of Athenian tragedies mainly because of their skillful balancing of two fundamental human forces, represented by the Greek gods Apollo and Dionysus. The Apollonian force refers to reason, morality, and the rigid classification of ideas, while the Dionysian embodies a primal energy, arising from the libido, that defies the intellect and passionately drives people toward intoxication.

Nietzsche criticizes philosophical inquiry for neglecting the Dionysian force in its Apollonian obsession with conceptualizing the world. He sees humanity protecting itself in an illusion that is too safe, lacking the vigor of tragedy. His hope is for a Dionysian revival where people transcend traditional values and live more freely.

Stemming from these views is Nietzsche's love of art and creativity. Art came before philosophy and remains a truer, more raw expression of life's essence. As long as it bears all the tension and tragedy of our predicament, Nietzsche believes art will prevail as a potent source of human understanding. —CKG

QUESTIONS TO PONDER

• *Do you believe that our world is too focused on reason and control?*

• *What modern art forms effectively convey the Dionysian spirit?*

Impressionism

TO CAPTURE TRANSIENT BEAUTY

Brief moments in time that sparkle with beauty and then are gone: that is what the Impressionists sought to capture.

WHEN & WHERE

c. 1860–1900

France

When the Impressionists hit the scene, Paris was the Western art epicenter. The annual art show, Salon de Paris, could make or break an artist's career. Polished, academic history parables were the style. Impressionism was a radical and unwelcome break from that mold. Critics detested the relative sketchy quality of their paintings. The term "impressionist" was given as slander since the work was seen as unfinished, a mere impression. The general public was not amused either. Times were tough for the early trailblazers....

Impressionists had found a new way to paint. Most actually went out into the world that they were representing and painted *en plein air*. They loved the beauty of everyday life: the way that sunlight dances on water and dapples through trees, the way that light affects ladies strolling along wooded paths and mothers bathing their children, how water lilies bloom and commoners converse in cafés. Quick strokes and thick dabs of brightly colored paint next to one another created an optical blend. Portraits could be rendered in a matter of minutes; landscapes in an hour or two.

It goes without saying that the public opinion of Impressionist art has changed dramatically since its beginnings. The Impressionists have painted their way into the hearts of millions. —ARR

Selected artists: Claude Monet, Edouard Manet, Pierre-Auguste Renoir, Camille Pissarro, Mary Cassatt, Edgar Degas, Berth Morisot, Paul Cézanne

Paul Cézanne (1839–1906)

AHEAD OF HIS TIME

Although Paul Cézanne was a peer of the Impressionists, he always remained on the fringe of the movement. The methods he employed in his paintings relative to space, perspective, and composition were decidedly modern and foreshadowed early 20th-century artistic genres, especially Cubism, although this was not attributed to him until after his death.

Cézanne was born and raised in Aix-en-Provence, France, where he grew up alongside celebrated French novelist Émile Zola. As a young man, Cézanne studied law and took art classes. In 1861, against his father's wishes, he followed Zola to Paris to pursue a career in art.

In Paris, Cézanne met the Impressionists and became friends with Camille Pissarro; however, he never fully embraced the movement, opting instead to "make of Impressionism something solid and durable, like the art of the museums." As such, Cézanne was less concerned with subject matter than he was with form and skill. A temperamental and emotional man prone to depression, Cézanne was riddled with self-doubt. He had few friends and after enduring myriad rejections by the Salon, he returned to Aix-en-Provence where he lived and painted in near seclusion until the end of his life.

Although Cézanne exhibited with the Impressionists in 1874 and 1877, it wasn't until 1895 when he was invited to mount his first solo exhibition in Paris that he achieved any real degree of commercial success. By then, however, he was bitterly disillusioned and the accolades held little meaning. He died after a brief illness and was buried near his home. —RJR

Notable works: *Boy with Red Waistcoat*, 1890; *Still Life with Ginger Jar, Pumpkin and Aubergines*, 1894; *Mont Sainte-Victoire*, 1900 (page 122).

FUN FACT

Although Paul Cézanne and Émile Zola were close friends from childhood, Cézanne ended the friendship after Zola wrote a novel titled L'œuvre (The Masterpiece), *the story of a misunderstood, failed artist who eventually commits suicide. Cézanne believed the story was about him.*

The Young Bacchus

MICHELANGELO MERISI DA CARAVAGGIO, 1597

Caravaggio's paintings are known for their dramatic lighting and uncompromising realism. In contrast to the artificiality and false perfection that had defined Mannerism, Caravaggio's pioneering Baroque style featured homely subjects in harsh contrasts of light and shadow (called *chiaroscuro*, or in its more extreme form, *tenebrism*), with every blemish and vice prominently displayed. *The Young Bacchus* is a fine example of his brutally honest approach.

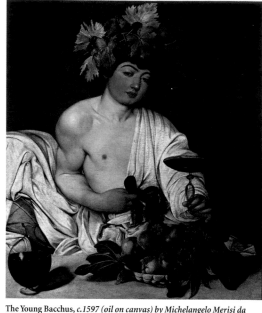

The Young Bacchus, *c.1597 (oil on canvas) by Michelangelo Merisi da Caravaggio. Movement: Baroque.*

Caravaggio had already painted one portrait of Bacchus (the Roman god of drunkenness and the Greek equivalent of Dionysus) in which the god looked hungover and suspiciously like Caravaggio himself. It's a reasonable guess, based on the recurrence of Bacchus in his work, that Caravaggio identified himself in part with the god. In fact, if you ever visit this painting in person, you can see a tiny reflection of Caravaggio in the carafe to the left.

Here, Bacchus is looking a little less green with nausea than he did in Caravaggio's earlier *Sick Bacchus,* but he still appears fairly intoxicated as he tilts a glass of wine toward the viewer. Leaning lazily on some cushions in a provocative posture, it's hard to imagine that this is an immortal god we're looking at. The rotting fruit before him reminds us that life is brief for mere humans, but that Bacchus is spared the ordeal of death and decay. In a time and place when Christian imagery dominated the general subject matter of painting, Caravaggio defied convention one more way by representing a pagan theme. —DDG

Birth of the Cool

NEW YORK CITY IN THE 1950s

Emerging from World War II as a cornucopia of economic and artistic innovation, New York City became home to a number of European artists and intellectuals who melded their unique traditions with American ideals. The streets bustled with newly invigorated music and art venues, dedicated to making New York City not only the cul-

Founded in 1937, the Guggenheim Museum helped make New York City the capital of post-war Avant Garde art.

tural capital of America but of the world. In this climate of artistic invention and creativity, a close-knit network of museums, dealers, galleries, and artist groups emerged, most notably under the umbrella of Abstract Expressionism. The movement's most famous painters, including Franz Kline, Jackson Pollock, Willem de Kooning, Mark Rothko, and Helen Frankenthaler, explored new ways of painting by injecting their work with emotion-filled gestures, drawing from their subconscious and personal experiences. Their work came to signify a distinctly "American" point of view—of confidence, individuality, and creativity.

Photographers William Eggelston, Walker Evans, and Lee Friedlander captured the look of everyday Americans in urban and suburban settings. In the seminal photo-essay "The Americans," Robert Frank presented images of the hopeful and the destitute—in cars, city halls, funerals, and drug store cafeterias—across the United States, capturing a strong impression of life in mid-century America. Artists working in this invigorating but tumultuous time portrayed the economic and political realities of postwar life while representing a kind of free creative practice symbolic of a country standing up to the Cold War threat of Communism. —SBR

Icon Art

PAINTING THE DIVINE

When is a painting not just a painting? When does it become a symbol of the mystic, the spiritual? For more than 1,500 years, the faithful from the Orthodox Christian tradition have stood in front of images or icons of their God, seeking a connection to the divine. Byzantine icon paintings—relatively small, gold-leafed two-dimensional works of art emblazoned with colorful images or symbols of God the Father, Jesus Christ, the Virgin Mary, saints, and martyrs—have become the most recognizable form of icon art today. Although most Byzantine icons were painted on wood panel, icons were also cast in metal, carved in stone, embroidered on cloth, frescoed, or printed on paper. You would just as easily find an icon painting in a private home as you would in the candlelit niche of a church; for the believer, the icon can bring sacredness and reverence to any location.

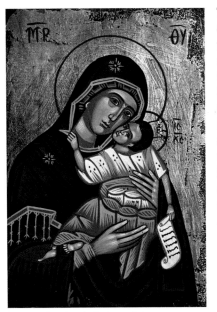

Traditional Greek Orthodox icon painting

The Byzantine style began in the 5th century and continued to develop until the fall of Constantinople (present-day Istanbul) in 1453. By this time, the rich cultural heritage of icon art had been widely diffused—by the spread of Orthodox Christianity—to Bulgaria, Serbia, Romania, Greece, and Russia. Its traditions continue to influence contemporary icon artists in Eastern Orthodox countries as a powerful reminder of the spiritual experience these images can evoke.
—SBR

Gemüseorchester

THE VEGETABLE ORCHESTRA OF VIENNA

Form meets function in the homemade, edible instruments used by Vienna's *Gemüseorchester.*

Some of the instruments, including the carrot recorders and eggplant castanets, have a look of raw, carnal minimalism to them. Others, such as the "cucumberphone," incorporate more aesthetic appeal, combining various vegetables of contrasting colors.

"Carrot flutes" from Vienna's Gemüseorchester. Photo © and courtesy of The Vegetable Orchestra.

All of them are fully functional musical instruments.

"Cucumberphone" from Vienna's Gemüseorchester. Photo © and courtesy of The Vegetable Orchestra.

Founded in 1998, the Vegetable Orchestra plays regular concerts all over the world, yet rarely on the same instruments. The taxing demands of performance and the natural process of decay create a high rate of turnover in the instruments themselves, allowing for the musicians-cum-luthiers to continuously experiment with constructive techniques.

After each concert, some of the instruments are given to audience members as souvenirs. (One can only speculate as to the shelf life of these keepsakes—even the most devoted fan must eventually grow weary of the fauna attracted to a decomposing celeriac bongo.) The remaining instruments are cooked into a soup that is served to the spectators.

Needless to say, the *Gemüseorchester* is likely the world's only orchestra that handcrafts its own instruments before each concert. They are, almost certainly, the only musicians who feed their woodwinds to the audience after performing. —DJS

Top Sellers

THE WORLD'S PRICIEST PAINTINGS

How much money would you put down for an original painting by a well-respected artist? Whatever amount you offer, chances are that it wouldn't put a dent into the price paid for the world's most expensive works of art.

Paintings that have sold for large amounts of money include big names like Picasso, van Gogh, Renoir—many of the artists we touch on in this book. Over the last few decades, these top sellers have sold for tens of millions of US dollars, and a handful have even been sold for more than a hundred million.

Coming in at $135 million US is Gustav Klimt's *Portrait of Adele Bloch-Bauer I* (page 332). This decadent painting contains real gold and silver; while creating it, perhaps Klimt had a sixth sense for its future value! Coming in around $137.5 million US is Willem de Kooning's *Women III*. And finally, the painting that has sold for the most amount of money is Jackson Pollock's *No. 5*, which sold for a whopping $140 million US.* All three of these pricey paintings were sold in 2006.

Who needs real estate or the stock market? Investing in canvas, paint, and the brushstrokes of the masters might be the safest way to go! —GRG

* *Numbers refer to reports at the time of this printing. The list is subject to change as transactions occur.*

Exercise 15

TURTLE WITH ED TADEM

Draw a simple circle for the head and a misshapen oval for the body and shell. Add a line for the mouth.

Rough in the eye, shell ridge, and stubby legs.

Create the pattern of irregular rectangles on the shell. Add long claws and wrinkles to the neck.

Develop the shell pattern further. Continue adding wrinkles, and indicate the scales on the legs.

Fill in the pupil, shade the undersides of the shell and chin, and add the cast shadow. Add hatchmarks to the shell for ridges, and create more wrinkles and scales. Finally, fill in the claws and draw pebbles that hint at the turtle's dry, dusty locale.

Creating the Perfect Studio

MAXIMIZING YOUR WORKSPACE

Where you choose to draw or paint can have a significant impact on your artistic experience. Whether your studio is temporary or permanent, keep the following four points in mind: lighting, convenience, comfort, and privacy.

Large windows with plenty of natural light are ideal for an artist's studio.

Your workspace should welcome plenty of natural light. If you're above the equator, north-facing rooms offer the most consistency, and the sun never beams in directly. (If below the equator, south-facing rooms will do the trick.) But if you don't have this luxury, work under daylight simulation bulbs. Unlike common household bulbs that emit mostly yellow light, daylight simulation bulbs create a bright, clean white light that helps you see colors and values accurately.

It's not easy to focus on a drawing or painting when your materials are all over the place. When using an easel, a taboret is a great organizational tool; this small cabinet has a tabletop for placing your paints, brushes, and jars, along with drawers for storing your materials. When working on a table, designate specific areas for specific tools so you always know where to reach.

The more comfortable you are, the longer you'll last in the studio. Choose a room where you can control the temperature, and be sure to use a padded chair. You may find that touches like music and candles help you loosen up and get lost in your art.

Finally, you will be most efficient when uninterrupted. Set up your studio in a quiet place with low traffic. (Just make sure it's not so private that you don't have a window for ventilation.) If you're shy, you'll find that privacy will make you more daring in your artistic pursuits. —ETG

Benedetto Croce (1866–1952)

ART AS LYRICAL IMAGE

"Art is not philosophy, because philosophy is the logical thinking of the universal categories of being, and art is the unreflective intuition of being."
 —Croce, "Aesthetics," *from* Encyclopedia Britannica, *14th Edition*

The Italian aesthetician Croce wasn't a big fan of Cartesian dualism—the idea that there are separate physical and nonphysical entities that mysteriously interact with each other, like mind and brain or body and soul. He offered, as an alternative, that such problematic parings are in fact inexorably intertwined, dependent on each other for their very existence. It's all in the tradition of Idealism, which opposes the Realist idea of an objective reality existing independent of the mind.

Relating his Idealism to art, Croce argues that intuition is identical to expression. When you have the intuitive sense of an idea, it already exists as an expression in your mind, even before you consciously establish it as a concept. In Croce's view, art is all about intuitions, so art is really the foundation of conceptual knowledge. The images and feelings that people experience in life produce a lyrical expression of their intuitions, which is art. The work of art is the external manifestation, or symbol, of the intuition, and is successful insofar as it captures and preserves the intuition's spirit.

Croce uses poetry as an example. Every poem contains images that are brought to life by an artistic feeling. Poetry only exists if image and feeling are united as a *lyrical intuition,* and the person who understands poetry experiences the intuition just as the poet did. —CKG

QUESTIONS TO PONDER

• *Have you ever felt an intuitive understanding of an artwork's essence?*

• *Do you believe that reality exists outside the mind, or is it simply an idea that we share?*

Post-Impressionism
THE SEARCH FOR MEANING

WHEN & WHERE
c. 1880–1900
France

With zeal for the expressive power of painting to represent an individual's emotions, the Post-Impressionists covered new ground. This "movement" is more of a loose group of artists who were united only by the fact that they wanted to push beyond Impressionism's boundaries. Individually, they were very diverse in style and content.

Many of these artists started their careers with the same aspirations as the Impressionists: to capture fleeting moments of light and temporal beauty; however, they sought to lace symbolism and deeper meaning through their work. They retained the expressive brushstrokes of their predecessors, but specifically tried to maintain the structure of forms. Where Monet let sky blend into ground, van Gogh contained the edges with outlines. Some explored the spiritual in nature; others explored the scientific. Using a heightened sense of color, they asserted the personal onto ordinary content. In doing so, they stepped farther away from naturalism and swirled, dabbed, and dashed their way closer to abstraction.

The bright colors and thick impasto of van Gogh's paintings have become icons for all art. Seurat's pointillist paintings are filled with energy and based on scientific theories about color. Gauguin traveled to remote Tahiti to find the spiritual in his art. And Cézanne revolutionized the understanding of space by fracturing it into pieces.

The Post-Impressionists were the gateway through which the Modern artists of the 20th century passed. Their legacy lives on as a popular era in art history and in the inspiration they provided for great abstraction. —ARR

Selected artists: Paul Cézanne, Henri de Toulouse-Lautrec, Paul Gauguin, Georges Seurat, Vincent van Gogh

Edvard Munch (1863-1944)

EXPRESSIONS OF ANXIETY

"For as long as I can remember I have suffered from a deep feeling of anxiety, which I have tried to express in my art." —Edvard Munch

Norwegian artist Edvard Munch believed that art should consist of more than "pretty pictures to be hung on drawing-room walls." Instead, he sought to make "art that gives something to humanity…that arrests and engages. An art created of one's innermost heart." Indeed, as an early innovator of Expressionism, Munch's emotionally compelling paintings, lithographs, etchings, and woodcuts achieved these noble objectives and more.

The second of five children, Munch was raised in a close family. He learned how to draw as a young child from his aunt Karen, who assumed caring for the children following Edvard's mother's death from tuberculosis; years later, his sister also succumbed to the disease. Both tragedies left an indelible mark and influenced Munch's work, much of which depicts the sadness, anguish, fear, and anxiety associated with the human condition.

Munch attended technical college for a year before dropping out to devote his life to painting. In the years that followed, he attended art school and traveled frequently to Paris and Germany. In 1892, he staged his first exhibition at the invitation of the Union of Berlin Artists, but critics were outraged by Munch's unconventional artistic methods, and the exhibition closed after one week; however, his reputation as an artist-on-the-rise was solidified. His success grew from that point forward, but not without its proverbial roller coaster ride that included a nervous breakdown, gambling, drinking, and unhealthy relationships, one of which ended in a lovers' quarrel and shooting that wounded Munch's left hand. —RJR

Notable works: *Evening on Karl Johan,* 1892; *The Scream,* 1893; *Ashes,* 1894.

The Third of May, 1808

FRANCISCO GOYA, 1814

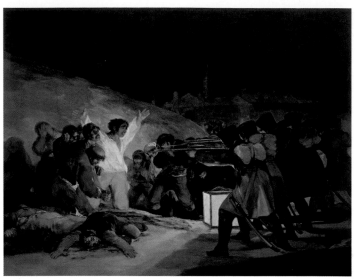

Execution of the Defenders of Madrid, 3rd May, 1808 (The Third of May, 1808), *1814 (oil on canvas)*
by Francisco Jose de Goya y Lucientes. Movement: Romanticism.

Francisco Goya's painting, often called *The Third of May,* is not only a work of art, but a tribute to a time of courageous political resistance and blood-stained heroes. To fully understand Goya's masterpiece would require a course in Spanish history; we have time only to briefly reflect upon the event.

When Napoleon became emperor of France in 1804, he made immediate plans to conquer and occupy neighboring Spain because of its strategic access to the Mediterranean Sea. At the request of Napoleon, Spain's king, Charles IV, naïvely allowed French troops into his country. The French promptly seized control of Spain, and in 1808, Napoleon's brother Joseph Bonaparte was crowned king. On May 2, the people of Madrid rebelled against this foreign occupation and a brutal battle ensued. Before dawn on May 3, hundreds of captured Spanish rebels were mowed down by Napoleon's firing squads.

In capturing this scene of death and carnage, Goya combines stunning imagery, deep symbolism, and raw treatment of brushstroke and composition to paint one of the world's most provocative war pieces ever created. —DDG

Los Angeles in the 1960s

LIGHT, SPACE, AND PLACE ON THE "LEFT" COAST

If you were an artist living in Los Angeles in the 1960s, your artwork might echo a city filled with sunshine and golden opportunity, a landscape burgeoning in new postwar technology and industry. The imagery emerging at this time reflected both utopian and dystopian views of LA; the sleek, luminescent work of the so-called "Light and Space" artists coexisted with the gritty, often politically charged work of the assemblage and California pop artists. The gap between art and life vanished as artists captured the unique sense of space and light found only in southern California and embodied the changing cultural landscape of Los Angeles.

In the 1960s, many Los Angeles-based artists began using materials and technology made for the burgeoning aerospace industry.

"Finish Fetish," the "Cool School," or the "Light and Space" artists like Robert Irwin and Larry Bell used materials and technology employed in Southern California's surfboard, aerospace, and automobile industries, favoring slick, translucent surfaces. Assemblage artists Ed Kienholz, George Herms, and Betye Saar created sculptures and collages from found objects and detritus that had lived other lives, now joined together to form new connections for the artist and the viewer. The infamous Ferus Gallery in Venice and the Pasadena Museum of Art (now Norton Simon Museum of Art) attracted artists Ed Ruscha, Marcel Duchamp, and even Andy Warhol, becoming lively centers for creative exchange. These artists and institutions helped shape the identity of Los Angeles as an emerging art nexus with a cultural perspective and aesthetic unique from New York and Paris. —SBR

Persian Miniatures

PAINTED POETRY

Peek inside any Persian scientific, historical, or poetic manuscript made since the 13th century and you will find tiny painted worlds filled with brave soldiers, noble sheiks, and love-sick princesses surrounded by flowers and animals. Traditional miniature paintings served as illustrations accompanying a text, like a snapshot of the action and key players in a story. The size of the image was dictated by the borders of the page, most no larger than a contemporary 8-1/2 × 11-inch sheet of paper. Often, when these books changed hands, the paintings were torn out and recomposed into new books. Many times the illustrations were painted over to make a new work of art, making it difficult to determine the origin of each painting. Soon the illustrations began to occupy entire pages and the text became secondary to the visual art. Elite art schools devoted to learning the craft of miniature painting appeared in Iran during the 15th century, each with its own distinctive style and focus.

Miniature painting on ceramic tile from Turkey.

Through trade, Persian miniature styles reached other countries and influenced Islamic miniature traditions in Turkey, India, and China. In turn, the Persian miniatures absorbed changes in colors, settings, and forms inspired by these cultural exchanges. Despite their small scale, the characters and settings of each miniature painting contain larger-than-life drama and intrigue fit for any 20-foot history painting you may find in the Louvre museum in Paris. —SBR

Walk-Through Exhibits
THE ELASTIC SPACE OF GIANNI COLOMBO

"My whole world has been turned upside down. Up is black, south is white…" —*Peter Griffin*[15]

Many walk-through exhibits have an inherently disorienting effect. The use of elaborate visual cues distorts the viewer's perspective, twisting the fabric of time and space around the observer.

Exhibits such as Gianni Colombo's *Spazio Elastico* (the Elastic Space) deliberately disrupt the participant's sense of balance and physical reality. The Italian artist created a dark room, illuminated with ultraviolet light and crisscrossed by horizontal and vertical fibers. A series of motors moved the fibers back and forth in a surreal web of glowing strands.

Spazio Elastico *by Gianni Colombo. Photograph courtesy of Archivio Gianni Colombo.*

Cromo Dromo *by Gianni Colombo. Photograph courtesy of Archivio Gianni Colombo.*

Emerging from the golden age of kinetic structures, Colombo transcended the concept of art as a passive, static object to be merely observed. Those who traverse such exhibits are not passive bystanders—they become drawn into the work as active participants.

Colombo's Elastic Space appears to morph around its viewers, functioning as a walk-through Rorschach test as it evokes a variety of reactions. For some observers, the exhibit is a diabolical Cat's Cradle that traps them in its snares. For others, the fluctuation of the fibers appears to acquiesce to their presence, bowing low as they walk by. —DJS

Burning Man

WHAT HAPPENS IN THE BLACK ROCK DESERT STAYS IN THE BLACK ROCK DESERT...

"Trying to explain what Burning Man is to someone who has never been to the event is a bit like trying to explain what a particular color looks like to someone who is blind."

—*http://www.burningman.com/whatisburningman*[16]

B urning Man was start- ed spontaneously in San Francisco in 1986 by Larry Harvey and Jerry James as an act of what they have come to call "radical self-expression." The first Burning Man was just that—a group of people gathering around an effigy of a man, which was subsequently burned on the beach.

A common scene on "The Playa" at night. Photo courtesy of Arlene Mendibles.

The annual event gradually morphed into what it is today: a chance to live, breathe, and be art. More than 48,000 people converge on "The Playa," a 400-square-mile expanse of the Black Rock Desert north of Reno, Nevada. The temporary city, which exists for about a week, becomes an outlet for creative expression of all types.

Photo courtesy of Arlene Mendibles.

The Man burns near the end of the event, although the festival has come to involve much more than simply watching a wooden statue burn. People describe the experience as life changing and a continual natural high. There is even a term for the discomfort you feel upon coming back to "real life" after the festival: The Reality Bends. —GRG

1 2 3

Exercise 16

MAI TAI WITH EILEEN SORG

Apply a layer of bright yellow to the pineapple, darkening the color in places with a slightly darker yellow. For the skin, use olive green, reddish brown, and a touch of black.

Apply reddish brown for the cherry and layer over it with red, leaving white highlights. Brighten the right side with a touch of orange-red. Fill in the stem with dark brown and reddish brown, and create the leaves with olive green and green.

Start the drink with a layer of orange-red, using lighter pressure to suggets ice cubes. Then add touches of this color on the ice cubes and at the base of the glass for reflections.

Darken the liquid using reddish brown, and add shadows to the floating ice cube with light and dark warm grays. Outline the glass with gray. Use reddish brown and heavy pressure for the deepest shadows within the liquid. Bottoms up!

Paint Palettes

CHOOSING YOUR MIXING SURFACE

Throughout history, palettes for acrylic and oil have ranged from slabs of wood and sheets of glass to ceramic plates and newspaper (as used by Picasso). Today, the most common types are wood, white plastic, and disposable paper. If you're working over a brown underpainting (as many early artists did), try using a wooden palette; while mixing, you can envision how the colors might appear on your painting. If you're working on white canvas, white plastic is a good option. You can even clean acrylics off the plastic with mild soap, warm water, and a little elbow grease. But if you're the type of person who likes the idea of frequently refreshing your mixing surface, disposable paper palettes (which are coated with a thin layer of wax) are ideal.

Many artists opt to seal their palettes in a plastic box between sessions to keep their mixes fresh. If using acrylics, spritz the palette with water or enclose a wet sponge before sealing it to lengthen the paint's life.

Unlike those mentioned above, a watercolor palette has wells or indentations that hold thin, watery washes. White plastic watercolor palettes are inexpensive and easy to clean. However, a palette with a lid that snaps shut is a good investment if you'd like to keep your paints moist between sessions.

Palettes can be ovals or rectangles, with or without a thumbhole, and with or without a lid. When it comes down to it, palettes are a matter of taste. Experiment and enjoy the process! —ETG

Martin Heidegger (1889–1976)

ART CREATING TRUTH

"Truth wills to be established in the work as this conflict of world and earth." —Heidegger, The Origin of the Work of Art

The quote above summarizes much of Heidegger's main ideas about works of art, but it definitely needs some explanation. First, we have to understand what Heidegger means by *world* and *earth*. In a work of art, *world* can be thought of as the subject matter, while *earth* is the actual stuff (paint, wood, words, etc.) used to create it. The two realms are fundamentally separate, and there is tension between them, yet each relies on the other for its own revelation.

The first half of the quote is especially intriguing. As opposed to the common belief that art simply expresses pre-existent truths about the world, Heidegger suggests that the truth is uniquely created in works of art. The truth about being, or "what is," even strives to be discovered through art. Art is therefore extremely valuable because, as an origin of truth, it is also an origin of history and human understanding.

He uses a van Gogh painting of ordinary peasant shoes to illustrate his points. Shoes themselves are quite mundane in both construction and purpose, yet an experience of van Gogh's simple work unveils a vast, layered reality about such a pair of shoes. Through the painting we realize, for example, the brutal daily life of the person who wears them. It shows us what shoes are in truth. —CKG

QUESTIONS TO PONDER

• *Does art merely reflect truth about the world, or can it reveal new truth?*

• *Is art superior to ordinary forms of thought and language*
in its ability to grasp ideas?

Art Nouveau

ORNAMENTAL INDUSTRY

Curvilinear, biomorphic lines were the style. Architectural forms appeared to organically grow from the ground up. Outrageous embellishment celebrated new forms in architecture, all types of design, and fine

> **WHEN & WHERE**
> *c. 1885–1910*
> *Europe, USA*

art. Whereas other movements considered the *Fin de siècle* (French for "end of the century") an era of cultural degeneration and produced works fraught with angst, the Art Nouveau movement embraced technological advances and promoted a hopeful decadence in art and life.

Detail of Casa Batlló, Barcelona, Spain, Antoni Gaudi, 1905-1907.

Some Art Nouveau artists explored modern materials—such as glass and cast iron—for creative expression. The movement drew inspiration from the organic lines of Celtic art, the bright colors and graphic outlines of Japanese woodcuts, and the Arts and Crafts movement. Art Nouveau wanted to erase the line that divided the fine arts from craft and design; everything was to be touched by beauty!

Art Nouveau was the first movement to go truly international, encompassing all of the arts and spreading like wildfire across Europe and North America. Theater posters by Alphonse Mucha graced public spaces with sinuous ladies and floral designs. Ornate Tiffany lamps lit up the United States. Gaudi's undulating buildings erupted from the Spanish landscape. In Austria, Gustav Klimt seemed to bury his painted figures in ornamentation.

Art Nouveau's popularity waned with Modernism's emergence, evolving into the more streamlined Art Deco aesthetic. However, several architectural landmarks in the Art Nouveau style are listed as UNESCO world heritage sites and are considered shining jewels of history. —ARR

Selected artists: Aubrey Beardsley, Antoni Gaudi, Victor Horta, Gustav Klimt, Henri de Toulouse-Lautrec, Charles Mackintosh, Alphonse Mucha, Louis Comfort Tiffany, Henri van de Velde

Edouard Manet (1832–1883)

TRADITIONALLY UNTRADITIONAL

Edouard Manet was born in Paris into a privileged family. His father was a judge and hoped his son would pursue a career in law; however, Manet was more interested in art than academics. As a young man, he traveled throughout Europe to study the masters and was particularly influenced by Goya and Velázquez.

It was never Manet's intention to spark controversy with his art—he was a refined man who deeply desired acceptance into the mainstream art world; however, he also had very distinct artistic philosophies. For one, he believed in art's intrinsic nature and that aesthetic value was more important than content. He also believed that "one must…create what one sees," and thus painted scenes inspired by the cafés, bars, and theaters of Paris, particularly in bourgeois social circles. And his technique, composed of loose, unfinished brushstrokes and flat compositions, ignited the sparks of Impressionism, although he never associated himself with the movement nor did he exhibit with any of the Impressionists.

But it was ultimately the convergence of his ideas and methods on canvas in *Luncheon on the Grass* that set off a firestorm of criticism. The critics felt that his image of a classical female nude seated beside two clothed gentlemen in a modern setting was vulgar and offensive. And the painting firmly established Manet as a member of the Avant-Garde, much to his annoyance. Although Manet resisted his role as innovator, his work opened doors for an entirely new generation of artists. —RJR

Notable works: *Luncheon on the Grass,* 1863; *Olympia,* 1865; *A Bar at the Folies-Bergère,* 1882 (page 272).

Fun Fact

Edouard Manet was a generous man who often helped friends in need. A letter from Claude Monet to Manet in 1879 reveals the artist's benevolent spirit: "I often think…of how much I owe you, and it is really most kind not to have asked for that money back, which you must badly need…."

When Are You Getting Married?

PAUL GAUGUIN, 1892

In 1891, French artist Paul Gauguin left France and lived the remainder of his life in the South Pacific. It was during this time that he created his best-known paintings.

When Are You Getting Married? was completed while he was living on the island of Tahiti. During this time, his painting style absorbed the lively Polynesian culture that surrounded him and was influenced by artistic styles of the region—his colors became brighter, his shapes became flatter, and his brushstrokes became rougher.

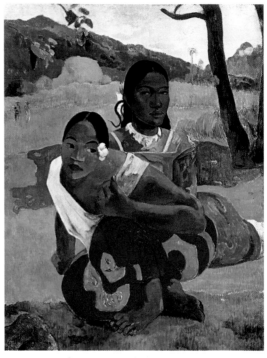

Nafea Faaipoipo (When Are You Getting Married?), *1892 (oil on canvas) by Paul Gauguin. Movement: Post-Impressionism.*

This painting of two Polynesian women touches on a cultural tradition involving the language of flowers. In Tahiti, a flower behind the left ear of a woman indicates that she is either married or engaged. We can imagine that, based on the title of this piece, Gauguin wished to capture an intimate moment of a bride-to-be and loved one. —DDG

This is London

YOUNG BRITISH ARTISTS OF THE 1980s AND 1990s

Branding yourself as one of the youthful and vibrant artists of the late '80s/early '90s art scene in London could bring celebrity and notoriety, especially if you had the backing of any one of the number of emerging art collectors, gallerists, and journalists.

"YBA," a term derived from a series of exhibitions, "Young British Artists I" to "Young British Artists VI," held between March 1992 and November 1996 at the gallery of ad man turned art collector Charles Saatchi, included artists such as Tracey Emin, Damien Hirst, Chris

Many YBAs embraced new materials and technology, like large-scale video installations, to innovate their art practices.

Ofili, and Rachel Whiteread. These artists, emerging from universities and art schools, broke with previously defined models of art production, cross-pollinating between mediums and processes. In a spirit of "anything goes" for art-making practices, these art stars appropriated medical objects, built sculptures from fresh food, preserved animals in formaldehyde, added animal dung to canvases, and mounted large-scale video installations. This astonishing experimentalism marked this burst of art-making as one of the most widely diverse contemporary scenes around, one not easily contained within a single style or movement. Recognizing the importance of the art market that surrounded them, these artists cemented their reputations as independent entrepreneurs by taking control of their careers: Many courted the media, befriended potential collectors, and collaborated with fellow artists. By the late 1990s, the work produced by YBAs became bonafied investments—it's amazing what a little bit of precocious talent, confidence, and self-promotion can do for your career! —SBR

Islamic Calligraphy
THE ART OF WRITING BEAUTIFULLY

When you see a mosque, do you notice the intricately detailed patterns covering the surfaces? Can you get close enough to see that most of the patterns are made up of writing? The writings, or calligraphy, are considered one of the most important of the Islamic arts because they are used to record and preserve the word of Allah, or God. Calligraphy, or the act of careful handwriting with brush or pen, became a decorative element used in Islamic art as a way to honor God without drawing a picture of Him. The forms of flowers, fruits, and trees, along with geometric shapes, patterns, and spiraling lines (arabesques) make up the main stylistic elements in Islamic two- and three-dimensional decoration. The words and letters of the 28-letter Arabic alphabet can be arranged in ways that create shapes and designs to mimic animal and human forms. The calligraphic lines might be a verse from the Qu'ran (Koran) or lines of poetry, all plotted to precise mathematic proportions. Before paper, calligraphy was inscribed on papyrus or parchment scrolls as well as coins and dyed silk; the art of Islamic calligraphy spread through international trade of these items to China, Africa, and Europe.

Calligraphic lion.

Most Islamic buildings have some type of decoration completely covering their stone, stucco, or marble surfaces; the all-over design and embellishments reflect God's never-ending omnipresence in our world. The act of calligraphy is as important as its artistic value; the artist performs a kind of meditation, a prayer to God through the inscriptions. When we look at Islamic calligraphy, we can appreciate the multifaceted purpose of the seemingly simple act of writing. —SBR

The Art of the Uncontrollable
THE ZEN INSPIRATION OF THE GUTAÏ GROUP

"One who is steeped in Virtue is akin to the new-born babe…its bones are tender, its sinews soft…" —Tao Te Ching, *chapter 55*[17]

Drawing from a deep well of ancient Zen Buddhist thought, the Gutaï Group of post-war Japan gave central importance to the uncontrollable and the chaotic. The resulting art forms were diverse, varied, and unconventional.

Jiro Yoshihara covered the wheels of a bicycle with paint and rode across a vast white surface, creating haphazard strokes before an audience of spectators.

In a piece entitled *Chizensei-Kouseimao,* Kazuo Shiraga suspended himself above a large, paint-covered canvas, swinging overhead and swiping his feet with chaotic movements.

Other works of Shiraga's incorporated a more elemental feel: In a performance piece known as *Challenging Mud,* the artist rolled his body in soft clay, becoming one with the earth.

Saburo Murakami added strong allusions to the theme of regeneration. In the appropriately titled *Breaking Through Many Paper Screens,* the artist represented the phoenix-like beauty that can emerge from destruction.[18]

Such deliberate incorporation of accidental elements into Gutaï art brings to mind the Zen koan: "How do you stop a bell from ringing if it is very far away?" —DJS

Foodscapes

MOUNTAINS OF MEAT

That landscape looks good enough to eat. No, seriously, is that tree made out of bacon? Are those mountains made of salami? Is that a forest of broccoli? At first glance, Carl Warner's works appear to be normal enough, but when you get closer to the photos, you see that the scenes are actually composed entirely of food.

From cold cuts to fruits and berries, Warner painstakingly re-creates entire landscapes with ordinary pieces of food. When finished, he photographs the product in several layers and merges them into one breathtakingly delicious-looking "foodscape."

Photo courtesy of Carl Warner (www.carlwarner.com).

Each foodscape takes days to create. With an initial idea in his head, Warner says he can often be found staring at food in the grocery store. When the idea is finalized, he spends most of his time planning out the finished product. Once he starts assembling the foodscape, he has to work under time constraints to prevent the food from wilting or spoiling. On average, assembly of the final product takes between two to three days, after which the photography begins.

When I first saw the photos, I was sure they were created on a computer—they looked too good to be real. I was awed when I learned that he makes them all by hand. —GRG

Exercise 17

ICE CREAM SUNDAE WITH ED TADEM

Use a vertical guideline and basic shapes to build this symmetrical sketch.

Refine the shape of the glass, adding a fancy curved edge. Then indicate the blob of whipped cream and the cherry.

Continue developing the forms, adding streams of fudge on the ice cream and wavy lines on the glass to indicate a reflective surface. Start shading the ribbon of fudge.

Build up the shading with hatchmarks, making the fudge the darkest value. Soften the shading on the ice cream and erase areas of the glass to suggest shine.

Paintbrushes

BRUSHING UP ON THE BASICS

Perhaps not enough emphasis is placed on the importance of the paintbrush, which shapes and forms each stroke of a painting. Skimping on the quality can have significant consequences, including frayed, unwieldy bristles or stray hairs that become part of the painting.

Brushes come in three basic hair types. Soft natural-hair bristles are made up of the hair of an animal (such as a weasel or badger). These bristles, which are very resilient and hold a good amount of moisture, are an excellent choice for watercolor. Soft synthetic-hair bristles are made up of man-made fibers and are recommended for acrylic paints. Bristle brushes, which have thick, coarse hair, are best for oil painting and can be either natural or synthetic.

At right are the most common brush shapes: fan, flat, round, and rigger. With these brushes, you can produce a wide range of strokes—as a beginner, you really don't need more than these. And although brushes are available in a wide range of sizes, you'll need a smaller selection than you imagine. Try starting with two flats (small and large), three rounds (small, medium, and large), a medium fan brush, and a rigger.
—ETG

Fan Brush
Splayed bristles in a crescent shape; great for drybrushing (page 278) and loosely dabbing on paint

Flat Brush
Ideal for thick strokes, large washes, and (when used edgewise) thin lines

Round Brush
Bristles taper to a soft point, allowing for a variety of stroke widths

Rigger or Liner Brush
Only a few hairs thick; perfect for fine lines and details

REMEMBER THIS!

Here is an excellent piece of advice from artist Joseph Stoddard:

"Use the largest brush you are comfortable with while painting a particular area.

This will help you stay loose and avoid painting too much detail."

Jean Paul Sartre (1905–1980)

CREATING BEAUTY, FINDING MEANING

"If literature isn't everything, it's not worth a single hour of someone's trouble." —Sartre

The famous 20th-century philosopher Jean-Paul Sartre was a French Existentialist, which means you will be instantly cooler once you start throwing his name around. Sartre is the most recent of our philosophers—the only one born in the 20th century. As a result, his beliefs still enjoy relatively fresh popularity in today's classrooms and coffee shops.

Having written his own fiction, Sartre is aware of the impact art can have on people's beliefs. In fact, one of his main strategies as a philosopher is to communicate his views through creative literature. He wants the readers of his fiction to vicariously think and feel his thoughts and feelings. In his novel *Nausea,* for example, he wants readers to authentically feel the sickening anguish he does when confronted with the accidental nature of human existence.

Seeing art chiefly as an intellectual pursuit, Sartre believes that every artist must commit to bettering society and taking responsibility for his or her work. This is especially important considering art's power to evoke empathy from those who experience it. Art holds up a mirror so people can recognize their own flaws and overcome them. According to Sartre, it can help us see the indifference of the physical world and find the courage to embrace it. When we create art, its beauty lives on after we're gone, giving lasting meaning to our otherwise insignificant lives. —CKG

QUESTIONS TO PONDER
• *Has a work of art ever revealed to you a profound truth about our world?*
• *Can the creation of art add meaning to a person's life?*

Fauvism

THE EMANCIPATION OF COLOR

Wild beasts! The artists of the Fauvist movement were crazy about color. Their paintings were passionate and vibrant, reflecting their belief that painting should capture pure emotion. Their expressive images were so wild that they shocked the public and became the laughing stock of Paris … and then, they transformed art as the world knew it.

WHEN & WHERE
c. 1905–1908
Paris, France

Led by Henri Matisse and André Derain, the Fauves were a loose collective of painters united by a love of expressive brushwork and the unbridled use of color that pushed beyond mere description. They were inspired by van Gogh's violent colors in his paintings, Gauguin and Cézanne's distortion and simplification of forms, and the sophisticated simplicity of African masks and statuary. The Fauves updated traditional themes by painting them in a non-naturalistic way.

Although short-lived, Fauvism was the first major Avant-Garde art movement of the 20th century and left an indelible mark on modern art. By 1908 the movement as a whole had fizzled out and many of the artists defected to the Cubist ranks. Only Matisse continued to paint in the Fauvist style, leaving the most enduring legacy with his harmonious images full of decorative, flat expanses of color depicting utopian images of figures in nature.

Whether it is in images of cityscapes or nudes frolicking in a forest, the Fauves had a *joie de vivre* aesthetic that transcends time. —ARR

Selected artists: Georges Braque, Andre Derain, Raoul Dufy, Henri Matisse, Georges Rouault, Kees van Dongen, Maurice de Vlaminck

Caravaggio (1571–1610)

GOING FOR BAROQUE

At a time when art depicted religious subjects with reverence and veneration, a young, bold Italian artist called Caravaggio broke from tradition and painted Biblical themes and figures with a realism few had attempted previously. Caravaggio depicted subjects more genuinely, which meant showing the less favorable reality of the often unsightly, sometimes dirty human form. He even selected ordinary people from off the streets to model for him.

Caravaggio's paintings reveal an intensity and power unmatched by any other artist of his day thanks to his revolutionary implementation of *chiaroscuro*: a technique that illuminates the primary subject in the foreground while the remaining details are obscured by dramatic shadows. His innovative approach not only helped usher in the Baroque period, but it has influenced countless artists ever since.

Had it not been for his artistic talent, however, Caravaggio would have been little more than a common criminal, for he possessed a demonic Achilles' heel: a volatile temper and foul disposition. With a number of vices, including drinking, gambling, and a proclivity for brawling, Caravaggio's notorious reputation is well documented in court records, which show numerous arrests, imprisonments, and flights from the law.

Although we can't know if Caravaggio's explosive nature helped or hindered his art, we do know that he might have reached even greater potential had his reckless life not caught up with him at such an early age. Fleeing yet again after committing murder in a fit of rage, Caravaggio contracted a fever and died at the age of 39. —RJR

Notable works: *The Young Bacchus,* 1597 (page 152); *The Conversion of Mary Magdalen,* 1599; *The Calling of St. Matthew,* 1600.

FUN FACT

In 1986, British filmmaker Derek Jarman wrote and directed a fictionalized account of Caravaggio's life in the film aptly titled Caravaggio.

The Milkmaid

JOHANNES VERMEER, C. 1658-1660

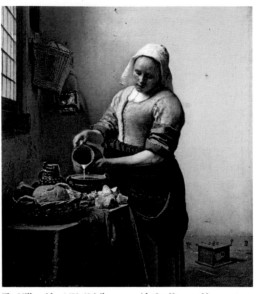

The Milkmaid, c.1658-60 (oil on canvas) by Jan Vermeer. Movement: Northern Baroque.

In his classic book *The Story of Art*, E.H. Gombrich describes Jan Vermeer's paintings as "still lifes with humans."[19] *The Milkmaid* (also called *The Kitchen Maid*) perfectly suits this description. Today, this is one of Vermeer's most beloved works, and in one significant way *The Milkmaid* is unlike most of artwork we've reflected on so far—it actually enjoyed popular acclaim at the time it was painted.

Part of *The Milkmaid's* charm lies in its subject matter. The scene is simple and private. The soft, warm light that falls into the room creates a peaceful atmosphere as the milkmaid quietly goes about her domestic duties. It seems unlikely that the passage of time will alienate any audience from this painting's inviting character.

Another pleasing quality of *The Milkmaid* is Vermeer's photorealistic treatment of the subject. Perhaps it is difficult for us, living in an age of high-definition television and multi-megapixel digital cameras, to fully appreciate the degree of realism in a painting and the skill it requires. Vermeer did, however, work with the aid of a camera obscura (page 36), which contributed to his photorealistic touch. Take a close look at the window, basket, and lamp in the top left corner. Vermeer's brushstrokes create astonishing detail that enhances the scene's humble beauty. —DDG

"Impressions" of 19th-Century Paris

FROM HAYSTACKS TO RAILROAD TRACKS

Strolling down the wide, well-lit streets of central Paris, you would never guess that the majority of the architecture dates back only 150 years. Paris launched a massive modernization campaign under the supervision of Baron Haussmann, a civic planner dedicated

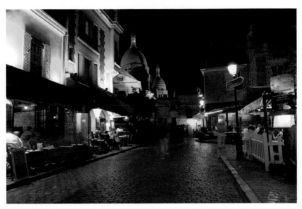

The Parisian neighborhood of Montmartre, or Martyr's Hill, became home to many artists during the 19th century.

to revitalizing the city—from gutters to gas lamps. Tiny winding streets gave way to wide "boulevards" with magnificent sightlines of monuments like the Arc de Triomphe and the Eiffel Tower. As leisure time increased, artists, poets, photographers, and philosophers began to cultivate a café culture where ideas about art and life were shared over late night cups of espresso and absinthe. Artists like Mary Cassatt, Claude Monet, and Gustave Caillebotte painted everyday life—boats on the bay, children at play, the everyday Parisian. Their "impressions" of city life helped form a name for this group and those to follow: Impressionism.

Not all the images produced during this time depicted modern Paris in a positive light. Many were discontent with the social upheavals occurring in Paris. Post-Impressionists Vincent van Gogh and Henri de Toulouse-Lautrec depicted the seamier side of Parisian life—the struggle of the lower classes, the absinthe addicts, cabaret dancers, the destitute—and the loss of human connection many felt in an age of rapid industrialization. Look past the bright colors and light-filled canvases, and you can see the often edgy social commentary in which these artists were actively engaged. —SBR

Deer Stones

NOMADIC ART OF MONGOLIA

By definition, nomadic peoples do not leave much behind. When they migrate, they blend with their new environments, creating a hybrid culture unique to its time and place. The people who populated the northern Mongolian/southern Siberian steppe followed this pattern and, around 1,000 BCE, began creating unique works of art called "deer stones." Named for the repetitive deer and antler designs found on many of these slight granite monoliths, several hundred are scattered throughout upper Mongolia's remote wilderness—an area twice the size of the state of Texas. Archeologists have traced the origins of deer stones to between 1,000 BCE and 700 BCE, which corresponds to the time when Mongolian culture shifted from sedentary herdsmen to nomadic horsemen. The stones stand as memorials to powerful chiefs, brave warriors, and favorite horses.

Mongolian megaliths on Siberian plateau.

Many scholars regard the tattoo-like carvings that adorn the stones as stylized representations ranging from Mongolian forest elk to the mythic Tree of Life. Unfortunately, the stones, exposed to the harsh windswept grasslands for more than 3,000 years, have suffered severe erosion. Even though these totemic sculptures remain a mystery, they can be appreciated as dramatic archaeological monuments to the creativity of Mongolia's Bronze Age people. —SBR

The Dead House

THE TRANSFORMATIONS UNDERGONE BY A HOME

Gregor Schneider made a series of bizarre, illogical changes to his own home in an artistic work known as "Totes Haus u r" (Dead House—Unterheydener street, Rheydt).

Schneider began to transform his home at the age of 16, after his father died. Some consider the Dead House to be a cathartic exploration of the incomprehensible, uncontrollable nature of death.[20]

The German artist created false partitions, windows leading nowhere, winding corridors, lead-lined walls, and rotating parlors. In the moldy, dark cellar of the Dead House, Schneider hung a disco ball from the ceiling, drawing a macabre association between the inverse mysteries of love and death, Eros and Thanatos.[21]

Schneider stirred controversy by proposing the creation of a public space in a museum "for people to die in". He was disturbed by modern society's practice of sticking our dying into sterile, lifeless hospitals far from sight, thus perpetually evading the reality of death.[22]

Ironically, I researched Schneider's work while sitting in a Victorian home-turned-coffee shop. Two tables away from me, a self-congratulatory college student was explaining to his peers that he knew exactly what he would be doing and where he would be living 40 years from now, still

Totes Haus u r, Rheydt. *1985–today. Photo courtesy of Gregor Schneider.*

psychologically insulated from the unpredictable nature of his own mortality. *He would do well*, I thought, *to become acquainted with the Dead House.*
—DJS

The Secret Language of Comics
COMMUNICATING WITH SERIFS AND BALLOONS

A re there secret messages hidden in the pages of comic books? Do the fonts and balloons tell us more than just the words? While this might not be something you spend much time thinking about, there is a method to drawing the various "speech balloons," "thought balloons," "dream balloons," and "everything else balloons" that you come across while reading a comic book. This "secret" art form involves communicating with shapes and using visual indicators that elicit a quick and direct response from the reader. If you read comics, chances are that you subconsciously pick up on it already—you might even find that a comic that doesn't stick with the traditional "rules" feels just a little bit off as you read it.

Most of these norms make sense, and clearly someone has put some thought into them. One that might pique your interest is the rule for crossbars (or serifs) on the letter "I." Nate Piekos, a professional letterer, explains: "An 'I' with the crossbars on top and bottom is virtually only used for the personal pronoun, 'I.' The only other allowable use of the 'crossbar I' is in abbreviations. Any other instance of the letter should just be the vertical stroke version."

An example of two different "Burst Balloons" used to indicate screaming. Courtesy of Nate Piekos (http://blambot.com).

Piekos's entire essay, "Comics Grammar & Tradition," is quite revealing and decodes a number of comic conventions. —GRG

Exercise 18

TIKI TODEM WITH ED TADEM

Start this Tiki totem with a rounded cylinder; then add some grass at the base.

Block in the features, making your lines angular to look wooden.

Add details and refine the forms, erasing any lines you no longer need. The curved lines suggest a carved depression.

Begin shading the eyebrows, nostrils, and lips. Add a few more blades of grass.

Darken your lines and continue shading, keeping the tone uneven to create the appearance of carved wood. Finally, add more grass.

Drawing and Painting Surfaces
PAPER AND CANVAS BASICS

The surface on which you draw or paint (also called the "support") will always influence the quality of your final artwork. Subtleties in texture, the vibrance of the paint, and the length of your art's life are just a few things tied up in the support. Before you make a trip to the art store for supplies, check out this overview of paper and canvas.

Drawing Paper

Paper can vary in weight (thickness), tone (surface color), and texture. It's a good idea to start out with smooth, plain white paper so you can easily see and control your strokes. *Then* check out other options. Paper with a rough texture (also called "tooth") is ideal for charcoal and pastel—and it may even appeal to graphite artists drawn to bold, broken strokes. (Note that using acid-free, archival paper will increase the lifespan of your art by preventing it from yellowing and becoming brittle.)

Watercolor Paper

This paper is coated with a layer of sizing, which helps the surface absorb the paint slowly. A variety of textures exist on the market, notably *hot-press* (smooth), *cold-press* (textured), and *rough* (just what it sounds like). Watercolor paper is also labeled by weight. I recommend starting with 140-lb paper, which is thick enough not to buckle or warp excessively under your the moisture of your paint.

Canvas

Pre-primed and stretched canvas, which is available at any art and craft store, is the best way to go for both acrylic and oil painting. This canvas is stretched taut over a wood frame and coated with acrylic *gesso*—a white primer that provides an ideal surface for holding paint. Without it, the canvas may awkwardly absorb the paint or become damaged when exposed to the harsh solvents (as used in oil painting). Also, gesso's bright white color helps the layers of paint above it glow. —ETG

The Human Body
CELEBRATING OUR CORPOREALITY

"The human body is the best picture of the human soul."
—*Ludwig Wittgenstein,* Philosophical Investigations

The human body is probably the most popular subject in the history of art. Whether it's being mimicked, idealized, or deconstructed, it is a perennial fascination of artists and art lovers alike. The body is both face and form, means and end, content and canvas. Its popularity isn't surprising, though, considering we experience life through our bodies, and to a debatable extent, they are part of who we are.

More interesting is the way standards of beauty have changed over time and between cultures, especially when it comes to the "ideal" human form. The female form, for example, has been glorified in an intriguing variety of ways over the years and across the continents. Fat, skinny; tan, pasty; 25 neck rings, no neck rings; if you can name it, it's been a symbol of beauty. There's no denying that the particular beliefs and concerns of a population shape its notions of bodily beauty; art continuously documents for us the trends of the times.

But, again, we have to find a balance. There are certain faces that almost everyone would agree are beautiful, and others that aren't so easy on the eyes. As it is with beauty in general, our views are formed by both nature and nurture, and it remains a mystery which influence has a greater effect on our opinions. —CKG

QUESTIONS TO PONDER

• *Why are humans so fascinated with seeing the human body depicted artistically?*

• *Are our views of bodily beauty based more on our genes or personal backgrounds?*

Expressionism

ANGST OF AN AGE

At the beginning of the 20th century, Germany suffered from political and economic upheaval, and war loomed on the horizon. Expressionist artists responded to this climate of cultural angst and disillusionment by using art as a vehicle for expressing intense human emotion and purifying social ills.

WHEN & WHERE

c. 1905–1925

Germany and Austria

Germany was the epicenter for two distinct Expressionist groups: Die Brücke and Der Blaue Reiter. The artists of Die Brücke (1905–1913, Dresden) held up a critical mirror to what they saw as the misplaced values of society. Their paintings and prints convey feelings of tension, loss, and isolation engendered by the forthcoming war. Images with lacerating jagged lines, bold colors, and distorted, zombie-like figures occupy a claustrophobic space. Die Brücke engaged the problems of the urban environment by turning their backs on nature and imposing their angst onto representational imagery.

In contrast, Der Blaue Reiter (1911–1914, Munich) attempted to spiritually transcend the painful human condition by denying society in art. These artists were bound by a lyrical love of color, undulating forms, and a push towards the metaphysical in art. A fascination with music, sensory experiences, and nature permeated their hopeful paintings.

Expressionism inspired subsequent movements, such as New Objectivity and Abstract Expressionism, to convey raw emotion through paint. They responded with deep, personal emotion to a painful period in history by abstracting reality so that we could feel it too. —ARR

Selected artists: Max Beckmann, Wassily Kandinsky, Ernst Ludwig Kirchner, Käthe Kollwitz, Franz Marc, Paula Modersohn-Becker, Emil Nolde, Egon Schiele

Claude Monet (1840-1926)

A LASTING IMPRESSION

"Painting is such torture! And I am no good at all."
—Monet, in a letter to Gustave Caillebotte, September 4, 1887.

More than 80 years after his death, Claude Monet remains one the most beloved painters in the history of art. A master of *en plein air,* or painting "in the open air," Monet was also one of the founding fathers of Impressionism and was particularly adept at painting landscapes and rendering light in such a way as to capture the mood of a scene. In later years, he painted the same scenes and structures at different times of day to reveal the variances of natural light.

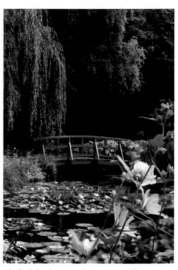

The lush landscape and exquisite gardens surrounding Monet's home in Giverny inspired some of the artist's most celebrated works of art.

Born in Paris, France, Monet was raised in Le Havre. As a young man, he made money by drawing caricatures. He began painting landscapes under the tutelage of artist Eugène Boudin, whom he later credited as a significant influence. In 1860, Monet moved back to Paris. Following a brief turn in the African Light Cavalry in Algeria, he joined the studio of Charles Gleyre and attended the Académie Suisse. It was during this time that he met fellow future Impressionists Renoir, Pissarro, and others, who eventually joined forces to mount eight independent Impressionist art exhibitions between 1874 and 1886—initially to exceptionally harsh criticism.

Monet suffered ample rejection and financial hardship for the first two decades of his career, but he began making money with his paintings in the early 1880s. He purchased a home in Giverny where he lived, gardened, and painted for the rest of his life. Today, Monet's Gardens at Giverny are open for public tours.
—RJR

Notable works: *Poppies at Argenteuil,* 1873; *The Artist's Garden at Vétheuil,* 1881; *The Artist's Garden at Giverny,* 1900.

L'Absinthe

EDGAR DEGAS, C. 1875-1876

This is one of several paintings depicting Parisian bohemian life at the end of the 19th century that we will discuss before the end of the year. Here we have an evocative scene from Edgar Degas, set at the Café de la Nouvelle-Athenes in Paris.

Critics and audiences alike loathed this piece for years after its creation because they disapproved of the people in the scene. Although familiar faces in the artists' community, this woman and man (a local actress and her well-known bohemian artist companion) were considered immoral and uncouth by "proper" society and, therefore, outrageously unfit subjects for a painting.

In a Café, or L' Absinthe, c.1875-76 (oil on canvas) by Edgar Degas. Movement: Impressionism.

Meanwhile, absinthe itself is known for its high alcohol content and even hallucinogenic power, and its presence adds to the painting's scandal. What does the look on the woman's face and her large glass of absinthe suggest about her life? Her expression has a way of eliciting curiosity, pity, and even laughter all at once. And what do you make of the man's expression? Degas successfully captured their disillusioned, almost despondent gazes—ones that still intrigue viewers today. —DDG

Black Mountain College

IN THE SPIRIT OF COLLABORATION

The creation of Black Mountain College in 1933 occurred during a time when the world was at war, suffering a global economic depression. The progressive liberal arts school nestled in the mountains of North Carolina began recruiting European artists and intellectuals including Joseph Albers, the first art teacher at Black Mountain. Unlike other colleges and universities at this time, Black Mountain was owned and operated by its faculty; all members, student and teacher alike, participated in the operations of the school, including farming, construction, and kitchen work. Given its unique nature, the school attracted independent visionaries such as Jacob Lawrence,

The former site of Black Mountain College was nestled in the Great Smoky Mountains just outside Asheville, North Carolina.

Walter Gropius, Cy Twombly, Francine du Plessix Gray, Franz Kline, and Robert Creeley. On any given day, students could witness Buckminster Fuller's experimentations with the geodesic dome or the modern dance/performance art collaborations between Robert Rauschenberg, John Cage, and Merce Cunningham. By the mid-1940s, the school's reputation for immersive programs in poetry, art, dance, and photography combined with a world-class teaching staff, attracted even the likes of poet William Carlos Williams and Albert Einstein, who served on the Board of Directors. Unfortunately, as a greater number of students and faculty were lured away by the burgeoning art centers of New York and San Francisco, the college, always financially unstable, closed its doors in 1957. But the spirit of Black Mountain lives on in the work and words of former students as they carry on the work of the original American Avant-Garde. —SBR

Cheongsam

FASHION, POLITICS, AND CULTURE SEWN TOGETHER

Who could have imagined that a dress could repeatedly influence political and cultural agendas of a country? Women have been wearing the traditional long, flowing dress called a *cheongsam,* or "Mandarin dress," for more than 500 years in China. The modern *cheongsam* is a contemporary version of the *qipao* worn by members of the Qing Dynasty, who ruled China from the 17th to 19th centuries. The original version was wide and loose fitting, covering the majority of the woman's body, except the face, hands, and feet. The modern version we recognize today, with its silky fabrics, form- fitting silhouette, high neckline, and side slits, went through many symbolic transformations after the fall of the Qing Empire in 1911. From official high-class call-girl garb in the 1920s to a fashionable symbol of political resistance against Communist oppression in the 1960s, today's stylish party dress has shifted in and out of trends, often due to government crackdowns on its citizens' dress code.

Within this global marketplace, traditionally ethnic dress has begun to transcend borders; the *cheongsam* can just as often be seen on a Hollywood starlet at the Oscars as on a local Chinese woman shopping in Hong Kong. You could easily order one from the Internet or have a custom dress made by your local tailor, "suited" to your personal taste. —SBR

Traditional Chinese cheongsam (qipao) *in red silk, a color considered to attract luck, good fortune, and prosperity.*

Rebirth of the Synthetic

RETURNING WAX PAPER TO ITS NATURAL STATE

According to a Hasidic Jewish folktale, the mystic rabbi Zusya taught his followers that, in the afterlife, he would not be asked, "Why were you not Moses?" but rather, "Why were you not Zusya?"[23] The rabbi invites all who hear his preaching to seek and fully embody their true, unique essence.

A material as processed as wax paper has undergone countless transformations and disintegrations since the days when it was part of a tree in the forest. Has such a material lost its essence, its natural state? And is it possible to return it to the condition from whence it came?

Through a technique known as "pleating," Jacy Diggins has compressed the cellulose fibers used to make wax paper back into their natural state—but not entirely. Her creation appears cavernous and ethereal; a far cry from the original form that once stood in an open-aired woodland.

While the sculpture is elemental in appearance, earthy and almost fungal in shape, the paper has not been returned to its embryonic origins—it has simply undergone yet one more transformation. Some would call it a resurrection or regeneration.

The process brings to mind a line from Bob Dylan's song, "Mississippi": "You can always come back, but you can't come back all the way." —DJS

Husk *by Jacy Diggins.*
Photograph courtesy of Mingei
International Museum,
Andrew Scoggins, photographer

Coral Castle
MASTERPIECE OF STONE

A historical landmark in South Florida, the "Coral Castle" represents more than 20 years of work by one single man, Latvian immigrant Ed Leedskalnin.

From base to roof, Leedskalnin built the entire compound with massive stones, hand tools, and loads of determination. By massive, we're talking several tons each, held in place only by their combined weight. Aside from walls and a nine-ton gate that somehow opens with a push of a finger, he also built an accurate sundial, several rocking chairs (yes, out of stone), tables, and a giant obelisk that functioned as a marker for true north. When asked about how he moved the massive stones, he would make vague references to a "perpetual motion holder" and claimed that he knew the tricks of the Egyptian pyramid builders.

Leedskalnin created the property in honor of his "Sweet Sixteen," a Latvian girl he was engaged to marry but who backed out the day before the wedding. After her refusal, he left Latvia and traveled before settling in Florida, where he began assembling his masterpiece in the 1920s.

Reclusive by nature, no one ever saw how he managed to move the stones. Theories abound, from plausible to incredible, but we may never understand the method, as he did not share his secrets before passing away. —GRG

Exercise 19

GIRAFFE WITH EILEEN SORG

Apply a base layer of dark yellow with yellow ochre for darker areas. Suggest shadows on and around the with light blue-violet. Note the shadow cast by the chin onto the neck. Now use reddish brown for the stem and olive green for the leaves.

Apply light umber to further deepen the periwinkle shadows, fill in the spots, and add ridges around the eyes. Brighten the giraffe with mineral orange, filling in more spots and adding more hair along the neck.

To finish, fill in the eyes and those long lashes with black. Use black to darken the nostrils, dark tufts of hair, and other shadows.

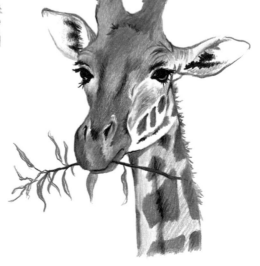

Introduction to Drawing

THE FOUNDATION OF ART

From simple doodles and geometric patterns to photorealistic renderings, drawing can result in a vast range of styles and degrees of intricacy. But the importance of drawing isn't about breadth—it's about what the process cultivates within the artist.

You may have heard the saying, "Drawing is the foundation of all art"; this statement hits the nail on the head. Drawing (most simply described as mark-making on a two-dimensional surface) forces us to concentrate on the most basic of the elements and principles of art as we attempt to represent the world around us. Drawing promotes the study of proportion, form, light, shadow—everything you need to thoroughly grasp before moving on to other forms of visual art, such as painting or sculpture. Essentially, drawing teaches you to see the world as an artist and lay the groundwork as a draftsman.

There's a whole host of drawing media available, from graphite pencil to charcoal, which yields intense, velvety black strokes. Other options include colored pencil, pen and ink, and conte crayon. As exciting and exotic as some of the possibilities sound, I urge you to begin your drawing journey simply with a set of graphite and a set of colored pencils. —ETG

READY TO START?

Here's what you'll need: graphite and colored pencils, pencil sharpener, erasers (kneaded and rubber), blending stumps (also called tortillons), and drawing paper.

Nature in Art

FINDING SUBLIMITY IN OUR SURROUNDINGS

"A morning-glory at my window satisfies me more than the metaphysics of books." —*Walt Whitman*

Try to imagine what would be missing if all references to nature were removed from the history of art. It would be, well, a very bleak landscape! Claude Monet's *Waterlilies,* Beethoven's *Pastoral Symphony,* and Walt Whitman's *Leaves of Grass* are just a few examples of nature's sheer ubiquity in art. Particularly in the realms of painting, drawing, photography, and poetry, nature is a constant source of inspiration for artists.

The cynic in you might not be impressed: "Of course nature is everywhere in art! It's the world in which we live!" Granted, nature aside, the remaining bulk of artistic subject matter consists primarily of people, relationships, and man-made structures, which, taken altogether, pretty much sums up the stuff we see and interact with everyday. But, there remains a special fondness artists have with nature. Its colors, shapes, and shades resonate deeply within us, soothing and exciting us in ways that human creations don't. Why?

Your inner skeptic may be bored again: "Meh; it's probably just an evolutionary thing. We come from nature, so of course we connect with it." Okay; that would explain an appreciation for it as a source of food and shelter. Still though, it remains a mystery why its beauty nourishes us in ways that seem to transcend physical need, and why it stirs our imaginations to reflect it in our own creation. —CKG

QUESTIONS TO PONDER

- *Why do you think the natural world is so often referenced in art?*
- *Why do humans feel so moved and inspired by nature?*

Cubism

ART WOULD NEVER BE THE SAME

W ho has two eyes on the side of his mask-like face and flat, basic shapes for a body? A figure in a Cubist painting, that's who! Though it may seem crude to some, Cubism revolutionized the art world

WHEN & WHERE

c. 1907–1920s

France

like no movement before by questioning the very nature of reality, space and time, the physical world, and the relativity of human perceptions.

Cubism was pioneered by the joint efforts of Pablo Picasso and Georges Braque. The two painters developed an innovative pictorial language that took an unprecedented look at the arrangement of space. Before Cubism, Western art depicted specific subjects in a specific time or place. Picasso and Braque eliminated specifics; their art was a philosophy. The subject of the painting was no longer the focus—now the focus was the painting itself.

Cubism developed in two phases: Analytical and Synthetic. Analytical Cubism involved the deconstruction and analysis of forms, exploring simultaneous, multiple perspectives and confusing the relationship between the figure and the ground. This radical fragmentation reduced forms into geometric shapes, like spheres, cones, and, of course, cubes. They painted how we comprehend objects, not how we see them. Synthetic Cubism, the second phase, was characterized by reconstructing what the preceding phase had torn asunder. Collage, which often combined painting with overlapping bits of paper and found objects, emerged as an art medium.

By redefining truth as relative to one's frame of reference, Cubism's contributions to art history are immense. Its bold, pluralistic steps forward opened the floodgates for all subsequent movements—after Cubism, anything became possible in art. —ARR

Selected artists: Pablo Picasso, Georges Braque, Juan Gris

Salvador Dalí (1904–1989)

THE STUFF OF DREAMS

"I myself am Surrealism." —*Salvador Dalí*

To call Salvador Dalí's art bizarre is, at best, an understatement. Known primarily as a master of Surrealism, a mode of art intended to reflect the network of the unconscious mind, Dalí's work in the genre depicts ordinary objects in strange contexts using dreamlike, sometimes nightmarish, imagery.

This graffiti mural pays homage to the eccentric artist.

Born in Catalonia, Spain, Dalí's childhood was peculiar in its own right. He was born nine months following the death of his brother, who was also named Salvador. Dalí's parents believed that their second son was his dead brother reincarnated, and they subsequently convinced the young boy of the same; this belief both haunted and influenced the artist for the rest of his life.

Dalí was an eccentric man whose audacious nature often sparked controversy and garnered attention, which was precisely his objective. As a student at the Academy of Fine Arts in Madrid, Dalí was expelled just shy of graduation for refusing to take his final exams on Raphael—he brazenly claimed that his knowledge on the subject far surpassed that of his instructors.

In the late 1930s, Dalí moved to a more classical style, which drew sharp criticism from the Surrealists and resulted in his being excluded from the movement; however, painting wasn't Dalí's only artistic endeavor. During his long, diverse career, he also wrote books; crafted jewelry; and designed theatrical sets, costumes, and furniture, including a lip-shaped, pink satin sofa inspired by actress Mae West, appropriately named *Mae West's Lips Sofa*. —RJR

Notable works: *Premature Ossification of a Railway Station*, 1930; *The Persistence of Memory*, 1931; *The Ghost of Vermeer from Delft which can be Used as a Table*, 1934.

Luncheon of the Boating Party

AUGUSTE RENOIR, 1880–1881

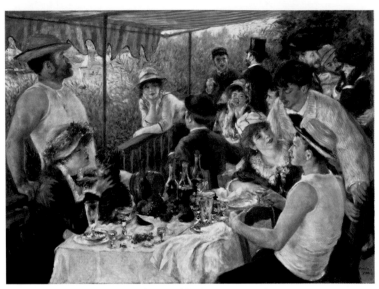

Luncheon of the Boating Party, *1881 (oil on canvas) by Pierre Auguste Renoir.*

The story behind *Luncheon of the Boating Party* by Auguste Renoir is as delightful as the scene itself. This snapshot of leisure shows people taking a lunch break on the banks of the Seine River in France while on a boating excursion. Renoir featured his actual friends in this painting, giving viewers a glimpse into his colorful social life. From a Parisian actress to a local seamstress, his friends spanned the classes and included a variety of artistic talents.

Let's focus on the two prominent people nearest the viewer. The pretty young woman holding the dog at left is a seamstress from Montmartre named Aline Charigot. Nine years after he completed this painting, Renoir married her. She was frequently the subject of his later paintings, which often depicted domestic life and featured their children. The man with the straw hat sitting casually at right is Gustave Caillebotte, a fellow Impressionist painter. In 1882, Caillebotte helped organize an exhibition in Paris where Renoir's *Luncheon of the Boating Party* made its debut.

The painting can also be valued out of context for its intriguing display of human interaction. Spend a moment exploring the possible relationships. Who is looking at whom? —DDG

Into the Woods

YADDO, SARATOGA SPRINGS, NEW YORK

Founded in 1900 by the financier Spencer Trask and his wife, poet Katrina Trask, on 400 acres of woods in upstate New York, the artist community of Yaddo offers peace and seclusion in a supportive creative community away from the distractions of the outside world. Since its founding, more than 5,000 artists—working in all mediums from photography and printmaking to musical composition and dance, and from all nations and backgrounds—have sought artist residencies at Yaddo, ranging from two weeks to a few months. Yaddo's name, pronounced like "shadow," came as a suggestion from their young daughter and grew out of the Trasks' desire to make a permanent home for the expanding art salons they frequently hosted.

Unlike many other small artist collectives that rise and fall due to economic instability or popularity, Yaddo continues to thrive in large part due to public and private donations as well as its strange combination of seclusion from, and access to, New York City. Many also believe the land Yaddo occupies is imbued with mystic good fortune and creative inspiration; in the 1830s, Revolutionary War veteran Jacobus Barhyte's tavern (the current site of Yaddo) was frequented by many well-known writers, including Edgar Allan Poe, who supposedly wrote part of *The Raven* while dining there. Many award-winning artists and writers have since walked the grounds of Yaddo, including Nobel Prize winner Saul Bellow, Sylvia Plath, Leonard Bernstein, and Truman Capote, embracing the Trasks' tradition to "create, create, create." —SBR

Longmen Grottoes

STONE SPLENDORS OF ANCIENT CHINA

Located about eight miles south of present-day Luoyang in Henan province, China, the Longmen Grottoes are a national and international treasure of art and history. The Grottoes resemble a network of honeycombs in the rock walls above the Yihe River. Spread out over a half mile, the carvings within the more than 2,000 caves and niches are dated as early as 493 CE. More than 100,000 stone statues, almost 3,000 stone tablets, and hundreds of bas-relief images of lotus blossoms, dancers, singers, and deities reflect the development of Chinese Buddhism between the 5th and 10th centuries. Most of the statues portray Buddha; some caves, like Wanfo, have more than 15,000 small statues depicting the Buddha chiseled into the rock walls. One cave, aptly named Prescription Cave, contains more than 150 medicinal recipes carved into the limestone walls.

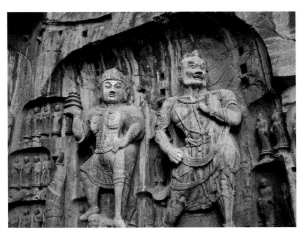

Giant stone statues of a Bodhisattva and the Guardian of the Buddha at Longmen Grottoes, China.

The limestone makes for an easy carving material, but it is highly susceptible to wear and tear from the elements. The slightest amount of water trickling into a surface crack quickly erodes the intricately carved surfaces of the statues, rendering many beyond repair. After UNESCO designated the Grottoes a World Heritage site in late 2,000, the Chinese government, along with many international institutions such as the Getty Foundation, increased their efforts to conserve and partially restore many of the damaged caves and statues. Without their continued efforts, many of these priceless works of art would be lost to future generations of travelers. —SBR

Sand, Hands, and Soul

ILANA YAHAV'S VISUAL STORYTELLING

While some artists have an amazing ability to extemporaneously produce flawless detail with the stroke of a brush, Israeli artist Ilana Yahav takes spontaneous creation to a new level, fashioning precise images from nothing but sand strewn across a glass table.

Ilana Yahav performing before a live audience. Photograph courtesy of Ilana Yahav.

You've Got a Friend. *Photo courtesy of Ilana Yahav.*

Performing before an audience, Yahav manipulates the sand in synchronization with music. Rather than creating one static picture, she weaves a story from a series of images that intersect and intertwine throughout the presentation. The apparent minimalism of her media masks the hypnotic complexity of the end result: a visual, auditory, and narrative masterpiece.

Yahav "stumbled upon" this medium, in her words, after experimenting with various techniques and materials. Regardless of the materials used, however, one consistent factor in all of her work has been the use of fluid hand motions to express emotion. "I fell in love with the idea of drawing with sand," she states, "because of its simplicity. You have to use what God has given you: sand, hands, and soul." —DJS

Crop Circles

ALIEN ART OR HUMAN MASTERPIECES?

Theories of the origin of crop circles range from the mundane to the extraterrestrial. But regardless of their true origin, crop circles have undeniably become a cultural phenomenon and appear by human effort across the globe. Some groups create them to debunk theories of the supernatural, others create them to see how intricate a pattern they can execute, and others even create them for profit by forming company logos in fields the world over.

Geometric crop circle.

The first recorded image of a crop circle (defined as a design or pattern in a field created by flattened crops) dates back to 17th century England. Since then, they have gone from simple circles to complex mathematical patterns, beautiful designs, and even familiar cultural icons.

Some things have remained constant over the years, however: Crop circles generally appear in a field without warning and without substantial evidence of their makers. Many crop circle creators do their work at night, adding to the mystery surrounding the phenomena. Others keep their work secret, letting no one know what they've done and relishing in the stories that take shape around their work.

Though humans do create many of these circles, there remains enough mystery to allow the human mind to wonder. What if aliens really are creating art in our fields? If they are, shouldn't they be paying for the privilege? —GRG

Exercise 20

MARTINI WITH ED TADEM

Start this martini by drawing an upside-down triangle on a stick. Use ovals for the base and olive.

Rough in the liquid and an olive in the glass. Add toothpicks to the olives.

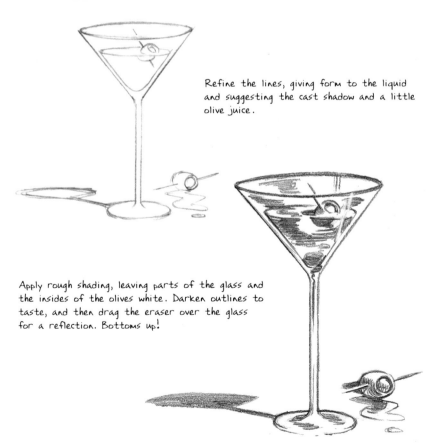

Refine the lines, giving form to the liquid and suggesting the cast shadow and a little olive juice.

Apply rough shading, leaving parts of the glass and the insides of the olives white. Darken outlines to taste, and then drag the eraser over the glass for a reflection. Bottoms up!

Drawing What You See

MOVING BEYOND WHAT YOU IMAGINE

Although it's not something we think about consciously, humans have stylized ideas of what every object looks like, and we often translate this to our drawings and paintings. For example, we might draw a face with circles for eyes and a triangle for the nose. However, once we learn to really observe an object, we find that our ideas can interfere with our ability to render realistically. Below are a few exercises to help you draw what you really see instead of what you think you see.

Negative Space Drawing

This exercise forces you to draw only the negative space of a scene. If you try this, you'll notice yourself focusing more on the accuracy of shapes than how you think the objects should look, resulting in a more realistic representation.

Drawing Upside Down

If you've taken an art class, you've probably learned this one. Simply draw from a reference that has been turned upside-down. You'll find that disorienting yourself a bit will again bring your focus on the shapes and distract you from your brain's misleading ideas.

Grid Drawing

Using a photocopy of your reference (so you don't ruin the actual photo), draw a grid of squares over your image. Then lightly draw a corresponding grid of squares over your canvas or paper. The intersections of lines will act as guides as you record what you see in each square of the reference into each square of your drawing or painting surface. —ETG

TRY THIS!

Throughout the drawing and painting process, hold up your work in front of a mirror. This can help you see and correct inaccuracies in proportion.

Patterns of Beauty in Nature and Art
THE GOLDEN RATIO AND THE FIBONACCI SEQUENCE

"If there is a God, he's a great mathematician." —Paul Dirac

What do the *Mona Lisa,* the Parthenon, and a common pinecone have in common? They all conform to a specific mathematical ratio, called the "Golden Ratio," that has fascinated the world's great thinkers for millennia. It may surprise you, but there is an intimate and longstanding relationship between beauty, art, and math.

One of the easiest ways to define the Golden Ratio is through the famous sequence of numbers named after the mathematician Fibonacci. See if you can identify the pattern in the following set of numbers: 0, 1, 1, 2, 3, 5, 8, 13, 21, 34... Each number is the sum of the previous two numbers. When you divide any of the numbers (after the first few) by the one before it, you get roughly the same number (about 1.6, or ϕ), and the value becomes increasingly refined as the numbers get larger.

This "golden" proportion, when applied visually, creates specific kinds of rectangles and spirals whose precise shapes we find all over the place in nature. Cones, shells, and flowers, for example, typically illustrate the pattern in the elegant arrangement of their features. The uncanny recurrence of the ratio in nature, and its mysterious connection with beauty, has inspired many artists, from Dalí to the architects of the Great Pyramids, to employ it in their own compositions. —CKG

QUESTIONS TO PONDER
• *Why is this pattern found so often in nature?*
• *What would make one set of proportions more beautiful than another?*

The Ashcan School and The Eight

THE FIRST STREET ART

Artists of the Ashcan School drew creative inspiration from the vibrant landscape of New York City in the early 20th century. Featuring non-idealized slices of American life, Ashcan imagery ranged from streetcars on muddy roads and quaint family scenes to women drying their hair on rooftops in lower-class neighborhoods.

WHEN & WHERE

c. 1908–1918

New York City, USA

Members of the Ashcan School focused on the often gritty realities of urban life, resisted the oppressiveness of academic art, and believed that any subject matter was valid. Some members had a newspaper illustration background that allowed them to quickly capture a scene in real time. This emphasis on drawing and the somber tones of the city contributed to a lack of extreme color in their thickly painted work.

In 1908, Robert Henri gathered eight of the Ashcan artists, cleverly calling them The Eight, and put together a show that marked a milestone for American modern painting. The literal nature of the artwork shocked a general public accustomed to the academic conventions that these artists detested.

This small group of young artists was able to find beauty in places previously unexplored, and the American Scene Painters of the '20s and '30s continued what the Ashcan School began, honoring the real people of America. —ARR

Selected artists: The Eight—Arthur B. Davies, William Glackens, Robert Henri, Ernest Lawson, George Luks, Maurice Pendergast, Everett Shinn, and John Sloan; Jacob August Riis, George Bellows, Guy Pène Du Bois, Edward Hopper, Alfred Maurer

> **FACT**
> *This movement received its name from a disparaging critic who was less than enchanted by the rawness of its themes.*

Albrecht Dürer (1471–1528)

DESTINED FOR GREATNESS

Albrecht Dürer was an accomplished painter, draughtsman, and print-maker whose profound methodological, mathematical, and scholarly approaches to his crafts established him as the premier artist of the German Renaissance. A highly intelligent man, Dürer wrote a number of theoretical discourses on proportion and perspective in art. Evidently conscious of his own talent and virtuosity, the artist also had a penchant for creating flattering self-portraits.

Albrecht Dürer's Nuremberg home is today a museum dedicated to the artist's life and work.

Dürer was born in Nuremberg, Germany. As a teen, he apprenticed with painter and woodcut artist Michael Wolgemut; he then traveled a bit before returning to his native country to marry Agnes Frey in an arranged union.

Although Dürer's artistic talent was evident at an early age, he ultimately came into his own during visits to Italy in 1494 and 1505, respectively, where he drank in the exquisite beauty of the Italian Renaissance masters. A number of Dürer's works following these visits feature a variety of allegorical, mythological, and religious themes with a marked Italian influence. Dürer also possessed a deep appreciation of nature—demonstrated in his vivid watercolor landscapes—and a desire to perfect proportions, which accounts for his superior renderings of human and animal subjects.

As Dürer's oeuvre grew, so did his fame and reputation. He was the painter to the Holy Roman Emperors for much of his career. —RJR

Notable works: *Self-Portrait*, 1500; *A Young Hare*, 1502; *Adam and Eve*, 1504.

FUN FACT

Already confident in his artistic abilities, Albrecht Dürer drew his first self-portrait at the age of 13—well before he began his art apprenticeship.

Vanitas

WILLEM CLAESZ. HEDA, 1628

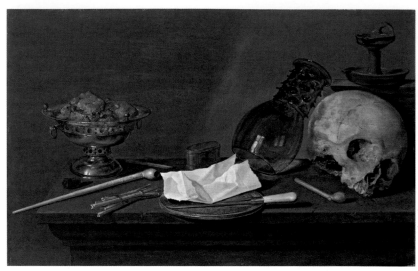

Vanitas, *1628 (oil) by Willem Claesz. Heda.*

This rather ominous work by Dutch artist Willem Claesz. Heda belongs to a genre of symbolic still life paintings popular in the 1500s–1600s. These paintings, of which Heda's work serves as an example, were used to communicate essential lessons about life's brevity and the emptiness of earthly pleasures and possessions. In fact, *vanitas* is a Latin word that translates to "emptiness." A Biblical passage from the book of Ecclesiastes was often associated with these paintings, most of which were titled *Vanitas:* "Vanity, vanity, all is vanity," or as a more modern translation bluntly declares, "Everything is meaningless... completely meaningless!"

Heda's painting depicts the ephemeral nature of life, and the objects he has chosen for his spiritual statement serve as a symbolic vocabulary. The most obvious symbol is the skull, which of course reminds us that at some point we all must face death. The dying coals and the overturned wine glass reinforce this message.

Few modern viewers are likely to find *Vanitas* very inviting, but the potency of its visual symbolism proves Heda's still life subjects to be an ideal vehicle for his message. —DDG

Pilchuck Glass School

HAND-BLOWN ART

If you want to see one-of-a-kind glass works, be prepared to get wet! Set on 54 acres of beautiful forests north of Seattle, Washington, Pilchuck Glass School was founded in 1971 by world-renowned artist Dale Chihuly. Chihuly is the creator of glass sculptures found in museum and private collections the world over, including Seattle art patrons John and Anne Hauberg.

An artist puts the finishing touches on his glass creation.

Begun as an experimental summer project for Chihuly and a handful of his artist friends, the makeshift residences and studios on the former tree farm took root, with help from Chihuly's friends, including radical mixed-media artist Italo Scanga and the uncommon generosity of the Haubergs. The school has attracted artists (specializing in all different media) every summer to teach, create, learn, and expand their creative horizons surrounded by a community of other passionate art makers intent on learning the intricacies of glass. But the school isn't just about blowing glass; you can learn about hot and cold glass techniques, neon art, stained glass, engraving, flame-working, and multimedia sculptural processes.

Every year in the spring, Pilchuck opens its doors for the public to view the spectacle of glassblowing up close and to learn about glass-making procedures from working artists in their studios. Visitors also have the opportunity to take a bit of Pilchuck with them: The school offers works of art for purchase during their annual Art Auction. —SBR

Hahoe Mask Dance of South Korea

PERFORMING SOUTH KOREAN HISTORY

What kind of spectacle combines drama, intrigue, rhythmic drumming, elaborate costumes, and masked dancers bounding around a stage encircled by a rapt audience—a Las Vegas show? The latest hit from Broadway? Or perhaps an 800-year-old South Korean dramatic satire filled with over-the-top performances? The Hahoe Mask Dance is one of Korea's most traditional folk plays, originally performed to appease local deities and exorcise evil spirits to ensure a bountiful harvest. Both the dance and the city for which it is named, Pungcheon Hahoe village in Andong, South Korea, are considered national treasures and recognized by UNESCO as a tentative World Heritage site. The village, notable for its preservation of 16th century architecture, writings, and variety of ancient folk arts, traditionally hosted the masked dance starting on New Year's Day with festivities that lasted up to two weeks. The Hahoe Mask Dance involved a cast of characters drawn from all areas of society—the arrogant aristocrat, a Buddhist monk, a dull scholar, and a naïve bride, to name a few.

Two players perform the Hahoe Mask Dance before a crowd.

Currently, the dance is performed by Hahoe Mask Dance Drama Preservation Society members for village members and tourists alike, every weekend beginning in late spring. The mask dance has lost much of its original ritualistic significance and is performed today as an entertaining chapter of folk art history. —SBR

!

Nothingness
INTO THE VOID OF IVES KLEIN

Why are you so petrified of silence? Here, can you handle this...
—"All I Really Want," Alanis Morissette

Ives Klein harnessed the palpable tension many individuals associate with emptiness as the principle medium for *Le Vide*, a walk-through exhibit consisting of nothing more than a whitewashed room.

Artists throughout history, from ancient Japanese gardeners to postmodern minimalists, have made use of empty space to purposefully call attention to an object of interest. Klein, however, took this concept one step further by focusing the observer on the emptiness itself; the experience is purposely unnerving.

Sigmund Freud wrote volumes on the human tendency to fear "the shadow." Many fear the unknown that may lurk in the darkness. "From ghoulies and ghosties and long-leggety beasties, and things that go bump in the night, Good Lord, deliver us," prayed the pious inhabitants of rural Cornwall and Scotland.

In *Le Vide*, Klein presents us the inverse of the shadow—the fearsome sterility of empty, white light. The void threatens to reveal to us that, in the unknown recesses of the universe, we may find neither beast nor fiend, but rather cold, indifferent nothingness staring back at us. —DJS

La spécialization de la sensibilité a l'état de matiére première en sensibilité picturale stabilisée, *Galerie Iris Clert, Paris, France, 28 avril–mai 1958.*

The da Vinci... Horse Picture?

NOT QUITE A SECRET MESSSAGE, BUT CLOSE

D id Leonardo da Vinci leave secret messages on the backs of his paintings? Is there a map to a treasure the Vatican is dying to keep secret behind the *Mona Lisa?* Maybe not, but in 2008 curators at the Louvre discovered some previously unknown sketches on the back of one of his paintings, *The Virgin and Child with St. Anne.* What did they find, you ask? Some hidden message, map, or code to be cracked? Actually, they found three sketches: a skull, a horse, and baby Jesus with a lamb.

While this may not be mystery-thriller novel material, it's a very exciting development in the art community. Although artists often use the back of what they are working on to sketch out ideas, this is the first known example of Leonardo da Vinci doing the same.

This hadn't been noticed before because the painting was completed on four heavy planks of wood and is very difficult to take down. Even when these sketches were noticed, they were originally thought to be stains. Only under infrared photography did the actual images emerge.

So, while not a real life da Vinci code, these images are still an incredible find.
—GRG

Exercise 21

HORSE WITH EILEEN SORG

Shade the muzzle, nostril, and eye with blue-gray; then add blush pink to areas on the muzzle and nose. Lightly stroke orange on the upper part of the face and nose, as well as around the muzzle, jaw, and neck. Use heavier presure for the inner ear, mane, and eyelashes.

Fill in the rest of the head and neck with brown, avoiding the orange areas. Trace the outline of the eye with dark brown.

Apply dark brown over the brown along the base of the mane, behind the ear and jaw, and around the eye. Fill in the iris with the same color. Use black to deepen shadows and to fill in more of the eye, mouth, and nostril. Finally, add highlights to the mane and nose with yellow.

Graphite Pencil

DISCOVERING THE POTENTIAL OF AN EVERYDAY TOOL

Graphite pencil is a great starting point for a beginning artist. Not only do you have most of the materials lying around the house, but you can use a little something called an "eraser," which makes experimentation a lot less scary.

Start out with an understanding in pencil hardness. The lead (or graphite center) of each pencil is labeled by number and letter. "H" pencils are hard and produce light lines, whereas "B" pencils are soft and create darker lines.

You may want to purchase a set of pencils with a range of hardness levels. Create little gradations of each pencil, moving from dark to light by changing the amount of pressure applied. This will give you a feel for the values you can produce with each. Note the differences in value above between a 6B (left), HB (middle), and 3H (right).

The higher the number that accompanies the letter, the harder or softer it is. HB and F are not considered hard or soft. Beware of the extremes; super-hard pencils can scratch your paper, and super-soft pencils smudge easily. (Note that the common "number 2" pencil is actually an HB.)

A common shading technique for graphite is called hatching *(left), which involves filling in an area with parallel marks. Crosshatching, at right, builds on hatching with additional layers of parallel strokes.*

Use a blending stump (rolled paper) to create soft blends by rubbing it over the graphite. (Avoid using your finger, which leaves oil on the paper.)

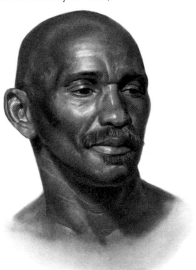

Some people might be tempted to dismiss pencil as an informal medium used for sketching or creating studies before working in another medium. In fact, as evidenced by the piece at left, graphite pencil can be used to create stunning, photo-realistic work. —ETG

Portrait of Anthony Ramey in graphite by Lance Richlin.

Animals, Art, and Consciousness

WHERE ARE THE LINES?

"All animals are equal but some animals are more equal than others."
—George Orwell

Creativity and art are typically thought to be exclusively human domains. We see lots of beautiful patterns in nature, and animals do some pretty clever things, yet we usually don't consider such occurrences to be art. We also tend to assume that non-humans do not appreciate art. My cat doesn't seem to enjoy Mozart any more than the sounds of the trash truck outside.

We don't talk about beauty as art unless it's created on purpose by an intelligent mind. But what about the behavior of some more sophisticated animals, like the elephants that we see on page 16? They hold paintbrushes, dip them in paint, and carefully produce clear, recognizable images on canvas. Is it art? In one sense we say yes, but a skeptic might say no, arguing that the elephants have no concept of art but are simply trained to reproduce the creative acts of their human trainers. We can then point to the studied work of gorillas and chimpanzees who willfully paint pictures of their companions and surroundings, sometimes from memory. At that point it seems silly not to call their work art.

When we see art created and enjoyed by animals other than humans, it raises a whole bunch of really tricky, touchy issues. When an ape draws a picture and conveys an abstract understanding of its content, we are immediately faced with major arguments not only about consciousness, but ethics, anthropology, and even theology. It's just another way art gets to the core of who we are and what we believe. —CKG

QUESTIONS TO PONDER
• *What level of consciousness is needed to create art?*
• *What kinds of issues might be raised by a gorilla's creation of art?*

Futurism

BURNING WITH LIFE

Dynamic, young, and energetic, Futur-
ists embraced the new and rejected the
inertia of the old with a fiery passion. Sur-
rounded by the exponential technological
growth of the industrial revolution, these
artists demanded that art follow suit. They relished humankind's dominance
over nature and violently trampled over anything static with their painting,
sculpture, music, and poetry. To the Futurists, matter equaled energy.

> **WHEN & WHERE**
> *c. 1909–1915*
> *Italy and Russia*

The urban landscape, machines, dancers, and abstract images of movement
and sound defined the Futurists' frenetic works. These artists also utilized
simultaneous moments in time, as in Cubism, but depicted moving objects—
not just shifting viewpoints. They were also inspired by the energy of Seurat's
optical mixing techniques and Edward Muybridge's photographs of animals
in motion.

This movement included both the Italian and Russian Futurists, although
the achievements of the more aggressive Italian group often define the move-
ment. In 1909, Filippo Marinetti wrote the powerful *Manifesto of Futurism* in
response to what he believed was the oppressive antiquity of Italy. Though
Marinetti was the most vocal of the group, Umberto Boccioni and Giacomo
Balla created the work that visually defined Futurism. Despite their obsession
with progress, they scorned new ethical ideas like Feminism, and their Fascist
associations eventually lost them favor. Some say the legacy of Futurism can
still be seen in Western culture's obsession with all that is young and new.
—ARR

Selected artists: Giacomo Balla, Carlo Carrà, Umberto Boccioni, Virgilio
Marchi, Filippo Tommaso Marinetti, Luigi Russolo, Antonio Sant'Elia, Gino
Severini

Paul Gauguin (1848-1903)

FROM STOCKBROKER TO SYMBOLIST

Paul Gauguin was born to a radical French journalist father and Peruvian-Creole mother. Soon after Gauguin was born, the family fled France for Peru to escape persecution for his father's outspoken opinions. As fate would have it, Gauguin's father subsequently died on the voyage, and the family spent the next few years living with relatives in Lima before returning to France.

After traveling the world with the navy, Gauguin settled in Paris where he became a stockbroker; he married in 1873 and eventually had five children. Gauguin enjoyed painting as a pastime, but he did not pursue it seriously until 1874 when he formed a deep friendship with Camille Pissarro, who also became his mentor. Gauguin exhibited with the Impressionists three times in the years that followed his 1876 debut at the Salon, and an economic downturn in the early 1880s opened the door for him to pursue art full time—although it also negatively affected his finances. His wife moved back to her native Denmark with the children while Gauguin stayed on to paint in Paris.

Gauguin's rich cultural background and world travels undoubtedly contributed to his artistic sensibilities, and by the 1880s, he was living primarily in the South Pacific. He eventually moved away from Impressionism in favor of a bolder, flatter style that gave way to more symbolic meaning, and his art took on a distinctly primitive flavor. He liked to paint tribal island life untouched by the influence of Western European colonization, which he resented immensely. He spent the last several years of his life living and painting on various South Pacific islands. —RJR

Notable works: *The Arlesiennes (Mistral)*, 1888; *Ancestors of Tehamana*, 1893; *Where Do We Come From? What Are We? Where Are We Going?* 1897.

FUN FACT

At the time of Gauguin's death, he was awaiting a three-month long incarceration for openly disparaging the Catholic church and speaking out against colonialism in the South Pacific.

Snap the Whip

WINSLOW HOMER, 1872

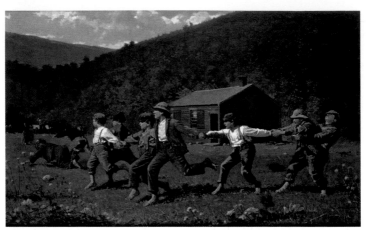

Snap the Whip, *1872 (oil on canvas) by Winslow Homer. Movement: 19th Century American Art.*

Boston-born artist Winslow Homer began his career first as an apprentice to a lithographer; then he became an illustrator. Homer is best known, however, for his evocative oil paintings of seascapes and of American life in the latter half of the 19th century.

In *Snap the Whip* we find young schoolboys playing a vigorous game that was a test of their strength and tenacity. The object of the game was for the participants to remain standing and connected, hand in hand, as the human "whip" snapped. The painting was first exhibited at the 1876 Centennial Exposition in Philadelphia where it was much acclaimed, although Homer's potentially "sentimental" subjects were frowned upon by a few elite critics.

This childhood scene may evoke a sense of wistfulness in modern viewers; its imagery recalls a simpler, more rural way of life that seems lost to our hi-tech world. Viewing audiences in the 19th century would likely have experienced similar nostalgia. At the time, in the wake of the Civil War and as urbanization increased, many of the little red schoolhouses, such as the one depicted here, were beginning to disappear across America. Today Homer's continuing ability to inspire a longing for days-gone-by through his paintings is one of many reasons that he remains a beloved American artist. —DDG

Dorland Mountain Arts Colony

ART OFF THE GRID

Founded as a non-profit arts commu-
nity overlooking the Temecula Valley
in California, Dorland Mountain Arts
Colony began as the 1930s homestead of
Ellen and Robert Dorland, who built an
adobe structure on the site as a weekend
getaway from their home in Pasadena.
Ellen Dorland, an accomplished pian-
ist and teacher, dreamt of re-creating
an artist colony similar to the ones she
had visited on the East Coast; however,
she wanted it to be surrounded by the
rustic wildlife of southern California,
where visiting artists could work unen-
cumbered by the noise and pace of the
modern world. Originally planned with-
out the technological conveniences of
telephones, electricity, or television, the

*Horton Cabin for writers at Dorland before the
2004 fire. Photo courtesy of Dorland Mountain Arts
Colony.*

Dorlands' private retreat for friends and family quickly evolved into a ha-
ven by 1979, attracting more than 1,200 visual artists, writers, and composers
from across the globe. The colony, recognized by the Nature Conservancy as a
wildlife preserve and sacred Native American burial ground, is determined to
safeguard the heritage of its lands for future generations. Many world-famous
artists and musicians, like jazz legend Mason Williams, continue to show their
support for the colony by lending their talents to fundraising concerts and
events.

Tragically, in 2004, a wildfire swept through the colony, destroying all 10
buildings on the property and charring almost 9,000 acres. After five years
of fundraising, the colony is rising from its ashes; work has begun on new
574-square-foot cottages (which will have electricity) to house artists seeking
both muse and solitude amid the scenery. —SBR

"Tiger and Magpie" Paintings
NEW YEAR'S GREETINGS FROM KOREA

Almost every culture—through art, music, or myth—gives certain animals human-like characteristics and abilities. In the South Korean folk art paintings called *minhwa,* popular during the Chosun period (1392–1910), the images of the tiger and the magpie contain many powerful and protective qualities. These two animals are often paired in paintings, as the magpie is a bringer of joy and good tidings, and the tiger is a powerful symbol used to repel evil spirits. Traditionally, the chattering bird is usually depicted in paintings just out of reach of the frustrated tiger's claws in the upper branches of a pine tree (a symbol of the New Year).

The magpie and tiger are common imagery in South Korean art.

The magpie and the tiger represent a variety of superstitions and beliefs. Some claim the tiger is a noble, fierce, and loyal guardian and a friend to man. The magpie is alternately seen as a noisy thief or a harbinger of good luck. During the 19th century, tiger and magpie paintings were hung at the entrances of homes or painted directly on the front gates, replaced every year on New Year's Day to ensure prosperity for the following year. Today, the images of the tiger and the magpie can be seen in the most unconventional of places, from postage stamps and tourist items to celadon pottery and tattoo designs! —SBR

Sand Mermaids

BEACH SCULPTURES OF JEFF SHERMAN AND LILA FULTON

Jeff Sherman and Lila Fulton's award-winning sand sculptures are the product of artistic talent, professional experience, and the boredom of a small child.

Jeff and Lila have sculpted and painted entire families of mermaids on the beaches near their Southern California home since 1996. An accomplished massage therapist, Jeff forms the inanimate sand with the same finesse he devotes to his clients. Lila attends to the finer details of the sculptures.

Mother & child. *Photo courtesy of Jeff Sherman.*

Sirena by Tower. *Photo courtesy of Jeff Sherman.*

Since winning "Best of Show" in 2002 at a contest in Newport Beach, California, the couple has participated in several sand-sculpting competitions, earning second place in the US Nationals. A series of fine-art prints and notecards has been printed featuring their mermaids, with more to follow.

Jeff and Lila's technique, however, came about by accident. While commissioned to create a mural on the wall of a home in Laguna Beach, the couple brought their daughter along. The girl quickly grew bored watching them paint and asked her parents to bury her in the sand, requesting a mermaid tail for good measure.

Sounds like their young daughter was a nascent aficionada of unexpected art forms. —DJS

Fig Leaves
COVER THINE NAKEDNESS

"Then the eyes of both were opened, and they knew that they were naked; and they sewed fig leaves together and made loincloths for themselves."
—*Genesis 3:7* Holy Bible NRSV: *Catholic Edition*

With that one simple verse, the fig leaf became a symbol of censorship and has been used for ages to cover up not just nakedness, but anything that "the powers that be" might find offensive.

Following the Renaissance, a movement toward modesty and propriety resulted in the application of fig leaves over paintings, sculptures, and any other art that showcased exposed genitals. Even the work of great masters was not immune.

Bronze sculpture sporting a fig leaf.

There is some controversy about restoring these works to their original non-fig-leaf glory. In many cases, removing the fig leaves could do more damage to the original than leaving them in place, especially in cases where the leaves were attached to sculptures using rods drilled into the stone. Ouch!

In either case, fig leaves probably aren't going anywhere any time soon. We can only hope that people today have the good sense not to haphazardly and permanently attach them to anything they might deem offensive. —GRG

Exercise 22

PINEAPPLE WITH ED TADEM

Draw an oval for the pineapple and two curved guidelines for the leaves. Then draw a criss-cross pattern that curves around the form of the pineapple.

Draw the leaves, making them smaller and more condensed at the base and wider and longer at the top.

Using the gridlines as a guide, create the diamond shapes. Round off the edges to give the shapes form and makes them appear three-dimensional.

Now add spikes to each diamond shape, pointing each one upward.

Shade with lines that follow the forms, emphasizing the grooves between the shapes and keeping the left side of the pineapple darker.

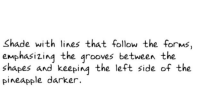

Introduction to Pastel

A MEDIUM OF IMMEDIACY

Although some artists argue over whether pastel is a painting or drawing medium, many agree that it combines the best of both worlds. It offers the color and richness of painting with the control of drawing—and because there is no brush or palette between you and the paper, you'll find it an intimate and tactile experience. The medium is extremely versatile in appearance; you can create delicate strokes, bold strokes, soft blends, rough textures, or airy sketches. And pastel involves no drying time, so colors stay as true as the moment you stroke, making it perfect for the spontaneous artist who treasures immediate results.

Pastels are powdered pigment mixed with a binder and packed into sticks. They are available in both hard and soft varieties, with the softer pastels containing a higher pigment-to-binder ratio. You can also find them in pencil form, which offers a clean alternative to sticks.

Oil pastels are much different from the "dry" pastels mentioned above. These oil-based sticks have a creamy consistency and yield more vibrant hues. They aren't used in combination with dry pastels; however, they can be used effectively alongside oil paints.

Paper is an important part of the pastel equation. No matter what type of pastel you choose, work on paper that has a textured surface so the raised areas catch and hold the pastel. You might also opt for toned (or colored) paper, which eliminates distracting bits of white from showing through your final piece. —ETG

READY TO START?

Here's what you'll need: pastels (a 12-piece set is a fine start), textured paper, soft rags for blending, blending stumps, drawing board or tabletop, and newspaper to place beneath your textured pastel paper.

Art as Therapy

ESCAPING THROUGH EXPRESSION

"…Sometimes I wonder how all those who do not write, compose or paint can manage to escape the madness, the melancholia, the panic fear which is inherent in the human condition." —Graham Greene

The creation of art is often described as an escape, but the diversion is not always a lighthearted one. Ask some people why they create art and they won't say "because I want to," or "because I like to," but "because I have to." For many, art is not just a pleasant hobby or a talent with which they can make money, but rather a necessary way to release pain or even cope with life. It enables them to express and comprehend abstract feelings that ordinary methods of communication and reflection fail to grasp.

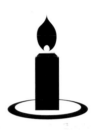

Creativity can profoundly reduce anxiety and depression, and has even been shown to help people heal from psychological trauma. It offers a unique and mysterious outlet for emotional distress. But what is it about the imagination that can soothe and even heal? As usual, opinions are not hard to find, but there seems to be agreement between everyone from medieval scholars to modern psychiatrists that solitude is an essential component of therapeutic art.

Temporary isolation from the burdens of reality can make it easier for us to find mental relief. Then, we can then find comfort in our own creation.
—CKG

QUESTIONS TO PONDER

• *How has creativity helped you find relief or clarity during hardship?*

• *Why does art comfort us in ways that nothing else can?*

Russian Avant-Garde

ABSTRACT REVOLUTIONS

Basic geometric shapes and clean, utili-
tarian designs; the Russian Avant-Garde
was radical in its non-objectivity. Russia had
been in social and economic crisis. The Rus-
sian Revolution of 1917 not only liberated

> **WHEN & WHERE**
> *c. 1913–1934*
> *Russia and Ukraine*

the proletariat; it also inspired artists to completely deconstruct the old art of
the fallen monarchy. They strove to remove all excess and find the spirit and
common good in the austere. The Suprematism and Constructivism move-
ments are the highlights of this utopian era.

To Kazimir Malevich, fundamental geometric shapes—squares and circles—
were the ultimate abstraction and essence of art, and the only forms capable
of communicating "pure feeling." Suprematism developed in 1913 with
Malevich's aptly titled painting *The Black Square*. In his own words: "The
square=feeling, the white field=the void beyond this feeling."[24] To Malevich,
rendering recognizable objects from the real word is a lie, and supreme reality
exists in non-representational forms.

By 1918, Russia had become the Soviet Union and the dominant abstract
art was Constructivism. No longer was "feeling" paramount; art was to be
repurposed for the good of the people. Utilitarian designs with an abstracted,
machinelike aesthetic were engineered with the optimism of a new order.
Sculptures and architectural models made of industrial materials were
vehicles for socialist ideals.

Neither movement withstood the enforcement of Socialist Realism controlled
by Joseph Stalin. Although they were no longer free to make revolutionary
work, their work had created a revolution in Western art. —ARR

Selected artists: Naum Gabo, El Lissitzky, Kazimir Malevich, Laszlo Moholy-
Nagy, Liubov Popova, Vladimir Tatlin

Frida Kahlo (1907–1954)

VIVA LA VIDA!

"I paint self-portraits because I am the person I know best."

—Frida Kahlo

If ever an artist possessed the ability to chronicle her life on canvas, it was Frida Kahlo. Colorful, gripping, and psychologically expressive, Kahlo's art was a cathartic means for her to express her deep emotional anguish over the traumatic events that shaped her life. Among them, a childhood attack of disabling polio, a tragic accident that left her in lifelong pain and affected her ability to have children, and a distressing relationship with husband and fellow artist Diego Rivera.

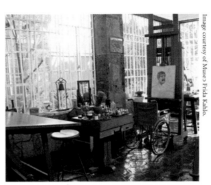

Inside la Casa Azul—today the Museo Frida Khalo.

Kahlo was born and raised in Coyoacán, Mexico, in *la Casa Azul,* or the Blue House—today the Frida Kahlo museum. A spirited and determined child, Kahlo attended the National Preparatory School and intended to study medicine; however, at just 18 years old, she sustained life-altering injuries to her back, collarbone, ribs, and pelvis when the bus in which she was riding collided with a trolley. She began oil painting during her recovery.

When Kahlo was 21, she married Rivera, a well-known Mexican muralist. The relationship, while passionate, was also turbulent due in large part to Rivera's numerous infidelities. "I suffered two grave accidents in my life," Kahlo once said. "One in which a streetcar knocked me down…the other accident is Diego." The marriage ended in divorce, but the couple reconciled and remarried a year later.

Kahlo's final painting before her death depicts a group of watermelons, one of which bears the prophetic expression *"Viva la Vida,"* or "long live life." To be sure, Kahlo's art is not just full of life, but will continue to live on through the ages. —RJR

Notable works: *Frida and Diego Rivera,* 1931; *The Two Fridas,* 1939; *The Broken Column,* 1944.

Portrait of Pope Innocent X

DIEGO VELÁZQUEZ, 1650

In 1650, Spanish artist Diego Velázquez painted this portrait of Pope Innocent X while traveling through Italy. The pope, who was 75 at the time of the sitting, was known for his temperamental nature and rough appearance—and Velázquez showed no reservation in depicting those qualities in his portrait. Generally artists were forgiving in their representations of their subjects, but through the hot stare of this pope, we know that Velázquez opted for a more realistic approach.

Portrait of Pope Innocent X, *1650 (oil on canvas) by Diego Rodriguez de Silva y Velázquez. Movement: Baroque.*

If the measure of a painting's success is determined by its influence on other artists, *Portrait of Pope Innocent X* is a smash hit. In general Velázquez impressed a number of famous painters with his raw and unglamorized approach, but this particular painting received special attention from figurative painter Francis Bacon (1909–1992), who created a few haunting interpretations of this enthroned pope. —DDG

Collecting Art

NOT JUST FOR THE RICH AND FAMOUS?

Collecting art is an exciting mix of treasure hunting, art history, innate curiosity, intuition, and luck. In the art world, many institutes—museums and galleries alike—devote large portions of their budgets to send directors and curators to "scout" works at art fairs, and in private collections and art exhibitions around the world. But what about the everyday person who would like to start collecting art?

No matter what kind of art you collect, it should be something you will enjoy for years to come.

When it comes to collecting, many people may feel intimidated by the perception that art collecting is out of their price range. But collecting art is not limited to only the rich, famous, and/or those academically trained individuals holding multiple degrees from prestigious universities. You can easily start a collection without a six-figure salary; attending gallery openings will introduce you to new and emerging (and more affordable!) artists in your area. Talk to the artists at the openings, introduce yourself to gallerists, and go to museum events—the more exposure to contemporary art, the better! Though many find it helpful to be independently wealthy and knowledgeable in the provenance (or the history of ownership of the object), condition, and current market values, it is not required. Have fun and trust your instinct—if you are going to have to live with this work of art for a while, you might as well enjoy it! —SBR

Sumi-e

THE ART OF JAPANESE BRUSH PAINTING

Brush painting has been a major art form in Japan, China, and Korea for more than 2,000 years. The ink and wash style of painting was developed in China and brought to Japan by Buddhist monks in the mid-14th century. Sumi-e, as it is called in Japan, and calligraphy (the art of writing beautifully) share many similar aesthetic and meditative characteristics. Unlike many other artistic techniques that favor a buildup of paint, often through thousands of marks on the canvas, Japanese ink wash paintings are prized for embodying the essence of a person, an animal, or a landscape with just a few strokes of the artist's brush dipped exclusively in tints and hues of black. The tools of brush, ink, ink stone, and paper are called the Four Treasures; the brush is typically made from bamboo and boar, horse, or wolf hair. The ink is not really a true ink but an elaborately decorated stick made of charcoal and glue which is rubbed in water on the stone to form black ink, or sumi-e.

The art of Japanese sumi-e.

Sumi-e was an important part of the cultural exchange between Japan and Europe during the 19th century. Western artists were inspired by the refined spirit of Japanese ink brush painting; many iconic works of art by Cézanne, Gauguin, and Matisse reflect their interest and integration of sumi-e's style and subject matter. Sumi-e continues to be embraced by artists today looking to express themselves through the highly restrained yet spontaneous gestures inherent to this graceful art form. —SBR

Drawn to the Ocean

JIM DENEVAN'S FREEHAND BEACH DRAWINGS

Traversing the sand at low tide, Jim Denevan pulls a rake in time with the rhythm of the waves, appearing to waltz with an inanimate partner across some antediluvian ballroom floor.

On the beaches of northern California, Denevan creates gigantic circles, spirals, and straight-edged patterns. Astoundingly, none of his freehand drawings are calculated or measured. Denevan achieves precision through a technique he learned as a surfer known as the "line-up"—he finds an object in the distance and orients his movements according to this horizontal focal point.

Photo courtesy of Jim Denevan.

At times, Denevan's body language bespeaks the monastic deliberation of some desert mystic lost deep in thought. Indeed, the artist has appropriately described the beach as his "cathedral"; after a medical crisis in his family years ago, he found a cathartic outlet in sand drawing. There is something in Denevan's work reminiscent of the Nazca lines of pre-Hispanic Peru (page 46), which may have been "prayer lines" ritualistically walked by ancient shamans.

Ever the modest creator, Denevan walks to the top of a nearby cliff after finishing a drawing, crouching to watch the crowds that invariably gather below. A withdrawn spectator, he watches the tide's inevitable march inward as his handiwork is slowly wiped from the sand. —DJS

Photo courtesy of Jim Denevan.

The Gardner Heist

THE LARGEST ART THEFT IN HISTORY

On March 18, 1990, two men walked into the Gardner Museum in Boston, Massachusetts, and pulled off the largest art heist in history.

For an hour and a half, these men (clad in police officer attire) moved unchecked through the museum, cutting priceless masterpieces out of their frames and taking whatever appeared to strike their fancy. By the time they were done, the two thieves walked out with 13 pieces valued at several hundred million US dollars.

Strangely, the museum's most valuable piece, Titian's *Europa,* was left intact by the criminals along with several other highly valued pieces. It is speculated that the thieves were not "art thieves" in the traditional sense, as they didn't appear to take particular care of the pieces they did steal.

Now, many years later, there is just as little known about this heist. Though the museum has offered a $5 million no-questions-asked reward for the return of the art, no one has stepped forward with any credible information.

As part of her will, museum founder Isabella Stewart Gardner left explicit instructions that nothing in the museum ever be changed. Even today, as you walk through the collection, there are empty frames where the stolen paintings once hung. —GRG

Exercise 23

COCKER SPANIEL WITH ED TADEM

Rough in the positions of the head, body, and legs.

Add the teardrop-shaped ear, pointy tail, and upturned muzzle. Indicate the eye.

Start adding fur, using long, zigzag strokes. Then refine the small nose.

Erase any lines you no longer need and continue to build up the fur, keeping in mind that this dog is rather shaggy. Then add the mouth.

Fill in the eye and mouth, and add the whisker markings. Shade with long, dark lines that follow the direction of hair growth.

Introduction to Oil Painting

THE MEDIUM OF THE MASTERS

Often described affectionately with words like rich and buttery, this classic painting medium is a favorite among fine artists. The paint consists of ground pigment suspended in oil, which traps light and creates a luminous effect on the canvas. The slow-drying properties of oil allow artists to create smooth blends and rework their paintings over multiple sessions. This large window for manipulating and refining a work of art can result in an impressive degree of realism.

Oil painting is notoriously messy and calls for quite a few materials. Because it's not a water-based medium, you'll need special solvents for thinning the paint and cleaning your brushes. You can use either turpentine or mineral spirits for this—but keep in mind that these liquids are toxic and cannot simply be poured down a drain. Also, be sure to work in a well-ventilated room, as oil paints and solvents emit strong fumes.

Now that you're sufficiently intimidated by oil painting, experience it for yourself. You might just find it as alluring as the great masters did. —ETG

READY TO START?

Here's what you'll need: set of oil paints, solvent, glass jars for holding solvent, mixing palette, palette knife, set of bristle brushes, small soft-hair brushes for detailing, linseed oil, primed and stretched canvas, rags, and artist's easel.

Perception and Reality
DABBLING IN THE WEIRD STUFF

"Reality is merely an illusion, albeit a very persistent one."
—*Albert Einstein*

Have you ever wondered whether everyone sees colors the same way? What if the color you call red, someone else calls blue? Whenever she looks at the sky, she sees what you call red, but she has always been taught that the color she sees in the sky is called "blue," so that is the name she gives it. There is no way to prove that such inconsistencies don't exist, because we only have access to our own sensations. Even if we agree about the properties of light waves and that their corresponding effect on brain activity is generally the same for everyone, it does not necessarily follow that individual experiences of color are identical.

The color conundrum is just one of many puzzles raised by the interaction of perception and reality. To understand the physical properties of any object, like a piece of artwork, we must rely on our senses, but how much can they really tell us about reality? What can you say with complete confidence about the cover of this book? You might say that it is smooth, or solid. But, on a microscopic level, it may contain mountainous peaks and valleys, and on an even smaller scale, its subatomic particles might not even be touching! So what is it like in reality? Can we ever know? —CKG

QUESTIONS TO PONDER
- *When you analyze a piece of artwork, are you analyzing its objective reality or just your subjective experience of it?*
- *Is all of reality relative to experience, or are there certain truths that are the same for everyone? If so, what are they?*

Dada

WAKE UP!

Can a urinal or a print of the *Mona Lisa* with a mustache painted on it be art? With World War I as its backdrop, the artists of the Dada movement met absurdity with absurdity. The Industrial Revolution had cre-

WHEN & WHERE

c. 1916–1920

Zurich, Berlin, New York

ated weapons that eliminated scores of people in ways previously unimaginable. Dada artists created provocative, contradictory, and irrational "anti-art" as a protest against the civilizations that allowed the war, insulting their cultural treasures—art. What *is* art if humanity has become so debased?

Dada artists had no set aesthetic or media. Collage, paint, and sculpture were popular choices, with chance and chaos serving as creative vehicles. Many images contained human-machine hybrids and disfigured bodies. Some artists even incorporated trash into their work. Theirs was an art of the street, no longer separated from everyday life. Dadaists divorced art from the idea of beauty, and challenged viewers to think critically.

In 1916, Hugo Ball founded a café called Cabaret Voltaire in Zurich, Germany, where Dadaists engaged in discussions, poetry readings, and performances. They displayed images that mocked the government, art world, and contemporary culture in nonsensical arrangements along the walls interspersed with declarative political statements.

After the war, many of the movement's artists evolved into Surrealists and spread out across the European continent and to New York. —ARR

Selected artists: Jean (Hans) Arp, Hugo Ball, Marcel Duchamp, George Grosz, Raoul Hausmann, Hannah Höch, Francis Picabia, Kurt Schwitters, Tristan Tzara

FUN FACT

The origin of the name Dada is in dispute. The most popular theory is that Dada artists randomly stabbed at a French-German dictionary and hit the word "dada," French for hobbyhorse. The other is that the word is simply nonsense or babble, reflecting the artists' attitude toward fine art.

Jean-Auguste Dominique Ingres (1780–1867)

FOR THE LOVE OF HISTORY

Jean-Auguste Dominique Ingres believed unquestionably in the virtues of history. As a student of fellow Neoclassicist Jacques Louis David, Ingres acquired a reverence for the past and embraced the art of antiquity. He also maintained contempt for the Romantics throughout his long and sometimes turbulent career—even though his own work possessed many of the same principles. Inasmuch as Ingres desired to be a historical painter, however, he was most gifted—and most successful—as a portrait artist.

Ingres was born in Montauban, France. His father, an amateur artist, sculptor, and musician, encouraged his son's talent and later sent him to study art in Toulouse. Ingres eventually began training under David and won the coveted Prix de Rome scholarship in 1801 for his painting *The Envoys from Agamemnon*. The artist subsequently moved to Rome in 1806 where he lived and worked until 1820.

What Ingres possessed in artistic skill and talent, however, he lacked in innovation and creativity; moreover, he often infused his art with unconventional and even peculiar stylistic interpretations. As a result, his work was frequently the subject of criticism and controversy. Yet Ingres was also nothing short of a brilliant draughtsman; he used his divine skills to make money by drawing portraits of tourists in Rome when times got particularly tough. In 1820, Ingres moved to Florence, followed by a move to Paris in 1824. Here, the artist finally hit his stride with his portrait of Louis XIII. He received numerous commissions and accolades and continued to work until his death at the age of 87. —RJR

Notable works: *Odalisque,* 1814; *Amédée-David, Marquis de Pastoret,* 1826; *Louis Bertin,* 1832.

FUN FACT

In addition to being a painter, Ingres was an accomplished violinist; he learned to play the instrument as a child and continued playing throughout his life.

Jane Avril

HENRI DE TOULOUSE-LAUTREC, 1893

Henri de Toulouse-Lautrec, renowned Post-Impressionist painter, is also known for his art nouveau lithographs such as this one, depicting the legendary French can-can dancer Jane Avril. Toulouse-Lautrec made a name for himself by producing vibrant, stylized scenes of *fin de siècle* Paris and portraying notable characters from late 19th-century Parisian nightlife. His works helped bolster the popularity of some of Paris's nightclubs including the now famous Moulin Rouge.

This poster is different from the works we've featured so far because it was created as an advertisement rather than as a piece of fine art. It served to announce that Jane Avril would perform at the Jardin de Paris, which was a café-concert (similar to a beer hall with live entertainment) located along one of the most famous streets in Paris, the Champs-Elysees.

Poster advertising Jane Avril (1868-1943) at the Jardin de Paris, 1893 by Henri de Toulouse-Lautrec. Movement: Art Nouveau.

By the time this lithograph was produced in 1893, Jane Avril's star had risen to make her the second most famous dancer in the city. Only the controversial Louise Weber (also known as "La Goulue") outshone Avril, and Toulouse-Lautrec also depicted her in his lithographs. Here he immortalized Jane's famous high kick, part of the provocative can-can dance that she performed at various hot spots around town.

—DDG

Art Collections of the Rich and Famous

AMASSING A WORLD-CLASS COLLECTION

Many collectors of fine art have transcended their "day jobs"—real estate mogul, hotel financier, entertainment executive—to become known more for what they collect than what they do. Billionaire philanthropist Eli Broad was an accountant and real-estate magnate before opening the Broad Art foundation with his wife Edythe in 1984. David Geffen, of Geffen Records, made his name in the music and entertainment industries, and museums regularly borrow works of art from his contemporary art collection. Charles Saatchi, a major patron of the arts recognized for his role in the promotion of the YBAs (Young British Artists) in early 1980s London, founded the advertising agency Saatchi and Saatchi. Their collections can end up as gifts to museums or form the foundation for new art institutions, as Eli Broad's collection did for the BCAM, Broad Contemporary Art Museum, housed next to the Los Angeles County Museum of Art.

Often, these grand collections, amassed over years, go to auction where they can easily fetch hundreds of millions of dollars. The private collection of late designer Yves-Saint Laurent went to auction at Christie's and sold for the equivalent of a record-breaking $670 million US. As diverse as these collectors (and their collections!) are, they share a common interest in the inner workings of the art world and market, a passion for art, and a desire to share their collections with the public. —SBR

Netsuke

UNITING FORM AND FUNCTION

As elegant as the Japanese kimono is, it lacks pockets, a contemporary and often over-looked article of utility. What to do? In lieu of a pocket, objects were placed in small containers (*sagemono*) hung from the kimono's sash (*obi*), and secured at the top by a *netsuke,* a toggle carved from ivory, bone, wood, or clay and decorated with lacquer and precious metals. Problem solved! Netsuke evolved from a humble button to an artistic commodity, becoming popular collectibles during Japan's Edo Period, from the 17th to the mid-19th centuries. Any number of subjects would be carved into netsuke—plants, animals, famous historical people, deities, even shunga, or erotic and sexually suggestive sculptures. Also, since netsuke were not technically considered clothing, those wearing the most outlandish and expensive-looking toggles could avoid the strictly enforced dress codes against flaunting one's wealth in public.

Netsuke are intricately carved works of art just under 3 inches tall.

By the end of the 1800s, Japanese clothing trends shifted, revealing their Western influence; suits with pockets replaced the traditional kimono, and the value placed on netsuke waned. Yet their popularity as collectibles has only increased; currently, you can find authentic netsuke in many museum collections, with their market prices ranging from a few hundred dollars to a couple thousand. For a form of sculpture usually no bigger than your thumb, netsuke has played an important functional and aesthetic role in the shaping of modern Japanese culture. —SBR

Tactile Painting

THE ART OF JOHN BRAMBLITT

John Bramblitt feels the slick, runny texture of the Ivory black oil paint. He adds definition and shadow to a portrait, and then feels for the thick, toothpaste-like consistency of Titanium white. As a blind painter, Bramblitt creates works with a singularly tactile quality.

Hickory Street Studio *by and courtesy of John Bramblitt.*

When two colors feel similar, the artist must add various mediums to the oil paint in order to change its texture. For expediency's sake, he often arranges his paints according to color, avoiding the trouble of feeling for the necessary hue.

Garden at Night *by and courtesy of John Bramblitt.*

Fabric paints create an easily felt, raised line on the canvas, allowing Bramblitt to draw an initial sketch of his subject. Many of his portraits are based on visual memories that were "burned into his brain," to use the artist's words, before the gradual deterioration of his sight. If a subject is new to him, Bramblitt feels the contours of the person's face until developing a clear mental image.

Bramblitt's art is further informed by his *synesthesia,* a neurological phenomenon in which sensory stimuli become interconnected within a person's mind, allowing him to create visual representations of music, emotions, and personalities. "Art," he affirms, "is almost impossible to repress…like life, it always finds a way." —DJS

Stock, Money, and Art

MONEY IN EXCHANGE FOR ART THAT IS BASED ON MONEY

How would you like to own a piece of the stock market? I'm not talking about a share in some company, but rather an actual one-of-a-kind, never-again-to-be-produced work of art based on the stock code of your choice?

One Pound. *Photo courtesy of Anthony White (www.anthonywhite.net).*

Australian artist Anthony White produces just such works upon request. But once he paints a piece representing a company from a given stock exchange (such as YHOO, representing the company Yahoo!®), he will never again paint that particular symbol.

Anthony's popular art touches on human attraction to the "unique" and the desire for ownership. His Stock Code Series is a similar in concept to his Money Series, which consists of prints of various currencies starting at one unit (*e.g.* $1), increasing by one unit each time he creates a painting. Again, no painting will ever be repeated. Appropriately, the price of the painting is the same as the amount depicted on the piece; for example, $1 for the $1 piece, $2 for the $2 piece, and so on. He is well into the 200 range in all the currencies currently available (the Australian dollar, the US dollar, the UK pound, and the EU euro). And here's a bonus: Anyone who purchases art from him is welcome to stay at his studio in Yeppoon, Australia.

In his own words, he is "exploring the relationship between money and art."
—GRG

Exercise 24

GUINEA PIG WITH EILEEN SORG

Lay down the fur with brownish orange, following the direction of hair growth. Apply blush pink to the nose, feet, and ears. Use hot pink for the nostrils and mouth.

Create darker areas of fur with brown, and apply this color to the edges of the ears and on the feet. Fill in lighter fur areas with yellow ochre.

Add dark shadows and fill in the eyes with dark brown, leaving a highlight in each eye.

Apply light, cool gray and blue violet for shadows in the white fur. To finish, deepen the outlines around the eyes and the shadows beneath the feet with black.

A Brief History of Oil Painting
FROM PIGS' BLADDERS TO METAL TUBES

Before oils, Western artists painted with tempera—a mixture of pigment and egg binder that dried quickly, didn't allow for soft blends, and cracked over time. In the 15th century, Jan van Eyck and his fellow Flemish artists of the time popularized the use of oils in Western painting, layering it in thin glazes to create subtle variations in light and shadow. His painting *The Arnolfini Marriage* (page 292) is often credited as one of the first examples of great oil technique and is thought to have paved the way for a new level of realism in art.

Early oil painting involved more than artistry—there was a little chemistry thrown in too. The first oil painters experimented with paint formulas, mixing ground pigments with assorted oils at varying temperatures. The most common oil used was—and still is—linseed oil (pressed from flaxseed), but some artists used walnut, safflower, or poppyseed oil. A few artists, including da Vinci, Messina, and Rubens, are known for adding their own ingredients to improve the paint's characteristics.

Some early artists stored their paints in small sacks made of pigs' bladders, which (as you might guess) helped seal in moisture. In the early 1840s, oil paints became available in collapsible metal tubes. No longer confined to their studios, artists ventured outside and learned to capture atmosphere and light in its presence, giving way to a painting approach called "plein air" and facilitating the birth of Impressionism. —ETG

Fun Fact
The earliest oil paintings yet discovered were found in Afghanistan's Bamian caves. Experts date these murals of Buddhist imagery back to the 7th century— 800 years before oils showed up in Western paintings![25]

Art and Christianity

ART IMITATING GOD

"Pictures about Jesus's childhood, teachings, sufferings and death are—regardless of our beliefs—in a very real sense pictures about us."
—*Neil MacGregor,* Seeing Salvation

The Christian religion is unique in its belief that God literally became a physical, human person. Of course, the belief in Jesus Christ as both God and man presents some dense philosophical puzzles, but it also potentially opens the door for certain kinds of worship—and artwork—that might be unacceptable in other religions. For example, in the minds of many Christians, since God revealed himself in human form, worshipping that person (including his physical characteristics) is worshipping God. Artistic portrayals of God through the face of Jesus (or other, more abstract symbols) are therefore accepted by most Christians.

In Orthodox branches of Christianity, religious icons bearing the face of Jesus, Mary, and other saints are made to be objects of worship. However, the Roman Catholic Church and most Protestant Christian groups oppose the worship of icons as idolatry (see the Ten Commandments), hence the various schisms and iconoclasms that decorate the timelines of history books.

A large percentage of the world has been saturated with Christian art during the last couple of millennia. From the poetry of early Church fathers to the architecture of medieval cathedrals, from Renaissance paintings to modern worship music, art has long been a source of inspiration and comfort for Christians. The story of Christian art is not without conflict, but then what good story is? —CKG

QUESTIONS TO PONDER

• *How would the world of art be different today if it weren't for Christian art?*

• *Is it okay for a person who worships Jesus Christ to worship a picture of him?*

De Stijl & Neo Plasticism
THE QUEST FOR UNIVERSAL ORDER

Let's get flat! With the beauty of a straight black line; the sobriety of a white ground; and the simplicity of red, yellow and blue, the reductionist De Stijl movement sought absolute "pure" abstraction in painting, sculpture,

WHEN & WHERE

c. 1917–1931

The Netherlands

and design. Clean, flat geometric shapes and black intersecting lines were the vehicles to explore the unity the artists felt between humankind and the universe.

When World War I began, artists in the Netherlands were cut off from the rest of the art world. In this isolation, they were able to incubate and create their own style. Despite the chaos of war surrounding them, they found order, rationality and harmony in their art. Some studied theosophy, which guided their search for the mystical nature of God and how to communicate that through art. Coming from a Dutch Protestant history of iconoclasm, austerity came naturally.

In reducing painting and design to its most elemental state, the De Stijl artists found what they considered to be "universal beauty"[26]. By opposing vertical and horizontal black lines on a white ground to form an asymmetrical grid, Piet Mondrian, a leading member, believed that he was uncovering "the underlying structure of nature"[27]. Carefully placed primary colors occupied squares within the grid, balancing one another by varying size and quantity. Everything had its place and purpose.

Though great achievements were made, when artistic differences arose among the artists regarding the use of diagonal lines over verticals, they simply had to go their separate ways. —ARR

Selected artists: Theo van Doesburg, Piet Mondrian, J.J.P. Oud, Gerrit Rietveld, Georges Vantongerloo

Pierre Auguste Renoir (1841-1919)

A CELEBRATION OF BEAUTY

*"For me a picture...should be something likeable, joyous, and pretty...
there are enough ugly things in life for us not to add to them."*

—Pierre Auguste Renoir

Judging from the scenes depicted in many of his paintings, Pierre Auguste Renoir seemed to find much inspiration in the events of day-to-day life. Thus, it was in concert halls, theaters, cafés, and other public places where people gathered to socialize that Renoir found some of his most captivating subjects. The warmth of friendship, community, and domestic harmony are dominant themes in his art.

Renoir was born in Limoges, France, where, as a young man, he cultivated his artistic talents painting china in a porcelain factory. After moving to Paris, he studied art at the Charles Gleyre studio where he met, among others, fellow Impressionist Claude Monet, with whom he developed a lasting friendship. He also attended the esteemed École Des Beaux-Arts from 1862 to 1864.

Although Renoir is considered one of the foremost Impressionists, his combined natural ability and meticulous studies of French, Spanish, and Italian masters enabled him to move effortlessly between Impressionism and Classicism. Indeed, he was as skillful at conveying an impressionistic scene as he was at capturing the finest details—often within the same painting.

In the mid-1880s, Renoir began moving away from Impressionism to focus on portraits and figures, including a series of nude bathing scenes. He achieved financial success as a portrait painter and married his longtime love Aline Charigot in 1890, with whom he had three sons. An even-tempered and optimistic man, Renoir continued to paint and create art even after debilitating rheumatoid arthritis confined him to a wheelchair. —RJR

Notable works: *La Grenouillère,* 1869; *Dance at Le Moulin de la Galette (Le Bal au Moulin de la Galette),* 1876; *Two Sisters (On the Terrace),* 1881; *Luncheon of the Boating Party,* 1881 (page 202).

The Ashes of Phocion Collected by His Widow

NICOLAS POUSSIN, 1648

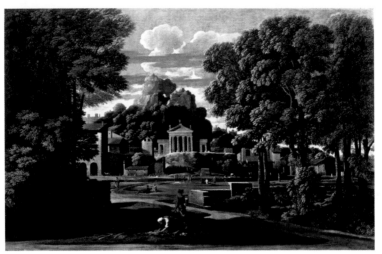

The Ashes of Phocion Collected by His Widow, *1648 by Nicolas Poussin. Movement: French Baroque-Classicism.*

This impressive painting by Nicolas Poussin is one of several "classical landscapes," which paired themes of antiquity (history before the Middle Ages) with idyllic scenes in nature. At first glance, the viewer's eye is drawn to the elegant and dignified backdrop, and it is almost too easy overlook the real focus of the work, which is taking place in the foreground.

Phocion was a successful and, for most of his life, highly respected politician in Ancient Greece. As an old man, he fell out of favor with both the Athenian leaders and citizenry and was sentenced to death. At the age of 84, he was forced to kill himself by drinking hemlock. His body was cremated, and his ashes were left to the care of his wife.

In this piece, Poussin captures the somber moment during which Phocion's widow collects his remains. The beauty of the setting contrasts with the lonely and mournful act taking place within it. Viewers are often struck by the minimal role held by the people in this composition; the focus seems to be the buildings, trees, and sky. It's almost as if Phocion's ashes are present only to be framed by those objects, pitting man's fleeting existence against the backdrop of nature's permanence and magnificence. —DDG

Celebrity Art Collectors

MADONNA'S MADONNAS

If you are an artist, having a fa-
mous (or infamous) movie star
collect your work may often raise
your profile in the art market, mak-
ing you more desirable to other col-
lectors. Many stars of screen and
stage collect museum-quality works:
Madonna, Elton John, and Victoria
Beckham (aka "Posh Spice") collect
works by Damien Hirst; actress Jane
Fonda and singer Robbie Williams
collect the work of Andy Warhol;

*Hollywood celebrities often amass world-class art
collections sought by auction houses and galleries.*

and the work of controversial British artist Banksy adorns the home of Brad
Pitt and Angelina Jolie. The private collection of comedian/writer Steve Mar-
tin, who started collecting at the age of 21, is permanently enshrined in the
Bellagio Hotel Gallery of Fine Art in Las Vegas and includes some heavy-hitters
in 20th-century modern and contemporary art—from Picasso and Roy Lich-
tenstein to Eric Fischl and Francis Bacon.

Though some celebrities treat the activity of collecting works of art as a dis-
tracting pastime, most regard their collections as serious, long-term endeavors,
and tend to immerse themselves in learning all they can about the artworks they
acquire. Though much of his spectacular collection of premier works of art by
Jean-Michel Basquiat went to auction in 2002, Metallica drummer and long-
time art collector Lars Ulrich understands the commitment it takes to collect,
stating, "Collecting is not about the trophy on the wall, it is about the journey."[28]
—SBR

Hand-Painted Pop

THE BILLBOARD ART OF LOLLYWOOD

Navigating the bustling streets of Lahore, the capitol of Pakistan's film industry, you may encounter towering hand-painted tin billboards advertising the latest horror or action movie. Often referred to as the "Pop Art of Lollywood," these billboards are truly unique art forms made by untrained artists and can be found in front of every cinema and film house in the city. Working under the direction of the film producers, artists compose the designs from film stills, then paint the images directly onto large sheets of whitewashed tin. Imagine the surprise of turning a street corner and coming face to face with a Lollywood superstar two stories high staring down at you! Up close, the brightly painted faces of the actors appear shockingly gaudy, but when viewed from a distance, the effect is much more subtle.

The tools of the trade for the Lollywood sign painter.

Most of the signs are painted by artists whose skills have been passed down through familial generations rather than obtained through formal art school training. Unfortunately, many see this hand-painted art form dying out as a younger generation of artists chooses computer-produced graphics over oil paint to create billboard art and advertisements, and possibly weakening the community's ties to the film industry it so ardently supports. —SBR

Les Coléres

THE RAGES OF ARMAN

It is said that the Zen master Ikkyu, while being apprenticed as a child, once broke his benefactor's teacup. When the teacher entered the room, Ikkyu hid the cup and asked him, "Why do people have to die?" The teacher responded that death is a part of life, and all humans must meet their end sooner or later. Ikkyu then produced the shattered cup, stating, "It was time for your teacup to die."[29]

Certain art forms, such as images drawn on the beach at low tide or in the accumulated dust on a vehicle, are inherently prone to deterioration. French-born artist Arman, however, showcased acts of sudden and deliberate destruction via a series of performance pieces known as *les Colères,* or the Rages.

Throughout the 1960s and '70s, Arman violently smashed musical instruments, furniture, cash registers, and coffee grinders in public. Many of the dismembered objects were later embedded in polyester, concrete, or plaster, permanently preserving the wreckage.

Despite the name, however, the Rages were not a showcase of cathartic violence itself, but rather of the transformation undergone by the subjects.[30] Arman hoped to capture a "freeze frame" of the precise moment at which an object dangled between integrity and destruction.

To be sure, sudden destruction is just as much an integral part of life as the gradual, evolutionary weathering brought on by wind, rain, and sea. Having studied Zen Buddhism,[31] the late artist was wont to ponder the impermanence of all that exists. —DJS

Trash or Treasure?

THE VALUE OF GOING FOR WALKS AND LOOKING IN DUMPSTERS

W hat's the most valuable thing you have ever found in the trash?

Whatever it is, it probably doesn't hold a candle to the painting one New Yorker happened upon while out for her morning coffee. According to *The New York Times*[32], while walking on the upper West Side of Manhattan in New York City, a woman named Elizabeth Gibson came across a painting on the side of the road that had been taken out with the trash. She thought "it had a strange power," so she decided to take it home and hang it in her apartment.

With the help of Google™ and the Antiques Roadshow™, she was able to determine that her painting was a masterpiece of Rufino Tamayo, one of Mexico's most famous painters, and that other works by him had sold for more than $500,000 US.

Armed with this new information, Elizabeth contacted Sotheby's and explained the news of her find. They were delighted to hear of the painting's recovery, as it had been stolen years earlier. They were even able to get in touch with the painting's original owner.

Elizabeth collected the $15,000 reward and happily returned the work to its rightful owners. The work later went on to sell for more than $1 million US.
—GRG

Exercise 25

COFFEE CUP WITH ED TADEM

Start by drawing a tapered cylinder around a vertical guideline and a basic circle for the lid.

Erase the vertical guideline. Define the lip of the cup, add the jacket, and detail the lid.

Clean up and refine your outlines, delineate the cast shadow, and add a logo to the cup and jacket.

Begin shading, suggesting the liquid inside the cup and adding a steaming coffee cup to the logo. Fill in the hole in the lid. Darken all the shadow areas, and leave the horizontal lines on the jacket fairly strong to suggest a ridged texture.

Using an Underpainting
EXPLORING THE INITIAL LAYER OF PAINT

In moments of artistic inspiration, sometimes our instinct is to dive straight onto the white of the canvas and immediately begin blocking in our subject with paint. But before jumping into anything, consider the advantages of using an underpainting, whether you're working in oil, acrylic, or even watercolor.

An underpainting, also called an "imprimatura," is a thin, transparent initial layer of paint applied to canvas or paper. Because paints are never completely opaque, the color of the underpainting will influence the hue and temperature of all successive applications of paint. Many artists even allow some of the underpainting to peek through between brushstrokes. All of this comes together to create visual unity within a piece through color harmony.

For those who are intimidated by a blank canvas, an underpainting may give you the jumpstart you need by eliminating the white of the canvas right off the bat. It also prevents bits of the white canvas from showing through your final work and giving it an unfinished appearance.

Several types of underpaintings exist in the art world—it seems that every artist has his or her own way of handling this technique. Whether you stick to muted neutrals, go all out with bright hues, or use a variegated wash of multiple colors, it all falls under the broad underpainting umbrella. —ETG

Artist Caroline Zimmermann uses a gradation of orange to purple as an underpainting for this warm, rich floral still life.

Artist Tom Swimm uses a lively magenta underpainting as the first step to creating this sunlit café scene.

Art and Judaism

ANSWERING TO A HIGHER POWER

"You shall not make a carved image nor any likeness of that which is in the heavens above or on the earth below or in the water beneath the earth. You shall not prostrate yourself before them nor worship them, for I am Hashem your G-d—a jealous G-d, Who visits the sin of fathers on children to the third and fourth generations, for My enemies; but Who shows kindness for thousands [of generations] to those who love Me and observe My commandments."

—Exodus 20:3-5

For Jews, the above quote is the second of the Ten Commandments that, according to the book of Exodus in the Torah, were delivered to Moses on Mount Sinai. Because of it, followers of Judaism have long been cautious when it comes to art. The commandment does leave some room for interpretation: Are only carved images prohibited? Is it only bad if I worship the image? Just how literally should I take this? As a result of such questions, there is a multiplicity of opinions among Jews regarding the boundaries of acceptable art.

Probably the most celebrated Jewish artist in the history of fine art is Marc Chagall, who earned high regard in the 20th century for his work in painting, stained glass, and other media. There are many secular Jews who have created art without concern for the Ten Commandments. Chagall is unique because, besides being of Jewish descent, he also adopted elements of Jewish faith and much of his work contains religious themes. —CKG

QUESTIONS TO PONDER

• *Based on your reading of the Second Commandment, what kind of artwork do you believe Jews can lawfully create?*

• *How does the scripture apply to Christians, since it is also part of their Bible?*

The Bauhaus

THE PURSUIT OF A NEW WORLD ORDER

The Bauhaus was more than an art movement; it was an innovative school cultivating a modern perspective on art and society. In contrast to other art movements, the Bauhaus school in Germany

> **WHEN & WHERE**
>
> *c. 1919–1933*
>
> *Weimar, Dessau, Berlin, Germany*

moved toward idealism rather than social critique in response to the pressures of war and searched for purity in art and craft. They strove for a new social order in which the artist and the community shared social responsibility, and art functioned for the people.

Founded by German architect Walter Gropius, the Bauhaus had a multimedia curriculum and communal philosophy. This group searched for truth and rationality in a modern aesthetic that united art, craft, design, and technology. Stressing craftsmanship and embracing mass-production, they created practical designs for furniture, pottery, and architecture, as well as paintings and sculptures. Characterized by clean lines, simplified forms, and neutral colors, the Bauhaus aesthetic was anti-decorative and prized function over form. Fine art no longer reigned supreme; "be useful or be nothing" was the motto. The curriculum focused on new ideas, never following an historical precedent.

Leadership of the school changed hands many times and in 1933, the Nazis forced the school to close its doors. Many Bauhaus artists moved to the United States, where the style grew and profoundly influenced all types of design, typography, and theater. Bauhaus design can still be seen in buildings in Western Europe, the United States, and Tel Aviv, Israel. —ARR

Selected artists: Anni Albers, Josef Albers, Lyonel Feininger, Walter Gropius, Johannes Itten, Wassily Kandinsky, Paul Klee, Laszlo Moholy-Nagy, Piet Mondrian

Georgia O'Keeffe (1887–1986)

SHAPING AMERICAN MODERNISM

Georgia O'Keeffe was one of America's foremost modernist artists. A master of abstraction, O'Keeffe is best known for her powerful plant and flower still lifes and vibrant desert landscapes—most inspired by her love of the Southwest.

O'Keeffe was born in Sun Prairie, Wisconsin. She began taking art lessons at a young age and declared her intention to become an artist while still in high school. Following graduation, O'Keeffe moved to Chicago where she studied at the Art Institute for a brief time, followed by a short stint at the Arts Students League in New York. But O'Keeffe soon became discouraged and moved back to Chicago to work as a commercial artist; she later moved to Texas to teach elementary school art classes.

Georgia O'Keeffe found inspiration in New Mexico's desert landscapes.

O'Keeffe ventured into art once again a few years later after attending summer art classes. She created several charcoal drawings, which made their way to famous New York photographer and gallery owner Alfred Stieglitz. Stieglitz exhibited the drawings and formed a relationship with O'Keeffe that eventually led to the couple's marriage in 1924. Stieglitz spent the rest of his life promoting O'Keeffe's work, and her popularity grew steadily.

In 1946, Stieglitz fell ill and died unexpectedly. Three years later, O'Keeffe moved to New Mexico permanently where she continued to work until she died. —RJR

Notable works: *Evening,* 1916; *Evening Star VI,* 1917; *Calla Lily Turned Away,* 1923.

Fun Fact

The Georgia O'Keeffe Museum and the Georgia O'Keeffe Museum Research Center

are located in Santa Fe, New Mexico, at 217 Johnson Street.

Visit www.okeeffemuseum.org.

Rain, Steam, and Speed

JOSEPH MALLORD WILLIAM TURNER, C. 1844

Some artists are particularly gifted at evoking a mood or a powerful impression with their paintings. Joseph Mallord William Turner was one of the best. A survey of Turner's works reveals a breathtaking array of vast skies, tumultuous fires and storms, and the overshadowing presence of nature.

Rain, Steam, and Speed, The Great Western Railway, *painted before 1844 (oil on canvas), by Joseph Mallord William Turner. Movement: Romanticism.*

Many artists of Turner's time were repulsed by the noise, pollution, and unnatural feel of the Industrial Age; they were distraught with its machinery and its encroachment on the natural world. Turner hints at this controversy with *Rain, Steam, and Speed,* a depiction of perhaps the greatest of all 19th century transportation innovations: the steam locomotive. The Great Western Railway's "Firefly Class" locomotive was the most technologically advanced model available of its time. Here we see it rushing toward us across another engineering masterpiece of the era—the Maidenhead Railway Bridge.

Significantly, the machinery in Turner's painting is eclipsed and overpowered by the natural world surrounding it. Although he portrayed human technology, Turner did not betray his love for nature. In this case he remained true to his Romantic roots by shrouding the locomotive and bridge in rain, clouds, and mist, creating an evocative contrast between the painting's natural and man-made elements. —DDG

What is a Biennial?

THE ULTIMATE ART EXPERIENCE

Biennial, or *biennale* in Italian, refers to a festival occurring every two years for a few months in places around the world such as Venice, Berlin, Taipei, Istanbul, Sao Paulo, Shanghai, and Sydney. It has come to mean a festival that showcases advances in contemporary visual art. Funded through a mix of public (government) and private (individual) money, the oldest biennial began in Venice, Italy, in 1895. A second venue opened in 1951 in Sao Paulo, Brazil, and the third city to start the biennial trend was Sydney, Australia, in 1973, on the occasion of the opening of the Sydney Opera House.

On the occasion of the 1889 World's Fair (a precursor to the contemporary art Biennial), Gustave Eiffel built this iconic Parisian landmark.

The origins of the contemporary biennial date back to the mid-19th-century world's fairs, where nations seeking to "brand" themselves as technologically advanced centers of commerce sent representatives to the designated fairgrounds (they rotated from city to city each year) to demonstrate their developments in manufacturing, industry, engineering, culture, and politics. Like these earlier fairs, modern day art biennials carry an international flavor; countries all over the world send their best representatives from the fields of fine art, architecture, design, music, and dance, building grand installations to showcase their works in permanent pavilions (many of which have remained intact since being built in the early 1900s). Besides the Internet, where else are we presented with an unprecedented level of cultural diversity and emerging artistic talent on a global scale in one location? —SBR

Tibetan Sand Paintings

THE BEAUTY OF IMPERMANENCE

Museums, galleries, artists, and collectors go to great lengths to protect and promote the longevity of their works of art. But what if the art is meant to literally blow away once it has been created? The importance of Tibetan sand paintings lies not in their permanence, but in their transient nature. Created by Tibetan monks, sand paintings, or mandalas, are intricately designed geometric compositions of pulverized, colored marble shaken down long steel tubes into a chalk-outlined design on a flat surface. Sand, flowers, and semi-precious stones are also incorporated into the designs. The mandala, its shape representing the multi-layered nature of the cosmos, is created for healing or purification purposes. According to Buddhist scripture, the mandala conveys positive energy to the environment and to the viewer, and its construction is surrounded in ritual and ceremony, involving singing, chanting, and music.

Once complete, the sand is swept up and dispersed in flowing water—a metaphor for life's impermanence as well as an effective method for distributing the healing power of the mandala to the earth. Many of these works take weeks to create, so if you are lucky enough to witness the creation of a sand painting, make sure you don't sneeze—the entire design would have to be unceremoniously swept away and begun again! —SBR

A one-of-a-kind completed Tibetan sand mandala painting.

Cosmetic Interpretation

ART TRANSFERRED FROM CANVAS TO CUTIS

I'll be brutally honest for a minute: I'm not the sort of person who notices the finer points of a woman's make-up.

That being said, even *I* can appreciate the talent and creativity required to take one artist's painting and distill its abstract subtleties into a few square inches of a person's face.

Marlena Reichert is a self-professed "make-up geek" who has mastered the medium so thoroughly as to be able to digest a visual image and represent the overall gestalt of its colors through cosmetics. After all, according to Marlena, "make-up, itself, is art."

Marlena Reichert showcasing make-up based on the oil painting below.

In addition to abstractly representing artwork such as Mary Capan's oil painting (right), Marlena has created cosmetic translations of particularly vibrant flowers, including purple posies.

Marlena has posted a number of online instructional videos that guide the viewer through this intricate process, from the application of primer and

Abstract Sunset *by Mary Capan (oil on canvas).*

eye shadow pencil to the selection and blending of colors. Her website invites readers to "embrace your cosmetic addiction."

I'll stick with my own caffeine addiction, thank you very much. —DJS

Scanwiches

ART THAT'S GOOD ENOUGH TO EAT

What better way to preserve that delicious sandwich from the deli down the street than by scanning it and uploading it to a website? Scanwiches.com does just that, and it's absolutely, mouthwateringly incredible.

Started by Jon Chonko, a New York City designer, Scanwiches.com has become an Internet phenomenon.

Photo courtesy of Jon Chonko (www.scanwiches.com).

Chonko uses his girlfriend's old scanner, which has a broken lid, and just plops the sandwich down directly on the glass. He scans it, performs some minor color adjustments in Photoshop®, and then uploads the image to his site.

The stark contrast of the black background and the vibrant colors of the sandwiches make for stunning images.

The site allows you to cycle through the images, each with its own short description:

• *Market Café: Turkey, Lettuce, Mustard, Mayo, Relish, Tomato, on a roll*

• *Alidoro: Salami, Fresh Mozzarella, Arugula on a baguette*

• *Deli & Salad Bar: Chicken Cutlet, Salami, Ham, Buffalo Mozzarella, Lettuce, Tomato, Mayo on a poppy seed roll*

• *Deli & Salad Bar: Brie, Tomatoes, Cucumber, Arugula, on a hero*

Although the process seems haphazard, the results are beautiful. It's nice to know that food doesn't need always need a stylist to look good. —GRG

Exercise 26

GARDEN GNOME WITH EILEEN SORG

Use orange-pink to color the skin tone of the gnome's face, ears, and wrists.

Add some lines of medium, cool gray to the beard, defining the shadows.

Once the base skin color is down, use brown to define the nose, eyes, ears, cheeks, and wrists. Apply blue-violet to the eyes, leaving a small white area on each of the eyes for a highlight.

Create the gnome's signature hat with a single layer of orange-red. Add dimension by varying your pressure to create highlights and shadows. Apply a layer of bright blue to the shirt and then add the folds using dark blue. Apply black for the deepest shadows and to define the face.

Building an Oil or Acrylic Painting
FROM SKETCH TO HIGHLIGHTS

So you've applied your underpainting, and you know what you want to paint. What's the next step? Below are a few notes to keep in mind as you tackle the "big picture" of painting.

The Sketch

There are several tools you can use for sketching on your canvas. Unlike watercolor paint, acrylics and oils will cover up your sketch so you can be much bolder with your groundwork. Painters use everything from graphite or charcoal to indelible pen (which I prefer, as I don't have to worry about sediment mixing in with the paint). Some also create the sketch using thinned paint and a brush rather than a drawing instrument. When you create your sketch, avoid adding too much detail; block in only the most important divisions in value.

Fat over Lean (applies to oil only)

Artists generally begin an oil painting with thin layers of paint (diluted with solvent). They then build up the shapes and colors slowly, using thicker paint (containing more oil) and more deliberate strokes with each layer. This common approach is often called "fat over lean" and helps prevent cracking on the surface of the painting.

Working from Dark to Light

A common approach to oil painting involves working from "dark to light," which refers simply to applying darks and shadows first, leaving lights and highlights for the later stages. This eliminates the need to apply each intricate shadow individually, allowing you to focus on that which is illuminated and saving brushstrokes in the long run. —ETG

Caroline Zimmermann works from dark to light in the above step-by-step sequence. After applying the underpainting, she blocks in the shadows (A, B), builds up the middle values (B, C), and finishes with the highlights (bottom).

Art and Islam

UNVEILING GOD'S PERFECTION

"God is beautiful and loves beauty." —Muhammad

Islamic art attempts to reflect spiritual experience by revealing an object's inherent, God-given perfection. Instead of simply imitating the appearance of nature or humanity, artists from the Islamic tradition strive to disclose inner beauty through the outward appearance of a particular work. Philosophically, this endeavor is rooted in the belief that everything in our world emanates from the perfection of Allah. The underlying beauty is itself the Divine Presence—the beauty of Islam. The artist's task is to bring it out.

To prevent idolatry, there are rules against portraying animals or humans in art (based on verses from the Qur'an that correspond closely with the Second Commandment in the Jewish Torah). Instead, there is a focus on abstract imagery, including organic forms and geometric shapes, which, when woven together, produce intricate, symmetrical designs known as *arabesque*.

Architecture is also an important aspect of Islamic art. The domes, walls, arches, and minarets of mosques, for example, are often creatively composed while retaining appropriate shape and function. They are then elegantly adorned with arabesque designs as well as calligraphy, which provides a lovely yet lawful way of venerating sacred texts.

Like every religion, there are varying degrees of legalism within Islam. Muslims who are more liberal in their beliefs may find nothing wrong with creating art that is secular or that contains representations of living beings, but more conservative groups will disregard any craft that fails to properly glorify Allah.
—CKG

QUESTIONS TO PONDER

• *What kind of beauty could a non-physical spirit possess?*

• *In what ways is the Islamic view of art similar to and different from the Christian and Jewish views?*

The Harlem Renaissance

FORGING A NEW IDENTITY

As jazz music circulated through the clubs and African-American authors were writing novels, poetry, and prose, a new type of artist was emerging in Harlem, New York. Dignified images of African-American

> **WHEN & WHERE**
> *c. 1920s–1930s*
> *Harlem, New York*

individuals and communities were replacing old, negative stereotypes. Black Americans were positively redefining themselves in the vibrant movement known as the Harlem Renaissance.

After World War I, millions of African-Americans left the South and traveled North, looking for opportunity in what is known as the Great Migration. With this, a new kind of Renaissance began in urban centers.

Originally known as "The New Negro Movement," the Harlem Renaissance represents a florescence of creative activity. Asserting a type of art separate from that of Europe, they sought to create a new identity in their work, one that was distinctly their own. African-American artists paid homage to their folk traditions and African heritage. New styles were developed and traditional styles in painting and sculpture were mastered. Paintings of slaves being emancipated from bondage, jubilant dancers in jazz clubs, and Black neighborhoods bustling with life are indicative of their content. Through struggle and success, these artists represented pride in their ethnicity.

The legacy of the Harlem Renaissance runs deep through the fabric of American culture. Through music, theater, literature, and art, the artists of this movement redefined how African-Americans saw themselves and how the world saw African-Americans. —ARR

Selected artists: Romare Bearden, Aaron Douglas, Palmer Hayden, William H. Johnson, Loïs Mailou Jones, Jacob Lawrence, Archibald Motley, Augusta Savage, James Van Der Zee

Peter Paul Rubens (1577–1640)

PROPONENT OF BAROQUE, CATALYST OF DIPLOMACY

Peter Paul Rubens was a Flemish Baroque painter of the highest caliber. An ardent enthusiast of Italian art, Rubens helped bridge the divide between the artistic realism of the North and the more sensual art of the South. Although Baroque originated in Rome, it was Rubens's artistic contributions in the style that largely aided in its recognition on the international stage. His vast body of work consists of religious themes, mythology, portraits, and landscapes.

Rubens was born in Germany during his family's time in exile from Flanders. His father was a well-known Protestant and fled to escape religious persecution during Spanish rule. Following his father's death a decade later, Rubens and his mother moved to Antwerp where the boy was well educated in Latin and classical literature, and raised a devout Catholic. He began training as an artist when he was only 14 years old.

This tribute to Peter Paul Rubens stands near the Antwerp Cathedral of our Lady, which also houses some of the artist's finest paintings.

In 1600, Rubens traveled to Italy where he remained for eight years studying sculpture and the masters of the High Renaissance. His exposure to the drama and intensity in Caravaggio's and Annibale Carracci's work profoundly impacted his own. He returned to Antwerp in 1608 at which time Albert and Isabella, the rulers of the Spanish Netherlands, appointed him the court painter; the position proved fruitful. Rubens actively served as a diplomat and received knighthoods from both Charles I of England and Philip IV of Spain. He married twice in his lifetime: first to Isabella Brant and then to 16-year-old Hélène Fourment, four years following Isabella's death. —RJR

Notable works: *The Holy Family with Saints Elizabeth and John the Baptist*, 1615; *Marie de' Medici, Queen of France, Landing in Marseilles*, 1623; *The Garden of Love*, 1634.

FUN FACT

Peter Paul Rubens was fluent in five languages, including Latin, Spanish, French, German, and his native Flemish.

A Bar at the Folies-Bergère

EDOUARD MANET, 1881–1882

In *A Bar at the Folies-Begère,* Edouard Manet's last major painting, we find ourselves seated across from a woman named Suzon, who really was a bartender at the Folies Bergere café-concert. Similar to *L'Absinthe* by Degas (page 192), the highlight of the piece is the woman's expression. There is a melancholy in her eyes, and we have the distinct impression that she would rather be anywhere but here. What do you think is going through Suzon's mind?

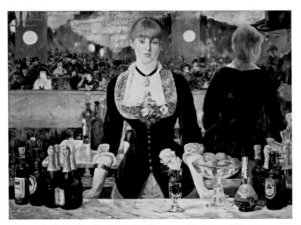

A Bar at the Folies-Bergère, *1881-82 (oil on canvas) by Edouard Manet. Movement: Impressionism.*

Some critics claim that the scene behind the bartender is, in fact, a reflection in a mirror. If so, they point out that the reflection isn't accurate—that it is portrayed at a seemingly illogical angle. But why would Manet do this? Perhaps he means to reveal that Suzon's world is distorted by her unhappiness and emotional isolation. Or maybe he simply wants to make the composition more balanced. Do you think the background is a mirror image or not?

Another curiosity—rather than signing his name separately on the canvas, Manet placed it on the bottle at the lower left of the painting. Was this a case of subliminal advertising or was it simply a touch of whimsy? —DDG

Art at the Venice Biennale

ART IN THE CITY OF BRIDGES

The Italian city on water hosted the first art Biennale in 1895, which included artists from 16 nations. Founded as the "International Exhibition of Art of the City of Venice" to promote "the noblest activities of the modern spirit without distinction of country," the exhibition became known as the Biennale, for its schedule of festivities devoted to art occurred every two years. Usually held in the summer months, the Biennale is juried by an international committee composed of artists, curators, a director, and government officials. You can wander all over the city to see art and performances—from the 30 permanent national pavilions scattered throughout the Giardini de Castello district (walking distance from Venice's San Marco square) to the Arsenale, a 12th-century complex of warehouses and shipyards built to house the fleets of the Venetian Republic.

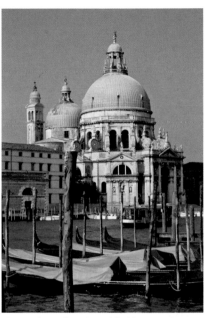

The city of Venice hosts the world's oldest Biennale every two years.

During the 20th century, the upheaval of war often dictated the schedule and nature of the Biennale's exhibitions. World War I shut down the Biennale until the national Fascist government took over in the 1930s and introduced new festivals devoted to music, film, and theater. Following World Wars I and II, modern art—including German Expressionism, French Fauvism, Post-Impressionism, and later, Abstract Expressionism, Pop Art, and Conceptual art—populated many of the pavilion spaces. Though world events—from political unrest to social activism—continue to inform the organization of the contemporary Biennale, the individual works of art remain the heart and soul of this, the grandfather of global art exhibitions! —SBR

Skin Deep

THE ART OF POLYNESIAN TATTOO

It might be hard to imagine the connection between a thickly inked tattoo on the arm of a college student and Polynesian tattoo practices, but the former could not exist without the latter. Like many cultures around the world, the art of tattooing indigenous to the islands of Samoa, Hawaii, and New Zealand dates back centuries and is enjoying a revival of sorts with the popularity of tattoos throughout the Western world. Yet Samoan *tatau*, Maori *moki*, and Hawaiian *uhi* have existed for more than two centuries as cultural markers as well as forms of art. Each share common techniques and motifs, from needles carved from sharpened bird bone or turtle shell to ink made from crushed charcoal and juices of native plants. Within Polynesian societies, the tattoo artist (usually male) was held in high esteem by the community and governed the tattoo process through a strict code of protocols and rules. Tattoo sessions could last from one day to a few months, depending on the occasion and the initiate's pain threshold. Tattoos served as markers of wealth, political and social standing, age, marital status, tribal affiliations, or as simple adornments. Only the teeth and eyes were exempt from the tattoo needle!

A contemporary "tribal" tattoo takes inspiration from the earliest Polynesian tattoo designs.

With the arrival of European explorers to Polynesia during the 18th and 19th centuries, tattoos became taboo. The resurgence of Polynesian tattoos among indigenous cultures began in the late 20th century despite the dominance of European culture. Whether they function as signifiers of one's heritage or to commemorate a late-night drunken escapade, tattoos continue to visually intrigue us with their mix of artistry and complex heritage. —SBR

Marbles and Hair

THE UNIVERSAL ART OF MONA HATOUM

"Hatoum's art is hard to bear (like the refugee's world, which is full of grotesque structures that bespeak excess as well as paucity), yet very necessary to see as…art that travesties the idea of a single homeland."
— *Edward W. Said, 1999[33]*

Using a medium as innocuous as dozens of identical marbles, Mona Hatoum contemplates the issues of migration and the fluidity of international boundaries. The artist has created a map of the world, minus the steel-and-concrete reinforced barriers: All seven continents are made from interchangeable glass marbles.

Map *(second version), 1999 / clear glass marbles / dimensions variable / installation: Capricci (possibilities of other worlds) / Casino Luxumberg / July 7–September 2, 2007 / photo: Christian Mosar / Photo courtesy of Alexander and Bonin, New York.*

Traffic, *2002 / compressed card, plastic, metal, beeswax and human hair / 19 x 25-1/2 x 26-3/4 in / 48 x 65 x 68 cm / photo: Arturo González de Alba / Photo courtesy of Alexander and Bonin, New York.*

Not all of her work is presented in such unassuming media. By using such an elemental material as human hair, Hatoum evokes a visceral reaction from the observer. Much of her work delves into the very human phenomena of political oppression, violence, and torture.

As a Palestinian born in Lebanon, Hatoum often makes reference to those who are born far from their homelands. One sculpture—a suitcase sprouting hair—alludes to the pervasive issue of human trafficking, commanding the viewer's attention while appealing to one's sense of the grotesque.

Hatoum uses such unsettling, unnerving aesthetics to draw the viewer into a heartfelt examination of the darker corners of human existence. —DJS

The Amber Room

A TREASURE LOST AND FOUND (MAYBE)

"We've found it—the Amber Room, the Eighth Wonder of the World, the Tsar's lost treasure chamber. We thought it was lost forever." It may sound like the plot of a new adventure movie, but it might just be the truth. Treasure hunters have been searching for "the Amber Room" since it was dismantled by the Nazis during World War II. And hunters just may have found it in 2008.[34]

Initially created for Frederick I in 1907, the almost 600-square-foot room was covered from floor to ceiling with amber and gold leaf. Estimates suggest that the room could have a value approaching $500 million US.

Although the find has not yet been officially verified, searchers have come across a huge underground cavern, and electromagnetic testing has revealed that it may contain up to two tons of gold. Unfortunately, the chamber may very well be booby trapped (aren't they always?), so we won't have a definite answer until it can be safely excavated.

If the room has been found, it will bring to a close one of the greatest mysteries of our time. If the room has not been found and is still out there, well, maybe we'll get that new movie out of the search. —GRG

Exercise 27

PUPPY WITH EILEEN SORG

Fill in the irises with reddish brown and apply it around the eyes, nose, mouth, and cheeks. Add dark gray to the nose, using heavier pressure for the outlines. Darken and outline the eyes with dark umber.

Lay in the highlights on the puppy's head with a light, cool gray, stroking in the direction of the hair growth.

Now ceate the dark areas of fur with a dark, warm gray. Use the same color to darken areas around the eyes and fill in the nostrils.

Fill in the rest of the fur, adding teal in areas for color and shine. Add a light glaze of orange-red to parts of the face. Use dark gray to darken areas of the dog, especially the nose, muzzle, and ears. Work reddish brown over the fur for more color.

Applying the Paint

GETTING THE MOST OUT OF YOUR BRISTLES

Below are methods for manipulating paint to create specific effects or textures. If you're not up for trying them out yourself, you may want to read through them nonetheless; the terms will come in handy for understanding and describing an artist's technique. If you do plan to experiment, a word of advice based on personal experience: Prevent disaster by practicing them several times *before* incorporating them into a work of art. —ETG

Scumbling
Dust your bristles with paint and lightly scrub over areas of the canvas, creating a soft, blurry layer that allows the color beneath to show through.

Drybrushing
Load your brush with a bit of paint and wipe it gently with a paper towel to remove excess paint. Then pull the brush lightly across your painting's surface, leaving behind a rough trail of color.

Stippling
Using the tip of your brush, dot on small strokes of paint in irregular clusters for a mottled texture.

Spattering
Load your brush with thinned paint and run a finger over the bristles to produce a spray of color.

Impasto
Accent areas of your oil or acrylic painting with thick, buttery brushstrokes. This is particularly effective for highlights and final touches; the peaks and shadows of each brushstroke add texture and dimension.

Using a Palette Knife
Brushes aren't the only way to get paint on the canvas. Apply paint directly using your palette knife. This can create interesting striations and smooth, geometric shapes.

Eastern Aesthetics

OMMM...

"We are formed and molded by our thoughts." —*Buddha*

Balance. Simplicity. Meditation. Clarity. Emptiness. Detachment. Peace. The One.

These are some of the most common themes found throughout traditional Eastern thought. Buddhism, Hinduism, Confucianism, Taoism, and other systems of belief, despite their differences, share many such concepts. And while Eastern ideals have gained much popularity here in the West during the last century, their ancient roots have long influenced all aspects of Asian culture, including art.

Imagine the perfect symmetry of a Chinese porcelain vase, the simple elegance of a Haiku, or the idyllic ambiance in a Japanese Bonsai garden. The sense of tranquility and inner harmony is central to the mindset and manifested in the work.

Since there isn't any Second Commandment to worry about in Buddhism or Hinduism, religious artists have carried on a proud tradition of sanctioned idolatry that has produced a plethora of Buddha sculptures, Vishnu icons, etc. In these, too, we find remarkable balance and symmetry, which facilitate contemplative forms of worship, such as meditation and mantra.

On the other hand, there is some tension between art and Eastern thought. The sensory realm can be quite distracting, so for those who are attempting to renounce the physical world or deny earthly pleasures, art is nothing but a nuisance. —CKG

QUESTIONS TO PONDER

• *What kinds of art make you feel reflective and serene? Why?*

• *How have your own culture's ways of thinking been reflected in the history of Western art?*

The Mexican Renaissance

THE RECLAMATION OF VOICE

From the mire of the bloody Mexican Revolution, a flowering of artistic activity grew in Mexico. Through paintings, photographs, and prints, artists used their voices to criticize brutality and exalt the memory of

<div style="border:1px solid black">
WHEN & WHERE

c. 1920s–1950s

Mexico
</div>

their great indigenous civilization. This art was about the people—people as members of a cultural community and as distinct individuals. They celebrated their pre-Columbian heritage in imagery, but employed a Western sense of aesthetics and media. This blend created an art that was specifically Mexican.

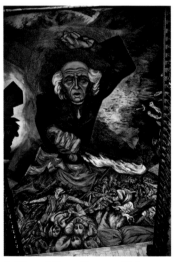

José Clemente Orozco, Government Palace, Guadalajara, Mexico, 1939.

"Los Tres Grandes" (The Big Three), Diego Rivera, José Orozco, and David Alfaro Siqueiros painted Mexico City and beyond with vivid, didactic frescos and murals that were accessible to all—worker and politician, wealthy and poor. Idealized pictures of a pre-conquest past and Mexican folk imagery projected a hopeful future. Yet, scathing images of the atrocities of colonialism and dictatorship criticized the present. Much of this work was meant to promote socialist ideals and protest oppression.

Though hardly as political, Frida Kahlo's intense, personally symbolic paintings explore a lifetime of physical and emotional suffering in a world mixed with Mesoamerican and European culture. Often surreal in organization and imagery, her many self-portraits depict her as a proud Mexican woman in scenes both darkly disturbing and vibrant with life.

This was a prolific movement that continues to grow and update itself. Many contemporary Mexican artists still investigate their identities as being a blend of two great cultural forces. —ARR

Selected artists: Lola Álvarez Bravo, Manuel Álvarez Bravo, Frida Kahlo, Tina Modotti, José Clemente Orozco, Diego Rivera, David Alfaro Siqueiros

Wassily Kandinsky (1866-1944)

THE HARMONY OF COLOR

"All methods are sacred if they are internally necessary. All methods are sins if they are not justified by internal necessity."

—Wassily Kandinsky

Although Russian artist Wassily Kandinsky is hailed as one of the founding fathers of abstract art, the designation is a bit of a misnomer. To be sure, Kandinsky's art *was* abstract; however, unlike other artists of the genre who used their art to intentionally distort the realities of the physical world, Kandinsky's art neither represented nor resembled any form of reality. Rather, he sought to create a purely spiritual encounter by way of the colors and shapes he employed in his art.

Kandinsky attended the University of Moscow where he studied law and economics and eventually taught. Years later, he gave up his professorship and moved to Munich to attend the Academy of Fine Arts. In 1911, he co-founded a Munich artists' circle, *Der Blaue Reiter,* or The Blue Riders, whose members shared a collective belief in the interconnectedness of art and spirituality.

Kandinsky developed an early appreciation of music thanks to his parents, both musicians. Indeed, music is a central theme in his artwork, which is infused with vibrant color and compelling lines and shapes that seemingly flow into and out of each other like the notes of an expressive concerto. It's hardly surprising, then, that Kandinsky named many of his works "Improvisations," "Impressions," and "Compositions."

Kandinsky was also a profound art theorist and writer. He authored many highly philosophical tomes during his lifetime, including the seminal "Concerning the Spiritual in Art." In the 1930s, he fled Germany for France after National Socialists confiscated his art and classified it as "degenerate." —RJR

Notable works: *Composition V,* 1911; *Painting with Green Center,* 1913; *Yellow, Red, Blue,* 1925.

Disputation of the Holy Sacrament

RAFFAELLO SANZIO, C. 1509–1510

After beginning his career in Umbria and Tuscany, the brilliant painter, sculptor, and architect Raffaello Sanzio—better known today as Raphael—moved to Rome at the age of 25. There he began the most celebrated period of his career. Not long after his arrival, he was invited by Pope Julius II to fresco the walls of a new library. The rooms that Raphael painted at the Vatican are now called the *Stanze di Raffaello*, or *Raphael Rooms*, and the first room that he completed contains three of his greatest masterpieces, *The School of Athens*, *The Parnassus*, and this fresco, *The Disputation of the Holy Sacrament*.

We can see here a magnificent gathering of prominent figures from both heaven and earth. Down below, a multitude of great artists and church leaders—including Pope Julius II—are debating a controversial doctrine of Roman Catholic theology known as "transubstantiation," which means that the substance of the bread and wine actually changes into the body and blood of Jesus Christ during the Holy Eucharist. Up above, along with an array of Patriarchs and Saints, Raphael depicts Jesus Christ himself presiding over the dispute. Christ is lending his voice—and his ultimate authority—to a quintessential Church doctrine. —DDG

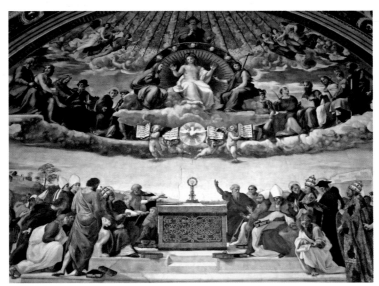

Disputation of the Holy Sacrament, c. 1509–10 (fresco) by Raphael (Raffaello Sanzio). Movement: Italian Renaissance.

The Whitney Biennial

NEW YORK CITY

Every two years in springtime, writers, artists, curators, collectors, and art lovers descend on the Whitney Museum of American Art in New York City for the Whitney Biennial—the show the critics love to hate. Artists today work in more genres, using a greater variety of materials than ever before. The Whitney Biennial aims to take the pulse of American art through the work of emerging and established artists, whose work embodies the hippest and hottest trends and styles. Begun in 1932, shortly after the museum was founded, the Biennial is regarded as one of the leading exhibitions of its kind, often faltering but never failing to intrigue and titillate. Originally designed to showcase new paintings and sculptures by American artists, the museum changed formats in 1973 to include all media to better reflect the changing landscape of American art.

Since the Whitney Biennial is not easily categorized or organized around a single subject, style, movement, or artist, numerous critiques and controversies follow it. Some argue that the Whitney Biennial is provincial, behind the times, and no longer relevant; that one can see more relevant and interesting art at any number of the global art fairs. As the Whitney grapples with its identity, many of the artists involved pose questions about what it means to be American. Is the Whitney Biennial truly "American" if the curators (and a number of the artists) have only tangential ties to the United States? Whatever the case may be, if art is a reflection of our times, the Whitney Biennial is one mirror we can use to explore contemporary trends in American art. —SBR

Shadows and Light

WAYANG PUPPETRY OF INDONESIA

Backlit against a translucent white screen and accompanied by chanting and a gamelan orchestra, the *wayang*, or shadow puppets, of Bali are dramatic theatrical expressions encompassing lighthearted comedy as well as religious teachings. Dating from the 10th century, the play of these fully articulated puppets provides entertainment as well as lessons in ethical and moral values. The puppets can be either two-dimensional flat figures cut from leather or three-dimensional painted wooden sculptures, usually made to resemble historical figures or deities. The *dalang*, or puppeteer, commands a high amount of respect from the community since he plays the multiple roles of actor (he voices all of the wayang puppets), teacher, historian, and entertainer for the masses. The performance must include jokes and songs as well as historical and social commentary.

Whether on wood or leather, wayang puppets are prized for their highly detailed, hand-painted surfaces.

A new type of wayang puppet theater has emerged in the 21st century: skateboard shadow puppets. Electric lamps, lasers, and computers are used to tell stories of modern-day events and characters. Since the projection screen is twice as big as the conventional screen, the puppeteer has numerous assistants who move around behind the massive screen on skateboards—hence the name! Wayang puppetry retains its relevance by adapting its characters and weaving in contemporary social and political issues while maintaining its commitment to entertain with a good story, hand-crafted puppets, and a committed storyteller. —SBR

Tractor as Pencil

THE MUNDI MAN OF THE AUSTRALIAN OUTBACK

Ando's immense depiction of an early Australian pioneer can only properly be viewed from the air. The brim of the figure's hat alone is a mile across. Each line of the image is 10 meters wide. (For some reason, I picture Paul Hogan leaning against a muddied Jeep, in costume as "Crocodile Dundee," dismissing some poor amateur's notepad sketch: "That's not a drawing...*this* is a drawing.")

Artist Ando and his tractor.

The image was etched into the soil of the Mundi Mundi Plains of Australia, just outside the city of Broken Hill, New South Wales. Ando's stylus was a tractor, modified for the task. Tines from a piece of farm equipment were attached to the vehicle to create furrows in the soil; it was outfitted with hydraulics in order to avoid disturbing animal and bird habitats. Over the course of nine months, Ando and his Canadian assistant, Christine Righetti, etched the image into more than 4 million square meters of outback soil.

Mundi Man *by Ando.* © ANDO. All rights reserved.

The Australian artist has been painting since he was 4 years old. He states that while he has painted landscapes on canvas several times, "This is the first time I have used the landscape *as* my canvas!" —DJS

Superman

LI WEI AND HIS DEATH-DEFYING ART

Look! Up in the sky! It's a bird…It's a plane…It's Chinese artist Li Wei!

Whether he is half buried in the earth like a meteor, getting kicked off a skyscraper, or floating effortlessly into the air, his work is terrifying and captivating in equal parts. Blurring the line between performance art and photography, Li Wei creates scenes that combine death-defying feats and truly inspired creativity.

His intriguing "Falls To" series includes pictures from all over the world with the artist buried head first up to his shoulders in the ground, while the rest of his body protrudes—ram-rod straight—into the air.

The very first of his photographs I saw (below) shows him getting kicked off of a skyscraper by a friend, with an expression of horror on his face. It's an incredibly captivating shot.

Li Wei admits to being in real danger during some of his shoots but takes as many precautions as he sees fit. Aside from the real Superman, he is the closest most of us can come to seeing someone fly and fall from great heights. —GRG

Chinese artist Li Wei and his death-defying art. Photo © Li Wei.

Exercise 28

SCOOTER WITH ED TADEM

Block in the
basic shapes
of the
scooter.

Now add the
handlebars, seat, light,
kickstand, and wheels.

Erase unneeded lines and add more
details. Then sketch the curb and
some pebbles on the ground for
interest.

Shade the
areas in shadow.
Use wide
crosshatching on
the floorplate
for texture.
Darken the
shadows and
edges to make
them "pop." Now
this scooter is
ready to ride!

Alla Prima Painting

MINIMAL PLANNING, MAXIMUM RESULTS

When oil first came onto the art scene, the process of painting involved several carefully planned sessions. As you've learned, artists began with an underpainting (page 258) and built up glazes of paint, letting the layers set and partially dry before applying the next. This was traditionally the *only* way to use oil paints until the beginning of the 17th century, when a few artists branched off and took the medium in a new and fresh direction. Translated from Italian to mean "at once" or "at the first," *alla prima* refers to the act of finishing a work of art in one or just a few sittings, all while the paint is still wet—no extensive groundwork, and no coming back day after day to refine details.

Also aptly called "direct painting," *alla prima* became the preferred approach in the middle of the 19th century. The Impressionists were drawn to the spontaneity and painterly qualities produced by this method. Brushstrokes became bold, loose, feathery, and suggestive; accuracy of shape and form became less important than accuracy of atmosphere.

In today's fine-art world, both approaches to oil painting are in use. Which one suits your personality and style—the original method of careful planning in layers, or *alla prima?* —ETG

African Aesthetics

HONORING THE SPIRIT WORLD

"When you pray, move your feet." —*African proverb*

Africa is a continent as diverse as it is enormous. The farther we get away from it, the easier it is for us to mentally merge its countries into a single, sprawling Serengeti. In reality, though, Africans include anyone from Islamic Egyptians to the Christian Sudanese, from tribal Nigerians to Caucasian South Africans, to name just a few possible groups. In other words, it's silly to lump them all into a single demographic, just like it is to homogenize the inhabitants of any continent. That said, the largest percentage of Africans occupy the Sub-Saharan region in the heart of the continent where there continues to be a strong nucleus of tribal tradition.

Among the multitude of tribes still present throughout Africa, there are some identifiable traits unifying the traditional artwork. Much of the art resembles humans or other animals; however, it isn't meant to represent particular individuals. Instead, it strives to universalize traits in order to abstractly convey the general spirit of a population.

Sculpture is an especially popular medium because of its capacity to depict the three-dimensionality of form. Also, masks are commonly used in ceremonial dances and rituals to represent deities, deceased ancestors, or other spirits. Through elaborate wood and leather designs, the masks display the people's respect for spiritual power and their adherence to animism. Many famous Western artists, including Picasso and van Gogh, were so impressed by African art that they consciously infused elements of its raw dynamism into their own work. —CKG

QUESTIONS TO PONDER

• *How might a tribal culture view beauty differently than a more technology-minded society?*

• *Would you consider ceremonial dance to be a kind of art?*

Surrealism

DISSECTING THE ANATOMY OF THE SUBCONSCIOUS

Melting clocks and floating men! Surrealism is preoccupied with dreams, fantasy, and desire. The theories of psychologists Sigmund Freud and Carl Jung encouraged the artists of this movement to work from the subconscious and to create art that perplexes the mind, challenges conventional logic, and questions the reality of appearances.

WHEN & WHERE

c. 1924–1955

Europe

Surrealism was born out of the Dada movement and offered a similar post-World War I vigor to shake up society's mindset. Unlike the nonsensical Dadaists, Surrealists were interested in the "marvelous"—that which inspires creativity and positively reconstructs the subconscious. Surrealism had two distinct styles: highly polished, lucid dreamscapes with elaborate and un-settling visual trickery and childlike, almost primitive images born out of a stream-of-consciousness painting process. Both violated the viewer's sense of well being by subverting reason.

Surrealism's popularity has endured in part because of its ability to transcend cultural boundaries by tapping into what unites us all: a fascination with the mysteries of the subconscious. —ARR

Selected artists: Jean Hans Arp, Andre Breton, Salvador Dali, Marcel Duchamp, Max Ernst, Rene Magritte, Joan Miro, Man Ray, Meret Oppenheim, Yves Tanguy

FUN FACT

The Surrealists played a drawing game called "Exquisite Corpse," in which one artist began a drawing on a sheet of paper, concealing all but a sliver. A second player continued the drawing based only on the few visible lines. Drawing and concealing continued until all players contributed, resulting in a surreal—and often humorous—drawing.

Thomas Gainsborough (1727–1788)
PORTRAIT OF AN ENGLISH ARTIST

In his *Fourteenth Discourse* on art delivered to the Royal Academy in the late 1700s, artist Sir Joshua Reynolds said the following of English painter Thomas Gainsborough: "If ever this nation should produce genius sufficient to acquire to us the honourable distinction of an English School, the name of Gainsborough will be transmitted to posterity, in the history of the Art, among the very first of that rising name." Although the two artists maintained a friendly rivalry, it was clear even to Reynolds that Gainsborough possessed a distinctive and exceptional talent. Today Gainsborough is considered one of England's finest 18th-century portrait artists.

Born in Sudbury, Suffolk, Gainsborough's father recognized his son's artistic talent early and sent the well-mannered 13-year-old boy to London to study under engraver Hubert Gravelot; Gainsborough also apprenticed with Francis Hayman. Unlike many artists of the day, Gainsborough never trekked to Italy or France to study the masters, nor was he interested in following rigid academic methods. Instead, he found inspiration in nature and preferred to paint landscapes. He soon discovered, however, that the money was in portraiture.

Following his marriage to Margaret Burr, Gainsborough settled for a time in Bath, a cultural center teeming with Britain's high society. In time, he became the preferred portrait artist among the wealthy. Eventually, Gainborough moved back to London, where he began receiving royal commissions and subsequently became a favorite of the aristocracy—including the king—even though Reynolds was still the official court painter. —RJR

Notable works: *Mr. and Mrs. Robert Andrews,* 1749; *The Blue Boy,* 1770 (page 362); *The Duke and Duchess of Cumberland,* 1785.

> ### FUN FACT
> *Gainsborough is especially known for his landscape portraits wherein the featured subjects are situated within a pastoral backdrop.*

The Arnolfini Marriage

JAN VAN EYCK, 1434

This painting is commonly interpreted as the portrait of a wedding between a rich Italian merchant, Giovanni Arnolfini, and his wife Giovanna Cenami. Evidence for this lies throughout the painting, and it's all easy to spot—if you're familiar with symbolism of the 15th century.

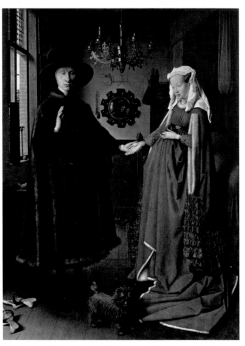

The Arnolfini Marriage, *1434 (oil on panel) by Jan van Eyck.*
Movement: Northern Renaissance.

Weddings at the time of this painting were rarely carried out in religious ceremonies but were typically low-key events at which the couple signed a legal contract in front of two witnesses. Upon close inspection of the mirror on the back wall, there are two people reflected—one of whom is perhaps van Eyck himself. Could these two people have served as the necessary witnesses? The English translation of a Latin inscription below the chandelier reads, "Jan van Eyck was here, 1434." Normally a work of art completed at this time would have been signed, "Jan van Eyck made this." The exception here suggests that the artist bore witness to the events in the painting.

Also embedded in this painting are symbols of loyalty (the dog) and fertility (the green color of Giovanna's dress and the bed), among many other symbols revolving around marriage. Sadly, however, the couple never had children.
—DDG

Art Basel

THE OLYMPICS OF THE ART WORLD

How many art-related activities could you squeeze in if given just one week? During the summer in the culturally rich city of Basel, Switzerland, you can find thousands of artists, curators, collectors, and lovers of modern and contemporary art jetting between the activities and exhibitions of the Art Basel, the four- to six-day premier world art fair since 1970.

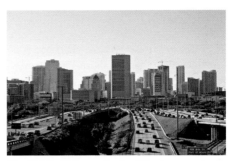

Miami Art Basel takes over the city of Miami every year in December.

Founded by a group of Swiss gallerists, Art Basel has since grown to include exhibition spaces for 300 galleries from around the world. Works by emerging artists costing a few thousand dollars sit next to million-dollar museum quality pieces in adjoining display booths; the Art Basel art-fair market functions as the great leveler. Deemed the "Olympics of the Art World" because of its all-encompassing reputation, the art fair also includes performances, public art installations, book signings, and lectures by curators and participating artists scattered throughout the city's concert halls, outdoor areas, museums, and theaters.

Art Basel Miami is the American counterpart to the Swiss fair, occurring every year in Florida. Similar to its European cousin, the exhibitions, installations, and art festivities of Art Basel Miami take over the city's convention center, outdoor parks, hotels, and even the famed South Beach. The sheer spectacle of thousands of people converging on one site to see, think about, and buy art is truly a sight to behold! —SBR

West African Barber Shop Signs

SIGNIFIERS OF STYLE

In many West African countries, the deceptively simple signs adorning the sides of businesses and passing trucks can transform everyday streets into veritable galleries of visual imagery. Neighborhood barber shops in particular owe their livelihoods to the sign painter's ability to depict hairstyles in an interesting, lively, and attention-grabbing manner. Brightly painted on plywood, African barber shop signs reflect the unique mix of African traditions of hair braiding and the stylistic influences of American culture. These quirky signs, depicting stylized portraits of men, women, and children, advertise a variety of hairstyles and techniques with names like the "Mike Tyson," "Boeing 707," "Four Lane Highway," and "Nelson Mandela," as well as the top fashions of the day. Most sign painters are self-taught and learn the trade primarily through apprenticeships and observing common imagery repeatedly.

American barber poles function much like the barber shop signs in Africa.

Barber shop signs can be found everywhere, including in-shop windows, painted directly on shop walls, and propped up next to a market stall. Often, barbers who do not have permanent shops but have a well-painted sign roam their neighborhoods with scissors and combs, hawking their services—in effect becoming traveling barbershops…just add customers! Like the striped barber pole in many parts of America, these signs announce an everyday service in a highly effectual and artistic way. —SBR

Junk Art in the Desert
THE CONSTRUCTIONS AND COLLAGES OF NOAH PURIFOY

In the later decades of his life, Noah Purifoy became known for his assemblage sculptures created in the vast southern Californian desert. He was experienced in the use of *objets trouvés* ("found objects," or junk art), having gained notoriety for creating "66 Signs of Neon" out of the wreckage of the 1965 Watts riots in Los Angeles.[35]

The White House, 1995, 40' x 52' x 20', exterior. Joshua Tree, California. *Courtesy of the Noah Purifoy Foundation (www.noahpurifoy.com).*

After relocating from Los Angeles to the rural town of Joshua Tree, the artist found a clean, virgin canvas of desert land. (Ironically, he initially had a difficult time finding junk with which to sculpt, due to the fastidious recycling habits of Joshua Tree residents.)

Purifoy's structures take a variety of forms. Some have a primitive, shamanistic look to them, evoking images of burial grounds and pagan ritual. Others appear post- and sub-industrial, including *Shelter,* which suggests a community of homeless squatters. Some sculptures, including one expansive "collage," are so massive that they are fully visible only from the air.

Many of Purifoy's constructions in Joshua Tree have a skeletal feeling of naked honesty about them. Lizetta LeFalle-Collins, curator of the California African-American Museum, once wrote that "the artist has peeled back the skin of a piece to reveal its interior life."[36] —DJS

Courtesy of the Noah Purifoy Foundation (www.noahpurifoy.com).

Great Bowls o' Fire!

JOHN T. UNGER'S SCRAPYARD ART

Who would have thought that a bowl of fire could be so beautiful? Artist John Unger's art portfolio ranges from bottle-cap mosaics to furniture, but he is perhaps best known for his amazing fire bowls. Hand-cut out of recycled steel, these bowls combine sculpture and function to create unique works of art with industrial flair that provide warmth and an exciting centerpiece for events. When in use, the flame-like edges of these bowls cast mesmerizing shadows that dance across the ground, acting as part of the art.

Fire bowl in action. Photo courtesy of John T. Unger (www.johntunger.com).

Fire bowl in progress. Photo courtesy of Preston S. Cole.

Unger buys the materials for making his bowls (and other works of art) at a local scrapyard, and he has shipped his art to buyers in 42 of the US states and in 5 countries so far. With the creative mandate "sustainable design with an edge," Unger focuses on creating work that lasts, has a minimal impact on the environment, and serves a purpose for its owners.

If it's keeping up with the Joneses that keeps you up at night, then a s'mores party showcasing a fire bowl would put you well ahead in the race. Not only is it less expensive than that new oversized high-definition television they just bought, you can't roast a marshmallow over a TV. —GRG

Exercise 29

DASHBOARD HULA DOLL WITH ED TADEM

Rough in the position of the head, shoulder line, curved spine, and legs.

Build the forms of her body around your guidelines.

Further develop the figure and add the skirt, erasing lines you no longer need.

Refine the eyes and mouth, and use poofy shapes to define the flowers. Refine the skirt.

Add a circular base under her feet. Shade with loose, dark lines, concentrating on the grass skirt and the shadow it casts on the legs, as well as the shadows on the figurine's base.

Painting *en Plein Air*

IN THE PRESENCE OF NATURE

Painting *en plein air* (French for "in the open air") refers to the process of painting outdoors or on location. In the mid-19th century, after oil paints became available in metal tubes, artists from the famous Barbizon School in France embraced this style of painting and

considered it an important step in working toward a realistic representation of the outdoors. However, when you consider possible setbacks like weather, moving objects, and shifting sunlight, why paint away from the comfort and convenience of a studio?

The first answer is technical in nature. If you're painting a realistic outdoor subject in a studio, you're most likely using a photograph as a reference. Although a photo is a helpful tool, you're at the mercy of the camera's ability to accurately record colors and values. A single exposure from a camera can create areas that are too dark or too light, and its colors can vary in hue and saturation from what you see in person. Painting *en plein air* eliminates the optical inconsistencies between a reference and the actual subject.

The second answer is sensory in nature. The most successful artists in history haven't just faithfully recorded the colors, values, and shapes of a scene—they've captured an atmosphere with their color choices and brushwork. And the best way to do this is to paint while actually interacting with your scene—seeing, hearing, feeling, smelling, and (why not?) tasting your environment. You'll never know what you can communicate with paint until you employ all of your senses! —ETG

Art and Language
COMMUNICATION AND UNDERSTANDING

"Language is the blood of the soul into which thoughts run and out of which they grow." —Oliver Wendell Holmes

Philosophy texts can be tough to read, to say the least (remember our quote from Schopenhauer?). This is partly because they were typically written long ago and translated from other languages. The main reason for their notorious impenetrability, though, is that philosophers tend to deliberately create their own jargon. They introduce new terminology because, as Holmes implies, new concepts can only take root in new language. Having a customized vocabulary allows philosophers to revolutionize thought.

Languages don't always have words, though. In one sense, language is anything that communicates meaning, and in that way, art qualifies as a language. As a means of expression, it gives shape to our ideas and can even surpass words in its ability to reveal our most indescribable feelings. So, does this mean that art can expand our conceptual framework in the same way words do?

There's no question that art can offer us new perspectives on the world, but to say that, without words, it can introduce new abstract concepts is a harder sell. Philosophers of language tend to agree that grammar and words are required for the cultivation of new ideas. Art is wonderful in the way it captures the intangible, but to analyze the impressions it imparts to us and apply them in other places, we might just need words after all. —CKG

QUESTIONS TO PONDER
• *Do you consider art to be a language?*
• *How much do we rely on the language of words to help us understand an experience of art?*

Abstract Expressionism

PAINTINGS AS VEHICLES FOR PASSION

Bold and visually engulfing, Abstract Expressionism was the first homegrown American movement with a worldwide impact. These artists considered art a transcendent aesthetic experience meant to be understood viscerally rather than intellectually.

WHEN & WHERE

c. 1940–1955

New York City, USA

Action or Gestural painting and Color Field painting were the two distinct artistic modes of Abstract Expressionism. Action painting was spontaneous and energetic, concerned with the artist's physical experience of applying paint to heroically sized canvases. Evidence of the artist's hand, labor, and emotion are imbedded in the paint as it streaks and drips its way across the canvas. The act of creation was considered as important as a finished work. Color Field painters, who often regarded the artistic process as mystical, meditatively allowed bright colors to consume the vast expanses of their canvases.

Abstract Expressionists were influenced by Surrealism, and the spirit of improvisation in jazz music inspired accidental discoveries in their painting process. The flatness of Piet Mondrian's paintings was the precursor to the idea that art should not look beyond itself for content.

During World War II, many artists fled Europe's devastation for New York City, bringing with them Paris's title as epicenter of the art world. Abstract Expressionism's nonrepresentational content was apolitical, allowing the movement to flourish despite the oppressive climate of the McCarthy era. The movement eventually gave way to Pop Art, but its legacy lives on in artists that use paint as a vehicle for the passion and tranquility of the unconscious mind. —ARR

Selected artists: Willem de Kooning, Helen Frankenthaler, Arshile Gorky, Adolph Gottlieb, Hans Hofmann, Franz Kline, Lee Krasner, Barnett Newman, Jackson Pollock, Mark Rothko, Clyfford Still

Jean Dubuffet (1901-1985)

ART SANS BOUNDARIES

"For me, insanity is super sanity. The normal is psychotic. Normal means lack of imagination, lack of creativity." —Jean Dubuffet

If ever an artist was deemed anti-establishment, it was Jean Dubuffet. The French painter, hailed as one of the most influential of the late 20th century, shunned what he felt was rigid academic art training and the social codes he believed hampered the essence of creativity.

But Dubuffet wasn't always so assured in his convictions.

Born in La Havre, Dubuffet moved to Paris in 1918 to study painting at the Académie Julian, but dropped out after six months to pursue art on his own. Within a few years, the discouraged painter abandoned art completely to work in his family's wine merchant business. He began painting again in the mid-1930s, only to take another hiatus a short time later. Finally, in 1942, Dubuffet returned to art for good with renewed vigor.

Close up of Jean Dubuffet's Group of Four Trees, *c. 1972, which graces 1 Chase Manhattan Plaza in NYC.*

An avid people watcher, Dubuffet was a keen observer of the everyday world-at-large. He was particularly intrigued by the art of so-called non-artists, including children and the mentally ill, which he subsequently termed *art brut,* or "raw art." He wrote a treatise on the subject and even formed a small society after accruing a number of works rendered by "those unscathed by artistic culture, in which, the mimesis has little role in the way that the artist draws everything...from their own depths and, unlike intellectuals, not from the conventions of classical or fashionable art." (*L'art Brut Prefere Aux Arts Culturels,* 1949)

Thus, Dubuffet's own art was also pure and lacking in pretension. Many of his subjects—though often rendered crudely and flatly—also personified a charming innocence and gentle naïveté. —RJR

Notable works: *Apartment Houses, Paris,* 1946; *Smiling Face,* 1948; *The Cow with a Subtile Nose,* 1954.

A Sunday on La Grande Jatte

GEORGES SEURAT, 1884-1886

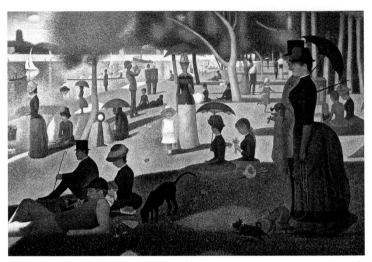

A Sunday on La Grande Jatte, 1884-86 (oil on canvas) by Georges Pierre Seurat. Movement: Post-Impressionsim.

Georges Seurat (1859-1891) was fascinated with the science of art. His goal was to create visually stunning paintings that stood apart from other works of the time, and he eagerly studied the fields of optics and color theory in order to realize this artistic vision. He contributed to the formation of the aesthetic theory known as *divisionism*—better known as *pointillism*—in which small dots of pure color are applied to encourage "optical blending." (For example, a cluster of blue and red dots would "read" visually as purple.)

At the age of 25, Seurat completed *A Sunday on La Grande Jatte,* which remains his most famous example of pointillist art. From a distance, the scene appears textured, almost like sandpaper. And if you look closely (a benefit of viewing the piece in person!), you can see the tiny specks of color that create the intricate scene. It took Seurat two years to finish this large painting. He spent months visiting the island in the Seine River of Paris where he made numerous small drawings and oil paintings of the people he found there. All of these artistic observations, including the famous woman with the monkey that you see in the foreground on the right, made their way into the spectacular finished work. —DDG

Old Favorites, New Discoveries

THE ARMORY SHOW

The Armory Show is now housed at Pier 94 on Manhattan's West Side, along the Hudson River.

The Armory Show, the largest annual contemporary art fair in New York City, was originally housed at its namesake, Manhattan's 69th Regiment Armory, the former training facilities for the National Guard (now listed on the National Registry of Historical Places).

The history of today's international art fair is linked to the Armory Show, which began with a bang in 1913 when President Theodore Roosevelt declared, "That's not art!" after viewing works by modern art masters Marcel Duchamp, Paul Cézanne, and Henri Matisse. From this auspicious beginning, the Armory has since shifted its name, venue, and ownership numerous times. In 2007, the show merged with powerhouse tradeshow organizer Merchandise Mart Properties, Inc., which many say has only increased its level of professionalism, attendance, and profits.

Currently the Armory Show is staged on Pier 94 on New York City's West Side. Over a period of four days, thousands of people buy millions of dollars worth of works by old masters and newly minted art school graduates. Given the reputation of the Armory, other galleries and smaller exhibition spaces link themselves with the older, more established show, earning the nickname "Armory Week." Though billed as an international event, the Armory has been dominated by European and New York based galleries. Many view the increasing importance of the art fair as a tragic sign of the power of the market over more traditional art institutions, such as museums and biennials. Only time will tell if the Armory Show and other international art fairs will survive and prosper as spaces where commerce and aesthetics thrive. —SBR

Holy Rollin'

THE SACRED ROCK CHURCHES OF LALIBELA

Instead of admiring the lofty grandeur of a cathedral, imagine peering down into a massive pit to find a medieval church, entirely cut from stone. Most churches are designed to soar high into the sky, striving to make a connection with the divine. However, the 13 rock-hewn churches of Lalibela are carved directly into the rocky fields and mountainsides of Northern Ethiopia. Labyrinthine tunnels connect several of the churches, and their secret chambers still contain the mummies of ancient monks and pilgrims. Lalibela, a holy city and pilgrimage site for Ethiopians and the worshippers around the world, takes its name from King Lalibela, one of the last kings of the 13th-century Zagwe dynasty. Begun as early as the 11th century, these monolithic churches are modeled after the design and layout of churches of another holy city, Jerusalem.

Many older Ethiopian Orthodox stone and rock-hewn churches are active centers of worship today.

Some speculate that the medieval Abyssinian sculptors were aided by the Knights Templar, as evidenced by the Coptic influence in the architectural details, but their basic structural design is indigenous to the region. Legend has it that the king also received aid from the Angel Gabriel and St. George! Clearly a collaborative project, the rock churches are not only an historical site but remain active centers of worship for the Ethiopian Orthodox Church and part of the modern city of Lalibela. —SBR

!

Homeless in Russia

THE PHOTOGRAPHS OF ANDREI ABRAMOV

Andrei Abramov photographs the newly homeless of Russia, combining social commentary with aesthetic distinction.

Until fairly recently, the phenomenon of homelessness was practically nonexistent in Russia. The chaos following the dissolution of the Soviet Union left thousands living on the streets, dispossessed of their apartments, jobs, and retirement pensions.

Pasha. Engels, Russia. Photograph by Andrei Abramov.

The visual drama of Abramov's photographs is matched by the inscrutable stories that often accompany them. Nikolai owns a home but, for reasons known only to him, chooses to live on the street during the warmer months. He considers himself an itinerant philosopher and an intellectual.

Aleksei has a home, but he can't remember where he lives. He suffered severe head trauma some time ago and hasn't been able to find his way back home in years.

Vova sleeps in the basement of an apartment building in downtown Saratov. Regarding his living situation, he enigmatically states, "I have no complaints."

One photo presents a sardonic piece of Marxist graffiti—"kill a bourgeois, plant a tree"—framed by two homeless men, Pasha and Tolik (below). Abramov says that the scene occurred naturally; he serendipitously had his camera with him at the time. —DJS

Pasha and Tolik with Graffiti. *Engels, Russia. Photograph by Andrei Abramov.*

Artistic Syndromes

TRAVELER'S WARNING: AVOID FLORENCE

"This painting is so beautiful that it's making me dizzy." "This sculpture is so touching—I think I may be sick." "The art in here is so incredible…I just want to destroy it." If any of these sound familiar, you may have one of two art-related syndromes.

Stendhal syndrome refers to dizziness, queasiness, or hallucinations brought on by exposure to great works of art. The term was initially coined by Dr. Graziella Magherini, an Italian psychiatrist who noticed that tourists were often affected by the great works of art in Florence, Italy.

Michelangelo's David *resides at the Academy Gallery in Florence, Italy.*

David syndrome, also described and studied by Dr. Magherini, is the strong desire to destroy a piece of art, again brought on by art's sheer beauty. She has found that while viewing Michelangelo's David, "Men of 35 to 40 years of age…are attracted by the extraordinary masculine beauty and, at the same time, are also agitated."[37]

If your vacation plans include Florence, you may want to prepare yourself for the possible onset of either of these syndromes—especially if you visit the Uffizi Gallery. It may behoove you to take an Italian along, as he or she is thought to be immune to both syndromes. —GRG

Exercise 30

KITTEN WITH EILEEN SORG

Apply bright green around the pupils and surround it with bright blue, leaving white highlights. Blend over these strokes with light blue and heavy pressure. For the ears, nose, and mouth, stroke reddish brown in the direction of hair growth.

Add light orange to the areas of the face as a bright underlayer for the fur.

Continuing with the fur, apply brown over the light orange around the face and neck.

Now add black to define the eyes and nose. Use black to add the stripes and whiskers.

Introduction to Acrylic

THE DEFINITION OF VERSITILITY

What started as a house paint in the first half of the 20th century has become a respected medium for the fine artist. Acrylic paint, which is made up of pigment and acrylic polymer, boasts a number of positive qualities that make it a viable competitor to oil and watercolor. First, you can dilute the paint with plain water (no harsh solvents needed!), but once it's dry, the paint is waterproof. Second, you can apply the paint in thick or thin layers, imitating either oil or watercolor, respectively. Third, acrylic is resistant to cracking and fading. Fourth, unlike oil, acrylic dries quickly so you don't have to wait long between applying layers. Fifth, you can apply acrylic to nearly any surface (so long as it's not waxy or greasy), making it perfect for use in collage. And the list goes on.

Here are just few things to keep in mind while using acrylic. Because it dries quickly, you'll need to work quickly. This can be seen as a positive or negative quality depending on your painting style—for some it interferes with blending, but for others it encourages loose and lively strokes and discourages overworking. Also, it's important to note that acrylic paints often dry darker than they appear when wet. —ETG

READY TO START?

Here's what you'll need: a set of acrylics, heavy paper or canvas, a set of synthetic brushes, two jars of water (one for rinsing the brushes and one for adding fresh water to mixtures), paper towels, and mediums (page 318).

Art and Politics
FREEDOM AND CONTROL

"Art is always and everywhere the secret confession, and at the same time the immortal movement of its time." —Karl Marx

Art is powerful in the way it can ignite ideas and elicit emotions. It can be used to inspire, intimidate, or even brainwash, and political leaders have never been oblivious to its functional capacities. The use of art for political purposes is a double-edged sword that some leaders have wielded with more wisdom than others.

Political philosophers are also concerned with art because of its cultural significance. Marx, for example, in his criticism of capitalist society, sees art reflecting the twisted ideology of the upper class. By the same token, he thinks it could give a voice to the oppressed majority of people suffering economic injustice. His views inspired generations of communist and socialist sympathizers to only accept art that catered to the needs of the masses. In some cultures, this led officials to ban any art that signified the luxurious lifestyle of the bourgeoisie.

While most Western societies strive to protect artists' rights, the majority of people also support a certain degree of governmental censorship to regulate obscene subject matter. As we've seen, the boundaries of the art world are not clearly defined. To simultaneously monitor inappropriate material and preserve artistic freedom is a difficult balancing act for legislators. Due to shifting cultural values and the interpretive nature of art, the lines of decency are frequently and hotly debated. CKG

QUESTIONS TO PONDER

• *Can you think of any examples of how art has been used in politics for both virtuous and corrupt ends?*

• *What kinds of art, if any, should be censored by political leaders?*

Pop Art

MASS CULTURE'S MIRROR

Pop Art, the major movement of the '60s, held up an affectionate and critical mirror to popular Western culture. By painting taxidermy animals; sewing giant, stuffed ice

cream cones; and printing thousands of Campbell's Tomato Soup can images, pop artists prompted audiences to analyze their own culture and question it—if not just laugh.

A new visual culture had emerged, with commercial images permeating every nook and cranny of daily life. Fueled by television advertisements, the post-World War II capitalist economy boomed, and consumerism reached an all-time high. Vibrant and modern young people idolized musicians and actors. As a backlash against the oppressive formal dogma of the Abstract Expressionist movement, Pop Art responded to this new materialistic culture and dethroned its predecessor.

The Pop Art movement was an attitude toward art focusing on democratic, impersonal, and urban themes. Inspired by mass culture and the revolutionary work of Marcel Duchamp, Kurt Schwitters, and John Cage, Pop artists re-contextualized common signs. They appropriated iconic American symbols and pilfered images from advertisements, television, comic books, cinema, and common household products. This anti-elitist approach redefined the boundaries between "high" and "low" art. Like Dada, Pop Art went beyond traditional painting to include junk sculpture, assemblages, prints, and performances.

Though any type of art today that directly addresses contemporary visual culture can be considered Pop Art, the era itself gave way in the 1970s to various other movements. —ARR

Selected artists: Jim Dine, Richard Hamilton, David Hockney, Jasper Johns, Roy Lichtenstein, Claes Oldenburg, Robert Rauschenberg, James Rosenquist, Ed Ruscha, Wayne Thiebaud, Andy Warhol, Tom Wesslemann

Henri de Toulouse-Lautrec (1864–1901)

DECADENCE IN FIN-DE-SIÈCLE PARIS

For Henri de Toulouse-Lautrec, art was an escape from the pain and tragedy of his life. Born in Albi, France, to an affluent aristocratic family, Lautrec was a sickly child who became disabled in his early teens after fractures in his legs failed to heal in full. As a result, he stopped growing at a little over four feet tall and was unable to take part in many normal childhood activities. Art subsequently became his outlet.

Much of Lautrec's art was inspired by the colorful bars and cafés in and around Montmartre.

As an adult, Lautrec was drawn to the excitement and thrill of Montmartre, a seedier section on the outskirts of Paris known for its decadent cafés, cabarets, dance halls, circuses, and brothels teeming with bohemians. Lautrec immersed himself in this subversive milieu, exposing the dark and often sad existence of the Paris underground in his lively paintings and lithography. Lautrec patronized the establishments, drinking, socializing, and sketching his observations; he'd then refer to the sketches to create finished artwork, much of which depicted actual clientele, rather than anonymous, unknown faces.

Lautrec catapulted to fame with his lithograph "Moulin Rouge: La Goulue," an advertisement for the Moulin Rouge and its provocative Can-Can dancer, Louise Weber. Thousands of posters were printed and distributed throughout Paris, which brought Lautrec instant recognition. Sadly, however, the heavy drinking associated with Lautrec's lifestyle rendered him an alcoholic, and he died at the age of 36. —RJR

Notable works: *Equestrienne,* 1888; *Moulin Rouge: La Goulue,* 1891; *At the Moulin Rouge,* 1892; *Jane Avril,* 1893 (page 242).

FUN FACT

Lautrec allegedly owned a cane customized with a secret compartment in which he stored alcohol.

Self-Portait

VINCENT VAN GOGH, 1889

Vincent van Gogh completed this final self-portrait less than a year before his death in 1890. It was created at the mental health asylum in Saint-Remy, France where he also painted *The Starry Night*. Six weeks before executing this painting, van Gogh had suffered one of his several severe mental breakdowns. Eventually, his condition improved enough that his doctors granted him permission to paint. Over the course of a month, he finished two self-portraits, providing us with two different perspectives of a genius coping with the effects of a troubled mind.

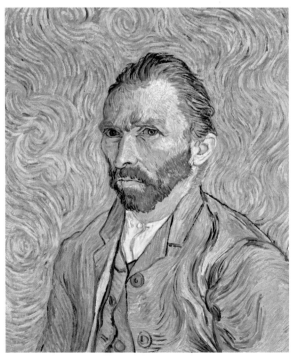

Self-Portrait, *1889 (oil on canvas) by Vincent van Gogh. Movement: Post-Impressionism.*

The most striking aspect of this version is the contrast of colors. The warmth of the artist's head stands out boldly against the cool blues and greens of the background, and they draw our attention to his face. Considering that this self-portrait was painted while van Gogh was institutionalized and near death, it may appear that he is surprisingly calm and composed. It's difficult, however, to ignore his scowl and the deep unhappiness and emotional unrest conveyed in his expression. Adding to the tension are van Gogh's trademark swirls, which seem to reflect the chaos and self-destructive impulses brewing in the artist's soul. —DDG

Living Pictures
THE PAGEANT OF THE MASTERS

In an outdoor ampitheater nestled in the hills above the seaside California town of Laguna Beach, the Pageant of the Masters presents dramatic reinterpretations of famous (and infamous!) works of art by live actors, usually local residents. This annual art festival extravaganza combines art, theater, poetry, and a bit of spectacle, as meticulously painted and costumed actors silently hold their positions in front of painted backdrops evoking the works of Paul Cézanne, Marc Chagall, and even Leonardo da Vinci's *The Last Supper*, as a narrator tells a story about each work. The theme for these *tableaux vivant* changes every year, ranging from Ancient Greco-Roman sculptures and European Impressionist paintings to Japanese samurai warriors. Housed inside a massive exhibition space known as the Festival of the Arts, the Pageant gives local artists a venue to showcase their art and hopefully make a profit.

During the 1932 Summer Olympic Games in Los Angeles and the depths of the Great Depression, the local Art Association created the Pageant as a means to draw much-needed business down to the normally quiet town 50 miles south of the City of the Angels. The festival was a success and, 70 years later, continues to attract vast numbers of locals and tourists traveling through southern California during the summer festival season. —SBR

Kente Cloth of Western Africa

WEARING ART ON YOUR SLEEVE

Do your clothes tell a story about your history, moral values, and religious and political beliefs? *Kente,* the hand-woven ceremonial cloth native to many West African countries, is more than a piece of colorful fabric. Each woven strip spells out in its warp and weft the wearer's identity and heritage. The cloth, which gets its name from the Akan Twi word for basket *(kenten),* is typically woven by men in 4- to 8-inch strips cut down and sewn together to form one large piece of fabric. There is a fine art to choosing which kente cloth to wear and how to wear it. The proper way to wear kente is to keep the woven strips even at the bottom, with the pattern aligning both horizontally and vertically. Even the way a kente cloth is wrapped and draped reveals hidden meanings and messages: A man is considered brave if he wears the cloth above the knee with the excess draped and gathered high on the shoulder.

Traditional kente cloth from Ghana.

Kente has been embraced on both sides of the Atlantic; the fabric has been appropriated by members of clergy and academia in America for ceremonial robe adornment. Kente cloth can also made into myriad contemporary dress items; you can find tailored shirts, pants, suits, and dresses made from kente. Though historically worn by royalty at special ceremonies, any modern occasion can be improved with this vibrant, geometrically printed cloth. —SBR

Detail of warp and weft of woven kente cloth.

Morpho Towers

THE MAGNETIC ART OF SACHIKO KODAMA

At times, Sachiko Kodama's work resembles a great, spiny caterpillar crawling and heaving itself forward toward another branch. A minute later, it simulates the flow of magma from an active volcano. What, for a moment, looks like a nest full of hungry birds gawking upward may suddenly transform, evoking the flawless movements of some otherworldly dancer.

Kodama's fluid, ever-changing sculptures look like something created by computer-generated graphics, born of the imagination of a sci-fi writer. But each configuration is real and tangible—if only for a moment.

Morpho Tower *by Sachiko Kodama, 2006.*

The artist's creations are formed by a magnetic, oily liquid known as "ferrofluid," flowing around a housing device and manipulated by a series of electromagnets located within the structure. The electrical charges create seemingly endless series of patterns that present themselves in an ebb and flow of spikes. The spikes emerge, rotate, change directions, grow, and disintegrate.

In some sculptures, such as *Protrude, Flow* and *Breathing Chaos,* the movement of the coursing ferrofluid appears wild and bestial. The "Morpho Tower" series, in contrast, involves various conical towers on which the spikes flower and molt with hypnotic harmony.

In stride with the enigmatic nature of these creations, Kodama asserts that her exact technique is a secret. —DJS

Detail of Morpho Tower *by Sachiko Kodama, 2006.*

Math + Physics = ART?

CREATING BEAUTY THE LEFT-BRAINED WAY

I'm willing to guess that not too many people associate the words "math" and "physics" with the word "art." Surprisingly, or perhaps not so, is that the image you see here is an example of all three of those words in action. In a freshman physics class at the Massachusetts Institute of Technology (MIT) called "Introduction to Electricity and Magnetism," students are taught to define vector fields by entering formulas into an application (see caption), producing visualizations of these fields. The resulting images embody organic harmony and are intrinsically beautiful.

Weird field by Gabriel Guzman (author). The application for generating these visualizations is available on the TEAL Visualizations page (http://web.mit.edu/8.02t/www/802TEAL3D), but the math has to come from you!

The application was originally designed to help students understand the complicated interactions of vector fields. It soon became apparent that these visualizations were not only useful for teaching, but in some cases they were aesthetically pleasing. Soon enough, a competition called "Weird Fields" was initiated to see who could create the most striking image.[38]

So, now we see that physics and math, while not universally considered fun, can still produce beautiful, weird fields. —GRG

Exercise 31

MINI COOPER WITH ED TADEM

Start by drawing a boxy shape. Then rough in the headlights, wheels, windows, door, and grille.

Sketch in more elements, such as the license plate, mirror, bumper, and grille reflectors. Round out the shapes and give them form.

Continue adding details, including the roof and seats as they're seen through the windows.

Refine and clean up your lines. Add details and lightly shade the inside of the car, the headlights, tires, door handle, and other details.

Shade more thoroughly, concentrating on the headlights, grille, underside of the car, and tires. Note the radial strokes on the tires.

Acrylic Mediums

MAKING THE PAINT WORK FOR *YOU*

If you're ever bored with the consistency, sheen, or behavior of your paint, experiment with the vast array of paint mediums on the market. These liquids, creams, gels, and pastes are sure to breathe new life into your art sessions by altering or enhancing your paint's characteristics.

Acrylic paint in particular boasts a wide range of mediums, and, as it's relatively new to the fine art scene, I imagine the number will only continue to grow. Peruse the list below to familiarize yourself with the most popular choices among artists today.

• To combat a common complaint with acrylics, *retarders* have been designed to slow the drying time of the paint.

• When painting in thin washes, *acrylic flow improver* breaks the surface tension of water, allowing your paint to flow more freely across your painting surface.

• For the opposite effect, thicken or add body to your paint with *acrylic modeling paste*. Use it to exaggerate your impasto strokes or create dramatic textures.

• To give your paint a coarse, granular look and feel, experiment with *pumice gels.*

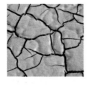

• *Crackle paste* might pique your interest as well, which causes your paint to develop cracks across its surface. —ETG

Ancient Aesthetics

FROM REAL CAVES TO ALLEGORICAL CAVES

"Mankind is poised midway between the gods and the beasts."

—Plotinus

Prehistoric people didn't have it easy. Outside of Greece and prior to its glory days, the world was overwhelmingly mysterious and confusing. On page 10, you can learn about cave paintings that exhibit the ancient human's desperation to make sense of a world that seemed infinite. Superstition and awe were the most natural responses for our planet's earliest human inhabitants, and art's power to broadcast raw emotion was perhaps never better suited to a time.

You can imagine the excitement when the universe first showed signs of order in the equations of men like Pythagoras and Thales. Convinced that there were forces at work greater than themselves, directing the cosmos and perhaps giving it meaning, these thinkers pursued the sources of their work's harmony. Hence the power and perfection of the gods, the ideal forms, and the portrayal of ultimate reality in theater, sculpture, and literature.

It's important to remember that academic disciplines were still in their infancy in Ancient Greece. The philosophers who studied things like the meaning of life were the same people trying to figure out math, science, ethics, art, and pretty much everything else. Art would only have been a cursory interest for someone like Aristotle, who was busy trying to organize the first systems of classifying the entire natural world when he wasn't tutoring Alexander the Great. Still though, there was no denying the impact art had on people's lives. Clearly art was here to stay. —CKG

QUESTIONS TO PONDER

• *What might have inspired the earliest artwork?*

• *How does ancient Greek art reflect the beliefs and concerns of that time?*

Minimalism

THE OBJECT IS THE ART

Do simple paintings and sculptures of cubes and pyramids transport you to another realm and inspire fantastic ideas? Probably not, and for Minimalists, they're not supposed to. The sparse, geometric

WHEN & WHERE

c. 1960–1975

USA

forms of the Minimalist movement are intentionally impersonal and meant only to be judged as objects at face value. Frank Stella once said of his paintings, "What you see is what you see."

Often viewed as a reaction to the pretensions of the Abstract Expressionist movement, Minimalism attempted to reduce art to its literal and fundamental elements, omitting unnecessary colors, lines, and textures. Minimalist paintings, sculptures, and installations were often large and confrontational with sterile and often repetitive objects that challenged the viewer to consider them as absolute "things." Mathematically composed forms were homogeneous, with no focal points. Several artists had their work manufactured, further eliminating any presence of the artist's hand or emotions.

Minimalism, also known as ABC Art, was very controversial at first, its blank forms attacked as banal and vacant. However, the movement became pervasive throughout the art world and the 1966 "Primary Structures" exhibit solidified its status as a force to be reckoned with. It branched out into the Light and Space movement, morphed into Post-Minimalism, and became the gateway for the highly cerebral movement called Conceptual Art. Though many viewers find the Minimalist penchant for pure aestheticism difficult to relate to, its concept was bold, daring, and eternal in its simplicity. —ARR

Selected artists: Carle Andre, Dan Flavin, Eva Hesse, Donald Judd, Ellsworth Kelly, Sol LeWitt, Robert Morris, Ad Reinhardt, Richard Serra, Tony Smith, Frank Stella

Marcel Duchamp (1887–1968)

READYMADE ARTIST

"The creative act is not performed by the artist alone; the spectator brings the work in contact with the external world by deciphering and interpreting its inner qualifications and thus adds his contribution to the creative act." —Marcel Duchamp

Marcel Duchamp was conceivably one of the most inimitable artists of the 20th century. His groundbreaking philosophies left a unique imprint on numerous Avant-Garde circles and continue to inspire today—even though he produced very few works in his lifetime.

Duchamp was born in Blainville, France, to a bourgeois family whose appreciation of art, literature, music, and other cultural pursuits made a considerable impact on the six Duchamp children, four of whom, including Marcel, became artists. Duchamp's grandfather, a businessman by trade, was also an artist and played a strong role in the family's artistic inclinations.

In 1904, Duchamp moved to Paris where he attended the Académie Julian for a year and drew and sold cartoons that reflected his keen intellect and sense of humor. He experimented with numerous forms, including Post-Impressionism, Fauvism, and Cubism; however, he never aligned himself with any particular style, and his nonconformist ideas challenged virtually every artistic convention of the time. Duchamp didn't want to push the boundaries of art—he wanted to obliterate them. As a result, his works were often met with great antipathy.

Among his more provocative works were what he called "readymades": ordinary manufactured objects that he modified or slightly manipulated, for example, by adding a signature or title, or otherwise dislocating an object's position in space. Thus, a bicycle wheel, a snow shovel, and a urinal became art in Duchamp's hands.

Duchamp's artistic brilliance was matched only by his enigmatic wit—and few things were off limits. Even his headstone reads: "After all, it is always the others who die." —RJR

Notable works: *Nude Descending a Staircase, No. 2,* 1912; *The Bicycle Wheel,* 1913; *Fountain,* 1917.

Breakfast in Bed

MARY CASSATT, 1897

Mary Cassatt has the distinction of being the only female artist whose work we feature in this section, and she is the only Impressionist, if not artist, who dealt primarily with themes of motherhood. In the 19th century, a well-off woman such as Cassatt had access only to the public and private lives of women like herself. So, not surprisingly, these women (and their children) became the subjects of her art.

Although the Impressionist movement was spurred on by a core group of predominantly French artists, a handful of painters from other countries also associated themselves with it. Cassatt was the most famous American artist to do so. By the time she painted *Breakfast in Bed* in 1897, she had parted ways with the Impressionists and chose not to associate herself with any particular style. Even so, the Impressionistic influence on this piece is undeniable.

In this tender moment between mother and daughter, the little girl's naïve contentment is contrasted with the more complex thoughts evident in her mother's drowsy expression. Abstract curves in the bedding juxtapose the warm detail of faces and limbs in a composition that remains, to this day, a lovely and touching portrait. —DDG

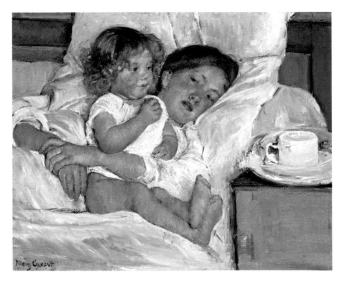

Breakfast in Bed, 1897 (oil on canvas) by Mary Cassatt. Courtesy of Huntington Library, Art Collections, and Botanical Gardens, San Marino, California. Movement: Impressionism.

Taking Art to the Streets
ART PARADE, DEITCH PROJECTS

Don't be surprised if you find a ukulele orchestra, street performers, homemade costumes, floats, balloons, portable sculptures, and people dressed as giant cockroaches and ice cream cones cavorting down the streets of New York City every September—it's just the Art Parade. Organized by Deitch Projects, longtime gallerist Jeffrey Deitch's alternative art space devoted to promoting contemporary art, the Art Parade has been invading the streets of Manhattan since 2005 with its eclectic combination of art, performance, and equal parts kitsch and comedy. As stated by Susanne Geiss, Deitch Projects gallery director, the idea for the Parade "grew out of the gallery's programs, as an extension of our performance and installation projects."

Unofficially marking the beginning of the art and gallery season in New York City each year, the Parade remains fresh and relevant by opening the call for proposals to all levels of artistry and experience, from established and emerging art practitioners to art school musicians—projects by Kenny Scharf and Yoko Ono keep in time with music and art by the Scissor Sisters and the Voluptuous Horror of Karen Black. Over the course of an hour and a half, you will be dazzled both visually and aurally by the sights and sounds of living artworks parading through the streets of New York to their own funky beats!
—SBR

Spirits in Stone

SHONA SCULPTURE OF ZIMBABWE

The iconic stone sculpture called Shona, whose name means "great stone house," comes from the southern African state of Zimbabwe. The sculpture gets its name from the Shona people, the largest indigenous group in Zimbabwe. Similar to many cultures around the world, the Shona believe that every living thing contains a spirit and through the process of carving, the spirit in the stone will be revealed. A variety of native stones, including serpentine, granite, and rare verdite, is polished with hot wax to a high shine. The stones vary in color from deep emerald green, smoky gray, inky black, and dark brown. Each sculptor's individual style draws from a wide array of source material—dreams, spiritual visions, historical figures, and everyday objects—to depict semi-abstract mythic beings, animals, and people. Well-known sculptor Bernard Matern-era compares the process for discovering the hidden forms inside each stone to the act of peeling fruit: "A rock is like a fruit—like an orange or a banana. You don't eat them without peeling them first. I open the rocks. The fruit is inside."

Shona sculpture of a family unit.

Many of these sculptors have reached international acclaim, and although this art form began in the 1950s, it has already caught the attention of serious international collectors—the collections of the Museum of Modern Art in New York and Queen Elizabeth II contain multiple pieces of Shona work. —SBR

Post-Human

ARTISTIC COLLABORATION BETWEEN MAN AND MACHINE

The "Metaformance" series of video recordings, created by Sergio Medrano and other Mexico City artists of the group *Creatura-Artefacto*, assimilates technology with the human body, performers with spectators, and the visual with the auditory. The end product borders on the indescribable.

Also known by the name *Posthumano,* the project meditates on the changing definition of the human being in this age of biotechnology and telecommunication, exploring the blurred line between man and machine.

Photo courtesy of Sergio Medrano.

Photo courtesy of Sergio Medrano.

Medrano plays the part of the "hybrid body," wearing an elaborate, sci-fi-esque apparatus that runs down his spinal column. His physical movements are translated into both sound waves and visual images by the "prosthesis" and then relayed to a remote computer. As the artist interacts with bystanders, the sounds of their voices are transmitted to the computer as well; all of the registered data is transmuted into a composite visual representation, and edited into a 20- to 30-minute video.

The walls between the visual, auditory, and physical senses melt—perceptions blend together. The work examines the incremental melding of human beings with technology and the ensuing decrease in the human characteristics that most consider immutable. As Medrano states, "In modern society, it has become increasingly normal for a human being to reinvent him or herself." —DJS

Photo courtesy of Sergio Medrano.

The Bad Dream

ON ELBOWS, PAINTINGS, AND LAWYERS

Have you ever accidentally torn, punctured, ripped, creased, or bent a precious painting or photograph? What about one you were about to sell for $139 million US?

Not many people can say that they've poked a hole in a Picasso, but Steve Wynn—the Vegas casino magnate—sure can.

While showing off Picasso's *Le Rêve* (French for "The Dream") to several friends, Steve gestured to make a point and accidentally pushed his elbow right into the painting, causing a "pop" and an elbow-sized hole.

Everyone in the room went quiet. According to the CBC[39], Wynn said, "The blood drained out of their faces." Keep in mind that this all happened the day before the painting was to be sold to billionaire Steven Cohen. If the sale had gone through, it would have been the highest amount ever paid for any painting. Oops.

Steve Wynn filed a claim with his insurance company for the $85 million difference between the proposed sale amount and the painting's estimate after the incident. Although the insurance company failed to recognize the claim (do they ever?), they settled with Wynn out of court—after he sued them.

The moral of the story? If you own a Picasso, make sure you have good lawyers. —GRG

Exercise 32

RETRO CHAIR WITH ED TADEM

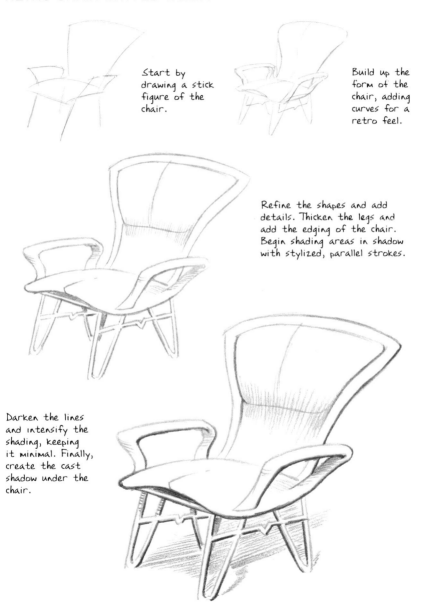

Start by drawing a stick figure of the chair.

Build up the form of the chair, adding curves for a retro feel.

Refine the shapes and add details. Thicken the legs and add the edging of the chair. Begin shading areas in shadow with stylized, parallel strokes.

Darken the lines and intensify the shading, keeping it minimal. Finally, create the cast shadow under the chair.

Introduction to Watercolor

LIQUID RADIANCE

"What a splendid thing watercolour is to express atmosphere and distance, so that the figure is surrounded by air and can breathe in it, as it were." —Vincent van Gogh[40]

Van Gogh had it right—the airy and atmospheric qualities of watercolor set it apart from all other painting media. Made up of pigment suspended in a binder of gum arabic, watercolor is a fluid medium that requires quite a bit of practice to master. (And even once you've learned to control the moisture, be open for a bit of spontaneity!) However, if you devote enough time to this medium, you'll understand why it is praised for its ability to quickly capture an essence, suggesting form and color with just a few brushstrokes.

Watercolor paints come in a few forms, so experiment to find the kind that suits you best. Collapsible metal tubes are the most common form, which release moist, goopy paint. Mix a small pea-sized amount of this with water to create a wash. Dry pans (small blocks of dry pigment) and semi-moist pots are other forms of watercolor. To use these, simply stroke over the pigment with a wet brush. Pans and pots are considered more convenient for painting on location because they are less watery and often come in closeable palettes.

Unlike other painting media, watercolor relies on the white of the paper to tint the layers of color above it. Because of this, artists lighten watercolor washes by adding water—not by adding white paint. To maintain the luminous quality of your watercolors, minimize the layers of paint you apply so the white of the paper isn't dulled by too much pigment. —ETG

READY TO START?

Here's what you'll need: set of watercolor paints, two jars of water, set of brushes, mixing palette (with wells), paper towels, watercolor paper, masking tape, drawing or painting board, and a sketching pencil.

Medieval Aesthetics

DIVINE INSPIRATION

"Ad pulcritudinem tria requiruntur, integritas, consonantia, claritas."
—St. Thomas Aquinas

A lot happened during the thousand years between the fall of the Roman Empire and the dawn of the Renaissance, but we tend to lump it all together. One reason for this is that the bulk of medieval thought was unified by a core belief in God. The Italian monk Thomas Aquinas is known first and foremost as a Christian theologian, yet he and his fellow saints are also the first place we look for any scholarly output from the Middle Ages.

You could say, rather ironically, that a thinker in the Dark Ages had to be quite a Renaissance man. As it was in Ancient Greece, the same guys trying to figure out the right way to live were refining the scientific method and analyzing art. The main difference in medieval times was that Christ had been born and the Christian God had replaced the pagan gods.

Toward the end of James Joyce's excellent novel *A Portrait of the Artist as a Young Man,* protagonist and aspiring young artist Stephen Daedalus discusses the definition of beauty with his friend Lynch. After citing the Latin text quoted above, Daedalus translates it as, "Three things are needed for beauty, wholeness, harmony, and radiance," and he accepts the words of St. Thomas as his own criteria for beauty. The choice of descriptors is very characteristic of medieval thought, reflective of the Judeo-Christian conception of God, and for Joyce to quote it says quite a bit about the era's enduring impact on Western thought. —CKG

QUESTIONS TO PONDER

• *How would a Christian worldview influence a theory of aesthetics?*

• *Do you agree with Aquinas's requirements for beauty?*

Performance Art

THEATER IN ART

WHEN & WHERE

c. 1910–Present

USA, Europe, and Japan

Art and life are inextricably linked for a performance artist. In often absurd and unconventional ways, performance artists have been challenging societal expectations about art, society, and everyday life for years. By blending theater, poetry, sound, visual art, and film media into one sensory experience, performance artists created a new genre that has delighted, shocked, amused, and confused audiences.

Covering everything from spirituality to sex and violence, this movement has generated controversy. From Joseph Beuys gold-leafing his face and tenderly stroking a dead hare to Chris Buren having himself shot in the arm to Yoko Ono sitting motionless on a stage while the audience calmly cut off bits of her clothing, performance artists often make disconcerting statements.

Performance art can happen in a theater or on a street; there are no site boundaries. Live audiences are participatory or not, present or not. The element of chance is unavoidable and often welcomed. Though performances are intentionally impermanent, most are documented with photos and film for posterity. Some props may remain as well, but the event itself is what is significant.

From its roots in Dada performances of the 1910s and John Cage at Black Mountain College in the 1950s, the performance genre has a long history. The 1950s and '60s saw the nonsensical "Happenings" reflect the zeitgeist of that era (page 25), while the Fluxus group held "events" that challenged convention. Today, performance art is still thriving and pushing the boundaries of contemporary art. —ARR

Selected artists: Marina Abramović, Laurie Anderson, Joseph Beuys, John Cage, Merce Cunningham, Allan Kaprow, Paul McCarthy, Yoko Ono, Nam June Paik, Carolee Schneemann

Jan van Eyck (1390-1441)

ALL IN THE FAMILY

Flemish artist Jan van Eyck did not invent oil painting, as he has often been credited, but he was one of the medium's earliest and most accomplished users. His command of the technique and his ability to render subjects, textures, patinas, and sheens with staggering realism led not only to his reputation as a great artist, but also to distinguished appointments, privileges, success, and wealth.

Archival documentation suggests that van Eyck's year of birth was about 1390 and that he was from Maaseik in Limburg, Belgium. Van Eyck had at least two brothers, Lambert and Hubert, who was also an artist. From 1422 to 1424, van Eyck was court painter to Holland's John of Bavaria. And from 1425 until his death, he served as royal painter and diplomat to Duke Philip the Good of Burgundy, with whom he shared a pleasant friendship. The relationship was so amicable that van Eyck made Philip godfather to one of his children.

In 1432, van Eyck began signing and dating his work, which is how historians have identified his involvement in the exquisite *Ghent Altarpiece:* a multi-paneled polyptych originally commissioned to Hubert in 1425. When Hubert died in 1427, van Eyck completed the altarpiece and may have even repainted some or all of his brother's contributions; however, it is difficult, if not impossible, to know which artist painted which panel or any of the Eyckian-style paintings rendered prior to 1432. —RJR

Notable works: *Ghent Altarpiece,* 1432; *"Man in a Red Turban,* 1433; *The Arnolfini Marriage,* 1434 (page 292).

Fun Fact

In 1428, Philip the Good sent van Eyck to Lisbon to paint the portrait of his betrothed, Isabella of Portugal, so that the Duke would have a means of evaluating his future wife.

Adele Bloch-Bauer I

GUSTAV KLIMT, 1907

In the early 20th century, an Austrian sugar mogul named Ferdinand Bloch-Bauer commissioned a Viennese artist, Gustav Klimt, to create a portrait of Bloch-Bauer's wife, Adele. Klimt was already a well-known innovator. He and his contemporaries, calling themselves the Vienna Secession, were pushing the boundaries of established styles and techniques. *Adele Bloch-Bauer I* is an example of Klimt's non-traditional approach. All of the gold and silver is genuine, applied as both leaf and paint. The stylized body is flattened into the background and turned into an ornament of sorts. Compare this to the self-portrait by van Gogh on page 312; this piece was painted only about 20 years later. Art was evolving at a dizzying pace!

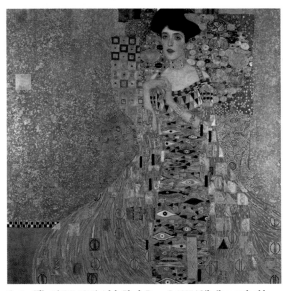

Gustav Klimt (1862-1918), Adele Bloch-Bauer I, *1907 / Oil, silver, and gold on canvas, Neue Galerie New York. This acquisition made available in part through the generosity of the heirs of the Estates of Ferdinand and Adele Bloch-Bauer. Image courtesy of Neue Galerie New York. Movement: Vienna Secession/ Art Nouveau.*

Since its creation, *Adele Bloch-Bauer I* has been on a complicated journey. The painting was confiscated by the Nazis after they invaded Austria in 1938. Following their fall from power, a legal battle ensued over whether it belonged to the Austrian State Gallery or to the only surviving niece of the Bloch-Bauers, Maria Altmann. In 2006, Altmann was legally declared the rightful owner. Later that year, *Adele Bloch-Bauer I* was purchased by the Neue Galerie in New York City as the centerpiece of their collection of Jewish-owned art looted by the Nazi government. That same year, Klimt's masterpiece was sold in the United States for more money than any painting in history up to that point—$135 million US. —DDG

The Auction House

THE ART OF THE DEAL

Almost anything can be sold at auction—from livestock and antiques to silverware and fine works of art. Auction houses have been providing a service to millions of investors since recorded human history. Derived from the Latin word *augere,* meaning "to augment" or "to increase," the oldest auction house, Stockholm Auction House in Sweden, dates to 1674. By the 18th century, art auctions were held in public gathering spaces, such as coffeehouses or taverns, with pre-printed catalogs detailing the works to be sold. Many contemporary auction houses such as Sotheby's (founded in 1744) and the world's largest, Christie's (founded in 1766), are rooted in these earliest traditions.

Every auction differs: The mood may be subdued or rowdy, depending on the type, quality, price, and "celebrity" status of the art up for grabs. Even in economically tight times, the value in a celebrity name such as Andy Warhol or Pablo Picasso can draw big spenders and even bigger crowds, expecting a spectacle of bidding wars and excited auctioneers. Beginning with an opening bid usually around 50 percent of the market value of the work of art, the auctioneer recognizes and raises bids in rapid-fire fashion. When the gavel falls, the hammer price, or nominal price at which the lot is sold, goes to the top buyer. The intricacies of the auction take years of practice and keen observation to perfect, but even a novice can appreciate the art of the deal. —SBR

A House United

THE CEREMONIAL BAI OF BELAU

In the vast blue of the southern Pacific Ocean, about 300 miles due east of the Philippines, large gable-fronted houses known as Bai sit among swaying palm trees on the island of Belau. Decorated with elaborately carved and painted symbols of wealth, fertility, mythic beings, and community members, Bai tell stories about each community through their architectural designs. Usually located in the village square, Bai serve as the social, political, and artistic centers for each community.

Some speculate that before contact with Europeans in the 19th century, the imagery may have included references to headhunting ceremonies, but currently, the most common designs found include circles (stone money disks), mythic birds and roosters (symbols for male virility and money), spiders and goddesses (female fertility), and "storyboard" paintings filled with historical events. These storyboard paintings are a relatively new addition to the Bai decorations.

Begun in the 1930s while the island was occupied by Japan, Belauan artists began to copy the traditional images carved into the rafters of the Bai onto portable boards for sale to tourists. The creation of these storyboards developed into a unique and important Belauan art form. The historical and mythical designs that decorate both the inside and outside of the Bai can now be transported around the world on flat wooden panels, a tradition that continues to this day. —SBR

Strandbeest

THEO JANSEN'S BEACH CREATURES

The first time I watched a video of Theo Jansen's Beach Creatures, I felt as if I were witnessing some sort of absinthe-induced hallucination. The visage of the beasts is so mythical—their movements so fluid and seamless—that they appear to have wandered right off the set of some Steven Spielberg film.

After verifying the reality of these creatures, I turned to a second question: *what* are they, exactly?

Jansen, an engineer by profession, matter-of-factly describes the creatures as "skeletons that are able to walk on the wind." Others have called them "wind-powered robots" or "kinetic structures." All of these descriptions fit: The inorganic beasts use translucent fins to harness the wind and propel themselves across the surface of the beaches of Holland.

"The walls between art and engineering exist only in our minds," states their creator.

Jansen continues to increase the structural sophistication of these creatures. He hopes to release a herd of them into the wild someday, free to roam and interact with each other on their own. —DJS

Animaris Rectus *by and courtesy of Theo Jansen.*

Mona Lisa Lifted

HOW WOULD *YOU* STEAL THE WORLD'S MOST FAMOUS PAINTING?

Would you believe me if I told you that someone walked out of the Louvre—right out the front door—with da Vinci's *Mona Lisa* under his coat?

Fantastic as this may seem, that's exactly what happened on August 21, 1911. An Italian employee of the Louvre, believing in his heart that da Vinci's masterpiece belonged in Italy, hid in a closet until the museum was closed to the public, and took the painting right off the wall and out the door.

For years, he kept the painting at his residence while he continued to work at the Louvre. Finally, upon deciding it was time to return the painting to Italy, he attempted to begin negotiations with the Uffizi Gallery. He was subsequently arrested for the theft but was considered a hero by most Italians, so he only spent a few short months in jail.

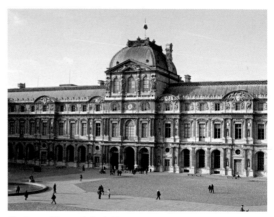

The Louvre Museum in Paris, France.

After the painting was recovered, *Mona Lisa* toured various museums throughout Italy until it was finally returned to the Louvre, where it has rested, in relative peace, ever since. —GRG

Exercise 33

RED-EYED TREE FROG WITH EILEEN SORG

Apply orange-red to the eyes and parts of the feet; then fill in the rest of the feet with yellow-orange, leaving white highlights. Create the base layer for the frog and stalk with chartreuse. Apply red to the eyes and shadows of the feet.

Stroke light green along the stalk and on the frog's eyes and legs. Apply bright blue to the frog's mouth, legs, and parts of the chest.

Fill in the pupils, nostrils, and areas on the feet with black. Shade the throat and chest with a light, warm gray and black. Deepen the stalk and frog with green. Add shadows to the stalk with a layer of olive green followed by dark purple. To finish, brighten up the shadows on the frog's throat and chest with dark purple.

Watercolor Pigments

EXPLORING THE PROPERTIES OF YOUR PAINT

For many of us, watercolor was the first paint we ever tried. But how unaware we were of its complex nature! Each color actually behaves differently depending on the characteristics of its pigment. Whether synthetic or naturally occurring, pigments vary in the way they lay on the paper and interact with one another. Get to know the pigments in your palette, and you'll gain more control over your washes.

Here are some of the ways watercolors are characterized and labeled:

- *Staining* pigments (such as alizarin crimson) are more permanent than non-staining (such as Naples yellow). When applied to paper, staining pigments are nearly impossible to lift or dab away completely.

- Watercolors are either *transparent* or *opaque*. Transparent colors (such as cobalt blue) allow light to penetrate and reflect the white of the paper, whereas opaque colors (such as cadmiums) have pigments that block light. To maintain a luminous look in your finished work, use opaque colors in small areas and in small amounts.

- Some colors (such as ultramarine blue) have larger pigment particles that clump together and sink into the grooves of the paper, producing a lightly textured, hazy appearance. This is called granulation.

- Watercolors are rated by *lightfastness*—the ability of a pigment to resist fading over time. *Fugitive paints* have a high lightfastness rating, as they fade faster than *non-fugitive paints.* —ETG

TRY THIS!

Using all the watercolors in your palette, create "interaction charts"
by mixing each color with every other color. Simply stroke two different colors side
by side and slightly overlap the edges; then watch the pigments intermingle.
You might run into some exciting results!

Modern Aesthetics
CELEBRATING HUMANITY

"Aesthetic matters are fundamental for the harmonious development of both society and the individual." —Friedrich Schiller

Society and the individual—that's what the modern era was all about. After millennia of submitting to the mysteries of supernatural authority, people began to believe in their own superiority. The arrival of the Renaissance in the 14th century was the dawn of mankind's trust in itself. Thus, humanism and naturalism were born under the veneer of enlightenment. These ideologies had faith in the human brain's ability to discover all truth through the natural world.

During that time, humankind's rationality was also celebrated in the art world. Finding inspiration in the realism of classical art, artists like Giotto di Bondone began to use lifelike perspective in their work. Later artists like da Vinci and Michelangelo meticulously studied the human body and represented its form in astonishing detail.

Exceptional progress in science and technology led many philosophers to cherish their own rational abilities and reject traditional notions of divinity; hence the ideas of people like David Hume and Friedrich Nietzsche. Eventually, however, the fixation with reason and cold machinery provoked reactions of Expressionism and Romanticism, where an apparent nostalgia for mystery rekindled imagery of passion and the sublime.

Finally, after it seemed like art had been dissected from every angle, the slippery slope of innovation dropped into the foggy seas of Postmodernism, where categories break down and subjectivity reigns supreme. —CKG

QUESTIONS TO PONDER
• How would artistic ideals change with God out of the picture?
• What kinds of art might reflect a relativistic, postmodern worldview?

Land & Environmental Art

SPEAKING THROUGH THE EARTH

WHEN & WHERE

c. Late 1960s–Present

USA and Europe

Surrounding islands with fabric, harnessing lightning to "perform" in a desert, filling a gallery with soil: Land or Environmental Art directly interfaces with the earth. As its many names suggest (Land Art, Environmental Art, Earthworks or occasionally Site Art), the work is usually huge in scale and sculptural.

This movement erupted in the landscape of the United States in the late 1960s—a time when many artists were challenging the very meaning of art and its status as a commodity. Land and Environmental artists asked viewers to reconsider our human relationship with the earth itself from personal, societal, and ecological perspectives. Some artworks are ephemeral, being installed on the land or cityscape, then dismantled after showing. Others are made of biodegradable materials that will erode, or become submerged or overgrown with age. Some are permanent structures. Due to their often remote locations or temporal nature, photo and film documentation is essential.

Reminiscent of Neolithic earth structures and mounds, land artists usually manipulate the earth itself. They have cut huge trenches into canyon walls, stacked and arranged stones and boulders, weaved saplings, and grown sculptures, some requiring large scale collaborative efforts and engineering. Environmental artwork is as diverse as wrapping human-made structures like buildings with fabric to simply planting 7,000 oak trees.

Environmental and Land Art peaked in the '70s. The ecological undertones of those movements have carried on into the concept of Sustainable Art. Much of the work still remains silently with nature. —ARR

Selected artists: Christo and Jeanne-Claude (page 105), Walter De Maria, Andy Goldsworthy, Michael Heizer, Nancy Holt, Dennis Oppenheim, Robert Smithson, James Turrell

Jean-Antoine Watteau (1684-1721)

THE THEATER IN ART

French Rococo painter Jean-Antoine Watteau was born in Valenciennes in northern France and studied art with Jacques-Albert Gérin as a teen. In 1702, he moved to Paris where he worked painting copies until taking a position as an assistant to Claude Gillot, a theater set designer and ardent admirer of *commedia dell'arte,* or Italian theatrical comedy.

In 1708, Watteau mentored with interior designer and decorative painter Claude Audran, who introduced him to Peter Paul Rubens's *Marie de' Medici Cycle* at the Luxembourg Palace, where Audran served as curator. Rubens's art influenced Watteau immensely; however, Gillot and Audran played no small role in shaping the young artist's unique aesthetic, which integrated color and nature with elements of theater, design, and comedy. Watteau was also gifted at depicting humanity with authenticity, realism, and a touch of pathos.

In 1712, Watteau was accepted into the French Royal Academy of Painting and Sculpture. Because his artwork did not fit into any preexisting group, however, the Academy created a new category called *fêtes galantes,* a term used to describe art that depicts light and playful courtly scenes set within pastoral backdrops. Watteau's requisite reception piece, *Pilgrimage to Cythera* (also called *Embarkation for Cythera*), is considered his career-defining *pièce de résistance;* it took five years to complete. The painting, which pays homage to the mythological Greek island of Cythera, is part of the Louvre's permanent collection. It was so popular that Watteau painted another at a friend's request; this second painting is housed at the Charlottenburg Palace in Berlin.
—RJR

Notable works: *Pilgrimage to Cythera,* 1717; *Le Faux pas (The Misstep),* 1718; *Pierrot,* 1719.

FUN FACT

Although Watteau is generally known for his paintings, he was also a superior draughtsman and relished drawing in chalk.

Jeremiah Mourning Over the Destruction of Jerusalem

REMBRANDT VAN RIJN, 1630

In *Jeremiah Mourning over the Destruction of Jerusalem,* Rembrandt van Rijn masterfully captures the essence of a great man shouldering an even greater burden. Rembrandt's series of self-portraits is widely admired and considered a valuable part of art history, but his body of work also includes many Biblical paintings.

This melancholy work was inspired by a story from the Hebrew Scriptures/Old Testament. The prophet Jeremiah had repeatedly foretold the destruction of the city of Jerusalem but his warnings remained unheeded. He had pleaded with his countrymen again and again to stop their

Jeremiah Mourning Over the Destruction of Jerusalem, *1630 (oil on canvas) by Rembrandt Harmensz. van Rijn. Movement: Baroque.*

wrongdoing—to return to God and to obey his commandments—but to no avail. Here we find him mourning the loss of his once glorious city to the invading Babylonian army. Notice the furrows in his brow and his slouching posture as he broods over the catastrophe he had been powerless to prevent. Even in his failure, however, heavenly light still seems to shine upon the courageous old prophet.

This painting features two characteristics that have become synonymous with Rembrandt's art: the focus on a single, dominant figure as a subject, and the use of *chiaroscuro,* an employment of highly contrasting darks and lights in a scene to create tension and drama. —DDG

Sotheby's

FROM BOOKBUYING TO FRANCIS BACON

In 1744, English bookseller Samuel Baker held his first auction, making $1,600 from the sale of 457 books. From these humble beginnings, the auction house Sotheby's has grown to become the world's third oldest auction house in continuous operation. Baker's nephew John Sotheby guided the burgeoning auction house in the 19th century into a world-class book seller. They soon branched out into art and antiques after the dissolution of the English aristocracy and landed elite during World War I. As a result of the breakup of Britain's vast country estates, Sotheby's began to receive commissions to auction the contents of many country houses.

From its humble beginnings as a London-based antique bookseller, Sotheby's sells everything from fine art and antiques to real estate.

By mid-century, Sotheby's expanded to America, with an office in New York City, and continued buying up lesser auction houses, spreading itself around the globe. Today, Sotheby's thrives, despite the economic downturns of the 1990s, and has more than 100 offices worldwide. The auction house also holds several world records, including the most expensive painting and work of art ever sold at auction (Pablo Picasso's *Garçon à la Pipe* at $104 million US) and the most expensive work of contemporary art sold at auction with British artist Francis Bacon's *Triptych,* which sold for $86.28 million US in 2008. —SBR

More than Meets the Eye

AUSTRALIAN ABORIGINAL "DOT" PAINTINGS

Originating as a way to obscure the secret knowledge of tribal histories and ceremonial practices from outsiders, Australian Aboriginal "dot" paintings evolved from traditional ground paintings, which functioned like maps by charting a clan's cultural heritage, creation stories, locations of holy sites, and food and water sources. As part of an elaborate ritual, the usually male members in a group used crushed seeds, flowers, and sand to craft these ephemeral paintings that were rarely seen outside a particular village or community.

By the mid-1970s, these temporary art objects (not originally made for the art market) began to attract outside interest, and Aboriginal artists banded together to form a collective, the Papunya Tula, which is credited with bringing international attention to this unique art form. Eventually, many in the Aboriginal community felt that the sacred nature of their ceremonies and cultural practices suffered from overexposure; artists soon adopted the stylistic practice of dotting a painting in order to camouflage overt references to traditional imagery from outsiders and the uninitiated members of the group. The paintings, now created on canvas with bright acrylic paints, have become the most recognizable forms of Aboriginal art from Western Australia, and many works of art sell at auction for up to half a million dollars. Though their traditions are shrouded behind a hail of dots, these paintings succeed in telling a story of a people who took ownership of their culture and their creativity. —SBR

Shoes on a Wire

ARTISTIC EXPRESSION OF THE COLLECTIVE SUBCONSCIOUS

The annals of urban lore have been filled with attempts to make sense of this phenomenon. Various urban legends attribute it to everyone from street gangs to satanic cults reportedly collecting tokens from their human sacrifices.

The more urbane observer casually dismisses the collection of dozens, even hundreds of shoes hanging from a single telephone wire or tree as a meaningless fad.

But could it be unplanned, collective artistic expression?

If, as psychologist Carl Jung suggested, all individual humans are united by a collective subconscious mind, why could we not spontaneously produce expressions of collective creativity?

Of course, one need not believe in a mystical, shared subconscious to make sense of the phenomenon. Maybe we're all simply fed up with the compartmentalization and hyper-individualism characteristic of modern society. Perhaps something inside of us desperately gropes for a lost sense of community.

Do we long to be connected to each other by something more than a shared power grid?

Or are we all just really bored?

I confess, I like the thought of some cooperative project, some glowing spark of humanity that ties us all together for one brief instant—if only through a bond as fragile as a shoelace. —DJS

Prison Art

EXPRESSING CREATIVITY BEHIND BARS

I hear the train a comin' / It's rollin' 'round the bend, / And I ain't seen the sunshine, / Since, I don't know when, / I'm stuck in Folsom Prison, / And time keeps draggin' on, / But that train keeps a-rollin', / On down to San Antone.

—*"Folsom Prison Blues," Johnny Cash*

Perhaps it isn't the first place one would purposely seek creative inspiration; then again, most of those who compose this unusual group of artists have few—if any—other places to turn outside of the small concrete-and-steel prison cells they call home. The luckier ones may get to spend time in a chow hall and fenced-in prison yard, but only for a few hours a week.

Yet despite these dismal circumstances, many prison artists produce exhibition-quality artwork.

Involuntary Blue *by Ray Materson. Young man standing in prison cell. Red heart tattoo. Image created entirely in shades of blue. Image courtesy of Ray Materson.*

Metamorphosis *by Ray Materson. Depicts a Monarch butterfly emerging from its cocoon. Image courtesy of Ray Materson.*

Artists in prison are often looked on as enigmas from within the prison community because their work does not conform to this population's unwritten rules of conduct, but instead consists of genuine self-expression. In fact, many of the artists continue creating even after they are released.

Because most penal institutions don't allow prisoners to possess essential art supplies, some of the most creative artists in prison are also the most ingenious. While serving time for drug-related offenses, Ray Materson used disassembled socks to weave small, intricate embroideries. Released from prison in 1995, Materson is reformed and now travels the globe lecturing and promoting his art; his work continues to be exhibited in museums around the world.

—GRG & RJR

Exercise 34

1940s CAR WITH ED TADEM

Draw one small rectangle on top of a larger one.

Round out the form and sketch in details, such as wheels, headlights, windows, and the bumper.

Clean up your lines, refining the shapes as you go.

Add details to the wheels, grille, and body of the car. Then draw the seats inside and start shading.

As you near the finish, darken the lines and shading, paying special attention to the grille and fenders. Check out the classic white-wall tires!

Art 101

Watercolor Techniques

MASTERING THE BASICS

Enough talk—time to try watercolor for yourself! When you've finished performing the techniques below, turn back to page 278. Spattering, dry-brushing, and stippling are all applicable to watercolor paint. —ETG

Flat Wash
A flat wash is a thin layer of paint applied evenly over an area of a painting. This is the fundamental technique for any watercolor painting.

Gradated Wash
Apply a few bands of color to the paper, overlapping the strokes. As you move away from the initial strokes, dilute the wash with clean water.

Variegated Wash
This wash is similar to a gradated wash, but instead of adding clean water as you move away from your initial sstrokes, incorporate a different color.

Lifting Out
Before the paint has dried completely, dab it with a paper towel or drag a bristle brush over the surface (shown) to remove the pigment.

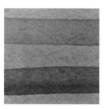

Glazing
To glaze, stroke a layer of watercolor over an already existing (and dry) layer. Your eye will blend the colors together and create a new hue. Shown: phthalo green (top) and phthalo blue (bottom) over violet.

Sponging
Dust a sponge with a watercolor wash, and use it as a tool for dabbing on paint (for a textured look) or for applying broad swipes of color.

Using Salt
Sprinkling salt onto a damp wash can result in a mottled texture. Simply brush off the salt when dry.

Wet into Wet
For feathery-soft blends, apply several layers of clean water to your paper, letting each soak in before applying the next. Let it dry to a satin sheen; then touch in several colors and watch the paper grab and spread your paint.

Postmodern Aesthetics (Part 1)
DECONSTRUCTING BELIEF

"God is dead. God remains dead. And we have killed him. How shall we, the murderers of all murderers, comfort ourselves?"
—*Nietzsche,* The Madman

Perhaps the most overused and least understood word in the history of pseudo-philosophical chitchat is postmodern. It just has such an irresistibly progressive ring to it! But what does it mean? Well, that's actually a pretty hard question to answer, due in large part to the fact that postmodernism is based on a core, possibly self-defeating, distrust of objective ideology.

Postmodernism is a metanarrative, meaning that it has an overall effect on the way its subscribers understand and interpret the world. Ironically though, it is a metanarrative against metanarratives. It states as absolute truth that there is no absolute truth. It holds that any quest for "capital-T Truth," like that of Christianity or Modernity, is destined to fail. There are only individual truths, and those morph in different contexts. Discourse is no longer seen as the means of finding truth but as the end in itself, full of possible truths.

Many have ascribed postmodernism's origin to Nietzsche's chilling words above. With the abandonment of universal values that he inspired, and the lack of a central source of meaning, there is no remaining basis for believing in ultimate truth or the ideal of beauty.

During the modern era, people counted on human reason to save them from investigative impotence, but as the work of philosophers like Descartes and Hume make clear, not even sound logic can provide entirely certain answers. Accepting that fact is the essence of postmodernism.

How does this relate to art? Tune in for Part 2 on page 359.... —CKG

QUESTIONS TO PONDER
• *What contemporary art have you seen that embodies the postmodern worldview?*
• *Do you agree that we can never find absolute Truth?*

Feminist Art

FROM MARGINALIZATION TO ART REVOLUTION

For centuries, most female artists had been swept under the art historical rug, but the women of the highly political and radical feminist art movement were tired of being marginalized and overlooked. Assert-

WHEN & WHERE

c. 1965–1980

USA

ing their voices in often aggressive ways through a wide range of media and venues, these artists turned a critical eye on cultural hierarchies.

Before feminism raised questions about women's roles in art, art had predominantly been made for men, by men, with women's art dismissed as inferior; however, during the cultural revolutions of the '60s, media trivialized as "women's work"—like sewing, pattern, decoration, and quilting—reemerged as legitimate forms of art. Rejecting objectified images of women in popular media, art, and pornography, feminist artists reclaimed their bodies and glorified traditional women's roles in their work. They also provided a female perspective on issues of class, race, sexuality, consumerism, and the art market itself.

This art movement operated in conjunction with the organized political wing of the feminist movement, sharing the same ideology: simply that women and men are equals and should be treated as such. Though the movement had its heyday in the '60s and '70s, any artwork created today confronting social injustice to women or questioning the role of women in a society can be considered feminist art. —ARR

Selected artists: Judith F. Baca, Louise Bourgeois, Judy Chicago, Jay DeFeo, Audrey Flack, the Guerrilla Girls, Rebecca Horn, Mlle Bourgeoise Noire, Alice Neel, Betye Saar, Niki de Saint Phalle, Miriam Schapiro, Cindy Sherman

Auguste Rodin (1840–1917)

UNFINISHED BUSINESS

Celebrated sculptor Auguste Rodin was a visionary—not because he sculpted the human form to be perfect, but rather because he didn't. To be sure, Rodin's work was nothing short of exquisite. But because his sculptures revealed a unique combination of profundity, human emotion, and physical realism, they also flouted tradition; moreover, Rodin's unconventional style led to criticism that his work appeared "unfinished," as well as false accusations that he cheated and cast sculptures directly from life. Fortunately, the added scrutiny wasn't enough to persuade Rodin to modify his aesthetic. He ultimately rose to be one of the greatest sculptors of the 19th century.

Rodin's The Thinker *is one of the most well-recognized sculptures in art history.*

Born in Paris, Rodin showed artistic promise at an early age and studied drawing, painting, and sculpture as a teen. He applied for admission to—and was rejected by—the École des Beaux-Arts three separate times. To sustain himself financially, he maintained employment in the decorative arts field, and later worked with artist Albert-Ernest Carrier-Belleuse. In 1864, Rodin met Rose Beuret, with whom he had a son. The couple remained companions for the rest of their lives—despite the artist's indiscretions—and didn't marry until they were in their 70s; they died that same year within months of each other.

In 1875, Rodin traveled to Italy where his exposure to the masters, especially Michelangelo, had an extraordinary influence on his art. His career flourished in the years that followed. He received numerous commissions and enjoyed prestige and an increasingly loyal following. —RJR

Notable works: *The Man with the Broken Nose,* 1864; *The Thinker,* 1889; *The Kiss,* 1898.

FUN FACT

Although Auguste Rodin is best known for his sculpture, he was also accomplished in oil, watercolor, and drawing. The Musée Rodin in Paris is devoted to the artist's life and work. Visit www.musee-rodin.fr

Bridge Over a Pond with Water Lilies

CLAUDE MONET, 1899

We learned earlier this year that Claude Monet devoted portions of his later life to creating "series paintings," in which he repeatedly captured various subjects in different types of light, weather, and ambiance. Although he painted *Houses of Parliament* (page 102) while traveling in England, Monet completed most of his series paintings in his native France. *Bridge Over a Pond with Water Lilies* depicts a scene near his home, which was located on a property he purchased in 1883 in the French town of Giverny, about 80 kilometers west of Paris. Monet, whose portraits of natural beauty are legendary, set up his easel in his own garden and painted in the natural environment surrounding him. This style of painting is known as "plein air" (page 298), and it was the preferred method of many Impressionists.

In this scene, the bridge and pond appear in the shadows of a late summer afternoon, with the late-day sun still reflecting on the distant trees in the background. Notice that this scene is painted almost entirely with soothing blue, purple, and green hues, applied with loose brush strokes. Monet's peaceful scenes and informal style has won him immense popularity with modern audiences. What do you think? Do you like his approach? —DDG

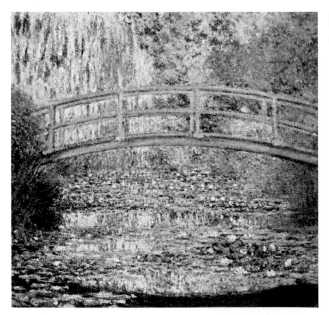

Bridge Over a Pond with Water Lilies, *1899 (oil on canvas) by Claude Monet.*

Christie's

UNDER THE AUCTION HAMMER

Nicknamed "the oldest fine arts auctioneers in the world," the 200-year-old auction house Christie's continually sets record prices not only for works of art but also for carpets, cameras, fast cars, and teddy bears.

After the French Revolution, the auction house, founded by English businessman James Christie in 1766, blossomed into a reputable center for buying, selling, and trading works of art. Even the Russian monarch Catherine the Great bought works of art from Christie's to found the world-famous art institution the Hermitage in St. Petersburg.

Whether you are bidding on a car or a collection of Persian miniatures, once the auctioneer's gavel falls, the sale is finalized.

Like many other international auction houses, Christie's has dozens of offices all over the world, but is centered in London and New York. The auction house broke new ground by becoming the first to exhibit works of art in Beijing, China (1995), and to sell $21 million US worth of jewelry in Dubai, the first jewelry auction of its kind in the Middle East. But Christie's is not without controversy; after taking the company private in 1998, a US Justice Department probe of possible price fixing with Sotheby's rocked the art world, damaging the reputations of both houses. Yet Christie's continues to make records in the auction world: The black dress worn by Audrey Hepburn in the film *Breakfast at Tiffany's* sold in 2006 for close to $700,000, and the highest price paid for a work by French Impressionist Claude Monet ($80.4 million US) is held, at the time of this printing, by Christie's. —SBR

Second Skin

SOUTH PACIFIC BARK CLOTH

Have you ever thought about wearing a skirt made from pounded tree bark? While this may not be your first fashion choice, many cultures, from Africa and Asia to the northwest coast of America, utilize this flexible, natural "fabric" called *Tapa* (the Tahitian word for bark cloth). Manufactured from the paper of the mulberry or breadfruit tree, this traditional textile can be found throughout the South Pacific islands of Polynesia and Melanesia. Tapa is formed through a labor-intensive process of stripping the fibrous layer of bark from the tree, drying, soaking, pounding it flat, and then cutting the thin, paper-like sheet into strips to be glued together, forming a larger piece of "cloth." The bumpy, highly textured cloth then can be made into a blanket, an item of clothing, or an elaborately crafted tapestry, highly prized among community members for its intricate designs of birds, flowers, and family crests.

Contemporary Tapa cloth features tiki designs.

Since cotton and other textiles have replaced Tapa for everyday clothing (which becomes quite soggy when wet; imagine wearing a wet paper bag!), Tapa is reserved for formal occasions and for gift giving. The island nation of Tonga historically has produced and continues to produce more Tapa cloth than any other part of Polynesia, with an emphasis placed on its cultural and ceremonial significance. —SBR

The Videos of Fischli and Weiss

MARVELOUS CONTRAPTIONS AND WOODLAND CREATURES

Peter Fischli and David Weiss's 1987 video *The Way Things Go* begins, unceremoniously, with a close-up shot of a trash bag dangling from the ceiling. Thus begins a chain reaction of collisions, explosions, wind, water, and fire that lasts for 30 minutes.

This modern-day Rube Goldberg contraption drifts in and out of moods, from the calculated to the chaotic. When a rickety wooden structure completely collapses, apparently by accident, it seems that the entire procession has been foiled...until the next step in the sequence begins.

Der Lauf der Dinge (The Way Things Go), 1987. Photos courtesy of Icarus Films.

When a chemical reaction causes smoke to crawl from a table in languid, long-fingered tendrils, the mood is downright ethereal. Other segments of the film border on the comical: the determined march of a teapot skittering across the floor evokes memories of Paul Dukas' scherzo "The Sorcerer's Apprentice."

The Swiss duo has also created a loosely related trilogy of films starring both artists dressed in rat and bear costumes. The giant animals discuss existential concerns as they wander through downtown Los Angeles, the picturesque Swiss Alps, and an Italian palazzo.

The second film in the series, *The Right Way,* ends like some primordial creation myth: The pair discovers music together perched on an alpine hill, overlooking an immense fog-laden valley. —DJS

Vegas, Baby

THE CITY OF SIN—AND ART

Q uick! What's the first thing that comes to mind when you hear the word "Vegas"?

I bet your word wasn't art, was it? Though it may be known primarily for gambling, bachelor and bachelorette parties, and smoking indoors, Las Vegas, Nevada, has become more than just a blip on the art world radar.

From casino art collections to the private collections of millionaires, the amount of fine art that resides in Vegas is starting to garner attention. The city even sought to revitalize its downtown area by offering incentives to artists who moved in and set up shop.

Combine this with all the money floating around that town, and you get a healthy amount of art, new and old—even a Picasso with a hole in it (page 326).

So, while Vegas may not currently rank with Paris, New York, or London as a destination for art lovers, it is definitely up-and-coming. And for those of us who aren't terribly fond of gambling, the growing number of galleries and studios makes a trip to Vegas a more interesting proposition than ever before. —GRG

The city lights of Las Vegas, Nevada.

Exercise 35
ORCHIDS WITH ED TADEM

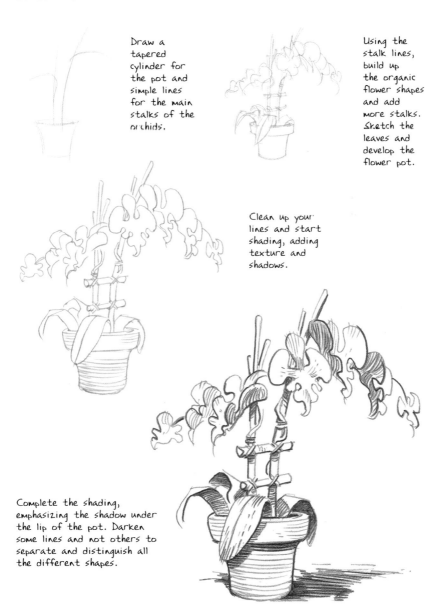

Draw a tapered cylinder for the pot and simple lines for the main stalks of the orchids.

Using the stalk lines, build up the organic flower shapes and add more stalks. Sketch the leaves and develop the flower pot.

Clean up your lines and start shading, adding texture and shadows.

Complete the shading, emphasizing the shadow under the lip of the pot. Darken some lines and not others to separate and distinguish all the different shapes.

Creating an Artist's Sketchbook

PERSONALIZED ART PRACTICE

A sketchbook is a useful tool for artists of any skill level. For beginners, it encourages practice; for seasoned artists, it's a place for honing skills and preparing for larger, more detailed work to be done later.

Carry your sketchbook and drawing implement of choice everywhere you go (just as you do with this book!). You never know when or where the perfect scene will present itself. And even if it doesn't, you'll still find plenty of elements around you that can provide practice—dishes, candles, flowers, cars, and even family members.

Unlike taking a photograph, sketching allows you to take notes about a scene as you draw. You might want to record the time of day, the direction of light, observations about color—anything that will help jog your memory of a scene's details.

When using your sketchbook for preliminary work, use it as an opportunity to experiment with focal points, composition shapes, and viewpoints. Complete several sketches of the same scene, and you might be surprised at which variation is most pleasing.

Consider making your sketchbook more than just an art tool. Make it your visual diary or journal, complete with notes about events, vacations, and the people around you. These personal touches will not only fuel your artistic inspiration and keep you practicing, but they'll turn your sketchbook into a valuable keepsake. —ETG

TRY THIS!

Glue an envelope to the inside front or inside back cover of your sketchbook.

Use this pocket to store small tokens from life, such as postcards,

letters from friends, magazine clippings, leaves, or small flowers.

Postmodern Aesthetics (Part 2)

AND YOU THOUGHT ART WAS SUBJECTIVE BEFORE!

"Abstract painting is abstract. It confronts you. There was a reviewer a while back who wrote that my pictures didn't have any beginning or any end. He didn't mean it as a compliment, but it was."

—Jackson Pollock

Postmodernism in art can refer to a few different things. As an adjective, postmodern is sometimes nothing more than lazy synonym for *eclectic* or *weird*. More precisely, postmodern art signifies a reaction against the modern era's idolization of reason and progress. In some way, whether through indistinct subject matter or unconventional composition, it reflects the tenets of postmodernism outlined in Part 1.

In recent philosophies of art and aesthetics, postmodernism has been a notable force. A variety of recent philosophers have drawn from Marxist politics and Freudian psychoanalysis to conclude that consumerism and the concept of self are detrimental to the postmodern worldview because they nourish a false sense of concrete reality. The postmodern view would be that the concept of self is simply a linguistic construct, and a misleading one at that. This leads to a deterioration of the subject/object dichotomy central to art in Modernism.

The artwork of Jackson Pollock and other Abstract Expressionist painters bears the hallmarks of postmodernism in its deliberate elusiveness—the room it leaves for interpretation. Barbara Kruger's work, on the other hand, reflects postmodern ideals in the way it combines mixed media, disparate subject matter, and provocative messages that challenge our identities and social norms. —CKG

QUESTIONS TO PONDER

- *Do you like the idea of postmodern art? Why or why not?*
- *What reaction might we see against postmodernism in the future of art?*

American Folk Art

THE HEART OF THE PEOPLE

Do you know someone who creates art using found objects, making sculptures for their garden or making paintings with old house paint on plywood? This person may be considered a folk artist. Defined as

> **WHEN & WHERE**
> *c. 1960s–Present*
> *USA*

work by an artist without formal training, folk art is often characterized by a naïve style, festive colors, and simple arrangements with an immediacy of meaning. Reflecting the traditions of small communities, folk art is an art of the people. The melting pot of the United States makes American folk art exceptionally rich and varied.

Folk art arrived in the US with the first European settlers and African slaves, many of whom were experienced craftspeople. These folk artists applied tech-

niques from their homelands to woodcarving, pottery, quilting, painting, architecture, and sculpture. Their art, featuring whimsical images of nature and social and moral themes, combines a vibrant blend of African, Native American, and European traditions.

Amish quilt.

In Europe, aspiring "fine artists" traditionally sought an education from guilds and universities, subsequently exhibiting their work in the fine art world. A dearth of art schools in this new world gave rise to Outsider Art, or folk art that expresses a cultural flavor unbound by the conventions of fine art.

Today, the practice of folk art in the South still flourishes. Although often dismissed as "crafty" or unsophisticated, folk art is an important part of American culture with a large fan base. —ARR

Selected artists: Leroy Almon Sr., Gee's Bend Quilters Collective, Rufus Hathaway, Edward Hicks, BF Perkins, Harriet Powers, Bernice Sims, Jimmy Lee Sudduth, Mose Tolliver

Titian (1488-1576)

POETRY IN PAINTING

"Nobody cares much at heart about Titian; only there is a strange undercurrent of everlasting murmur about his name, which means the deep consent of all great men that he is greater than they."

—John Ruskin, Victorian author and poet

More than 400 years after his death, 16th-century Venetian artist Titian is still praised as one of the greatest painters in history. A master of portraits, altarpieces, and religious and mythological themes, the strength of Titian's art lies in his subjects' tenderness, radiance, and refinement, thanks in part to his supreme command of color and flawless methods of execution.

Titian, or Tiziano Vecellio as he was christened, was born in Pieve di Cadore near Venice. His date of birth has been widely disputed, and various sources have listed different years from 1477 to 1490; however, most believe it was about 1488. As a child, Titian apprenticed in the workshop of mosaic artist Sebastiano Zuccato and then later trained with Giovanni Bellini. He was most influenced, however, by his mentor Giorgione, with whom he also collaborated on a number of works. In fact, Titian completed some of Giorgione's works-in-progress following the man's death, and historians remain unclear about the true origin of several pieces, which could be attributed to either artist.

During his long and illustrious career, Titian received numerous distinguished commissions, including from emperor Charles V of Bologna, Pope Paul III, and Philip II of Spain, for whom he painted a number of works featuring eroticized mythological figures based on Ovid's *Metamorphoses*. He termed these "poesie," which suggests a number of possibilities. Among them that the works are a form of visual poetry, that they are rooted in literature, and that the artist believed in taking liberties when depicting the stories on canvas.
—RJR

Notable works: *Assumption of the Virgin,* 1518; *Venus of Urbino,* 1538; *Portrait of Pope Paul III,* 1543.

The Blue Boy

THOMAS GAINSBOROUGH, C. 1770

The Blue Boy, c. 1770 (oil on canvas) by Thomas Gainsborough. Courtesy of Huntington Library, Art Collections, and Botanical Gardens, San Marino, California. Movement: Rococo.

In this portrait by British painter Thomas Gainsborough, *The Blue Boy* is actually a British youngster named Jonathan Buttall. Jonathan's father made his fortune as a hardware merchant, and he commissioned the renowned Gainsborough to immortalize his son. Gainsborough agreed and set to work on what would turn out to be one of the largest (48 inches wide and 70 inches tall) and most recognizable portraits in Western art.

Gainsborough's contemporaries would have immediately recognized that the boy's blue trousers and jacket were not in the style of the 1770s, which is when the painting was completed. Instead, Gainsborough dressed Jonathan in clothing that would have been stylish around a hundred years earlier, in the 1600s. Scholars generally agree that this was done as a tribute to the legendary 17th-century artist Anthony van Dyck, who often painted his subjects in casual poses against natural backdrops.

Gainsborough remains one of the best known of British portrait painters. Compare this piece to the *Portrait of Innocent X* that we discussed on page 232. How is each artist's treatment of portraiture unique? Which style do you prefer? —DDG

Out West with Bonhams & Butterfield's

FROM THE JAILHOUSE TO THE AUCTION HOUSE

The quirky beginnings of the properly British auctioneering house of Bonhams & Butterfield's may surprise you. Former sheriff William Butterfield traded his badge and gun for a gavel in 1865 to found Marble Head Auctioneers on the current site of San Francisco's iconic TransAmerica Pyramid. Butterfield cashed in on the pioneers and adventuresome spirits who traveled west to seek their fortunes during the mid-19th-century Gold Rush. He catered to the newly emerging middle class's tastes for the finer things in life, including art, antiques, and home furnishings. As the premier West Coast auction house continued to successfully expand into European and Asian markets over the next century, it caught the eye of private art auction house Bonhams, which bought and consolidated the two companies in 2002 to become the third largest auction house after Sotheby's and Christie's. Collectively, on both sides of the Atlantic, the auction house hosts almost 800 sales a year, more than either of the top two houses.

From classic cars and estate jewelry to real estate, many auction houses offer a wide array of objects to bid on.

Bonhams & Butterfield's sales run the gamut from classy cars to shocking graphic art. Known around the world as a leader in the collectible car auction arena, the auction house sold a rare 1926 Bugatti race car for $1.2 million US and the world's oldest Cadillac, a 1903 Runabout, for $337,000 in 2007. In the same year, the auction house took $400,000 for nine tiny works by American underground comic master Robert Crumb (known to many as R. Crumb).

You could say the maverick spirit of one-time "Wild West" sheriff Butterfield is alive and well! —SBR

Moai

NAVEL GAZING ON EASTER ISLAND

Long a subject of curiosity, speculation, and myth, the monolithic "heads" of Easter Island sit stoically in the same spots where they were erected during a very intense burst of creativity thousands of years ago. Scattered along the island's coast, the statues, known as *moai*, are not just giant heads but full-length figures kneeling with their arms clasped around their stomachs, their visages meant to depict ancestors, chiefs, or other high-ranking males. Usually carved from volcanic rock found at a single quarry inside the extinct volcano Rano Raraku and traditionally decorated with white coral and black obsidian, many of the *moai* are buried up to their necks under many feet of silt. Averaging 14 tons apiece and nearly twice the size of the carver, the creation and transportation of these colossal statues required a concerted group effort; most required teams of half a dozen men using only stone hand tools to carve and more than 100 men to assist in moving the statue.

Two moai on the slopes of Easter Island.

Many historians and archeologists speculate that only 300 of the nearly 900 statues created made it to their final resting places atop *ahu,* or flat stone plinths. As a result of clan warfare in the 1600s, many of the *moai* were toppled over, but about 50 have been re-erected since the 1950s. Due to its isolated location, one traditional Polynesian name for Easter Island was "the navel of the world." Taking a flight from Chile some 2,000 miles due east, you too could gaze upon these stone giants, silent witnesses for millennia. —SBR

Ancient Form Profaned by Pop Culture

WENDY MARUYAMA'S TEA HOUSE

An ancient Japanese legend from the Musashi province tells of a woodcutter who sought protection from a snowstorm inside an old-fashioned wooden hut. The shelter, however, proved defenseless against a fearsome snow-demon known as the *Yuki-Onna,* who effortlessly passed through the walls of the hut and took the woodcutter's life.[41]

Tea House. *Photo © Wendy Maruyama.*

In a similar vein, Wendy Maruyama presents a traditional Japanese cultural form that—while rich in patina—appears unable to withstand a relentless onslaught of commercialism. Her sculptures often vacillate between reverence for the spiritual depth of time-tested Japanese traditions and contempt for the superficiality of contemporary society.

Tea House. *Photo © Wendy Maruyama.*

Architecturally, the Tea House remains true to tradition, complete with sliding doors, *tatami* floor mats, and the raised alcove known as the *tokonoma.* The sliding doors, however, are covered with the likeness of Hello Kitty, enlarged ad absurdum. Other panels have been defiled with anime-style images, alluding to the manga comic books so prevalent in modern-day Japan.

If the structural integrity of the *Tea House* remains unaffected by all the pop culture references, the metaphysical nature of the edifice appears to have been irreparably distorted by this maelstrom of shallow consumerism. —DJS

Radiology Art
THE GUTS OF EVERYDAY ITEMS

Have you ever wondered what your Barbie™ doll looked like on the inside? Ever wished you could look inside your computer without having to take it apart? New York artist and medical student Satre Stuelke lets you do just that. Since 2007, he has taken CT scans of everyday objects, including toys, electronics, food—anything he thought could be interesting. He scans and then colorizes the images based on "the spread of densities within a particular subject," and minimally color-corrects them in Photoshop®.

There is currently a collection of about 40 images, most done by him, although he allows others to contribute to the effort. You just need access to your own CT scanner, which can be a little problematic for most people.

Aside from large-format, museum-quality prints, which he shows and sells at galleries, there are several movies you can watch of the scans. The videos provide a fascinating three-dimensional perspective of the objects, as you can see all the "guts" and how they relate in space to one another.

My favorite image is one of a simple toaster, which illuminates all the little bits and pieces that make this magic box work. In goes the bread, out comes the toast—so simple, yet so beautiful in this context. —GRG

The insides of your toaster. Image courtesy of Satre Stuelke (www.radiologyart.com).

Exercise 36

SUSHI WITH ED TADEM

Rough in the shape of the sushi tray and two chopsticks. Then draw the cylindrical rolls, using guidelines to line them up.

Next sketch the garnishes: ginger, wasabi, and a decorative veggie. Erase the guidelines.

Begin indicating the textures of the seaweed and rice, erasing guidelines as you refine the outlines. Shade the inside corner of the plate.

Strengthen your marks, making the tray and seaweed darkest. Looks good enough to eat!

Art Appreciation

A GUIDE TO UNDERSTANDING A MASTERPIECE

Let's wrap up your year in Art 101 by putting together a touch of everything we've learned. Whether you're prepping to impress someone on a date at the museum or just trying to understand the significance of a work of art for your own satisfaction, you'll find the prompts below helpful for discussing and appreciating a particular work of art. (Go ahead and tear out this page and use it as a cheat sheet—just don't let your date see you peek at it.)

• *Do you like the work of art?* Allow yourself an initial reaction before getting too analytical.

• *Address the work's aesthetic qualities.* Do the elements of art come together to create a pleasing composition?

• *Think about how the aesthetic qualities create a mood.* How do the style and use of the medium communicate the atmosphere or emotions of the scene?

• *Acknowledge the historical context.* Relating the piece to social influences and events of its time can open the door to a deeper understanding of the subject matter. And admiring a piece against the backdrop of art history gives it a place in the ever-developing scope of art.

• *Consider the piece within the context of the artist's life.* The work may represent a statement in response to personal circumstances, embodying a particular time in the artist's life or marking a turning point in the artist's approach to art. Whatever the case, personal insights can make viewing art a more intimate experience.

• *Do you like the work of art?* After pursuing steps 2–5, ask yourself this question again. Chances are you'll feel differently about a piece once you've taken the time to understand it on multiple levels. —ETG

Tips for Further Study

IF YOU'RE INTERESTED

"The more we study, the more we discover our ignorance."
—Percy Bysshe Shelley

The word *philosophy* literally means "love of wisdom." Philosophy is meant to satisfy those who crave deeper understanding. But, as the great poet Shelley implies, there is always more to learn. In these pages we have only scratched the surface of aesthetics and the philosophy of art. Hopefully, some of the topics addressed in this book have been thought provoking for you. If so, don't settle for a whetted appetite!

In case you were born in a cave and have only recently joined civilized society, there's this thing called "the Internet" that is quite useful when it comes to research. On the other hand, those of you who live primarily in the world of digital information may be surprised to learn that libraries actually do still exist! I hate to say it, but when it comes to philosophy, real books are far more edifying than Internet summaries. Furthermore, it is best to read the original texts whenever possible. Interpreting all the vernacular quirks can be a chore, but the hard work will pay off when you get the purest, most direct understanding of the initial ideas.

In addition to the philosophers of aesthetics covered in this book, some other prominent figures to check out include Plotinus, for an expansion of Plato's views; Marsilio Ficino, for a Humanist assessment of beauty; John Dewey, on the experience of art; and Jean-François Lyotard, for an analysis of aesthetics in the postmodern world.

May the wisdom of the world's greatest thinkers continue to enrich your life for years to come! —CKG

QUESTIONS TO PONDER

• *What topics in the philosophy of art are most interesting to you?*

• *Do you still have that old library card?*

Postmodern and Contemporary Art

EVERYTHING GOES!

WHEN & WHERE

c. Mid -20ᵗʰ century–Present

The Entire Planet

What an exciting time for art! New innovations, mediums, styles, and definitions abound. Art is coming at us quickly from all corners of the globe. All cultures, socioeconomic levels, gender identities, and diverse age groups are contributing threads to the tapestry. Pluralism is the word, and everything goes!

Today, artists have the freedom to create art out of literally anything. Many choose media according to which will best deliver their message, not because a particular material or style is their hallmark. In response to our technological age, electronic media has become more prevalent. Traditional mediums are still popular while more contemporary genres like installation and sound art have a large audience. Art is becoming an increasingly multi-sensory experience meant to speak to a vast and diverse audience. Every aspect of sentient experience is mined for content, and nothing is sacred.

The beauty of art is that it is a living entity. It can be a performance or documentation of the way that you breathe, how paint is applied to canvas, or a shadow on the wall. As it lives, it fights with itself, redefines itself, and repeats itself. We can only wonder about what new images and experiences the future will bring. So keep looking at, keep reading about, and keep on making art!
—ARR

Selected artists: Matthew Barney, Jean-Michel Basquiat, Louise Bourgeois, John Currin, Shepard Fairey, Ann Hamilton, Jenny Holzer, William Kentridge, Anselm Kiefer, Kerry James Marshall, Ana Mendieta, Yue Minjun, Judy Pfaff, Cai Guo-Qiang, Julian Schnabel, Richard Serra, Cindy Sherman, Lorna Simpson, Kiki Smith, Bill Viola, Kara Walker

Pablo Picasso (1881-1973)

REBEL WITH A CAUSE

"Success is dangerous. One starts to copy oneself and copying oneself is more dangerous than copying others. This leads to sterility."
— *Interview with Pablo Picasso,* Vogue *magazine, November 1956.*

Rumored to have started drawing before he could speak, Pablo Picasso's genius was evident at an early age. His father, a struggling artist, gave his son lessons and enrolled him in a prestigious Madrid art academy when he was 16. The institution's rigidity, however, stifled the budding artist, and he dropped out after a short time. Already a rebel, Picasso would continue to defy convention for the remainder of his career in favor of creating innovative, compelling art—often to the chagrin of critics and peers.

In 1900, Picasso moved from Spain to Paris. Inspired by the city's Avant-Garde cultural scene, he began pushing the boundaries as no artist had before. One such example is *Les Desmoiselles d' Avignon* (c. 1907), a painting of five nudes inspired by the Barcelona brothels Picasso had seen as a young man. In addition to the unsavory subject matter, critics were equally outraged by the painting's primitive, tribal-inspired characteristics and Picasso's use of fragmented, geometric shapes to grossly distort the faces and bodies rendered in the disturbing scene. And though the painting drew fierce condemnation (prompting Picasso to hide it for a decade), it ultimately opened the door to an entirely new artistic form: Cubism.

Irrespective of one's like or dislike of his work, Picasso's artistic brilliance cannot be denied. His bold methods and resolute philosophies across multiple mediums, including drawing, painting, sculpture, and collage, helped establish him as one of the most influential artists of all time. —RJR

Notable works: *Three Muscians,* 1921; *The Dream,* 1932; *Guernica,* 1937.

> *I hope you didn't think that I'd forgotten to include the great Pablo Picasso !*

Lovers in a Park

FRANÇOIS BOUCHER, 1758

At first glance, French artist François Boucher's *Lovers in a Park* appears quite innocent. The scenery is ornate and inviting, the colors are soft and cheerful, and the people appear to be at leisure—all in true Rococo form. If you pause a bit longer, however, you may notice some tension between the reclining lovers and the young maiden passing by. Is the man simply acknowledging the presence of the pretty flower gatherer, or is something more going on? Does he

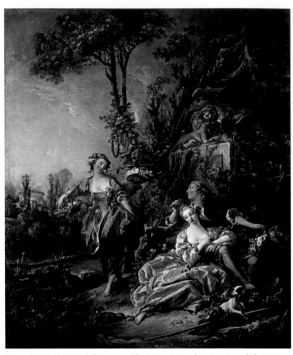

Lovers in a Park, *1758 (oil on canvas) by François Boucher. Courtesy of The Putnam Foundation, Timken Museum of Art, San Diego, California, USA. Movement: Rococo.*

want to take some of her flowers to weave into his lover's hair? Maybe he's attracted to this pretty stranger. Or perhaps she isn't a stranger at all.

This question becomes even more interesting when we take into account what historians know of Boucher's love life. The painter was intimate with two women: His wife Marie-Jeanne Buseau, and his patron—who also happened to be emperor Louis XV's mistress—Madame de Pompadour. It's not difficult to imagine that Boucher may have been portraying in his painting his own love triangle. Since we can't be sure if *Lovers in a Park* is an example of art imitating life, we'll have to be content simply to enjoy it for its lush beauty and intriguing mystery. —DDG

SOURCES CITED

1. Gallo, Antonella. "Labyrinth of Gibellina." *Best of Sicily Magazine,* 2003. http://www.bestofsicily.com/mag/art92.htm (accessed March 2009)

2. Media Art Net. "Wolf Vostell, You." http://www.medienkunstnetz.de/works/you/ (accessed March 2009)

3. Kaprow, Allan. *Allan Kaprow: Art as Life,* edited by Eva Meyer-Hermann, Andrew Perchuk, and Stephanie Rosenthal. Los Angeles: Getty Research Institute, 2008.

4. Jones, David M., Molyneaux, Brian L. *Mythology of the American Nations: An Illustrated Encyclopedia of the Gods, Heroes, Spirits, Sacred Places, Rituals, and Ancient Beliefs of the North American Indian, Inuit, Aztec, Inca and Maya Nations.* London: Anness, 2004, 134–135.

5. Getlein, Mark. *Living with Art,* 7th Edition. New York: McGraw Hill Publishing, 2005, 379.

6. Niemeyer, Oscar. *Curves of Time. Oscar Niemeyer Memoirs.* New York: Phaidon Press Inc., 2000, 176.

7. Painting Max. "Smallest Paintings: Is Small Beautiful?" http://www.paintingmax.com/doc/smallest_oil_paintings.html (accessed March 2009)

8. Willard Wigan MBE. "About Willard Wigan MBE." http://www.willard-wigan.com/about-willard-wigan.aspx (accessed March 2009)

9. The Daily Galaxy. "NanoArt -The World's Smallest Painting." April 9, 2007. http://www.dailygalaxy.com/my_weblog/2007/04/nanoart_the_wor.html (accessed March 2009)

10. Institute of Contemporary Art. "Accumulated Vision, Barry le Va." November 1, 2004. http://www.icaphila.org/news/?item=2004-11-01 (accessed March 2009)

11. Impact Lab. "World's Largest Sand Carpet." January 8, 2009. http://www.impactlab.com/2009/01/08/worlds-largest-sand-carpet/ (accessed April 2009)

12. MSNBC. "In the art world, this is really big." August 11, 2006. http://www.msnbc.msn.com/id/14309591/ (accessed March 2009)

13. The Guardian. Jones, Sam. "Royal Academy's preference for plinth over sculpture leaves artist baffled." June 15, 2006. http://www.guardian.co.uk/uk/2006/jun/15/arts.artsnews (accessed March 2009)

14. Processing (About). http://www.processing.org/about (accessed March 2009)

15. Family Guy. Episode 6, Season 4: "Petarded." 20th Century Fox Television. 2005. Peter Griffin.

16. Burning Man. Black Rock City LLC. "What Is Burning Man?" http://www.burningman.com/whatisburningman (accessed March 2009)

17. Tzu, Lao. *Tao Teh Ching.* Boston: Shambala, 1990, 80.

18. Poli, Francesco. *Postmodern Art: From the Post-War to Today.* New York: Collins Design, 2008.

19. Gombrich, E.H. *The Story of Art,* 16th Edition. New York: Phaidon Press Inc., 2006, 433.

20. The Guardian. Lack, Jessica. "Artist of the week 28: Gregor Schneider." http://www.guardian.co.uk/artanddesign/2009/feb/10/gregor-schneider-artist (accessed March 2009)

21. Postmedia.net. Smolik, Noemi. "Despair Not: One of the House is Blessed. Rejoice Not: One of the House is Damned." http://www.postmedia.net/01/schneider.htm (accessed March 2009)

22. The Guardian. Schneider, Gregor. "There is nothing perverse about a dying person in an art gallery." http://www.guardian.co.uk/artanddesign/2008/apr/26/art (accessed March 2009)

23. Bulber Martin. *The Way of Man: According to the Teaching of Hasidism.* New York: Citadel Press, 1964, 17.

24. Chipp, Herschel. *Theories of Modern Art.* Los Angeles: University of California Press, 1968, 341.

25. National Geographic. Barry, Carolyn. "Earliest Oil Paintings Found in Famed Afghan Caves." February 6, 2008. http://news.nationalgeographic.com/news/2008/02/080205-afghan-paintings.html (accessed March 2009)

26. Tansey, Richard G. and Kleiner, Fred S. *Gardner's Art History Though The Ages 10th Edition, II Renaissance and Modern Art.* Fort Worth: Harcourt Brace College Publishers, 1996, 1062.

27. Arnason, H.H. *History of Modern Art,* 3rd Edition. New York: Prentice Hall, Inc., 1986, 203.

28. Bennett, Will. "Rock Star Sells Out." May 6, 2002. Telegraph Media Group Limited 2009. http://www.telegraph.co.uk/culture/art/3576905/Rock-star-sells-out.html (accessed April 2009)

29. Ashida Kim. Zen Koans no. 85. http://www.ashidakim.com/zenkoans/85timetodie.html (accessed March 2009)

30. Oral history interview with Arman, 1968 May 18, Archives of American Art, Smithsonian Institution. www.aaa.si.edu/collections/oralhistories/transcripts/arman68.htm (accessed March 2009)

31. Arman (Biography/Chronology). http://www.arman-studio.com/index.html (accessed April 2009)

32. The New York Times. Vogel, Carol. "One Person's Trash Is Another Person's Lost Masterpiece." October 23, 2007. http://www.nytimes.com/2007/10/23/arts/design/23pain.html?_r=1 (accessed March 2009)

33. Said, Edward W. "The Art of Displacement: Mona Hatoum's Logic of Irreconcilables." 1999.

34. Mail Online. Gavaghan, Julian. "Tsar's missing art treasure that was looted and hidden by Nazis is now 'found.'" February 20, 2008. http://www.dailymail.co.uk/news/article-516707/Tsars-missing-art-treasure-looted-hidden-Nazis-found.html (accessed March 2009)

35. The Noah Purifoy Foundation. "A Celebration of Life and Art." http://www.noahpurifoy.com/NoahPurifoy.htm (accessed March 2009)

36. The Noah Purifoy Foundation. Wasserman, Abby. "The Desert Years of Noah Purifoy." http://www.noahpurifoy.com/reviews/omoc/desertyears.html#Top (accessed March 2009)

37. Canadian Broadcasting Corporation. "'David Syndrome' causes desire to destroy art." November 20, 2005. http://www.cbc.ca/arts/story/2005/11/20/Davidsyndrome_051120.html (accessed March 2009)

38. Massachusetts Institute of Technology. Thomson, Elizabeth. "Science becomes art in 'Weird Fields.'" March 23, 2005. http://web.mit.edu/newsoffice/2005/weird.html (accessed March 2009)

39. Canadian Broadcasting Corporation. "Wynn sues insurer over punctured Picasso." January 11, 2007. http://www.cbc.ca/news/story/2007/01/11/wynn-lloyds.html (accessed March 2009)

40. Vincent van Gogh. Letter to Theo van Gogh. Written c. 18 December 1881 in The Hague. Translated by Mrs. Johanna van Gogh-Bonger, edited by Robert Harrison, published in *The Complete Letters of Vincent van Gogh.* Publisher: Bulfinch, 1991, number 163. http://webexhibits.org/vangogh/letter/10/163.htm (accessed February 2009)

41. Hearn, Lafcadio. *Kwaidan: Ghost Stories and Strange Tales of Old Japan.* Mineola, NY: Dover Publications, 2006, 72–77.

Page 12: *Mona Lisa*, c.1503-6 (oil on panel) by Leonardo da Vinci (1452-1519) / © Louvre, Paris, France/ Giraudon/ The Bridgeman Art Library; Nationality / copyright status: Italian / out of copyright

Page 22: *Sunflowers*, 1888 (oil on canvas) by Vincent van Gogh (1853-90) / © Neue Pinakothek, Munich, Germany/ The Bridgeman Art Library; Nationality / copyright status: Dutch / out of copyright

Page 32: *The Birth of Venus*, c.1485 (tempera on canvas) by Sandro Botticelli (1444/5-1510) / © Galleria degli Uffizi, Florence, Italy/ Giraudon/ The Bridgeman Art Library; Nationality / copyright status: Italian / out of copyright

Page 42: *The Last Supper*, 1495-97 (fresco) (post restoration) by Leonardo da Vinci (1452-1519) / © Santa Maria della Grazie, Milan, Italy/ The Bridgeman Art Library; Nationality / copyright status: Italian / out of copyright

Page 52: *The Gleaners*, 1857 (oil on canvas) by Jean-Francois Millet (1814-75) / © Musée d'Orsay, Paris, France/ Giraudon/ The Bridgeman Art Library; Nationality / copyright status: French / out of copyright

Page 62: *Arrangement in Grey and Black No.1, Portrait of the Artist's Mother*, 1871 (oil on canvas) by James Abbott McNeill Whistler (1834-1903) / © Musée d'Orsay, Paris, France/ Giraudon/ The Bridgeman Art Library; Nationality / copyright status: American / out of copyright

Page 72: *The Creation of Adam from the Sistine Chapel*, 1508-12 (fresco) (see also 77430) by Michelangelo Buonarroti (1475-1564) / © Vatican Museums and Galleries, Vatican City, Italy/ Alinari/ The Bridgeman Art Library; Nationality / copyright status: Italian / out of copyright

Page 82: *End of an Arabesque*, 1877 (oil & pastel on canvas) by Edgar Degas (1834-1917) / © Musée d'Orsay, Paris, France/ Lauros / Giraudon/ The Bridgeman Art Library; Nationality / copyright status: French / out of copyright

Page 92: *Ophelia* by John William Waterhouse (1849-1917) / ©Private Collection/ Photo © Christie's Images/ The Bridgeman Art Library; Nationality / copyright status: English / out of copyright

Page 102: *The Houses of Parliament, London, with the sun breaking through the fog*, 1904 (oil on canvas) by Claude Monet (1840-1926) / © Musée d'Orsay, Paris, France/ Giraudon/ The Bridgeman Art Library; Nationality / copyright status: French / out of copyright

Page 112: *Self Portrait*, c.1660-63 (oil on canvas) by Rembrandt Harmensz. van Rijn (1606-69) / ©Prado, Madrid, Spain/ The Bridgeman Art Library; Nationality / copyright status: Dutch / out of copyright

Page 122: *Mont Sainte-Victoire*, 1900 (oil on canvas) by Paul Cézanne (1839-1906) / © Hermitage, St. Petersburg, Russia/ The Bridgeman Art Library; Nationality / copyright status: French / out of copyright

Page 132: *The Starry Night*, June 1889 (oil on canvas) (detail of 216295) by Vincent van Gogh (1853-90) / © Museum of Modern Art, New York, USA/ The Bridgeman Art Library; Nationality / copyright status: Dutch / out of copyright

Page 142: *The Tempest* (oil on canvas) by Giorgione (Giorgio da Castelfranco) (1476/8-1510) / © Galleria dell' Accademia, Venice, Italy/ Cameraphoto Arte Venezia/ The Bridgeman Art Library; Nationality / copyright status: Italian / out of copyright

Page 152: *The Young Bacchus*, c.1589 (oil on canvas) (see also 9648) by Michelangelo Merisi da Caravaggio (1571-1610) / © Galleria degli Uffizi, Florence, Italy/ Alinari/ The Bridgeman Art Library; Nationality / copyright status: Italian / out of copyright

Page 162: *Execution of the Defenders of Madrid, 3rd May, 1808*, 1814 (oil on canvas) (see also 155453 for detail) by Francisco Jose de Goya y Lucientes (1746-1828) / © Prado, Madrid, Spain/ The Bridgeman Art Library; Nationality / copyright status: Spanish / out of copyright

Page 172: *Nafea Faaipoipo (When are you Getting Married?)*, 1892 (oil on canvas) by Paul Gauguin (1848-1903) / © Rudolph Staechelin Family Foundation, Basel, Switzerland/ The Bridgeman Art Library; Nationality / copyright status: French / out of copyright

Page 182: *The Milkmaid*, c.1658-60 (oil on canvas) by Jan Vermeer (1632-75) / © Rijksmuseum, Amsterdam, The Netherlands/ The Bridgeman Art Library; Nationality / copyright status: Dutch / out of copyright

Page 192: *In a Café* or *The Absinthe*, c.1875-76 (oil on canvas) by Edgar Degas (1834-1917) / © Musée d'Orsay, Paris, France/ Giraudon/ The Bridgeman Art Library; Nationality / copyright status: French / out of copyright

Page 202: *The Luncheon of the Boating Party,* 1881 (oil on canvas) by Pierre Auguste Renoir (1841-1919) / © Phillips Collection, Washington DC, USA/ The Bridgeman Art Library; Nationality / copyright status: French / out of copyright

Page 212: *Vanitas,* 1628 by Heda, Willem Claesz. (1594-1680) / Haags Gemeentemuseum, The Hague, Netherlands/ The Bridgeman Art Library; Nationality / copyright status: Dutch / out of copyright

Page 222: *Snap the Whip,* 1872 (oil on canvas) by Winslow Homer (1836-1910) / © Butler Institute of American Art, Youngstown, OH, USA/ Museum Purchase 1918/ The Bridgeman Art Library; Nationality / copyright status: American / out of copyright

Page 232: *Portrait of Pope Innocent X* (oil on canvas) by Diego Rodriguez de Silva y Velázquez (1599-1660) / © Galleria Doria Pamphilj, Rome, Italy/ Alinari/ The Bridgeman Art Library; Nationality / copyright status: Spanish / out of copyright

Page 242: *Poster advertising Jane Avril (1868-1943) at the Jardin de Paris, 1893 (colour litho)* by Henri de Toulouse-Lautrec (1864-1901) / © Musée Toulouse-Lautrec, Albi, France/ Lauros / Giraudon/ The Bridgeman Art Library; Nationality / copyright status: French / out of copyright

Page 242: *Jeremiah Mourning Over the Destruction of Jerusalem,* 1630 (oil on canvas) by Rembrandt Harmensz. van Rijn (1606-69) / © Rijksmuseum, Amsterdam, The Netherlands/ The Bridgeman Art Library; Nationality / copyright status: Dutch / out of copyright

Page 252: *The Ashes of Phocion collected by his Widow,* 1648 by Nicolas Poussin (1594-1665) / © Walker Art Gallery, National Museums Liverpool/ The Bridgeman Art Library; Nationality / copyright status: French / out of copyright

Page 262: Rain Steam and Speed, The Great Western Railway, painted before 1844 (oil on canvas) (detail of 4053) by Joseph Mallord William Turner (1775-1851) / © National Gallery, London, UK/ The Bridgeman Art Library; Nationality / copyright status: English / out of copyright

Page 272: A Bar at the Folies-Bergere, 1881-82 (oil on canvas) by Edouard Manet (1832-83) / © Samuel Courtauld Trust, Courtauld Institute of Art Gallery/ The Bridgeman Art Library; Nationality / copyright status: French / out of copyright

Page 292: The Portrait of Giovanni (?) Arnolfini and his Wife Giovanna Cenami (?) (The Arnolfini Marriage) 1434 (oil on panel) by Jan van Eyck (c.1390-1441) / © National Gallery, London, UK / The Bridgeman Art Library; Nationality / copyright status: Netherlandish / out of copyright

Page 302: *Sunday Afternoon on the Island of La Grande Jatte (Sunday on La Grande Jatte),* 1884-86 (oil on canvas) by Georges Pierre Seurat (1859-91) / © Art Institute of Chicago, IL, USA/ The Bridgeman Art Library; Nationality / copyright status: French / out of copyright

Page 312: *Self Portrait, 1889* (oil on canvas) by Vincent van Gogh (1853-90) / © Musee d'Orsay, Paris, France/ Giraudon/ The Bridgeman Art Library; Nationality / copyright status: Dutch / out of copyright

Page 352: *The Waterlily Pond with the Japanese Bridge (Bridge Over a Pool of Water Lilies),* 1899 by Claude Monet (1840-1926) / © Private Collection/ Peter Willi/ The Bridgeman Art Library; Nationality / copyright status: French / out of copyright

ADDITIONAL CREDITS

Artwork on pages 17, 37, 57, 67, 87, 97, 117, 127, 147, 157, 177, 187, 207, 227, 237, 257, 287, 297, 317, 327, 347, 357, and 367 © Ed Tadem. Artwork on pages 27, 47, 77, 107, 137, 167, 197, 217, 247, 267, 277, 307, 337 © Eileen Sorg. Artwork on pages 18 and 218 (portrait) © Lance Richlin. Artwork on page 28 (3 paintings) © Joseph Stoddard. Photograph (night scene) on page 88 © Colin Gilbert. Artwork on page 108 © Frank Serrano. Artwork on page 128 and 258 (café scene) © Tom Swimm. Artwork on pages 258 (roses) and 268 © Caroline Zimmermann. Artwork on pages 278 and 348 © Walter Foster Publishing, Inc.

Photos on the following pages courtesy of Shutterstock®: 11, 13, 23, 24, 30, 31, 33, 34, 36, 40, 43, 44, 46, 50, 53, 56, 60, 61, 63, 64, 66, 71, 73, 74, 76 (earth), 78, 81, 83, 84, 88 (wine glasses), 93, 94, 95, 98, 100, 103, 104, 111, 114, 123, 124, 133, 134, 141, 143, 144, 153, 154, 158, 163, 164, 168, 170, 173, 174, 175, 178 (top two images), 183, 184, 191, 193, 194, 198, 201, 204, 206, 211, 213, 214, 224, 226, 228, 233, 234, 238, 244, 253, 254, 256, 261, 263, 264, 271, 273, 274, 280, 282, 284, 293, 294, 298, 301, 303, 304, 306, 308, 311, 314, 318, 324, 328, 336, 338, 343, 345, 351, 353, 354, 356, 358, 360, 363, 364. Images on the following pages courtesy of Shutterstock®: 29, 49, 58, 59, 68 (color wheel), 69, 189, 199, 209, 219, 249, 259, 269, 279, 289, 299, 309, 319, 339, 349, 359, 369.

About the Authors

Colin Gilbert (CKG) is a freelance writer, tutor, and photographer. He received his BA in Philosophy from the University of San Diego. In his spare time, Colin enjoys pondering the big questions with his lovely wife, Elizabeth.

Dylan Gilbert (DDG) is a writer, musician, teacher, and art aficionado based in Los Angeles, California. He graduated Cum Laude from The College of William and Mary with a BA in English Literature.

A lifelong lover of the arts, *Elizabeth T. Gilbert* (ETG) has spent years as a writer, editor, and in-house artist for Walter Foster Publishing. She holds a BA in English from the University of San Diego and makes her home in southern California with her beloved husband, Colin.

Gabriel Guzman (GRG) is a displaced American who lives and works in Montreal, Quebec. Computer programmer by day and martial artist by night, he is a photographer and freelance writer in whatever time is left in the day. He enjoys art in all its forms and is constantly on the lookout for what's new and exciting.

Rebecca J. Razo (RJR) has been a writer/editor for more than a decade; she has an English degree from California State University, Long Beach, and has completed postgraduate studies in 20th-century British literature. She lives in Southern California with her husband, David, and daughter, Breanna. (www.rebeccarazo.com)

Sharon B. Robinson (SBR) holds an MA in Art History from California State University, Long Beach. When she's not working in the curatorial and registrar departments at the Orange County Museum of Art, she can be found scouring the streets of Los Angeles for art and music. She currently resides in Long Beach, California, with her husband, poet and musician Glenn Bach.

Amy Runyen (ARR) is a fine artist, an illustrator, an art and art history teacher, and an author. She earned her MFA in Drawing and Painting from California State University Long Beach and her BFA in Illustration from the Savannah College of Art and Design. (www.amyrunyen.com)

David J. Schmidt (DJS), holder of a BA in Psychology from Point Loma Nazarene University, has written for publications in the US and Mexico regarding a number of topics. He has been to 20 different countries, speaks 5 languages fluently, and is able to fake about a dozen others—a talent that helped him immensely in contacting some of the artists for this book. Schmidt is always fascinated by the diverse and unique ways in which human beings express themselves.

ACKNOWLEDGEMENTS

Thank you to those who helped make this book possible: Jordan "Boobin" Andersen, Glenn Bach, Abigail Carrillo, Lela Gilbert, Erica Gipson, Amaris Jiménez, Robin Dodds Lang, Tim Marconi, Janet Rohlander, Nathan Rohlander, Jana Rumberger, Dennis Runyen, and Sydney Sprague.

aesthetics sculpture

musee du louvre da vinci oil paint

lisa van gogh

Value watercolor oddities

michelangelo impressionism

ainting art history metropolitan

elements of art instruction

tarry night Modernism color the

contemporary symboli

hilosophy da vinci watercolor pic

dernism expressionism

art history mod

instruction

starry night

mona lisa vermeer

picasso aristotle impressionism

michelangelo watercolor